Journey Of No Return

Journey Of No Return

Bette M. Ross

Fleming H. Revell Company
Old Tappan, New Jersey

Library of Congress Cataloging in Publication Data

Ross, Bette M.
 Journey of no return.

 I. Title.
PS3568.0842J68 1985 813'.54 84-24797
ISBN 0-8007-1415-6

TO my son,
James

With thanks to
Vera A. Lacey,
for her help with research.

To my husband, Guy,
for many nights of fixing dinner.

Contents

Genealogy

Flourinot Harmonie m. Marie Therese in Le Havre, France, in 1727
 They had two children, Genevieve (Gennie) and Phillippe
 Flourinot and the son, Phillippe, d. 1743

The widow, Marie Therese Harmonie, m. Henri Zellaire in Germantown, Pa., 1745
The daughter, Gennie Harmonie, m. Goodman Amos, also in Germantown, in 1745
 They had a son, Benjamin, b. and d. 1747
 Goodman Amos d. 1747

Gennie Harmonie m. Thomas Roebuck, 1748, in a homestead in the Northwest Territory
 And they had four children: William, Rosalind, Marguerite, Marie Therese
The son, William, m. Faith, of Boston, and returned to the Territory
 And their six children were: Hannah and Harmon, twins; Philippe; Matthew; Thomas and Joey

La Demoiselle, last great war chief of the Miami, m. a wife
 Their eldest daughter, Black Hoof, became hereditary chief of the Miami
Black Hoof m. Little Turtle, war chief of the Shawnee
 Their son was Tecumseh

Part I

Tecumseh

1

It was a blistering August afternoon. As Gennie rocked on the shaded porch of the house, she could see heat waves shimmering up from the wagon road that ran beside their cornfield two hundred yards away. Through the heat, hidden silver lances seemed to glisten among the green stalks.

She cocked her ear, listening. No, not yet. Rosalind would come and tell her. She brushed at a fly buzzing around the moist upper lip of the grandchild sleeping on her lap. *Maybe your mama's going to give us a little sister this time,* she thought, gazing fondly at Thomas.

Gennie's face was tranquil, the skin soft and clear. The spiritual beauty of living close to God radiated from her. Her hair was liberally streaked with gray, but was as abundant as it had been nearly forty years ago, when she had fallen in love with Thomas Roebuck and he had brought her to this fertile, rolling farmland on the Ohio. The one-room log cabin Thomas built for her had grown as their family had grown and now in 1782 consisted of nine rooms, two storied, with many outbuildings.

The twins, Hannah and Harmon, her oldest grandchildren, were playing nearby on the grass. Hearing a squeal from Hannah, Gennie shot a glance at the four-year-olds. Hannah was hunkered down beside Harmon, as alike in their jeans and little white homespun shirts and glossy chestnut hair as twins could be. Hannah had been born with a caul over her head. Her thoughts reverted to her daughter-in-law, Faith, laboring inside for the fifth time in barely five years. Her lips moved in prayer that the coming baby had no caul or anything else amiss. Faith could not be in better hands. Rosalind Hambleton, a middle-aged woman now, like herself, was the best midwife in the Ohio.

Hannah's bottom shot up suddenly, then the rest of her straightened. She sped toward her grandmother, arm extended, palm up and closed. Gennie grinned, the face lighting with girlish joy as this child, who looked like she imagined she herself had as a child, brought her a treasure to share. Hannah's wide cheeks were deep, berry red, cupping down into an elfin chin. Even at four she possessed an arresting face and a definite personality.

12

Gennie leaned forward over the baby to see what Hannah brought. Carefully the dirty fingers unclosed, exposing a woolly-bear caterpillar.

"Ain't it pretty, Gra'mama? Ooh, he tickles!" Suddenly she let it go and brushed her fingers on her jeans. The caterpillar lay still for a moment, then began wriggling across the smooth plank. Hannah leaned both elbows on her grandmother's knees and gazed down at her sleeping baby brother. "Did my *new* baby brother come yet?"

Gennie caressed the warm hair. "Not yet, *ma chérie*. I told you, it might be a little sister. Wouldn't that be nice?"

"It's a brother," Hannah said with resignation.

Gennie laughed. "It might not be."

"It is." Hannah trotted down the steps and back to play with Harmon.

Gennie's eyebrows lifted. So sure. Rosalind had insisted the caul was a sure sign of second sight, as well as a sign of good luck. She did not see how being born with a thin layer of extra membrane encasing the head signaled either one. She was only grateful to God that Rosalind's swift action in cutting it away had prevented Hannah from being smothered at birth. Harmon, born a few minutes later, had had no caul, thankfully.

"Twin, too," Rosalind's words came back to her. "That baby gonna set her mark on the worl'." Gennie smiled fondly at both twins. Suddenly her spine straightened. She stared at a dust cloud churning up from the road.

A single lane branched off from the wagon road beside the cornfield. Where it veered toward the house, a host of Miami on horseback were assembling. It was a large party, filling the lane. At their head she recognized Little Turtle, Shawnee war chief and ally to the weaker Miami. It was with curiosity rather than fear that Gennie wondered why they had come visiting. The Roebuck lands had been inviolate ever since La Demoiselle, the last powerful chief of the Miami, had awarded them to her husband.

Gennie grew aware of a servant standing next to her rocker. Her round, swarthy face was set toward the warriors. "What do you think they want, Rebekah?" said Gennie, addressing the middle-aged Miami woman by her Christian name.

"Off to war, Spirit-Who-Cries," she responded, using the name Gennie had been given by the Miami when she was young.

"Who do they fight this time?"

"Little Turtle will tell you."

Gennie smiled. Rebekah was jealous that Little Turtle treated Gennie as an equal, while he ignored Rebekah completely. Rebekah had been a

servant to the Roebucks for years. She had come to them when she had been cast out by her husband for her surly temper, and they had taken her in. She was a good worker, steady and of great integrity. But when autumn tinted the leaves, off came the calico and apron, shoes and stockings, her black hair would be unbound, and she would don moccasins and blanket and flee to the woods for a breath of life. She would be seen miles away, tramping steadily north, a *metomp* of bark around her forehead. She was a faithful friend, a sharp enemy, a judge of herbs, a weaver of baskets, a drinker of rum, and Gennie loved her dearly.

As the women watched, Little Turtle led his men at a stately pace toward the house. On the painted faces and the plumes fluttering from the lances, Gennie recognized war markings of both tribes. Her heart tightened with fear for these, her friends, as she realized that Rebekah had been right. This was more than just a skirmish. For the past year, battles had swirled around them. Not too much here, but farther south, across the Ohio. Sometimes they arose from quarrels among the tribes themselves. Sometimes white settlers were drawn in, and then the militias would mobilize.

The men on their pintos and bays drew to a halt several paces from the quiet scene of the playing children and the women on the porch. Little Turtle dismounted. Only then was it noticeable that he stood no taller than the shoulder of his horse. As he came toward the women, his face broke out in a warm smile. At his side, self-consciously imitating the stride of his squat, powerful father, trod Tecumseh.

Hannah and Harmon clambered to their feet and edged toward their grandmother. Gennie rose and handed Thomas to Rebekah.

She stepped off the porch, with her arms open wide. "Welcome, Chief Little Turtle. Welcome, Tecumseh. Will you eat with us?"

"Not today, Spirit-Who-Cries." Little Turtle took her hands. "Is it a good day for a battle?"

"It is a good day to be born," Gennie replied. Would Little Turtle tell her where they were bound and why they must fight?

"Another grandchild?" he asked.

"At any time." Her smile included Tecumseh. At fourteen he was taller than most of the men of the Miami and Shawnee nations. His features were lean, his nose straight and thin. His rangy shoulders promised great strength in years to come. If he lived! In his braid Tecumseh wore a single eagle feather. Bow and arrow pouch were slung over a sleeveless buckskin vest. Two knives in sheaths were belted around close-fitting, undec-

orated trousers. Tecumseh's moccasins were also without ornament. *Thomas would have approved,* thought Gennie. *When going into battle, wear nothing that will call attention to yourself.*

Suddenly Tecumseh looked down. Hannah was tugging at his trousers and raising her arms to be picked up. He glanced around as if to say warriors do not play with babies.

Gennie read his thoughts and laughed. "To Hannah, you'll always be the big brother who plays with her."

"Stop it, Hannah!" hissed Tecumseh. "Go away!"

Hannah started to howl and stuck a fist in her eye.

Little Turtle raised his voice a notch and said, "Perhaps you will visit us in another moon."

"Of course I will, Little Turtle." Understanding that he meant for her visit to include caring for those who might be wounded in the coming battle, Gennie added, "I will ask Rosalind to come also. She is a skilled healer."

Little Turtle nodded. "Not as good as you, Spirit-Who-Cries." He stared quietly at Hannah. "If she were Shawnee, she would not cry. I pray to the Great Spirit that her safety never depends on her silence." He turned.

"Little Turtle!" Gennie grasped his arm. "Can you not tell me—"

"Not this time, my mother. The Great Spirit will give us victory, and we will see you at the new moon."

Gennie nodded. "Tecumseh," she said softly. Little Turtle walked on as Tecumseh waited. "I love you as if you were my own child. Please be careful. I will pray without ceasing for you and your father."

Tecumseh flashed a quick smile, eagerness to be away on his first great adventure showing in every move. "Thank you, Spirit-Who-Cries. Uh, I will bring Hannah a present next time I come."

Gennie took the twins by their hands. Together they walked out to the road and watched until men and horses were out of sight.

"Why didn't Tecumseh stay and play with me, Gra'mama?" Hannah said in a plaintive voice.

"He will next time, *ma chérie,*" she said absently. *God keep you!* she thought. The Miami camp was about fifty miles north of the Roebuck lands. In spite of the grisly end of La Demoiselle, just a few years after Thomas won his land, the Roebucks and the Miami had remained steadfast friends. In time of famine, they had shared food. In time of sickness, medicine and skill. In time of war, peace. *Yes, God keep you, my friends.*

15

As she turned back toward the house, with the children, Gennie knew that she would learn soon enough who were the warring parties. She hoped it would be settled quickly, with little bloodshed.

"Gennie!" Rosalind stood on the low porch, flapping her apron with excitement. "Y'all got 'nother boy!"

Gennie laughed. "Coming!"

Hannah sighed in a fair imitation of her mother when she was saying I told you so.

Two weeks after Little Turtle had called his tribes together, the victorious confederacy of Shawnee, Delaware, Miami, Wyandot, Mingo, Ottawa, and Chippewa separated and went back to their own tribes to celebrate. At the camp of the Miami on the Upper Miami River, flames leaped high as Little Turtle followed by other warriors who had distinguished themselves danced and sang of their victory over the hated and feared Long Knife Daniel Boone.

For several days they had ridden southeast along the Ohio and had crossed into Kentucky. There, at Blue Licks, the valiant tribesmen faced the thief of their hunting lands. Bitter was the memory that Boone and his cohorts seven years ago had tricked tribes of weak-minded Cherokee into trading away 2 million acres of hunting lands that belonged to all, for a few wagonloads of guns and trinkets.

As word came that Boone was organizing parties of white men and their families to settle in Kentucky and Ohio, the tribes had risen under Little Turtle's cry to oppose him. The campaign had been waged in sharp, bloody bursts for a year. Into battle at Blue Licks rode Tecumseh at his father's side. Here they quashed the encroaching white settlers, crushing a force of Kentucky militia, the Long Knives, several times larger in strength than the Indian confederation. Daniel Boone escaped again.

In the waning hours of the night of celebration, after they had danced their thanks to the Great Spirit, Little Turtle drew his son aside to rest upon the warm earth.

"Someday it will be you who leads our men. At your birth the medicine man prophesied that you would be a great war chief—"

"Not as great as you, my father."

"True." The proud father laughed. "But perhaps one day. Remember, we are the Civilized People. . . ." Little Turtle dug at the cooling ashes in his pipe with a callused thumb and reached for his tobacco pouch.

Tecumseh sat even straighter beside his father. The firelight flickered over the exhausted bodies of their slumbering brethren. He, Tecumseh, would keep watch and not sleep, would listen and remember.

Little Turtle leaned his forearms on his crossed legs and began to speak. "The Master of Life made the Shawnee and their cousins, the Miami, from his brain; and all the Civilized People became their descendants. To watch over us he sent the *Grandmother.* Then from the Master's breast sprang the French and English peoples. They are ruled by their hearts. The Dutch came from his feet and are condemned to plod slowly. The Long Knives grew from his hands, and they are quick and clever." Little Turtle spread his hand, indicating Long Knives were not just the Kentuckians who carried the long, fearsome blades, but all who called themselves Americans.

"All these inferior races were made white," he went on, "and placed beyond the Stinking Lake. Because the white men can never be trusted, the Master set over them the *Grandson,* whose duty it must be to see all that the whites do."

Tecumseh, though knowing this history as well as his father did, nodded solemnly.

"Once in a while, Tecumseh, you will meet a man who is good, even though he is white. This is the lesson of the *Grandson,* taught to us so that we will learn not to judge a man by his skin. Such a man was Thomas Roebuck, the Englishman who warned the father of your mother to be wary of the French, who wanted him to sign a piece of paper that would steal away his hunting lands. Such a woman was Spirit-Who-Cries, who married Roebuck and learned the ways of healing. And they lived among La Demoiselle's people, on land that he gave of his free will." Little Turtle smiled at Tecumseh. "Will you remember?"

Tecumseh's boyish face drank in his father's words. "I will remember. Not all Long Knives are bad."

Little Turtle slapped his son's knee. "Only most of them. Let us sleep."

2

Victory at Blue Licks had not solved the problem of the Civilized People for long. The whites kept coming. In the years following, like some insatiable spirit-beast, the Long Knives gouged and gnawed and fouled the best of their hunting lands.

By the time Tecumseh was nineteen, he had become his father's chief lieutenant. Often gone from his home for weeks on end, Tecumseh traveled between Shawnee and lesser Miami camps and to those of allied nations, sitting with fixed attention for tales of woe and triumph, patiently tracking paths of white intrusion, committing to memory the whereabouts and strength of white militias. Neither the *Grandson,* nor treaty, nor bribe, nor war raid could halt them. Not even the white men's government, it seemed, was able to hold back the Long Knives.

A slight sneer drew back the fine skin of Tecumseh's lips as he thought about this, one summer day as he was passing through the woods near Fort Washington. A people who did not obey their leaders. Or was it that their leaders told the white people one thing and the Civilized People something else.

Suddenly he heard splashing and shrieks of childish laughter and realized that he was on Roebuck lands. He smiled and guided his horse toward the commotion. Through the leafy woods Tecumseh spied a skinny maiden, with jean-clad legs, bare feet, and arms sticking out like a grasshopper's, clinging to a long rope tied to the limb of a sycamore tree overhanging a pool. As he watched, nine-year-old Hannah pumped her body back and forth, swinging in broad arcs until, screeching like Motshee Monitoo, she let go and plummeted into the water. She was, as usual, surrounded by her five brothers. Tecumseh observed them unseen for several minutes. He thought about showing himself. But then they would want him to come home to eat with them, and he had no time for that, if he was to reach his destination by nightfall. Reluctantly Tecumseh rode on.

Tecumseh saw little of Hannah in the next three years. In spite of his clan's friendship with the Roebucks, his wariness of whites slowly hardened into avoidance of all of those whose people lived so contrary to the ways of the Great Spirit. Not all Long Knives were bad, as Little Turtle

18

had said, only most of them. But the images of Hannah often led Tecumseh to take the same path through the woods near the Roebuck farm. He enjoyed vicariously the laughter and the happiness the Roebuck children found in one another's company.

Three summers after their near encounter at the pool, he surprised Hannah on a path near the swimming hole. She was alone, picking berries, dressed in her usual boyish garb. He slipped off the pony and landed lightly beside her.

"Tecumseh! Hi. I didn't hear you." Her voice was high and musical.

He smiled. "I heard you. You sounded like a bear swiping fruit."

"Is that so? Then I guess you don't want a whortleberry."

He glanced at the reed basket brimming with berries and at her blue-stained fingers. Her lips were a matching blue. Tecumseh grinned. "I will have some, thank you." He tossed a couple of dusty, juicy berries in his mouth.

Hannah studied him, her eyes measuring the breadth of his bare chest. "You got bigger since last time."

"So did you."

"How is your mother?"

"My mother is well, Hannah. Thanks to Spirit-Who-Cries, mother is well again." *A skinny girl of twelve summers, as un-self-conscious and quick as a squirrel.* "You ought to be called Little Squirrel," he blurted suddenly.

Hannah let out a yelp. Tecumseh flinched, not as Hannah might have supposed, that she belittled his naming of her, but that instinctively he avoided creating noise when traveling alone.

"Oh, I'm sorry." Hannah laid a brown hand on his red-bronze forearm. "It is a good name. It just struck me funny. Things do, sometimes. Like when you hit your elbow." She gave him a dazzling smile, her brown eyes full of teasing laughter.

Tecumseh gazed into her heart-shaped, elfin face and was captivated. He told himself he wished she were his little sister. Then he might tell her all that was in his heart and learn what was in hers. But his throat was all bristly, and words remained stuck there like crows flapping in a thorn-bush.

"Come home with me," said Hannah.

He nodded. "I will."

"You will?"

"I was on my way to see your father. Would you like to ride with me?"

"Oh, yes!"

Tecumseh mounted. His eyes caressed her as she stood smiling expectantly up at him. Hannah was at the brink of womanhood and did not know it. Her body was as unformed as a reed but with the promise of great beauty. Her skin was olive tinted, her dark eyes lustrous and lively with feeling. *Shawnee girls her age. . . .* He did not finish the thought. He reached for her berry basket, then gave her his arm. Dexterously Hannah scrambled up behind him. She looped one thin, muscular arm casually around his waist. The effect on Tecumseh was startling. His skin where she was touching him felt extraordinarily sensitive. Her soft breath between his shoulders caused the hackles to rise.

Perched behind Tecumseh, Hannah was strangely silent on the short ride to the farm. When they broke out of the woods behind the house, she slid down the horse's rump and ran ahead of him. He sensed it was with a great feeling of relief, as if she were escaping.

Roebuck came out on the porch, flanked by Harmon and Joey, his eldest and youngest sons, to greet Tecumseh as he reached the hitching post in front of the house. Hannah hung back, teetering on the porch step. Usually, she made as much a nuisance of herself as her brothers did on Tecumseh's rare visits.

"Howdy, Tecumseh. Come set a spell."

Tecumseh put aside his mixed feelings as he dismounted. He tossed the reins over the hitching rail and gave his attention to the farmer. William Roebuck had worked hard all his life on the land Tecumseh's grandfather had deeded to his father. Roebuck understood well the special relationship his family enjoyed with the Miami and Shawnee and was careful with their friendship. Tecumseh returned the man's greeting but shook his head at the invitation to sit.

Roebuck studied him with pursed lips. Then he said, "Dropped some good-looking calves this spring. Care to see 'em?" He headed toward the animal pens behind the barn.

With noiseless tread, Tecumseh fell in beside him. Hannah and Harmon started after them, with Joey in tow. Their father motioned them away. He glanced sideways at his guest. "The missus says your folks enjoy a ham. Going to fire up the smokehouse in another month. I'll see that they get one."

"Thank you, William Roebuck. It is I who should be bringing you gifts, for allowing Spirit-Who-Cries to come to us."

"I couldn't keep my mother away, you know that."

The men came to a halt beside the calves' pen. Tecumseh declined the

offer of tobacco. Roebuck tucked a wad in his cheek. He leaned against a corner post of the pen and waited for Tecumseh to have his say.

Tecumseh planted his feet in an arrogant stance reminiscent of Little Turtle. "The Long Knives are sending General St. Clair to Fort Washington." Fixing his level gray eyes on the farmer, he added in an accusing voice, "Your people have complained to your fathers that the Civilized People have been hunting on their grounds."

"Now hold on, Tecumseh, they may be white folk, but that don't make 'em my people, no more'n the Iroquois are your people."

Tecumseh ignored his protest. "Your general is marching with more soldiers than there are deer in the fields. Your people want him to kill as many of the Civilized People as he can, so that they can steal the rest of our hunting lands."

Roebuck ran a hand around the back of his neck. "I heard, Tecumseh. What can we do for you? You know we wouldn't—"

Suddenly Tecumseh smiled. "It is I who have come to warn you, William Roebuck. Your family and your herds are safe. My people will cross your lands, and you need not fear."

Roebuck nodded.

"But you must not offer aid to this general."

Roebuck stiffened. He disliked being told what he could do by anyone. Reluctantly he admitted "I don't hold with what he's doing. Folks make a treaty ought to stick to it." Inside, Roebuck felt the stirrings of guilt. Easy for him to say; their lands, generous and abundant lands, were deeded forever to the Roebucks. But settlers were pouring west every day, needing and finding good places to farm and raise families, and just claiming. Not bad folk, but not bothered about asking who owned what. Trouble was bound to come here, as it had done other places.

Having said his piece, Tecumseh was turning away.

"Wait, Tecumseh. Be proud to have you stay for dinner."

"Many thanks, William Roebuck, but no."

Roebuck had invited Tecumseh to stay for dinner as much for his children as for himself. Being around Tecumseh imparted to all of them a special sense of being part of a unique alliance. Family, yet not family. Not under one god—Tecumseh had steadily turned aside any talk of their Christian God—yet linked. "Watch yourself, then. God keep you."

Tecumseh raised his hand in farewell. As he strode toward his horse, he heard light footsteps running behind him. He smiled and turned.

Hannah's face was flushed with excitement. A sunbonnet was jammed

21

down over her chestnut hair, its ends dangling down the front of her boys' shirt, beside her long braids. "Gonna be a fight, isn't there, Tecumseh? Take me with you! I can shoot!"

Tecumseh placed his big, thin hand on the sunbonneted head. He felt her warmth. "Even our own maidens will not be riding with us, Little Squirrel."

Hannah drew herself up. "My name is Hannah. Don't call me Little Squirrel anymore."

He removed his hand and regarded the pouting child-woman quietly. "I will bring you a prize."

"I don't—what kind of prize?"

He smiled gently.

Hannah answered with a radiant smile. Somehow, an understanding passed between her and the friend of her childhood, bringing them closer, though Hannah did not yet understand how. A year ago, she would have hugged him. Now, impulsively, she clasped her hands behind her back. "I'll be waiting, Tecumseh. 'Bye." She watched him ride away.

Later that day, cavalrymen from Fort Washington circuited the farms, warning the families to round up their livestock and take shelter in the fort. To no one's surprise, the Roebucks declined to go.

Hannah had lived all twelve years of her life on her parents' farm in the Northwest Territory. For decades the settlement had been identified only by its proximity to Fort Washington, a fur-trading center where Shawnee, Miami, Osage, trappers of the French and British nations, and American mountain men sold and traded beaver pelts. Increasingly, Fort Washington doubled as a military fort. Gradually a town had formed near the fort, about an hour's walk up the Ohio from the Roebuck lands.

Over the years Hannah and her brothers had grown used to their father and other farmers talking about the future of Cincinnati. Some of the homesteaders claimed it would soon be a town to be reckoned with. Commerce on the Ohio River made their settlement a crossroads to the new frontier, a provisioning stop for pioneers going farther west by flatboat or keelboat. Leaving Cincinnati, travelers headed down the Ohio River, all the way to the Mississippi, from there to float down hundreds of miles to Spanish New Orleans or to portage upriver to the French outpost of Saint Louis.

Roebuck refused to allow the boys to do less than the hands when it came to the butchering and smoking in the fall and in the corn harvest. "Any man can be a gentleman," he was fond of reminding them, "but if

he's a good farmer, too, he'll never starve." It was left to Faith to insist that the children's educations not be neglected, which meant long hours by lamplight after their chores, hours when their hired counterparts would be blissfully snoring away or taking furtive walks to town on a Saturday night. Not the Roebuck boys. Learning they should have, even their sister. All learned to form letters and spell words by reading Scripture verses. All learned to memorize by committing *The Shorter Catechism* and portions of *Westminster Confession of Faith* to memory. From somewhere Faith had secured a copy of a book by John Bunyan, called *The Pilgrim's Progress From This World to the World Which Is to Come.* Hannah and Harmon pored over its pages, fascinated by the adventures of Everyman and the stiff woodcut prints of his adventures. By tacit agreement, the book disappeared from sight when William was around. He believed firmly, along with Pastor Haversham, that young minds set not upon Scripture were fertile soil for the devil.

After dinner was cleared away from the big table the night after Tecumseh's visit, out came the books. "Was ever a man so fortunate to have five God-fearing farmers for sons?" Roebuck cried as he clumped into the comfortable kitchen from the last rounds and found them all around the big trestle table, Hannah among them.

"If the Lord blesses us with a preacher son, at least he'll not shame us," Faith said tartly. Her eyes met her husband's over the heads of the six. He knew that she objected to the long hours he made them labor.

"Nor will he starve," was his curt rejoinder.

Faith knew he was remembering the town meeting, at which he had argued with the elders to establish a salary to pay a full-time preacher to come west to minister to them. The Presbytery of Pennsylvania had heard their pleas. They simply had too few graduates of the college begun at Princeton a few decades ago to supply all the wilderness communities who found themselves without pastoral leadership. New graduates were required to accept a wilderness ministry for a short while, but as most of them already had families, the seven dollars per week was not enough to entice any but the most fervent to remain when their tours were up. The elders of the town stoutly refused to "sweeten the pot," opining that a man too well off would grow too comfortable to preach well.

"Pa?" Harmon looked up from the table. His olive skin and dark eyes were a match of Hannah's. At twelve, his supple frame lacked the bulk already evident in his chunky brothers. Harmon glanced at his mother, received an encouraging smile, and looked back at his father.

"Well, Son?"

23

"I want to go back east, to a regular school. Before Pastor Haversham left, he said I could live with him while I attended school. He said he was going to talk to you."

William looked strangely bereft. "Yes. That he did." Seven pairs of eyes watched him.

"He said I got a good mind, that he could tell I'd be a fine preacher, if I wanted to be one when I got out of school. . . ."

Hannah, listening, held her breath. How could her brother think of going away when he was only twelve years old? She prayed as she had prayed every day since Harmon had confided his desire to her. *Oh, please, God, don't let him go! Or else let me go, too.*

"How could you go without me?" she had pleaded.

"Girls don't go to school!"

"Then I could be your housekeeper—and Pastor Haversham's."

"Wouldn't work."

"Why not?"

"You don't have to hire out. We ain't that poor."

"No shame in working, Pa always says."

"But you're a girl. That's different."

Hannah had been confused and defeated by her brother's seemingly inexhaustible fund of knowledge on propriety for girls and boys. Now she saw that Harmon was biting his lip. Her mother was staring at William with a half-imploring, half-demanding expression. Her father heaved a sudden, sharp sigh.

"We'll talk about it some other time." Turning around, he left the kitchen and did not come in for another hour. Her father never mentioned Harmon's going away to school again. In her heart, Hannah thanked God for granting her prayer, but in a deeper part of her, she was uncomfortable, as though she had asked for something that she had no right to ask for, and wondered why it had been granted.

Six days later, word filtered into the little town of Cincinnati and out to the surrounding farms that General St. Clair's forces had been defeated by Indians only a third their strength. Over six hundred soldiers were killed, many more wounded. The name of Tecumseh, a cunning and fearless warrior, grandson of La Demoiselle, was carried on the wind.

Dismissing the losses of the soldiers with the cruel carelessness of the young, Hannah thrilled to hear the name of Tecumseh. Day by day, she went about her chores, waiting for him to return. She knew he had not been killed. Maybe he would bring her a scalp. She shivered with delicious horror and waited.

Days, weeks went by, while Hannah waited in vain. Secretly she was proud of his prowess. She refused to listen to anyone trying to "reason" with her that it was *white men* he'd killed. Tecumseh had said those white men were stealing his people's hunting lands, and Tecumseh would never lie.

Tecumseh did not come to the farm again. His scalp was posted at such a high price that enemies of the Shawnee or the Miami would cheerfully have accommodated the white chiefs by delivering it, if they could have found him.

Exhilarated with the victory they had won over the ineffectual American general and his straight, ridiculous lines of infantry and cavalry, night after night Tecumseh sat proudly at campfires, with his father and the other leaders, while they talked of their deeds. Indians from friendly tribes far and wide dropped in on their remote encampment to hear of the unbelievable conquest and to see for themselves the booty: jackets, swords, rifles, prized horses, gold pocket watches, and brass buttons, scalps that were but a sampling of those that would soon dangle from every lodgepole. And they went home with bellies warmed with rum and heads giddy with the possibility of reconquering their lands from the hated Long Knives.

3

Hannah carried a load of kindling into the kitchen and stacked it near the new Franklin stove. Faith was at work ironing a damp stock. The kitchen smelled warmly fragrant from the pot of thinned cornstarch that she used to stiffen the linen.

"This is my favorite room in the house, Mama," said Hannah. "Do you think that means I'm a homebody?"

Faith smiled. Her face was flushed from the heat of the flatiron. She brushed back a damp strand of wheat-colored hair and smiled at her daughter. "It might be. When I was growing up, my favorite place was the parlor. Of course I was only allowed in there to practice the piano and to play for company." She stopped. Her pale blue eyes traveled to the window and the garden beyond. Then with an expert flip she deposited the cooling iron on the iron stove top and hefted a heated one.

"Want me to do that?"

Faith shook her head. "I'm almost through."

Hannah scraped a chair across the new brick and sat close to her mother. Faith had always wanted a brick floor in the kitchen. When the iron stove arrived, William decided they should also brick the floor, and he and the boys had spent several days laying it and building in the stove. Faith and Hannah had made bright blue tie covers to go over the cushions for all the chairs and the window seat. The old covers, washed and carefully ripped and pieced in long strips, went into the rag-rug basket. The bright touches of blue, the smoky red brick, and new stove had transformed a sober, practical room into one that was inviting and cheery.

"Do you think you could still play the piano, Mama?"

Faith looked at her hands. She had managed to keep them soft, but they were strong, capable farm wife's hands, and no doubt.

Without waiting for an answer, Hannah went on. "I bet you miss it."

"Why yes, I—"

"Streets and carriages," Hannah went on dreamily, "and pretty clothes. Is everybody in Boston a farmer, Mama?"

"No. My father was a printer. Most of our friends lived and worked in town, too." Thoughtfully she replaced the iron on the stove and folded the stock, placing it carefully on the stack of crisp linens. She sat down

26

opposite Hannah, and her breath came out in a long sigh of reminiscence. "In those days, we girls thought of little else besides pretty clothes and how to sing and dance and embroider. And boys."

Hannah studied her mother with a smile. She was still pretty. She must have had a lot of gentlemen callers. "It sounds heavenly! How could you bear to leave?"

"Because your father was unlike any man I ever met. There was something about him. Something strong and rugged and—different." Faith laughed. "Oh, it was certainly different here. When we knew we were expecting you, I wanted to call you Miranda—my, you should have heard the cry! Not a proper Christian name at all, as if I had wanted to name you for a heathen from Persia! Well, every father's daughter from here to kingdom come was christened Faith, Hope, or Charity."

"Miranda! Really? It *sounds* heathen."

"Well I suppose it did. I heard it in a play by William Shakespeare."

"Have you been to a real play?"

"My, Hannah, every time a traveling company came, Father took us. He got the playbills before anyone else in town, with the orders to print tickets. I remember our minister preached against people going. He said plays were the work of the devil and would turn the minds of honest citizens from God. But Papa searched the Bible, and he didn't think so, so we went." She smiled at her daughter, a hint of mischief in her eyes. "Miranda was the daughter of the duke of Milan in *The Tempest.*"

"Miranda. . . ."

"Then when you came, you were twins, and we had already picked Harmon for a boy's name, to honor your French grandmother's people, who were named Harmonie, so—"

"Hannah rhymed better with Harmon than Miranda. I think it would have been a beautiful name," Hannah decided. "Did the Miranda in the play have long, golden hair, like yours?" Absently she began combing her fingers through her hair, wishing she had been born pale and beautiful like her mother.

Faith studied her daughter, the strong, regular features, high color, and vibrant dark hair. "As I remember, the actress who played her was beautiful like you, like earth colors more than sky colors, and she had the most beautiful clothes. . . . Honey, I think it is time you and I made a trip to Aunt Rosalind's shop."

"Oh, Mama, for a new dress? Can we?"

"We shall! We'll go through Aunt Rosalind's style book and find the prettiest one we can and send for the pattern and have her make it up."

Early next morning, they set off. William decided he needed things from town, too, and Hannah persuaded Harmon to go along. Hannah felt like a proper young woman, sitting beside her favorite brother on the second seat of the wagon.

"When we married, children," said Faith, still in the mood of reminiscence that had captured her yesterday, "I had no idea I was marrying into the most important family west of Pittsburgh."

"The *only* American family west of Pittsburgh," William added dryly.

"The Roebucks owned the best land in the Northwest Territory," Faith insisted stoutly.

"And your Ma nearly took a fit when she saw that there wasn't any more'n a few houses out here. Then folks got together and named it Losantiville. She felt right better, knowing it was a town."

" 'What's in a name? A rose by any other name....' "

"What's that, woman?" growled William.

"Nothing," laughed Faith. "I like *Cincinnati* better than *Losantiville.*"

"And I like *Hannah* better than *Miranda,*" added her daughter.

"Who?" said Harmon.

The four Roebucks went first to Fenn's store. Hannah always enjoyed the heavy, almost wet scent of the freshly milled flour and the pungence of new leather. Her glance swept the pretty, scrolled tins of fragrant spices and bulging sacks of coffee beans. Two ladies came in after them, newcomers to Cincinnati, she guessed, and suddenly Hannah was aware of the swish their dresses made and wondered what they wore underneath to create that pleasing, mysterious rustle, almost like a small varmint in stiff summer grass.

Hannah felt suddenly embarrassed by her own clothing. As usual, the twins were dressed as nearly alike as possible. Hannah had insisted upon wearing a jumper she had made of the same tough brown nankeen material as Harmon's trousers. Both wore faded red calico shirts, Hannah's with a loosely ruffled collar, a concession to her mother's insistence (and her own grudging realization) that it was time she stopped dressing like a boy. Their hair was exactly the same lustrous brown, his thick and water slicked, roughly shaped to cover his ears, hers falling below her shoulders, curling like wood shavings around her brow and ears.

Two men followed the elegant ladies into the store, attired in well-fitting long jackets that matched their breeches and hose and smelling as if they had just come from the barbershop.

Almost unconsciously, she compared them with her father, standing with his friends at the rear of the store, in his clean overalls and home-

spun shirt under the buckskin jacket, the inevitable cotton scarf knotted at his throat. He was not many years over thirty, and she knew that her father was accorded respect on their infrequent trips to town. He was often spoken of as honest and hardworking. As far as she could tell, all his efforts centered on his farm and his family. Any attempt to draw him into plotting a future for Cincinnati met with firm refusal.

"God gave it to me to know where he wanted me," she heard him say now (not for the first time), "and it is on my land. Rest o' you can jaw away about the future of this here country, warming your backsides at Fenn's stove, but peculiar thing is, it don't get the crops in one mite quicker."

Amid general laughter, Hannah and Harmon exchanged glances, painfully aware of what the well-dressed strangers must think of them.

"Now, Will, Cincinnati's becoming a regular town. Time folks thought about the kind o' town they want it to be. Fort Washington being at full strength with all them soldiers, yep, it's a right safe place."

"For now," said a farmer who migrated in last year. "But we ain't heard much o' Tecumseh lately, what he's up to."

Hannah's ears pricked up. No one commented on that remark, so she supposed it meant no one had heard any news. Besides, she comforted herself, if Tecumseh wanted anybody to know anything, he'd probably send a message to her. Harmon nudged her and jerked his head at the door.

"Mama," said Hannah, "I'll meet you at Aunt Rosalind's in a few minutes." Faith nodded, and Hannah slipped out the door after her brother.

"I wish Pa wouldn't carry on so about his farm this and his farm that," Harmon muttered when she caught up to him. "A body'd think the Lord God gave him the deed himself."

"Harmon!"

"Well—you know it's true."

"Hey, Harmon. Harmon! Wait up!" A dark, solidly built boy their own age loped across the street, his shoes pounding the hard-packed earth in thuds. "Han't seen y'all since Christmas."

"Hi, Peter," said Harmon.

Peter Ruskin fell in beside them. He glanced at Hannah, and abruptly color shot up into his cheeks. He reached up into his cap brim and fished out a small sliver of wood, which he propped between his teeth.

"Working at the mill?"

"Yep," said Peter. "Pa and me figger with our new mill we'll be sawin' up logs quicker'n saying scat to a cat. We got the only mill west o'

29

Marietta." He glanced again at Hannah. "Maybe y'all like to see it? I got the wagon."

"Sure would!" said Harmon. He glanced at his sister.

"You go, I promised to meet Mama at Aunt Rosalind's."

"Hey, c'mon, Hannah," Peter urged.

Hannah flashed him a warm smile, which inexplicably released a new flood of color to Peter's face. "May I come some other time?"

"Promise?" Peter blurted.

"Promise." The boys left after Hannah promised to tell their father of Harmon's whereabouts, and Hannah sauntered slowly down the boardwalk. Coming from a doorway next to Fenn's was the same crisp, aromatic odor she had detected on the two strangers. She peered in the door. The barber had his back to her, elbows out, hands busy, talking to someone. Then he swung around and Hannah gasped aloud as she saw what appeared to be a head with no body propped on the barber's chair.

The barber glanced over his shoulder at her. "Hello, Miss Roebuck. May I do something for you?"

"Good morrow, sir. No, I—I—" She stopped in confusion.

The barber glanced down and then laughed. "This wig gave you a start, did it? Some new gentlemen in town, from the east. They brought their wigs in to be cleaned and curled. I haven't had much call to fiddle with wigs, and danged if I know what I'm about, begging your pardon!"

Hannah laughed. "I thought it was a scalp."

"Now don't you go getting any fearsome ideas, young lady. This isn't even real hair. It's goat hair, I do believe." He rubbed it judiciously between his fingers. "Too fine for horse, too coarse for human."

"Pastor Haversham wore a wig."

"That he did."

"I thought it looked funny." She giggled.

The barber grinned. "Never could get used to one, myself. Folks 'round here don't have much use for 'em. 'Course maybe now it will get fashionable, like they are in Philadelphia. You here with the family?"

"Harmon and my parents."

"Fine man, your father. Young Harmon, too. Not like some of the rowdies in town."

"Thank you, sir. Well, good day."

" 'Day to you, Miss Roebuck."

As she left she heard him once again addressing the recalcitrant head. Fashion was certainly peculiar. She thought of Aunt Rosalind's house, which let directly onto the boardwalk, scarcely a block from Fenn's. Her

Aunt Rosalind was the only dressmaker in Cincinnati. Whole rooms of her house were filled with laces and patterns and stays and corsets and buckram.

When her young husband had been killed by a bear, Rosalind Roebuck had refused to move in with William's family, stoutly maintaining she was capable of making her own way. Hannah had always intuited something romantic about her aunt. Deep in thought, she did not notice the Indian coming from the other direction until he had planted himself in her path.

"Hello, Swallowtail." His feet were dirty. His jeans showed a clear line of dirt reaching to his knees, as if he had forded a stream without bothering to roll up his trouser legs. Mentally she backed away from him.

Swallowtail was a Miami brave about three years her senior. She and Harmon were both acquainted with him, and neither liked him. His people were town Indians, and because he seldom spoke well of either whites or the Indians who lived in the Miami camp eight miles upriver, the Roebuck twins had dubbed him Swallowtail. The name held.

"I see you, Hannah."

Swallowtail's face did not alter in greeting. His lips were heavy, his eyes dull looking. "I heard about Tecumseh."

Hannah's heart skipped a beat. Secretly she was very proud of her friendship with her handsome warrior friend. Once a painter had come to Cincinnati, and she had seen his watercolors propped around the newspaper office. All his Indian men looked like splendid heroes, and she had no difficulty imagining Tecumseh dressed like that, even with all the strange paint on the skin. But it had embarrassed her to look at his depiction of Indian women. Without exception, none of them had enough clothes on. She had certainly never seen an Indian lady like that! "What about Tecumseh?" she heard herself say reluctantly.

Swallowtail mumbled something about another battle, somewhere in Kentucky. He pulled out his knife and slowly began to toss it end over end. He carried the largest hunting knife Hannah had seen. She stared at it in fascination. She remembered with a shudder the rumor that he liked to kill animals slowly. Swallowtail noticed her attentiveness and slowly ran his thumb along the edge. "He lifted so many scalps he looked like a buffalo. All bloody and drippy." Eyes still on Hannah, Swallowtail added, "Must of fought like Motshee Monitoo. He's worth a whole post full of beaver skins. . . . You could get rich turning him in."

"That's a lie! You can go to hell for telling lies!"

Swallowtail snickered. "The colonel at Fort Washington will pay a

whole lot for him dead. It's a great honor. No chief ever been worth that much dead." Slowly the knife turned over in the air; up, caught, again and again.

Suddenly Hannah grew angry at this lazy, sly, snide creature before her. "You're jealous, that's what, Swallowtail. Tecumseh is the greatest Indian there ever was. He's my friend, and if you had any sense at all, you'd try to be like him and set a good example for your people instead of—instead of just doing nothing!"

"He is not your friend! Him and me are your *enemies!*" Angrily Swallowtail shoved the knife in his belt. "You'll see."

"Would you please stand aside and let me pass?"

"Think you're so good," Swallowtail hissed in her ear as he stepped aside, and she raised her head tartly and strode toward the safety of Rosalind's and her mother.

Oh, why did I make him angry? she thought. It would have been better not to remind folks that Tecumseh was their friend, in case he needed a place to hide. That is, if he *was* in another battle. The men in Fenn's said the wars were over. They said the Indians were all far away. She could not stand it if anything happened to Tecumseh. Suddenly Hannah stopped. It was true. Yes, it was. Did that mean she was in love with Tecumseh? She started on. He was ten years older than she. That meant he was twenty-five. Twenty-five wasn't too old. But fifteen was too young. Still, she wouldn't be fifteen forever!

Hannah reached her Aunt Rosalind's with her mind suddenly alive to new thoughts. Ignoring the small, neatly painted sign, DRESSMAKER—PLEASE RING, hanging beside the bell, she pushed up the latch and almost ran inside.

"Aunt Rosalind, are you home?"

"Hannah? You sound—what is the matter, dear? I'm in the parlor."

Hannah stepped through a small room, carpeted in a luxuriant rose pattern, where Aunt Rosalind met her clients. Metal plates depicting fashionable ladies and gentlemen of Paris graced the walls on either side of a floor-length mirror, perhaps inviting prospective clients to compare their attire to the elegance that could be theirs.

Rosalind Roebuck was bending over a long table, cutting a piece of mouse brown worsted with huge shears. She smelled wonderful. Her hair was jet black. Hannah thought she remembered at one time it was a softer shade, more like charcoal. She glanced up and smiled a warm welcome at her niece.

"There's an Indian boy I just *hate,* Aunt Rosalind. He frightens me!"

32

Rosalind laid down the shears, her brow knitting in concern. "What did he do, Hannah?"

"Well, nothing. But he kept playing with his knife and—and it was like he was threatening me. He said that he was my enemy." Disconsolately she stared out the window. Then she sighed, casting off the mood "Mama's coming. We want you to order a dress pattern for me. A fashionable dress, like Mama used to wear in Boston."

Rosalind smiled. "I have some new plates from Paris. Shall we look at those while we wait for your mother?" Hannah nodded. Rosalind's dress swished exactly like the ladies' in Fenn's as she reached on an upper shelf for the plates. "Good patterns and fashionable fabrics are so scarce, I cannot keep up with the demand. It'd be a mercy if folks stopped sending out only tobacco and knives and seed and remembered the ladies. I'll put some tea on."

Hannah followed her aunt into the kitchen. "Mama and I were talking about names this morning. I never thought much about it before. She said I was almost named *Miranda.* That's a beautiful name, like *Rosalind.* Does your name come from a famous lady in a play, too?"

"Didn't you ever hear of where my name came from?"

"If I did, I don't remember."

"Mother—your grandmother Gennie—had a lovely friend, a former slave from the West Indies. She was a midwife and very courageous. She died not too many years ago. Her name was Rosalind. Mother named me for her. She helped your grandmother escape from someone once who was very dangerous."

"Really?"

"It's all in her diary." Seeing the blank look on her niece's face, Rosalind added, "You didn't know she had a diary? Someday perhaps she'll let you read it. It's very exciting."

"I think it's exciting being here with you."

Rosalind laughed, a tinkling, merry sound. "It seems exciting to you because it is different from living on a farm. Would you like to live in town?"

"I think I would, Aunt Rosalind." They heard the bell ring and Faith call a greeting from the front room. "There's Mama. I wonder what she'd say if she knew we were talking like this."

Rosalind's black eyes met hers with an air inviting conspiracy. "One way to find out, Hannah."

4

During the five years after the defeat of General St. Clair's forces, Tecumseh rode tirelessly from one tribe to another, urging them to resist encroachment of white settlers wherever they appeared. The signs were known only too well: a man, alone or in company, often garbed as a trapper, tramping about beyond the time needed to set or clear traps, poking holes in the ground, hunkering down and staring thoughtfully about himself, his fingers in the soil as busy as a blind man's. He would be pacing this way and that, following streams, tasting the water, and finally slashing a symbol into the bark of a living tree and riding off with the air of a man who has reached a brave decision.

Tecumseh was dwelling among the Ottawas, several days to the east of the lands of the Miami, when a kinsman caught up with him with a message from Black Hoof. Noting that the exhausted runner gripped his mother's calumet, an ornamental carved pipe that guaranteed its bearer safe passage through all nations, Tecumseh realized the urgency of her message and led him at once inside the small, bark-covered wigwam provided him by the Ottawas. The kinsman was his uncle, a thin, wiry, younger brother of Black Hoof. He was a very frightened man. Tecumseh pulled down the flap to shield his honor and give them privacy.

His uncle dropped gratefully to the bearskin robe, placed the calumet across his knees, and stuttered out the most sacrilegious rumor Tecumseh had ever heard: "Little Turtle is gathering the tribes to make great talk with our white enemies."

"Did your ears hear this?" Tecumseh demanded.

The kinsman shook his head. "Black Hoof was there. White men with brass buttons came to visit Little Turtle and Black Hoof. Their message was that chiefs of all the tribes of the Northwest Territories are to be guests of General Anthony Wayne and the Long Knives at a place called Fort Greenville. It is not far from our camp, O Tecumseh. They honored your father by asking him to be spokesman for the Miami and the Shawnee. They promise to make at this meeting, for all time and all men, an honorable division of the land."

"*Division?* Land is indivisible." Tecumseh knew with every fiber of his being that only the Great Spirit possessed land. It was meant to be used

with reverence; it was meant to be appreciated as his continual gift to his peoples.

"What did my father say?"

"He agreed."

Tecumseh's cinnamon-colored face darkened in anger. "This cannot be, Uncle! Two summers have passed since I have seen my father, but he could not have changed so much. He knows they have not kept their promises in the past. What of my mother?"

"She advised Little Turtle to wait upon your return, knowing you test the temper of the other nations. She says she has received visions of evil forthcoming, if our people agree to go." His uncle leaned forward. "Black Hoof begs you to seek out Little Turtle and reason with him!"

"Where is my father?"

"He has gone to our Shawnee cousins."

"When?"

"Two moons ago."

"And you are coming only now?"

"I could not find you! I did not dare use the smoke to call you home. Everywhere I went, they said you had moved on. The Long Knives look for you, too, Tecumseh." Tecumseh nodded. "Black Hoof says—," he stopped, dismay written on his bony features.

"What?"

"She did not say I was not to tell you this. The Brass Buttons waited deliberately until you would be gone before coming to coax out Little Turtle."

Tecumseh got to his feet. He gazed into the red-rimmed eyes of his uncle with a calmness he did not feel. "I will ask the Ottawas to let you rest here until you are ready to return. Tell my mother that I will find Little Turtle. Carry to her my respect. I will do as she asks."

From the Ottawas' land it took him many days to reach the camp on the Scioto River. When the familiar pitched roofs of the houses of Little Shawnee Town came into view, Tecumseh's heart quickened. Several looked new: The peeled, fawn colored birch bark of the roofs, held down by freshly stripped poles, contrasted brightly with the bleached silver gray of older houses. He heard the voices of contented women off to the right of the village, near the river. Soon he glimpsed them, in buckskin and calico, working in small, individual plots. They would be putting in squash and pumpkins, beans and sweet potatoes for their families.

The peaceful sight reassured him. Never would his father turn his back on the Civilized People. He knew now that the story that had come to

35

him had been garbled and false. His uncle's exhaustion had invited Motshee Monitoo to sit on his tongue. He urged his horse onward.

Little Turtle must have been alerted as soon as the women spied the tall, handsome form of Tecumseh riding into their camp, for his father was waiting to welcome him. His name did not suit him as well as in former years. The squat, hard-muscled body had grown flaccid. Rivers of silver ran through his hair.

"What brings you here?" Little Turtle greeted him as he dismounted. "I did not know that you were coming to visit your Shawnee family. Or is it a certain maiden who has brought you here?"

A fleeting smile touched Tecumseh's lips. "Motshee Monitoo brought me, Father. He got into one of your people and caused that man to tell me a great lie, so great that I had to find you myself to prove that he lied."

Little Turtle did not meet his eye. They began to walk through the camp.

"Well, my father. About this brave and the lie he carried."

"What lie, my son?"

"That you would ever give our lands to the Long Knives."

Little Turtle looked pained. Between them lay the awareness that while the Great War, which ended fourteen summers ago in 1781, had pitted white man against white, it was the Civilized Nations who had suffered and lost most.

Slowly Tecumseh had come to realize that the lasting effect of the war on all his people and the people of the other civilized tribes was to nullify, at the white men's pleasure, any treaties forged with any of the white men's governments, be it French, British, or American. Promises no more binding than mists rising from lakes or smoke from a campfire.

Little Turtle said in a bluff voice, "We will no longer have to fight to keep our lands. The American government has promised that the white men may come so far and no farther."

"And how far is that?" Tecumseh demanded.

Little Turtle looked uncomfortable. "I will tell you a story. The Master of Life created us from his brain. By this it became known that we must use our brains to discover the Way of the People. The Way was shown to me when I defeated the Long Knives ages ago, with you at my side. But Black Hoof was given the vision that behind them streamed endless numbers of other Long Knives. She said there was only one way we could defeat them. We had to outthink them."

Little Turtle paused for an encouraging grunt from his son. None came. Tecumseh was thinking. The Americans may have believed that by win-

ning their war they had blocked the British from further interference in the lands they both wanted, but like a wolf that gnaws off its own leg to escape the trap of the hunter, the British used the Shawnee and others to continue the fight covertly. They supplied the men of the Indian Nations with liquor and knives and jewels, even promising them better rifles with which to destroy the Americans' forward forts and burn out their settlements. They were paying such a high premium for American scalps that it amused some of his brothers to produce scalps from buffalo humps. The British never knew the difference.

"Our nations walked proudly the day we conquered Boone at Blue Licks," Tecumseh agreed slowly, "and in the later time when General St. Clair knew defeat." He caught and held his father's glance, and smiled with deliberate love. "Our confederation was strong. The Great Spirit smiled upon us. But, O my father, that was too long ago." Unexpectedly, his voice trembled with emotion.

"Peace, Tecumseh. I know what lies in your heart." They entered Little Turtle's house and sat across from each other. The old chief picked up his pipe.

Little Turtle's eyes were watering. Tecumseh looked into them and saw a cloudiness that seemed to blur his father's vision.

"You know what lies in my heart?" he prompted.

"I hear, my son. I know that while I spoke for our nations at Greenville, you were sowing restlessness in other places." The father leaned back and drew deeply on his pipe. His milky vision seemed to see through the smoke. "Yes. . . ."

He already spoke for the Nations. Custom forbade Tecumseh from interrupting his father. His lips drew into a rigid line while something within his body writhed and massed like a nightmare forming.

"While I spoke for my people as their elected war chief, my own son was speaking out openly against any more treaties," Little Turtle repeated with reproach in his voice. He leaned forward. "It is too late, Tecumseh. It is done. The conference is over, the treaty is signed. You must cease your fighting. You dishonor me as your father and as your chief."

The mass became fear and sent sharp claws into his heart. "Tell me—tell me this, Chief Little Turtle," Tecumseh said. "How much did you give away?"

Little Turtle gazed out the doorway. He mumbled something.

"What?"

"The Ohio."

"The Ohio? How much of the Ohio?"

37

Again Little Turtle mumbled. This time his head swung low against his broad chest, reminding Tecumseh of an aged buffalo.

"That which they call the Northwest Territories."

"*All?*" Tecumseh sprang to his feet, unable to believe his ears. "You have given all of the Ohio to the Long Knives? Our hunting lands? Our homelands!"

"The Miami are too weak to remain independent, Tecumseh," Little Turtle explained, as patiently as if he were dealing with a child. "I have asked the Shawnee to adopt the tribe of your mother. My kinsmen of the Shawnee are themselves weakened by the lifeblood that flowed out of their mightiest warriors. Even their war chief was killed. They welcome us eagerly. They need us, my son." He went on to remind Tecumseh that his, Little Turtle's, prowess was widely known. The Shawnee had already voted to restore Little Turtle as war chief, as he had been before marrying Black Hoof and electing to live with the Miami.

"Our path is set," said Little Turtle firmly. "The clan of your mother must vacate. Her lands, the lands of the Miami, belong now, by treaty, to the Long Knives. I am returning to lead our people to our new home here, to join the Shawnee. Now you can ride by my side, Tecumseh. It will be good."

"No! I will not agree to it! Motshee Monitoo take you, Father!" He charged blindly outside, a roar in his ears. "Bring me my horse!" As he rode out of camp, his father's words followed him like a curse.

"It is done!"

5

"The Miami are on the move!"

A lad from town, bareback on a piebald pony, slid to his feet beside the hitching rail at the Roebuck farm. His cry brought all activity to a gradual standstill as Roebucks and hired help came to hear the unbelievable news.

"You mean they are leaving? Going away from their town?" Hannah gripped his arms through the rough shirt and made him look at her. Used to shaking erring little brothers, she thought nothing of shaking a townsboy into recalling truth from fiction.

Though puffed with importance and glad enough for an audience, the boy seemed to know little else, and as he galloped away to another farm Hannah broke away and headed for the house with a rapid stride. Gra'mama would want to know.

At seventeen, Hannah had flowered into a vibrant happy person with little patience for propriety. Her face had filled out, no longer so elfin, but with firm chin and generous lips that often quivered on the brink of laughter. Her voice was low-pitched but not soft. Her movements were quick and assured. She seemed to move in an aura of independence, a characteristic whose appearance in young women was not universally admired.

Hannah's pace slowed to a quiet tiptoe as she paused outside her grandmother's closed bedroom door. Gra'mama usually napped at this time of day.

Gennie no longer shared a bedroom upstairs with Hannah, but had a quiet room, set off from the rest of the noisy Roebuck clan. Her room looked out over a flower garden that she tended with joy and care. Hannah knocked softly. Hearing no response, she crept inside. She rarely entered her grandmother's room. Even the air was different. It felt quiet, like time waiting, clouding Hannah in a sweet and musty fragrance that reminded her of dried rosebuds tucked in a chest.

Gra'mama was asleep. Hannah glanced around. Gra'mama's huge saddleback chest rested against the wall. It had taken both Harmon and Matthew to haul it downstairs when she changed bedrooms. A delicate French porcelain tea service rested on her dresser. With one dear, mis-

matching extra teacup, painted with yellow daffodils. Hannah knew that it was the first gift Gran'papa had ever given her. Gennie had always promised Hannah that someday she would tell her about that teacup. One of these days Hannah would slow down long enough to listen to the old lady tell her the story. But there always seemed to be more exciting things to do than sit and listen to stories, especially because Gra'mama's stories often ended with her just staring off, as if she expected her listeners to see for themselves. Impatiently Hannah shook her head and tiptoed to the bedside. Gennie looked so frail and peaceful asleep. Maybe she should not awaken her.

As she was trying to make up her mind Gennie moved. Her eyes opened, bright and aware, the same warm brown as Hannah's. Her hand, dry and spidery, remained motionless on the blue-and-white wedding-ring quilt. "Hannah. What is it, dear?"

"Gra'mama, did you know the Miami are leaving their homes?" she whispered. "A boy rode out from town just now. He says they are packing up and leaving!" The voice of Hannah's father drifted in the window, telling his sons to hitch the team. Her mother's voice came through the open door: "Hannah? Bank the fire. Take the stew off till we come back."

"I will!" she called. "Wait for me, I want to come, too."

She threw Gennie a saucy smile. "I guess we're all going to town. You come, too, Gram. You feel strong enough?"

Gennie responded with a quick nod. "Yes. Tell your father to wait."

"Can I do anything?"

"Mercy, no. I have my clothes on, dear, all but my dress. Why are they moving?" Gennie worried aloud as she laid back the bedclothes and began to pull on a dark blue voile dress. "I've not heard of any trouble. Since I don't go about anymore, I don't hear these things. Perhaps we could have done something. . . . Run along, Hannah. Remember to take the kettle off for your mother."

Soon the wagon, bearing all nine of the family, was headed for town, jouncing along the towpath road beside the Ohio. Suddenly Faith stood up and stared at the river. "My land, would you look at that!" she declared. Eight more heads craned. Rounding a bend from upriver was a huge schooner, largest ship any of them had ever seen, with masts bare of rigging.

"It looks like Noah's Ark!" quipped young Joey.

They could see half a dozen crew walking about the deck, with little more to do than watch for debris in their path while the captain steered them around more solid obstacles.

Harmon rose and cupped his hands around his mouth. "What is it, mister, and where is it bound?"

A crewman yelled back, pride in his voice. "The schooner *Puritan* out of Marietta, bound for Philadelphia!"

"*Philadelphia?* Hain't you going the wrong way?"

They could see the crewman grin. "We aim to float this lady down the Ohio, all the way t'the Mississippi, and right down to N'Orleans, big as you please."

"Can you really do that?" called Roebuck.

"Them as put up the money to build it and fill 'er with cargo seems t'think so!"

William glanced over at his wife. "That is a right fine idea, Faith. I wonder what Ruskin and Kendall'd make of it. Think I'll have me a parley in town."

Faith nodded. "Mind the time. I want to be home before dark." She blessed her good fortune that William wasn't a drinking man. Many men telling their wives they were of a mind to parley truly had a thirst for barley.

By the time the Roebucks reached town, Faith forgot the awesome sight of the ocean-bound ship in the crush of people and the holiday air. The young messenger and his friends had evidently reached all the farms.

Cincinnati was jammed with people seldom seen, farmers with the dirt and sweat of the fields lining their faces, women with sunburned faces and faded dresses, with offspring in tow whom Harmon and Hannah had not seen since school days.

William Roebuck drew the buckboard to a halt in the midst of several others at the southern end of the main street. Gennie sat between him and his wife, looking small and fragile. Standing up in the bed of the wagon, the Roebuck children were a striking lot, tall and wiry, self-reliant looking even in adolescence. Harmon and Hannah were the oldest. Each year another boy had appeared: Philippe, sixteen; Matthew, fifteen; Thomas, fourteen; then Joey. The three middle boys were blue-eyed with wheat-colored hair and deeply tanned skin. The twins and Joey shared the olive complexion and dark hair and eyes of the one-quarter French blood in the Roebuck clan.

"I never saw so many Indians!" breathed Joey, wide-eyed beside Hannah.

Their attention riveted on the Miami warriors coming toward them. Not all had horses, but even those on foot had evidently decided to turn the hegira into a pageant. Men and women alike were garbed in ceremo-

nial dress of creamy buckskin, painted with blue-and-white design and decorated with porcupine quills that rattled as they walked.

Hannah's face, flashing with excitement, turned to her twin's.

"They must have come all the way from Pickawillany," said Harmon.

"And picked up every tribe between, lock, stock, and barrel," marveled Matthew.

Harmon threw his brother a look of contempt. "Lock, stock, and barrel!"

"All right, travois, squaw and lodgepole."

"That's rude, Matthew," Hannah objected. "Tecumseh said they do not like people calling their women squaws."

Would Tecumseh be with his people? Suddenly it hit Hannah. Tecumseh would be leaving, too! His fame had spread far beyond his blood tribes of Miami and Shawnee. Hannah had heard—they all had—that he was in the east, then in the south, then that militia at Fort Washington were blaming him for raids hundreds of miles away. He seemed to know all their moves, the soldiers were heard to complain, and they knew none of his. Hannah's heart swelled with unfamiliar feelings about Tecumseh. Twenty-seven years old, he must be, ten years older than she, the most talked-about leader of any of the Indian nations. Where was he now? And why were they moving?

She remembered the time, one autumn, when her father had given Tecumseh permission to take her and Harmon to visit a small Miami camp for the day. Was it two years ago? An interlude of peace, at any rate, at a time when blue smoke haze hung over the hills. Riding the big, broadhaunched plow mules single file behind Tecumseh, they had smelled the smoke fires long before dropping into the meadow where the camp lay.

"Is this where you live?" asked Hannah, digging her bare heels into the mule to catch up with Tecumseh.

"When I am not away. It is where my mother and my father live in summer." The day was hot. Tecumseh wore an undecorated buckskin vest and breechclout with leggings and moccasins.

The meadow was a beehive of activity. They would be moving to winter camp soon, Tecumseh explained, not far, but one with permanent housing that offered more protection from the bitter winds and snow. The smoke she had smelled a mile away came from banked firebeds heaped with green, leafy branches, slowly smoking under racks of fish and venison. Several looms were set up in one section, where a group of girls in calf-length tunics were industriously scraping hides. Nearby Hannah saw ears of corn, with the husks pulled back to hasten drying, tied in bunches

like upside-down bouquets of goldenrod, hung from sturdy poles. How pretty they were, she thought, as they twisted in the hot breeze.

Then they noticed the children, swarms of them, playing vigorous games at the far side of the clearing. They were strangely silent. Harmon questioned Tecumseh.

"They are taught early to be silent."

"Like wolf cubs, when the parents are away hunting?" said Hannah. He smiled down at her, and she flushed with pleasure. "That is exactly right, Little Squirrel. Come. My mother wants to meet both of you."

As they dismounted, the children ceased playing and stared at them. Even the older girls and women stopped working and clustered shyly at a distance. Few white-skinned people were ever seen by the children and women of the Miami, Hannah realized. She reached for Harmon's hand for reassurance.

Tecumseh led the way toward a group of women who appeared older than the girls at the looms and smoke racks. In their midst, Hannah could see three cauldrons with simmering contents. Huge baskets filled with red cherries were set nearby. The fruit, she knew, would be pounded in the cooked meat with sufficient bear fat to form a preservative. The resulting food was a nourishing staple of winter diets. She had tasted the concoction before and found the combination of sour cherries and bear fat nearly unpalatable.

"Mother." A woman nearly as tall as Tecumseh separated from the group and smiled.

Black Hoof was a handsome woman, her face square and finely pored, with a beak nose that brooded over a wide, strong mouth. Coarse, thick braids fell over her tunic. There was a presence about her, an inner strength that linked her to Tecumseh more surely than physical appearances. Hannah tried not to stare. She swallowed and remembered to curtsey as Tecumseh introduced them.

"So, Badger, these are the grandchildren of Spirit-Who-Cries."

"Yes, Mother."

Badger! Hannah nudged her brother.

The rest of the day passed in happy discovery, like a day out of time, where nothing was as it was in the world inhabited by Harmon and Hannah. Harmon was invited to test his skill with the bow when the young braves came back with more game to be smoked or salted for winter. Hannah was shown each of the occupations that filled the days of the girls and young women her own age and encouraged to try her hand at each. She tried on a buckskin tunic decorated with porcupine quills that

43

clacked when she moved, giggling with the girls as one after the other put on Hannah's jumper and blouse and paraded around in it.

What remained indelible in her memory of that day was the communal spirit of love enveloping the camp. It showed in the contented faces of the old ones soaking up the sun and in the bright, vigorous faces of the young children, for whom all the adults seemed to act as parents.

All the years when she was growing up and her grandmother was making regular visits to one or another of the Miami camps, she had never been permitted to accompany her. Rumors abounded of white children disappearing, sometimes for years at a time, sometimes never to be heard of again. Then, as now, Hannah was never able to make herself believe that her friends could do such terrible deeds. Hannah brought her attention from the Miami camp to the Miami parading past their wagon down the dusty streets of Cincinnati.

Suddenly she felt that someone was watching her. Her eyes, shaded by the sunbonnet, swept the crowd. *There.* It was that Swallowtail again. His gaping mouth was almost a leer. She wished heartily that he would go away with his people, too. Determinedly she ignored him and craned down the street with her brothers.

The street had filled with a tide of Miami and all their goods. Innumerable travois passed them, lashed together with tent poles, pulled by dogs and horses, and loaded with household goods, hides, loosely tied bundles of clothing, and sacks that might have contained grain. Children of all ages trooped by in moccasins and buckskin clothing, little black heads bobbing among the elders, babes strapped securely to cradleboards, fat cheeks and bright eyes seeming to take in all the attention.

A farmer in a neighboring wagon called to the Roebucks, "Couple hours ago the river was full of 'em, too. Not enough canoes for ever'body!"

"Where they headed?" William Roebuck asked.

"Back to Little Shawnee Town on the Scioto River, I heard."

Suddenly the air was filled with soft *oohs,* as Chief Little Turtle and his magnificent wife, Black Hoof, approached on black horses saddled with buffalo furs. Little Turtle was not a stranger to Cincinnati, but few had ever seen his wife. She commanded awe. Hannah remembered Tecumseh patiently explaining about his mother the day she had visited his camp. Black Hoof was hereditary chief of the Miami, a position equal to war chief, but concerned with domestic matters of the tribe. It all seemed so different. But she certainly looked like a chief.

Then Hannah heard, or rather felt, the high-spirited crowd grow silent. It was Tecumseh! So eagerly had she been examining his mother that he was almost upon them before she realized it. He had evidently seen her before she saw him. Without any direction from him that she could see, his horse cut through the flood of tribesmen and brought him toward the side of their wagon. Her heart beat in rapid flutters.

She remembered the last time she had seen him. It had been a year ago. She realized again that Tecumseh was simply the finest-looking warrior she had ever seen. So far above the town Indians that he looked like a different race. His fringed buckskins, leggings, and moccasins were, as always without decoration. A sweat-stained buckskin band held his shining hair in place. Two white-fringed turkey feathers dangled at a low angle in the braid over his right ear. Around his waist were looped several passes of narrow leather, from which suspended two pouches. His garb was ordinary, but the stir he created was unmistakable. Authority and confidence emanated from him.

Tecumseh stared silently at Hannah, his eyes passing over her face as if he would memorize it.

Hannah felt anguish in his glance. Somehow she understood. This move was something he was opposed to. His mother was hereditary peace chief, his father a Shawnee war chief. He would have had little choice.

"Oh, Tecumseh!" she cried out. "Will you ever come back?"

"I do not know, Hannah. My people must move. Did you not know that the Americans have taken our lands? The very place where my grandfather once sat and gave your grandfather the gift of land. Now his lands are taken." His voice was strangely impassive.

She knew he could talk with persuasion. They said he could weave a spell with his words. These words wrenched her heart. Impulsively she flung out her hand. He dropped his reins and grasped it. As their hands touched, a current went through them. They looked at each other with a shock of recognition. Hannah's eyes filled with tears. "Don't leave," she whispered.

"*Hannah!*" hissed Harmon. "What's got into you? Folks are lookin'."

Hannah pulled her hand away. She glanced involuntarily at her parents. But they and Gennie were saying good-byes to Little Turtle and his wife. She saw Little Turtle take Gennie's hand and cover it with his own.

"Spirit-Who-Cries," he said sadly. "Shall we meet again?"

Gennie laughed, and Hannah was surprised at the girlish tone to it. Almost as if she were experiencing today's happening in another time.

"We shall all be together soon." She turned to his wife. "Shall we not, Black Hoof?"

Black Hoof nodded. Black Hoof, like Tecumseh, appeared numbed by the fact of their move. "I will welcome our next time together, Spirit-Who-Cries." The women gazed at each other in perfect understanding. Then Tecumseh's family moved out and rejoined the tide.

Once again Hannah felt overwhelmed with a sadness she did not understand. She stood immobile in the back of the wagon while her brothers jumped over the side to greet friends on the plank walkway beside the road. William, too, had wrapped the reins around the brake and climbed down to seek his friends.

Peter Ruskin's father corralled him a few steps from the wagon. "They's talk of opening a territorial land office right here in Cincinnati, you know that, Roebuck? Here anyone's got the price can buy a six-hunnert-forty-acre stake at two dollars an acre, minimum."

Roebuck's callused hands rested lightly on his hips. "That right? Course we know prime land isn't going to go for any two dollars. I doubt a body could get it for less than five."

Ruskin rubbed the front of his shirt. "Even at that price, it's a wonder, isn't it? I'm gonna see about adding to the homestead."

"What about the mill?"

"I'm going after all the wooded land I can."

"How you going to ship it?"

Ruskin glanced keenly at Roebuck's face. "Ah, Will, I seen that look before. You got a scheme under yore hat."

Roebuck nodded. "Like to talk to you about it. You and Kendall and some of the other farmers."

The two men glanced around. Already over six hundred inhabitants crowded their new city. By last count, there were over one hundred log dwellings. And two real stores had started up lately, one a mercantile, in addition to the tavern and the blacksmith's that had been doing business for years.

"Yep.... Won't be long 'fore Cincinnati'll be swamped by folks comin' from east of the Appalachians. So crowded back there, prices for land is drove up out of sight. Same thing'll happen here, mark my words. I aim to be in on it this time."

Hannah watched her father nod in sober agreement. "A man can't have too much land." He looked with pride over his noisy brood of boys, cutting up as if it were Fourth of July and they had just seen a magnifi-

cent parade. "Got their future to think about. Let's see who's in town and meet over't the tavern."

Hannah could not stand it any more. She sank to the bed of the wagon and covered her eyes. They had just seen their lifelong friends driven from their homelands, and all anyone could talk about was how soon folks could run out and buy it up. She had a mad desire to run away, to catch up with Tecumseh, to somehow make up for what was happening to his people. Tears stung her eyes, and she began to cry.

6

A fragrant wind eddied around the clusters of people gathered in the graveyard anchored to the lee of the hill. A few fat drops of rain began to fall. It was midday, but the sky had never thrown off its morning blanket of gray wool. The blanket overspread them—the people, the sparse buildings not far away, the stripling peach and apple trees, the horses standing patiently in their traces—the gray blanket covered the wide land, making the presence of the people seem insignificant.

"Do not mind the rain, my friends. As the rain nourisheth our earth, so the spirit of our sister, Genevieve Harmonie Roebuck, nourished those who knew her. . . ." The wind whipped the parson's words away and shook them like a scattering of raindrops over the circle of his hearers.

Hannah listened obediently, but her attentiveness was at war with a curiosity that tugged her gaze from the parson's face to the circle of women and men gathered at the grave. Most of them were farmers, men dressed in their Sunday broadcloth, the women in their sober shawls and scarfs. Following the curve of mourners around the open grave, her eyes paused briefly upon a few buckskin-clad men waiting on cat feet for the doings to end. Trappers. Mountain men. When had they crossed paths with her tiny grandmother? Her gaze moved on. She was hoping Tecumseh had slipped in unremarked. But none among the Miami warriors who were present even resembled her Tecumseh. She had not seen him since last year, when almost the entire Miami tribe had vacated land that had been their home for as long as Hannah could remember and had gone to join the Shawnee.

Suddenly she realized Swallowtail was watching her. He was standing among other town Indians, the least certain part of the parson's flock. His eyes flicked to the parson, attending his words with a semblance of understanding, although Hannah knew that, like most town Indians, Swallowtail possessed only a few words of English, and those not always the ones the preacher used. He wore a black wool coat that was too tight for his pudgy middle and a tall black beaver hat. Some of his friends wore trousers, but below his coat, Swallowtail clung to the leggings and breechclout of the tribal Indian. Their women similarly wore a mixture of Indian and white-farmer dress. But they had come to honor Spirit-Who-

48

Cries, who now was on her journey through the spirit world to heaven. For their presence Hannah was grateful, because Gra'mama had never made any distinction between those she nursed.

"Her friends were all of our Lord Jesus Christ's children on the face of the earth. And she taught best by example. Her faith was strong, though storms broke upon her girlhood early when her father and brother were murdered in France and she herself threatened with lifelong imprisonment. . . ." Belying the adventure and drama of Gennie's early years, the parson's quiet words droned and melded with the rain.

Hannah had difficulty picturing her tiny, proper French gra'mama as the young French Huguenot girl who had executed a daring escape with her own mother and let herself be bound in servitude to a stranger in the wilderness colonies. And Gra'mama had been younger than she when she began her great adventure.

Restlessly Hannah tugged the scarf from her throat and shook out her hair, not minding the rain, which only made her hair curl more. Ranged around Hannah were her father and mother on one side and her twin and four other brothers on the other. Her brown eyes swept on to her twin brother's face. Harmon's eyes were staring at the open grave. His lean, eighteen-year-old body conveyed a somber, reflective attitude.

Last year Harmon had wanted to be a mountain man. Who would want to be like those strange men, big, silent, dirty men, who you sometimes thought had forgotten how to talk more than gutteral words, who disappeared for whole years at a time? She had been relieved when he had stopped talking about it and had sent up an extra prayer of thanks to God for keeping them together.

Suddenly the rain stung her cheeks with a cold blast. Aye. The Lord telling her to mind her duty. She cast her gaze into the shadowed rectangle and turned her thoughts back to her grandmother.

Going home. To France. To heaven. To be with Grandfather. Gennie Harmonie Roebuck. Spirit-Who-Cries. Hannah realized with a sense of surprise that she never really knew why the Miami called her Spirit-Who-Cries. Along with nearly everyone else, Hannah had been surprised into rare silence when the droves of Indians had converged on the settlement and found their way to the graveyard. Hannah felt the strand binding her to the frail corpse hidden in the pine box. She felt the pull of the wind. Pulling her this way and that. Toward the loving balm of family and friends who willingly gave up her grandmother to a long-sought, long-deserved rest. Toward the hills. Toward knowing what lay beyond this town.

Suddenly she realized the parson had stopped talking. Hannah swung her head up and joined her clear, hearty voice to a recital of the Twenty-third Psalm. As the voices drew to a hushed *amen* Hannah's eyes were drawn again to the distant, wooded hills. In all her eighteen years she had never been over that horizon. Someone bumped her arm.

"Hannah. We can go now." Fourteen-year-old Joey, rawboned, half a head taller than she, clamped his broad-brimmed Sunday hat on his head and bent into the wind. "Ma says, 'You got the berries done?' "

"I told her yes," she said in a low voice. She glanced ahead. Her three aunts and her mother were walking together out of the unfenced graveyard. Her father was tarrying with other farmers. Aside from funerals and weddings, the men seldom saw one another. Farm work was backbreaking and time eating in good weather, and only a fool ventured out on social calls in bad weather. So funerals as well as weddings became social occasions, and as her mother would say, who is to tell it wasn't more comforting that way.

As if by common consent, Hannah and her brothers hung about the barn upon returning from the funeral. They had all gotten up before dawn and, mindful of Pa's admonition last night to let their mother sleep in for a change, taken a pan of leftover Indian bread and some cold, bitter coffee and congregated in the barn to eat. They had split up the chores, she to gather wild strawberries, wash them in the creek, and hull them before setting them in the springhouse to cool, to be served after the funeral, with thick, sweet cream and biscuits.

Hannah was wishing she had a biscuit now as they unharnessed the horses and turned them out after a quick rubdown. She shook out a clean saddle blanket and spread it over an upturned feed bin. She perched on it and settled her chin in her palms.

"I wish I'd known Gra'mama better. Some of the things people said about her at the funeral I never knew before."

"She never talked much," said Harmon, not willing for his sister to blame herself for anything. Neither twin could do wrong in the eyes of the other. Harmon and Hannah shared a marked preference for each other's company that shut out the rest of the family. Frequently they roamed the hills near the farm together after chores, hunting or fishing or trapping. When Hannah could slip away from her mother's critical eye, she loved to shed her dress and petticoats and climb into a pair of Harmon's nankeen trousers and a muslin shirt, stuffing her luxuriant hair into a dusty fawn-colored felt hat like her brother's. "Gram never seemed to need to talk much."

"She was always busy," offered Matthew, fingering his dark blue Sunday shirt, which Gram had made from real store-bought goods. "Knew more'n most doctors," said Joey. "Even the Shawnee said so." "When were you talking with any Shawnee?" Hannah demanded. "You know Ma doesn't like us to get overfriendly with them." "Everybody says so," Joey said lamely.

There was a general nod of assent. The only difference Gra'mama's age had made in her ministrations had been that in the last few years, people brought their sick ones to the house to consult her and to receive her herbs and potions with respectful attention, rather than arriving with an extra horse, to summon her to the sick one's bedside, as in earlier years.

A smile curled up Harmon's wide mouth. "Even in dying, she did it just as if that was how she planned it. Calving was over, with a good crop of healthy calves, and we finished the spring planting. Joey even finished seeding Ma's kitchen garden. Did a right good job, too, Joey."

Praise from his oldest brother made Joey duck his head with embarrassed pleasure.

"Harmon, you ever read her diary?" asked Thomas. At fifteen, next to youngest, Thomas was already considered the most practical minded of the brothers.

"No, but I seed the calumet. Pa let me hold it once."

"Seen, Harmon."

"Seed, seen, I ain't going to be a schoolteacher."

Hannah shoved his shoulder affectionately. "Now you are putting on. Didn't you even see the diary?"

"It's in there," Harmon said shortly. They all knew "there" was the saddleback chest in Gra'mama's room.

Why hadn't Ma or Pa ever let them read it? A gleam of determination entered Hannah's eye. Couldn't be anything too shocking in a *grandmother's* diary, for pity sakes. Besides, nothing in it could hurt Gra'mama now. Grandfather Roebuck had died (*departed,* her aunts always chided her. Why? Dead to this life, reborn in heaven!) when she was still a child.

Then and there, Hannah determined that as soon as all their guests had left (who were only now arriving with pots of salads and platters of roasted fowl and deep-dish pies), she would spirit Gram's diary out of the house and into the hayloft, her favorite retreat. She rose and automatically dusted her clean skirts.

"Look, before we go in, got something to tell you."

The seriousness in Harmon's voice made each of them stop. Harmon

51

wasn't given to wild schemes. If he had something to tell them, it signified he'd already made up his mind.

An argument had been festering among them for weeks, drawing them closer in mature thinking, as well as dividing them. It had been laid aside when Gra'mama got sick and everyone felt that she was going to die. It had revolved around the farm. As the discussions had all taken place in the barn, and with Gra'mama properly laid to rest at last, it seemed natural now to continue.

Harmon had forced them to think when he observed, "One farm won't support five families same as it does one." He repeated it now.

"You are the oldest, the farm'll go to you," Thomas said, ever ready to face unpleasant truths.

"Not if I don't say so," Harmon retorted. "That weren't what I meant anyway. Pa was lucky. He was the only son, so when Grandfather Roebuck died, he just naturally took over for Gram. Pa's sisters moved away when they grew up. We got a good farm, but five brothers supporting wives on the same amount of land don't rightly make sense. And Hannah's entitled to one-sixth," he reminded them.

"When the land office opens, we can buy more land," said Matthew. Since childhood each had earned and put by small stakes from trapping and from helping neighbors during harvest and planting seasons.

Harmon nodded impatiently.

Thomas watched him shrewdly. "Only that isn't what you got in mind, either."

Harmon grinned at Thomas. "You ever think about 'prenticing out to a lawyer? You're right. What I got in mind is to leave the farm and do some trapping."

His brothers and sister eyed him in stricken silence. Hannah saw with chilling clarity those mountain men at Gram's funeral. Strange, unsolicitous creatures, self-contained like a turtle in its shell. She thought Harmon had forgotten his earlier dream.

Suddenly she burst out, "Oh, Harmon, don't go!"

"Now, Hannah." His voice was filled with special affection. When his eyes met hers, it was as if she were looking into her own hopes and longings. *You and I will always be close,* they said, *no matter how far away I get. You know that.*

Her eyes filled with tears. He was going, then. She felt as if she were being wrenched in two.

"Let's go, Roes," said Harmon, drawing them in with his nickname for

them. "Folks are already arrivin'. I promised Pa we'd see to everyone's horses and wagons, and Hannah's got to help in the kitchen and mind little ones."

Hannah tossed her head, not looking at Harmon. "I'd rather have your job," she said tartly.

7

Hannah thrust her long, trouser-clad legs out before her and studied her dusty shoes. She was tired, her head ached, and she could not wait for everyone to go home. Dusk was just an hour away. Most of their guests had at least an hour's ride ahead; there was little to fear from Indians as long as they remained in a large group. The main road from the east into Cincinnati continued beyond the town, along the southern boundary of the Roebuck farm, and was well traveled. Of course neighbors were always welcome to stay overnight, too.

Her brothers had gone inside after chores. Feeding and watering could never be neglected. Stock was too precious, both in trade and in difficulty of replacement. She had stayed in the barn. An occasional laugh, joined in by others, drifted out to her. She could hear them all, aunts, uncles, shrill voices of children, coming from the broad, low porch that fronted the farmhouse. Her headache had started when Harmon announced that he was going away to be a trapper. Then, as relatives and friends converged on the farm and began talking over old times, her headache was compounded by a slowly developing sense of what she had lost. Her grandmother was no less than a legend around Cincinnati. Why had she never taken the time or trouble to listen to her stories?

And then she discovered that her laugh was considered unladylike. She was proud of her forebears, and to be told her laugh showed a lack of breeding was humiliating. Seventeen-year-old Philippe had joined his town cousins in teasing his sister. "Oh, she makes heads turn, but she'll never get a husband with a laugh like that!" *Thanks a lot, Philippe.*

Usually, teasing by her brothers did not bother her. To her delight, she had discovered that that in itself they found disturbing. But when she felt so angry about so many things, as she did now, it was best just to get off by herself until it went away. Well . . . she could not sit here much longer.

As she heaved herself to her feet, Hannah remembered Gra'mama's diary and decided she would not wait to read it. She brushed away a wisp of conscience that she ought to ask permission. Going around back by the springhouse, Hannah entered the house quietly. No one was inside. She went purposefully to her grandmother's room, to the trunk, and raised the lid. She was surprised how easily it opened. A hinged compart-

ment was fitted in the lid. The first thing she saw was the diary, lying alone, touchingly vulnerable.

At first she did not handle it. Her eyes roamed the rest of the trunk's contents. She recognized the stock that Gra'mama had embroidered for Thomas. She traced the finely stitched initials, *TR,* intertwined in beautiful detail. She remembered that her father had wanted Grandfather to be buried in it; but with a gentle smile, Gra'mama had insisted that it would please her more if her grandson Thomas, whose initials were the same, would wear it on his wedding day. Thomas was then little more than a baby, but Hannah remembered her own mother accepting the trust.

Hannah thrust her hand deeper into the chest. Her fingers closed around something long and cold and heavy. She eased it up through the linens. The calumet La Demoiselle had given Grandfather. It was made of red stone, longer than her arm, hollowed like a clay pipe, covered with strange carvings and painted symbols. A shiver rippled through her body as she beheld it. Something about it—something held meaning for her. Impulsively she closed her eyes and grasped the calumet with both hands. Suddenly she gasped. An image had flashed through her mind. Seen, and then gone. Her heart raced. She opened her eyes and stared at the calumet. Hastily she dropped it back in the trunk and scrambled to her feet.

The diary. She reached down and clasped the diary. It was a small volume, bound in supple brown leather. She laid the book on Gennie's bed and closed the trunk. Whipping out a large kerchief from her trousers' pocket, she spread it on the bed. Carefully placing the book in the center of the kerchief, she pulled up the corners and tucked her precious package inside her shirt.

Several moments later, Hannah slipped into the barn. Dusk had rendered the interior of the barn gloomy, and she automatically reached for the lantern that hung on a hook inside the small side door. She carried it up to the hayloft. Pushing open the small door through which they dropped bales of hay onto the wagon, Hannah let in the last of the daylight. At last she opened the diary.

Genevieve Harmonie, ma livre, Septiembre 1744, she read. A chill started somewhere around the base of her spine and prickled over her. She glanced around. Something had moved. No. She listened. No. Nothing. She read the words again. Again she felt the sense of something out there. Determinedly she shook off the feeling. She returned to the diary. Seventeen forty-four. That was over fifty years ago! Over fifty years ago

Gra'mama had started her famous adventure. Settling comfortably, she concentrated on translating the flowing French script.

"Where is Hannah?" Her father's voice, out of patience, drifted up into the hayloft and cut through the utter concentration that had devoured Hannah's consciousness for over an hour. It was a small book. It had taken her less than an hour to puzzle out the curious French writing, the antiquated phrasing. The rest of the time she had just been sitting here, lost in her grandmother's struggle. Softly and reverently Hannah closed the book, gazed out at the night. The moon was rising. Suddenly she realized her family had been calling her for some time. Also that her face was wet.

Rubbing her cheeks with the back of her hand, Hannah scrambled out of the loft, remembering to replace the lantern as she left the barn.

For once, the household routine was disrupted. So many friends and neighbors had brought food that Faith had not prepared a meal. A platter of cold chicken lay on the sideboard. Biscuits and bowls of preserves, cakes and tiny preserved pickles and tomatoes, a cold chowder of corn, tomatoes, and green peppers. Her mother scrutinized her swollen face with raised eyebrows and pursed mouth as she came in, but said nothing.

Faith Roebuck was a gracious woman who had been brought up in a genteel family. She was loving and possessed a gay spirit, for years less at home among the sturdy, industrious women of Cincinnati than she had been among the social circles of her girlhood. Nevertheless, she reared Hannah to pay as much attention to canning, preserving, sewing, scrubbing, polishing, mending, and cooking as to the things she preferred: reading and writing and ciphering.

She had come to the far west with the hardy young farmer she fell in love with in Boston, where he had come to buy supplies. Faith made her home in the raveled settlement of Cincinnati, clinging to the edge of civilization on the bank of the Ohio River, and never looked back. Himself rugged like the land and largely unschooled, William Roebuck possessed a raw goodness, an uncomplicated sense of who and what he was, that Faith found compelling.

Born after Thomas and Gennie homesteaded their gift of land, William had spent his boyhood isolated from civilization. Mixed with the solitude came a gentleness that grew of nurturing farm animals. Books were scarcer than gold, and religious instruction a mixture of remembered Scotch Presbyterianism and Huguenot revolutionary Protestantism. Faith brought to the marriage a sound education and her Congregational

background, considered by many as among the less essential elements for survival on the frontier.

"Where were you, Hannah?" Faith said now as the rest of the family waited around the dinner table.

"I was in the loft, reading Gra'mama's diary."

"Hannah!" The family stared at her in stricken silence. The boys were not sure if she had desecrated something or not and waited to see what their parents would say. Her father scowled. Her mother nodded. "We were meaning to read it to all of you after Mother Roebuck passed on."

"You were?"

Her mother said, "There are lessons to be learned from the tribulations of others."

Hannah nodded, still too close to tears to talk about what she had read. Suddenly she broke down. "Oh, Mother, to be married to that horrible man!"

"*Grandfather?*" interjected Joey.

Hannah shook her head. "Before him. Poor little Gra'mama. All she ever wanted was just to stay home. She loved her farm in France."

"Remember those 'spells' she used to take, toward the end of her life?" asked Faith.

The family was silent, remembering. Gennie would drop whatever she was doing and rush outside. She'd stand in the doorway with her head cocked. "I thought I heard a baby crying," she would say with a little half smile. Hannah had sensed an awkwardness on the part of her parents at these times, but nothing was ever said, and the children knew better than to pry. Her grandmother had never mentioned the fate of her brother, who had been named Phillippe, or her father, who had died in France.

"There was a baby," Faith began. "He would have been Hannah's Uncle Benjamin had he lived. . . ."

When Faith finished speaking, Hannah said in a quavery voice, "Now I know why they called her Spirit-Who-Cries." She encased her shoulders in both arms. "I don't think I could have stood it. What happened after Benjamin died and Grandfather rescued her?"

Haltingly, William picked up his mother's story. His father, Thomas, had told William over the years about Gennie's life before he brought her to this farm and married her, and about his parents' friendship with the Miami. As the years had passed, Gennie had developed a special insight into the nature of sickness, especially in children.

"Mother always felt very close with Jesus—more'n I could get to,"

William confessed. "But mebbe she needed it. Many a time she said to me, 'There's something out there, Son. We're safe as long as we keep God close.' "

"I felt that, just reading her diary," Hannah exclaimed with relief.

William looked startled. "Did you now! Old Rosalind, the midwife, swore there was something—uh—supernatural—in the strength of the bond between Mother and 'her Jesus,' as she used to put it." William was looking increasingly uncomfortable with the turn of the conversation. Give him warm earth between his fingers, not feelings and superstitions that prickle you up like a porcupine. He glanced at Faith for help.

"In the diary Mother is quite definite about believing supernatural powers helped save her, body and soul. Rosalind believed it, too. Of course Rosalind was West Indian and a slave long before she found our Savior."

"Our aunt Rosalind was named after a *slave?*" said Joey. When his mother nodded, Joey said softly, "Wow. I wish I'd've known her!"

"She brought you into the world, Joey."

"She could fill your head with stories, Son," William said. "Now you take your sister here—"

"William. . . ."

He looked directly at his wife. "Let's tell her." Faith's eyebrows went up, but she kept her peace. No one had touched their supper. "Hannah is our firstborn. She was born with a caul."

'What was I born with?" demanded Hannah.

"A caul. An extra piece of skin covering the head, like a bag," said her mother.

"Yech! Do we have to talk about this?"

Faith laughed. "Don't worry, Hannah, it was supposed to mean the child was born with good luck. Rosalind used to say that the caul was a sign the child would have second sight."

"What's that?" asked Joey.

"Tell things before they happen, right?" asked Hannah.

William nodded.

"Did I have it, too?" asked Harmon.

"No," said Faith. "But since Hannah was a twin, the caul was supposed to be even stronger medicine, in Rosalind's words. It meant that she was born with the same kind of insight and feeling for the natural world that your grandmother had."

"That's scary!" said Hannah. "Everyone always says how much like her I am, but I don't want to be! I want to be happy!"

"I thought you wanted to go with Harmon," said Philippe slyly.

Faith and William looked at each other. "Go with Harmon?" said her mother. "Go where?"

"Sounds like you children been mulling things without us," said William.

"I wasn't going to say anything until after the funeral was all over—and things." Harmon's glance shot daggers at Philippe. "You sure like to see me in the soup kettle, brother."

"Philippe, it wasn't kind of you," Faith added. "Your brother had a right to tell us in his own time, if the Lord has put something in his heart."

The chair creaked as William leaned forward, hands braced on spread knees, a level gaze fixed on his eldest son.

Hannah threw a stony glance at Harmon.

"Pa," Harmon said, "I got no wish to be a farmer. I'm willin' to give up my share o' the farm for a stake. You know I always been good at trappin' and huntin'."

Faith was sitting transfixed, her work-roughened hand to her throat, staring at her son. "William. . . ."

William Roebuck nodded. "How long you had this fixin'?"

Harmon shrugged. "Always, I guess."

"He don't think the farm'll support us all," put in Thomas.

"That it, Son?" said his father.

"Well, that's part of it, but Pa, I just never wanted to be a farmer. That's God's truth."

William Roebuck looked at his wife. "Well, Son, I figured that not all of you would want to farm. Matthew here, and Philippe, they got more of the natural feel for the land, I got to admit."

"What about me?" said Joey.

"You got a feel for drivin' everybody crazy," quipped Philippe.

Joey flew at his brother and pulled him to the floor. "You take that back!" Around they rolled on the thick, braided rag rug.

"What'd I tell you?" Philippe gasped through his laughter. "God's truth!"

Matthew and Thomas couldn't resist joining in a chance to get at Philippe, who expertly needled them all at one time or another, and jumped into the fray.

"Go outside if you want to wrestle," said Faith mechanically. Thomas, Matthew and Philippe charged through the door with an excess of en-

ergy. Joey started after them, then hung back. Instead he went over to stand next to his mother's chair, an arm on her upright shoulder.

"Harmon, my son . . . ," said Faith.

"I know, Ma—"

Faith shook her head. "You are not cut out for that life. Those are lonely men. Here you have family and friends who love you—"

"That isn't it, Ma—"

William leaned over and captured his wife's hand. "Now wait, Mother."

"Oh, William!" She cast pleading eyes at her husband, then turned back to their eldest son. "Could you not be just as happy in town? Couldn't you be a storekeeper? That's not farming. And you could bide a while with one of your aunts. There are some lovely young ladies—"

"Before you go off half-cocked, I got another idea, if I could get a word in."

Faith, Harmon, Hannah, and Joey turned solemnly to William. "Son, you know 'bout the schooner."

Harmon looked puzzled. "The one that's being built up at Marietta?"

William Roebuck nodded. "Sometimes the Lord puts hankers in a body when he's plannin' a move. Mebbe he'd like it fine if you was to go along when we send the boat downriver."

"William, please! What *are* you talking about?"

"The boat, Mother. Last couple years, our farm's been producing far more wheat than we could use. Ruskin's mill been meeting the demand for lumber and then some. Josh Kendall, some of the other farmers, and some of the businessmen in town, like Fenn and Thicknesse and even Haney, they all got a stake in it. If you rec'lect, last year, bunch of us got together after we saw that schooner come floating down the Ohio. We figgered to get our goods to markets we never reached before. They're building ocean-going vessels now, right upriver from us! They float them to New Orleans and sell the cargo and the ship."

Philippe, Thomas, and Matthew crept back into the kitchen, dusty and breathing hard, in time to hear about the schooner.

"Then what happens to the ship?" asked Hannah.

"In New Orleans it's fitted with seaworthy masts and sails and sailed up the Atlantic coast and sold at places like Norfolk or Baltimore or even Boston. Well, our schooner is going to be in Cincinnati, ready for loading, in July. I'm proposing we send Harmon along to oversee our interests."

"Pa! Me!" Harmon sprang out of his chair. He had heard talk of the boat for months, but never really listened. His face blazed with excitement.

"You mean you're going to leave us anyway?" said Joey. His eyes were wide with distress.

"Heck, I'd be back in a few months."

His other brothers eyed him with envy. "I want to go," said Philippe. "I'm almost as old."

"Me, too! Me, too!" echoed Matthew and Thomas.

Laughing, Harmon shook his head. "Mebbe next time. You know he'll need the rest of you here." His eyes shot to his sister's and quickly slipped away.

"I allus thought you were going to be a mountain man, Harmy," said Joey.

"I want to go!" the words burst out before Hannah even thought about it.

"Hannah! Girls do not—"

"Why should boys have all the adventure? I want to go, too!"

"Now you hold on, young lady," said William.

"What has gotten into you?" said Faith.

"I'm eighteen, Ma! And I'm stuck out on this old farm, and I don't want to be."

"Well, listen to you," said Harmon. "May be more of Gra'mama in you than you thought, Sis. Whatever else she was, she wasn't afraid."

Hannah laughed, hearing a new ring in her voice. "What's to be afraid of?" she said recklessly.

Suddenly Hannah glanced at Joey. Her youngest brother was staring at her, his eyes pools of worry, the first glimmerings in his life that things do not always stay the same. Hannah felt a wave of pity that subdued for the moment her own rebellious spirit. Climbing to her feet, she went over to hug her youngest brother. She knew just how he felt.

8

The cadenced beat of the drum reverberated from the bald hillock, through the forest near Little Shawnee Town. Six men garbed in full war regalia emerged from the leafy depths around the hillock. The sun cast their bodies into strong relief as their shadows skirted an open grave. From their shoulders they hoisted a body wrapped in birch bark. Two of them dropped on light feet into the four-foot-deep grave to receive the body. They laid it with its feet facing westward, toward the Shining Sea.

"Umm yah! Umm yah!" Black Hoof began the slow chant. Her feet pounded the earth. Her body swayed in place. Her handsome face with the strong, beaked nose reflected her suffering. Her braids, twined with fluffy gray owl down, rose and fell against her breasts, and a necklace of owl beaks clacked softly against her white buckskin tunic as she danced. Black Hoof danced first, not today as hereditary chief of the Miami clan, but as wife of the dead.

It was her husband, Little Turtle, whom the warriors were settling in his grave. Others took voice and joined Black Hoof's rhythmic movements. A ring of women moved up through the men circling the grave and sank to their knees. Armed with shovels made of bison shoulder blades, they scooped the rich earth over their dead war chief.

Black Hoof had sent for Tecumseh when Little Turtle's time was near. Now, four days after his death, the son was not here, but Black Hoof knew that this was the day the Great Spirit wanted to see Little Turtle. It was not given to her to know why. She flung her arms against the sky. Her chant grew louder. "I was your wife for thirty summers," she sang. "Daughter of La Demoiselle, daughter of chiefs. Black Hoof married Little Turtle, who became greater than his wife, for she must be the Miami chief by blood. Little Turtle was war chief! My pride was great, for only the mightiest warriors are chosen war chief. Great Spirit, receive my husband, Little Turtle!"

Suddenly a new voice joined the chanters, a deep, impassioned voice: "Great Spirit, receive my father, Little Turtle, greatest war chief of the Shawnee! I, Tecumseh, come to honor you."

Tecumseh wended his way through the dancing throng pressing in to-

ward the grave, half a head taller than any. As always, his presence in his mother's camp created a stir. The dancers felt themselves growing taller. Their voices rang with more pure conviction of the words they sang. From inside them seemed to spring the single desire to be great for Tecumseh.

Black Hoof looked up swiftly as he reached her side. She continued to dance. Her eyes were awash with relief, but Tecumseh saw that lines of pain had etched frost cracks in the granite composure.

He stared into the grave and began to dance beside her. At last the singing women finished their task of filling in the earth. When the dance was finished, Tecumseh helped to lift the burial house, a small replica of Little Turtle's bark house, and position it over the fresh earth, where it would keep out marauding animals. It possessed great magic, which would also keep evil spirits away from Little Turtle while the *Grandmother* guided him to the Shining Sea.

Tecumseh turned from the grave. He took his mother's elbow and walked with her down the hillock, to the path leading back to the village. Here he untethered his horse, a fine Narragansett pacer he had acquired three years ago in a raid on a settlement near the English fort at Detroit. The path led around the edge of a weedy clearing. It occurred to him that in former years, at this time of spring, the women would have had this area cultivated. Such negligence disturbed him. Later he would talk to his mother about it.

"I am glad you returned in time, Tecumseh." Black Hoof's voice seemed remote. "Today was the day the spirits chose for his journey."

Tecumseh nodded, not really surprised at her choice of words. His mother possessed many powers. She was a healer and sometimes a diviner. These gifts she accepted with humility, as gifts of the Great Spirit.

"Tell me about my father's death."

She nodded and led the way to her house.

Inside, a swift glance around told Tecumseh that, here at least, little had changed since he'd left. Black Hoof's house was larger than the others, befitting a chief; comfortably furnished with benches, platform beds covered with thick furs, and shelves harboring prized metal cooking pots, bags of pemmican and dried corn, and bundles of extra clothing. Colorfully dyed straw tapestries hung from the birch and pole walls.

They sat on a fur robe, facing each other. His mother took up a sieving basket she was weaving. Her fingers searched out the stopping place and began to work without a glance from their owner.

"Don't you have women to do that?"

Black Hoof smiled. "Things I learned to do well in my girlhood are a comfort to me, now, Tecumseh."

A shadow crossed the doorway. A young maiden entered, carrying a rush tray of food. She knelt and placed it beside Tecumseh. Custom forbade her to speak unless he spoke to her.

"Not now." He looked at the maiden as he spoke. Her black eyes danced invitingly before she remembered the solemnity of the occasion. She blushed and lowered her eyes. At a gesture from Black Hoof she left the tray and went out. Tecumseh glanced at his mother. He had left Little Shawnee Town last year at this season and vowed never again to rest in his father's house. When his mother's summons had come, his first feeling had been one of irritation. Was Little Turtle really dying? He was not as old as many of their tribe. Was it a ruse to force Tecumseh to come to him? Immediately Tecumseh felt ashamed. Little Turtle would never have done such an unworthy thing.

Black Hoof was watching him as if she were following his thoughts. "Little Turtle never felt quite right with himself after you two quarreled. It is hard to be war chief. It is hard to make decisions that affect the well-being of thousands of Civilized People. . . ."

While he attended his mother's words, another part of Tecumseh allowed the sadness of his last meeting with Little Turtle to seep into memory. He remembered his outrage, his stunned disbelief, when Little Turtle had admitted agreeing to give all of the Ohio to the Long Knives. He had invoked Motshee Monitoo upon him. Motshee Monitoo had taken his father and now followed the son. Tecumseh knew it and accepted it. His father's hoarse cry, "It is done!" would never leave him.

Tecumseh turned his gaze away from the doorway and found his mother looking at him. Her eyes were wells of sadness.

"To persuade the people to peace is not always truthful," she said. "In such time, evil has sprung from noble intentions. Motshee Monitoo has come from the netherworld to perplex and punish our nation for giving the Long Knives our heritage."

"How has he punished you?"

"You will see, Tecumseh." She rose. "Come. It is time to coat your skin with bear fat and dance for your father's spirit."

As he followed his mother outside, Tecumseh remembered that he had not even told his mother that Spirit-Who-Cries also died four days ago.

9

Tecumseh stripped to his breechclout and began to smear his body with pure white bear tallow. While he had talked with Black Hoof, following Little Turtle's burial, the sun had gathered strength. It gleamed under the spreading coat of grease on the long muscles of his back and shoulders and arms. The maiden who had brought him food came with paint pots and ashes. He squatted outside his mother's house and allowed her to streak his face and chest with ochre, scarlet, and charcoal. Her teasing eyes repeated their invitation. Tecumseh ignored her. Her charms were not for him, beautiful though she was.

Coquettishly she drew her lips into a pout and proceeded with her task. "I am called Leaf-of-Gold," she murmured without looking at him. He did not answer. "When the dance is over, Tecumseh. . . ."

While she painted cool images of Little Turtle's clan on his skin, Tecumseh studied the clusters of men waiting for him to begin the dance. Many of the braves were near the age of his father. Something in their manner brought to mind a dying sycamore he had once seen, uprooted in strength by a spring flood. Its green leaves had wilted quietly, no riot of color to dance its death.

A group of younger warriors and maidens were laughing and teasing each other. Tecumseh smiled as he recognized Tall Tree, a man his own age and the only friend he counted from his brief stay among the Shawnee last year. He had painted his face chalk white. The long, gaunt face already possessed something of the mystic, rendering the paint a death mask, at odds with the man's muscular build.

"You are beautiful, Tecumseh," said Leaf-of-Gold softly.

He brought his attention back to her and laughed at the foolish words. She grinned and picked up her paints. Tecumseh sprang to his feet. He looked about for the drummers. They were already making for the hollow log and the small stretched-hide drums that served to beat the rhythms.

Their shadows were now completely within themselves as Tecumseh opened his mouth. He began to sing and to move his body in dance for the spirit of his father.

At dusk they stopped to eat. His mother reemerged. Tecumseh saw

from her face that she had been grieving privately. After they had eaten, she held up her hand for silence.

"Your weapons now," she said. She went to stand silently at the door of her house. One by one the revelers disarmed themselves and carried the weapons into her house. Tecumseh glanced at Tall Tree for an explanation.

"So we can free ourselves to drink rum," he said.

Tecumseh shook his head slightly. Even the younger girls and boys were leaving their small knives, which were mostly used to cut whistles from the reeds growing along the stream and to pry the meat from hickory nuts. A ripple of excitement charged through the Shawnee camp, building to a roar as women appeared bearing casks of rum from the storeroom.

Slowly they began to dance. The fire was fueled to bonfire proportions. Its searing flames glanced off the twisting, leaping bodies as they sang and danced with renewed energy.

"Awaken, ancestors of Little Turtle! Awaken the *Grandmother* to guide Little Turtle through the dangers of Spirit Land!" Sparks of fire shot into the blackness and spiraled above them. Tecumseh's moccasins pounded the earth and his voice rang out in the ancient syllables, calling the spirits to attend his father on his journey, recounting the mighty deeds of the fallen warrior. All night the drums sounded into the star-filled embrace of the chill spring night.

Tecumseh and the Shawnee and the remnants of the Miami tribe danced and rested and danced again. The night slowly turned. Men and women began to steal away to the spirit world of rum, until at last Tecumseh danced alone. To honor his father, Tecumseh danced on.

Toward morning, he saw Tall Tree weaving unsteadily toward him. He was balancing a gourd sloshing over with dark liquid.

"Now it is time to forget unhappiness," called Tall Tree. "It is over. I have brought you some rum, Tecumseh." Runnels of sweat streaked his white paint, mapping on his face an arid country of bleached ridges and valleys.

Tecumseh stopped dancing. The last tired drummer chose this time to steal away. "Insensibility does not honor a warrior, my friend. Dance with me."

Tall Tree stared at him a moment, struggling to focus his eyes properly. For a moment, his face bunched uncharacteristically in anger. Then he shrugged and ambled off, the gourd still carried ritually before him.

Journey of No Return

Tall Tree's drunkenness angered Tecumseh. He thought of his father. It was forbidden to think or speak ill of the dead, but Tecumseh's anger erupted in a new dance. It coursed like stinging nettles through his veins. He whirled and grunted and pounded the earth with ferocious intensity, creating his own music. Little Turtle had succumbed at last to the white man's lies. Death had claimed him as a coward, not a warrior. Through his mad twirls Tecumseh saw those around him who had stumbled and sprawled, felled not by exhaustion but by drunkenness. Tecumseh danced and howled his rage at the devil liquor that had done what lance and knife and gun could not. Finally he danced of revenge, of unbending opposition to their enemy, the Long Knives.

By morning a spirit of sickness settled over Little Shawnee Town. On aching feet, an exhausted Tecumseh trod through the slumbering camp. He forced himself to acknowledge the differences he had found and ignored in his mother's camp ever since his arrival yesterday. He had gone first to the council house and discovered it as deserted as the rest of the town. An odor of decay in the room told him that his father had lain here while they awaited the son. His chest had tightened with pain as he escaped the suffocating odor. Tecumseh knew he would not as easily escape the pain of their last meeting.

Roughly Tecumseh pushed this memory aside. Instead he blessed the spirits who had caused him to come at once to the home of his father and not delay to attend the funeral of Spirit-Who-Cries. As he had quit the council house he had had to step carefully to avoid offal and dog excrement littering the stamped earth of the common areas. It had looked as if it had been unswept for days.

The cold, gray morning renewed his senses, and he used his eyes to more purpose. He inspected the house used to store furs trapped over the winter season. It was more than half empty of the hundred-pound bales. Perhaps, he reasoned, Little Shawnee Town had done its spring trading earlier this year.

A few children were up now. They seemed querulous and dull, where on his previous visit he had not found them so. Some of their parents still slept on the open ground, where they had fallen hours before. A sickly sweet odor of rum emanated from them. To escape them, Tecumseh tramped around the perimeter of the town. The last frost had long since soaked into the earth. The earth was greening, yet their fields lay fallow. With heavy step, Tecumseh went at last in search of his mother.

Black Hoof appeared at the door of her house when he called. She was

dressed in her everyday garments of calico shirt, calf-length buckskin skirt, leggings and moccasins. Her hair was newly braided, minus the owl feathers. Her eyes were shadowed, but her expression was serene.

"Why are the women so late with the planting?" he demanded of her.

"They are doing the best they can. The men refuse to help clear the land." Tecumseh said nothing, so she added, lifting her shoulders, "I think Motshee Monitoo must be in league with the white men. Our men have a craving for rum that is never cured. All they want to do is trap and shoot and sell the skins for rum. Some of them do not even bring the meat back to their families."

Tecumseh's rage spilled over. "As chief, why have you not forbidden this? See what it has done to your people!" Casting about for a suitable object on which to vent his anger, he fixed on several braves snoring on the ground nearby, Tall Tree among them. Angrily Tecumseh strode over to Tall Tree and kicked him in the buttocks.

One after another, he kicked the celebrants into confused consciousness. "Get up, you dogs, you whining, stinking dogs. A year ago I left men, and I come back to find filthy drunkards. Where are the men who rode with Little Turtle fourteen summers ago at Blue Licks?"

Tall Tree scrabbled stiffly to his feet. His whitened face was dusted over with dirt. His eyes burned with resentment. His braids were pulled and snagged like weeds caught in the river.

"You should see yourselves!" said Tecumseh scathingly. "You, Tall Tree! Your name should be Little Boar, because you root and grovel in the ground!"

An intense stillness seized the camp. They were like a body without a head, its lifeblood pounding out in spurts. Uttering a low growl, Tall Tree lurched toward Tecumseh. His fist coiled. He launched a blow at the side of his head. Tecumseh was unprepared. The blow knocked him off balance. Had it carried the weight of a man in full possession of his faculties, it would have felled him. Tecumseh's lips drew back in a snarl. He whirled and kicked Tall Tree again as the force behind his blow carried Tall Tree past him. Tall Tree turned with a cry of outrage and lunged for him with both arms spread, the fingers curled. Tecumseh kicked him in the belly. Tall Tree felt the insult. Tecumseh would not even dirty his hands with him. His hands searched his body for a knife, and he cursed that he had given it up last night.

Like a cat, Tecumseh was upon him. He seized his wrist and forced his arm behind his back. Suddenly the anger drained from Tecumseh. "Peace, Tall Tree." He waited until he felt the tension lessen in Tall

Tree's arm, then released it. "Forgive me, my brother. You danced for my father, and I dishonor his memory."

Resentment simmered in Tall Tree's eyes. *Beware,* Tecumseh told himself, *the next time Tall Tree has too much to drink.* Sullenly his friend pulled away.

"Tall Tree," said Tecumseh. Tall Tree stopped. "Remember you are Shawnee. A Shawnee warrior with many coups." The shoulders shrugged off Tecumseh's words, and he walked on. Greatly subdued, the rest of the men and women straggled to their feet. Some staggered toward a revivifying plunge in the river. Others slipped shamefacedly to their houses.

Tecumseh faced Black Hoof alone at the fire pit, across the cold ashes of his father's memory.

She grimaced. "It will help for a time. Come. Eat with me."

"How did my father die?" asked Tecumseh as he sat with her in her house. "Is he responsible for—this—for Little Shawnee Town?"

Black Hoof was a long time in answering. "He felt the shame of the treaty. They were tricked, Tecumseh."

Tecumseh was bone tired and sick at heart over what he had done to Tall Tree. To fight a man was one thing. To humiliate him was another. Behind it was Tecumseh's deep concern over the Shawnee state of affairs. Yet he drew his back and head erect and struggled to impart an air of tranquility that, he was learning, invited confidences and truth telling. With great effort, he quelled his impatience.

"One thousand war chiefs and their braves," Black Hoof said. "General Wayne invited them to Fort Greenville, and they came with honor. They came to discuss ways to live peaceably on the land, as men should. For three days no talk. They celebrated. Drank rum and danced." Black Hoof spat upon the ground.

Tecumseh knew this. It had been the source of his final break with his father. He also knew Black Hoof would not get to the facts of his father's death without this recital, which she considered a part of the story that must not be lost.

"What kind of uncivilized peoples are these whites," she asked, "that they celebrate first and then expect to work? You have seen how our people become when their stomachs are filled with rum. They care for nothing but more rum. That is why I must take their weapons before they drink. It is our law now.

"Treaties were signed." Black Hoof could not bring herself to say more about the infamous treaties that had robbed them of all their ancestral

lands. "Little Turtle returned home. After you went back to live among the Miami, Little Turtle saw the truth. He set his face toward the Shining Sea and willed the beginning of death. Our people have lost the will to live."

Tecumseh absorbed his mother's words. "Then you must force them to. If you are not strong enough to rule without Little Turtle, you must choose a new husband. You cannot allow your people to live like this, like animals, in filth. . . ."

Black Hoof lowered her fine head in shame. He saw how clean her hair was, the whiteness of her scalp in the part of her hair. "You are right," her voice came. She lifted her head. Tears burned in her dark eyes. "It is good that you came. But I do not want another husband. I will pray to the *Grandmother* for strength to control my people. We will be strong again. I vow it, as the daughter of La Demoiselle."

"While I am here, I will help your braves clear the fields. The women can still plant. We will send out hunting parties and begin the smoke fires to preserve the meat. We will set more women to tanning hides. If any will not help, you must have them beaten. And Mother, you must call a council and force your people to foreswear the rum."

Black Hoof had been nodding as Tecumseh outlined their course. Now doubt assailed her face.

"What is the matter?"

"The rum. Even Little Turtle was not able to keep the rum from those whose desire was strong."

Tecumseh grunted and rose.

"Tecumseh . . . ," Black Hoof looked up at him.

He hid his impatience. "Yes?"

"I have observed you, too, my Badger." He smiled at the use of the pet name that she had given him in childhood. "You are an important warrior now, but I feel that you have not branched as you should."

Tecumseh frowned. He studied the winged brows of his mother, now drawn in concern. Not a wisp of gray showed in her black hair. He guessed she was many years younger than Little Turtle, probably no more than a child herself when she had borne him. He waited respectfully for her thoughts to gain wing.

"You were always a serious boy. Not like your friend, Tall Tree. All the boys looked up to you, even as a child. You are a worthy successor to La Demoiselle. From him, through me, your Miami blood mixes with the best of the Shawnee blood of Little Turtle. You will be mightier than Little Turtle."

Tecumseh knew that what she said was true. Already he felt it in himself. Her next words surprised him.

"Your trunk is strong, forming a mighty column that will protect the Civilized Nations, but a trunk without branches dies. Many may use it, but none will find rest in it. Is there a woman for your lodge yet, my son?"

Tecumseh knew his mother well enough to know that the soft words commanded a direct answer. "There is a woman for me."

Black Hoof reared her strong chin, her face warm with pleasure. "What is her clan? If she were among my people I would know."

"Her clan is not of the Civilized People," he said reluctantly. "They are Long Knives."

Black Hoof scowled in disbelief. Then almost instantly her brow cleared and she said, "Hannah. The grandchild of Spirit-Who-Cries. I should have known. Hm. You will cause many of your followers to turn from you, Tecumseh, if you take her for wife."

"I have not spoken to her of becoming my wife," he said.

The chief in Black Hoof gave way to the mother. Her heart turned at the pained shyness her son was allowing her to see.

"What if she would not have me?"

"*What?* Tecumseh! Think who you are. Not have you!"

"Other Long Knives could turn their faces from Hannah if she marries me." *Marries me. Marries me.* Suddenly Tecumseh smiled. "But I will ask her, Mother. It is not my destiny to be a trunk with no branches."

Chief Black Hoof smiled. "And I want to hold your son in my arms."

"Black Hoof," a male voice called from beyond the door.

She rose, "It is time for the clan to choose a new war leader," she told Tecumseh.

"Spirit-Who-Cries died the day my father died," said Tecumseh.

"The smoke brought the word." Black Hoof added after a moment's thought, "When our people lived at Pickawillany, she would come with Roebuck to visit my father. La Demoiselle loved her like a second daughter. How was she taken?"

Tecumseh shook his head. Who bothered with the way women met their deaths? He started to go with her. She gestured him back.

"You sleep, my son. You have chosen the Miami way of your grandfather. This matter concerns the Shawnee."

Gratefully Tecumseh stretched out on the soft furs. He felt himself drifting. Tecumseh had been living at Pickawillany, the home of his Miami grandfather, La Demoiselle, on the Upper Miami River, a town several days away from Little Shawnee Town, when the smoke signal had

brought word that Chief Little Turtle was dying. He had not slept more than a few hours since that time.

Many of the Miami at Pickawillany were making ready to go to Cincinnati for the funeral of Spirit-Who-Cries while he prepared to go to Little Shawnee Town. He freed his mind to drift to them, to picture the stir their colorful appearance caused and their plans to conceal their enjoyment of it. He imagined them wolfing the white people's food and ignoring the discourteous stares of the whites and the town Indians. He thought of them returning home and entertaining themselves exchanging derogatory tales about their hosts. And then the drums would commence, and the Miami would celebrate the passing of Spirit-Who-Cries with true respect.

Tecumseh avoided white towns when possible, possessed of a natural distrust of a people who lived so contrary to the ways of the Great Spirit. Still, if it had not been for Little Turtle's death, he would have gone. Hannah would have been there. He slept.

"Tecumseh. Tecumseh!"

Tecumseh awoke. Tall Tree was standing over him. His face was washed and his hair smooth and clean. "Chief Black Hoof calls you to the council house."

Tecumseh nodded. Groggily he followed Tall Tree out into the waning day.

A residue of death lingered in the stale air, mixing with the smoke of a dozen pipes. Black Hoof was the only woman in the council house. Surrounding her were twenty or more braves. Some of them Tecumseh recognized from last night's revels. Most of the others appeared to be elder statesmen. His mother stood as he entered.

Her face was shining with pride as she addressed him. "Welcome, my son. Tecumseh, you know the problems besetting our town. Do other councils face the same enemies? You live with the Miami. You have traveled to the Ottawas, the Delaware, the Potawatomi. Tell us, is it the same?"

Tecumseh's gaze traveled round the ring of serious faces: seamed faces of seasoned warriors, unlined faces of young and eager men like Tall Tree, who chafed for glory. He replied, "In towns where tribes have lost the civilized way and substituted the white men's way, it is the same."

"It is Motshee Monitoo! He is to blame," declared Tall Tree.

"Does Motshee Monitoo make the liquor? Does he throw an arm about your neck and force you to drink? Does he take back your manhood?"

"The whites have stolen our lands, Tecumseh! How can we get them back?"

Tecumseh shook his head. "I do not know. The white men's way is not the way of the Civilized People. Until we can throw off their way, we are helpless."

"Little Turtle signed the treaty. We are bound by honor to respect it."

"I do not believe that the Indian nations who signed the treaty can prosper under it."

Black Hoof broke in. "What can we do, Tecumseh?"

"We must appeal to the Great Spirit," declared Tall Tree.

A thunderous cloud of disapproval settled on Black Hoof's face at the interruption.

"Have the white people kept the treaty?" Reluctant nods. A small smile creased Tecumseh's face. "Then content yourselves with building up your strength. They will break it sooner or later. It is important that the Civilized Nations be not the ones to break the treaty. It would give them an excuse to demand more of us. Plant and harvest all that you can. Set your women to smoking meat. Guard your furs jealously, and sell them dear. Guns. Ammunition. Goods that endure. Not a skin for white men's liquor. Stay away from liquor. It robs the civilized man of his wit and strength. Forbid it in the town. The white men want what we have. Their eyes shine with greed for lands left to any nation. Give them no excuse to claim them."

His eyes went to his mother. "Be guided by your chief in this. Obey her. Stand with her to enforce these rules upon the cubs and colts."

Vigorous nods met his words. An elder leaned forward to speak. "To be a peace chief is an honor of blood. We must also have a war chief. We want you to be our war chief, Tecumseh. We will commit ourselves to obedience under you. Will you lead us?"

He smiled. "You honor me. I cannot stay among you now. I see other tribes faltering and falling before the march of the Long Knives. Pledge yourselves to me, and choose another to carry out my words. When the time comes, I will know that you are ready."

The councilmen glanced at each other. Small nods signaled approval. "We will accept your offer, Tecumseh. We will rededicate ourselves to the civilized way."

Tecumseh flashed them an approving smile. Through the red smoke, he met his mother's eyes and knew that she was pleased.

Tall Tree darted out of the council house ahead of him. Tecumseh

wondered if his friend was angry again. He hadn't long to wait. A small boy came and tugged on his hand.

"Tall Tree is in his house. You come."

Tecumseh felt for his knife, then remembered he'd left it in his mother's house. He followed the lad.

Tecumseh entered Tall Tree's house alone and gaped. His friend stood in the center of the room. Blood dripped from a dozen superficial slashes on his chest. His eyes were clear. They defied Tecumseh to speak. Tecumseh waited.

"I have rededicated my life to the Great Spirit," Tall Tree said. "I will never touch liquor again. I will live by the treaty, but never make the mistake of calling a Long Knife friend. I will go with you and be your slave. I saw a vision. I saw my destiny."

Tecumseh blew out a soft stream of air. "I have no need of a slave. I welcome you as my friend. I will be glad to have you with me."

The two men looked at each other. Tall Tree broke into a delighted, boyish smile.

"Get yourself attended to. We will leave in the morning."

Part II

Micah

10

"**R**emember that your stipend must last until you are established, Micah." Bishop Grundy gazed for a long period down at the straight, rust red hair slicked like a seaman's stocking cap over the head of the young newly ordained minister perched self-consciously on the stone bench in the quiet garden of the college of the Congregational Missionary Society on the outskirts of London.

The young man's hands were tucked under his bony posterior. *Sitting on his hands, literally,* Grundy thought. The man seemed to have no concept of what life would demand of him. Even the toes of his well-worn, polished shoes pointed at each other as if for solace, the bishop observed with an inward sigh.

"By the time that is gone, you should have expectations of being supported by your congregation."

"I know that," Micah stuttered in hasty agreement. It had been made clear enough. Any parson called by the Lord could do no less than the first ministers of the gospel, going out at Jesus' direction two by two, trusting as the birds and lilies in the beneficence of God.

Grundy shuddered to think what would become of the young man once he stepped off the boat in the colonies. Their blessed Lord certainly showed a sense of humor when he inspired Micah MacGowan to seek a calling in the ministry. He had been at the college five years. Grundy remembered when he had come. A tall, gangly youth of sixteen, the son of a poor clerk in a countinghouse. He had little of the charm of so many other young men who answered the call. Rather he reminded Grundy of a shivering puppy wagged by his own tail. Yet something about him—his earnestness, his ingenuousness, perhaps—warmed in others a protective instinct. Would that be enough to save him in the primitive wilderness of the colonies?

"Your ship docks in Baltimore. That is in the state of Maryland. If by chance your ship is delayed, or if you are not met, you are to walk to the parish church. I understand it is no more than four or five miles. I am assuming that you would not coddle yourself by hiring a trap to carry you there."

"Oh, no, Bishop Grundy." Micah smiled up at his superior with guile-

less blue eyes. His smile was quite nice. His lips were as freckled as the rest of his face, and his lashes and eyebrows were such a pale red they were nearly ash colored.

"Well, come along, lad. The president is expecting us to dine with him, this being your last night."

MacGowan got up with as much alacrity as on his first day there. He had shot up several inches since then, but seemed to keep the same weight, merely stretched thinner on his bones. Grundy, built as solidly as a bricklayer, worried anew about Micah.

When Micah MacGowan had first expressed the belief that his call was to the newly created United States, Grundy was not worried. The college routinely assigned young parsons to take their first two years abroad. It made them much more content with conditions as they found them in local parishes. No one doubted MacGowan's piety or his patience or his intelligence or willingness to serve. All admirable qualities for any young man of the cloth. And although MacGowan ate sparingly, Grundy had never known him to be ill. But he possessed an otherworldliness that was disconcerting.

"Disconcerting, it's downright frightening," was how the college president put it when Grundy confessed his fears that MacGowan was not cut out for the strenuous life required of a young country pastor. "Our Lord needs vigorous young men preaching the gospel."

The president of the Congregational Missionary College was waiting for them in his library, at ease in a deep leather armchair by the fire, when Grundy arrived with Micah in tow.

As the president greeted him, Micah recognized a familiar figure standing on the terrace. "Albert!"

"Micah!"

Albert came in through the open French windows. He was a stocky, ruddy-cheeked young man. "I could not believe it when our president said you were graduated, man." He crossed the room in three quick strides and pounded Micah's back in enthusiastic embrace.

"When did you get back?" The stutter was forgotten in the pleasure of seeing his old roommate again. "I'm to leave for the colonies myself tomorrow. I had been hoping I'd run into you there," he said almost shyly.

Albert laughed heartily. "Micah, old chap, 'there' is as big as England, Scotland, France, and Germany, with the Low Countries thrown in. A man could get swallowed in that wilderness and never turn up again. It's a grand place, but grander to be home!"

Grundy joined the president at the fireplace and smiled proudly at the

two young men. "Albert tells me he brought dozens of heathens to know our Lord."

"Did you?" said Micah. "I hope I shall do as well! Tell me about them. What do the heathens look like? Did they try to scalp you?"

"Here, let us share a glass of port, gentlemen, in honor of Micah's call and Albert's return. Hardly the prodigal, hey, Albert?"

Albert flashed a cocky grin at his eager audience. For the next hour he entertained them with a seasoned stock of tales, honed before audiences on stagecoach and shipboard.

Micah was entranced. "How could you bear to leave?"

"How? It's a matter of economics, old friend. The first few months it was enough to finally be preaching the gospel. You realize how poor those people are? Poor not in spirit, but in material possessions and in refinements of any sort. By my soul, 'tis like living in the Middle Ages. Worse: the Dark Ages. In England a civilized man can hear the most glorious music in the world and go to the theater for the most glorious language. In the colonies for amusement they play pranks upon one another and tell tall tales. The women work terribly hard and age young and die at an alarming rate. The men work hard, play hard, drink and swear too much. Satan is everywhere and God much hidden. Everything is—," Albert searched for the right words, "too much. Everything is too much. Too many different kinds of people, too many fights, too much land, too much water. And, yes, too much danger to life and limb. I saw a man gouge out the eye of another in a wrestling match. A wrestling match!"

"What a glorious field!" Micah cried enthusiastically.

"And not enough money from one end to the other to keep a parson from being a pauper," Albert said seriously.

His former teachers looked at him.

"They have a great fear of the Lord over there, but an even greater fear of those who carry the Word. Great care is taken to keep him powerless."

"*Powerless?* With God in command?"

"Aye," said Albert. He fixed Grundy with a reproving glance. "You might have told me this, sir. It does no good, either, that we have no bishops in America. A parson must look to England for every decision. Thus he is robbed of power both in the community and in his own church. An ambitious man must return to England if he is to rise at all."

Grundy caught his superior's eye and nodded his head slightly. They both knew that young men stuck in the colonies were just that—stuck. Every order had to come from England. There were no bishops there pur-

78

posely. English clerics could not control the policies of the church if men thousands of miles and months of traveling time away were empowered to make decisions. Few of the better men ever remained in the colonies. Second sons of good blood, disinherited from possessing their fathers' estates by the right of demesne, could do quite nicely for themselves after their return. Sought after as dinner partners and marriage partners, a well-favored young man could look forward to a good, comfortable career in the bosom of Mother Church.

Bishop Grundy said, "That will change in time, Albert."

"The war has been over for a dozen years. The Americans will never consent to give power to the church as long as her final authority rests in England."

"Hm," said Grundy. "Interesting. What do you think, Micah?"

Micah started. Men seldom asked his opinion. The slender, freckled hands cupping the bony knees rubbed the cloth thoughtfully. "Well, I never thought much about power, sir. A parson needs to carry out the will of God and not think about himself. Even in a foreign country, a parson needs zeal and faithfulness to his new town as well as to his own country. Wherever he is, he needs to bring Jesus Christ into the lives of the old, to comfort them, and to the young and rising generation, that they be not too much at liberty to live and do as they list."

Albert stared at Micah, then punched him affectionately on the arm.

Grundy felt tears start to his eyes. He wished Micah MacGowan was physically stronger. Shy though he often was, with occasional trouble articulating, Grundy knew that what God had given him was priceless: a clear vision of himself.

"You youngsters," the president was saying, "you go out with idealism and come back with realism."

"Ah," said Albert, with a gleam of mischief in his eyes, "our Micah will never be troubled with realism. Now, sir, tell me: How are you going to convince a man who hasn't seen a white face for a year that he must not use a savage to warm his bed, instead of finding a proper Christian wife?"

"Well, your worshipfulness," said Micah with a crooked grin, "I shall have to put him in the way of finding a desirable young lady."

"I can see a desirable young lady wanting a man with a year's worth of fleas and lice on his body!"

"Love conquers all," rejoined Micah.

Hearty laughter met his unexpected retort.

Grundy decided to get into the act. "Tell me how you plan to put the

fear of Satan and his legions in men when you can barely make yourself heard in the chapel."

"Perhaps I shall ask them to sing with me." His answer bordered upon the scandalous, and for a moment the president seemed to waver between reproving him and letting it pass.

"Tell me how you're going to prevail upon the farmers in the wilderness to come to church of a Sunday," said Albert, adding, "I never could!"

"If the men are as rough as you say, Albert, it is not me but their wives who will bring them. 'Tis women who civilize. But for my part I shall remind the goodmen that the Lord entrusted the souls of their children into the keeping of their parents. I fully expect the Lord to do his share," confided Micah.

"It is not the Lord I am worried about, Micah," Grundy said gently. "I expect you'll be as happy as the rest of them to come home when your tour of service is up."

"No, sir."

"I beg your pardon?"

"That will be home, sir. That is where the Lord will use me."

Albert's face lit with mischief. "If I were a betting man, I'd lay odds ye'll be having dinner at my table in three years' time!"

"Then you'd lose, my friend. If you want my company for dinner, you shall have to come back to the colonies. Er, America."

Micah could see that his words disturbed Grundy. But Micah was determined to travel to the farthest reaches of white society in America and put his roots there. That would be where the Lord lacked spokesmen! He had not confided quite all of his dream to his superiors. It was obvious they were worried enough about his constitution. And where was their trust in the Lord?

The Reverend Micah MacGowan stood at the rail of the *Calypso* as she moved slowly toward her mooring at Baltimore. All the way up the channel he had thrilled to the vibrant explosion of color from the trees. Eagerly he had scanned both sides of the shore for a glimpse of a real savage—wharves, docks, boats, dockhands, and now buildings and a wharf as busy as the one he had left in London four months ago. The air smelled sweetly fragrant, and the water was clear to an astonishing depth, no garbage or debris to scum its beauty. But no Indians.

Mentally Micah inventoried his luggage. One small trunk containing

his Bible and reference books and another of clothing: a Genevan pastoral gown, two stocks without lace, three bleached linen shirts, his pastoral wig, three pairs of black, woolen trousers, several pairs of black hose, several sets of smallclothes, handkerchiefs, his greatcoat, black shoes, and a pair of sturdy horsehide buskins that Albert had insisted he would need far more than formal shoes. Plenty of clothing for any man for two years. By then he should have a good-sized congregation, with plenty of parishioners handy with the needle and willing to make him new sets for a modest price.

He pictured himself behind a raised pulpit, the gleaming wood smelling of furniture oil, roomy enough to accommodate his Bible and the turned pages of his sermon. The seated congregation—the women with hands chastely folded, children scrubbed and suitably restrained, the men in dark suits, strong physical types needing his spiritual direction—so quiet that the crackle of logs in the stove at the rear could be heard . . . and outside birds would be singing. . . .

A sea gull keened, and Micah squinted up into the sun to watch it soar and dip over the harbor. His spirit soared with the bird, and his heart filled with joy. "Lord, I've come home!"

"Micah MacGowan? The new parson? Good heavens, lad, you mean to tell me you walked from the harbor?"

"It took less than an hour."

"But with your luggage—"

"Oh, this is all of it, sir. May I—"

"Goodness, yes, set it down, lad! I was not expecting you until day after tomorrow." Gratefully Micah lowered the two trunks from his shoulders and set them gently in the foyer. Andrew Lachlan drew Micah into his study. "If I did not know it already, I could guess you came from the missionary society college and that Bishop Grundy told you not to spend money so foolishly as to hire a trap."

Micah laughed. Lachlan grinned. He was of medium build, dressed not in a frockcoat as Micah had expected to find his host, but in a soft woolen vest over a well-washed muslin shirt with full sleeves and threadbare breeches. The seat was so shiny Micah was sure he glimpsed Lachlan's white smallclothes between the threads. From that he inferred that Parson Lachlan had no goodwife.

"It will be grand having an assistant! And someone to talk business with."

"But, sir, did they not write that I was going on?"

"Going on where? Isn't three thousand miles far enough?"

Micah grinned. "I believe it is a place called Losantiville, sir. Here, I have a map." The map crackled as he took it out of its oilskin envelope and smoothed it down over the top of Lachlan's littered desk.

Lachlan stared down at the map and then up at Micah in unfeigned astonishment. "Losantiville? I believe you are talking about Cincinnati. It was renamed a couple of years ago. What are they thinkin' of, over there? That is four hundred miles from here, down the Ohio River! You can't make it before the winter sets in."

"Then I shall go in the spring. Perhaps there is work around here needing doing, where a soul or two would not be sorry to see me coming."

"Plenty of work here. Why, so much that—"

MacGowan shook his head with a disarming smile. "I asked to be sent to a settlement where the Lord's people had no preacher."

"They have had preachers aplenty," Lachlan snorted. "Something about the frontier kills a man's natural piety. You will find them living no better than animals and not wanting to change. As if they fear to be reminded of their own sinfulness."

Micah's head bobbed in eager anticipation.

Lachlan groaned, "Oh, lad, there's Indian wars aplenty between here and there. They are likely to scalp you before you get within a hundred miles of Cincinnati."

"No, sir, that they will not do. I shall read to them from the Word, and they will not harm me. Our people in Sin—"

"Cincinnati."

"Cincinnati—have a right to the gospel, and the gospel they shall have."

"And does Bishop Grundy expect you to walk there, too?"

"I have some money."

"Lord save you, I've hurt your feelings. Well, young man, have a seat. Lettie!" When his housekeeper appeared, Lachlan said, "Take up part of the ashes from the chimney hearth and relight the fire. 'Tis chilly in here. Then we'll take a dish of tea."

While she busied herself, Lachlan studied his young visitor. He himself was a man with few illusions regarding the goodness of his fellow man, for which revealed truth he found solace more and more often in something stronger than tea. "Lad, this talk has given me a thirst. Perhaps a sip of wine to celebrate your safe arrival would not be amiss. Tell me about London. . . ."

11

"Oh, Mama, look, isn't it pretty?" Hannah swirled around her bedroom for her mother's benefit. They had just gotten back from Aunt Rosalind's shop. This time both had dresses made from patterns in the *Lady's Magazine,* Rosalind's much thumbed fashion journal from London. Hannah's was yellow linen, with fine piping of brown velvet scrolled across the shoulders and the bodice. The waist line was elevated, the skirt narrow and clinging. "It looks just like the picture. I feel like a different person, I feel so elegant. Try yours on."

Faith laughed, sounding suddenly younger to Hannah. "Sunday will be time enough. It is going to be nearly impossible to keep our dresses clean, living where we do. You look all grown up, Hannah. . . . But the neckline is a little low," she decided, contemplating the gentle swell of creamy skin.

"No, it isn't, Mama! See? I'll wear the scarf." Deftly Hannah snatched the ruffled gauze scarf of matching yellow and tied it around her shoulders in the "pouter pigeon" style demonstrated in the magazine. "See?"

Faith laughed. "You're right. Maybe we should have bought you that bonnet. It suited the dress."

"The brown silk one, with the taffeta gathers under the brim? Can we afford it? Aunt Rosalind said she copied it exactly from the Paris plate."

Faith grew pensive. "A farm wife has little need for such fine clothes. . . . Oh, let's do!"

"Good! I don't want to marry a farmer anyway. I want to live in town. I want to do things. I could work for my keep—perhaps Mr. Fenn would hire me. I think Aunt Rosalind would let me board with her."

"No one in our family has—"

"What was that?" William Roebuck came upstairs in time to hear his daughter's last remark. His dark hair was plastered to his head. He stripped off his shirt and used it to swipe at his hair and the sweat-soaked neckband of his long underwear.

"Well, aren't you pretty as a sunrise!" he said to Hannah. He grinned at his wife, cocking his head toward their daughter. "All grown up. . . . Need fresh towel in the washhouse, Ma," he told Faith. She nodded. Although

he had now a dozen men, in addition to his five sons, working for him in harvest season, he himself worked as hard as any.

"Now, what's this about boarding out?"

"Hannah wants to find shop work in town," said Faith reluctantly, flashing her daughter a look of chagrin at being obliged to reveal a confidence.

"Our Hannah would lower herself to being a shopgirl?" He laughed with disbelief. "A fine father I would be."

"Fenn's is a respectable place," Hannah said in a hopeful tone. "Or I could do some kind of piecework and earn my keep at Aunt Rosalind's that way. I could—I could ask the barber to teach me how to dress wigs. He doesn't look like he enjoys it much, and I—"

"Hannah!" said William sharply. "Is this how you honor your father? What sort of man would allow his daughter to leave home without the protection of a husband? Who has been putting these ideas in your head? Was it your aunt Rosalind? Hm. Be like her. She always did have chicken fluff for brains." He handed his grimy shirt to Faith without taking his eyes from his daughter.

"Why is it all right for Aunt Rosalind to work and not me?"

"Because she is widowed. Be a insult otherwise."

Hannah cocked her head, trying to make sense of her father's words. "Pa, I'm not trying to be sassy, but how would it be an insult for Rosalind to work if she weren't widowed?"

"Well, folks are of two minds about that. If her husband's ablebodied and forcin' his wife to work for a living, he ain't takin' proper care of her. And if he *is* takin' proper care of her, and she *still* works, she's shaming him."

Hannah looked at him strangely and then glanced at her mother. Faith had turned her back and was folding the tissue Hannah's dress had been packed in. She seldom intervened when William "instructed" the children, as he called it. She would get no support from that quarter. "Pa, I'm so sick and tired of shoes that are always getting caked with mud and dresses that you can't *keep* out of the dirt, and *just once* I'd like for this family to be dressed up when it wasn't Sunday! I'll not *ever* marry a farmer."

Faith's hands stilled, but she did not turn around.

William's eyes brightened with anger. "I don't rec'lect anyone asking for you! Farmer not good enough for you? Shame upon you, Hannah Roebuck. I never thought I'd see the day when my own daughter was ashamed of her father. Our Lord reverenced the soil. It's how he taught

84

folks how to treat each other, telling them about tilling and harvesting. But it's not good enough for you."

Hannah recognized the hurt in her father's voice. "I am not ashamed of you, Father. I'm not ashamed of any of my family. But you keep telling us how good we have it, and it looks to me like everyone in town has it easier than we do! You call shop work shameful, but Mama and I have been working all week at the butchering, just as hard as you."

Out of the corner of her eye, Hannah saw Faith nod. After the men butchered the hogs, she and her mother had struggled to cut up the huge sides of meat, grinding, slicing, drying or salting it down, preparing the bacon and hams for the smokehouse, rendering the fat for lard, washing out the intestines to make casings for sausage, and a myriad other chores, until by last night she was hardly able to lift her arms. Tomorrow would be Sunday. Monday they would start in again, using part of the lard and leaching ashes to make soap.

Hannah took a deep breath and plunged ahead recklessly, "Far as I can see, Mama works all the time. Harder than Aunt Rosalind. Even if Aunt doesn't have a man to look after her."

"That's enough, Hannah!" William roared.

Suddenly Faith turned and laid a hand on William's arm. "Hannah, when I came to the Territories with your father, we did it all without any hands to help."

William covered her hand with his. "You got a way to go to be the woman your ma is. In twenty years, she never complained. It's not like you got to work in the field."

Hannah lowered her eyes. She *had* hurt him. But he couldn't see how she was feeling. He couldn't see it at all.

"Times was, William Roebuck, you were glad enough for my help in the field!" Faith's voice was light and soothing, like cream.

How could her mother act that way? Before her father came in, she knew her mother had understood how she was feeling—she had felt her sympathy. In dumb wonder Hannah caught the look of understanding passing between them. She would never understand parents.

"Well," William went on in a somewhat mollified tone, "no daughter of mine is going to work in town. It isn't fitting."

"You and Mama take care of each other, and Aunt Rosalind doesn't have a soul, and Mama still works harder than Aunt Rosalind!" she repeated stubbornly to the braided rug on the floor.

"Hannah, Satan has been whispering in your ear. Mother, what started this? What more could a girl want than what she has right here?"

85

"I just want to live in town, Pa, where there's boards to walk on, and you don't get your slippers full of dust or mud the minute you set foot out the door, and folks drop in on each other, and there's things to do—"

"Why, honey, we see folks on Sunday. And you've got your brothers— it's beyond me what it is you are saying, Hannah! It would not be fitting for a young lady of good family to be prancing about on the streets of Cincinnati. That settles it."

"Well, I don't want to be a farmwife!"

"I've a mind to send you away from here, to some school!"

"Papa, would you?"

"You would want to go?"

"Oh, yes!"

"But, Hannah!" said her mother. "It would be so lonely without you!"

William looked at his wife strangely. "We'll say no more about it now, Hannah."

That night in bed, William turned to Faith. "Are you sleeping?"

"No. Thinking."

"About Hannah?"

"Yes."

"Did you mean what you said?"

"What about, dear?"

"About—about being lonely."

"Well, I suppose I did, I didn't really think about it."

"Were you lonely when I brought you here?"

Faith turned toward him. In the darkness he felt her warm hand find his shoulder and chest in a loving caress. His nostrils filled with the warm scent of her and the whipped glycerin and rosewater concoction she wore on her face and throat and arms at night. "I was a city girl, remember. Boston is a long way from the Northwest Territories."

He felt a coldness inside, an eroding sense of betrayal that she had never let on her true feelings and of defeat because he had never even considered the enormous change that he had required of her, bringing her to this vast, dangerous land.

"I grew up here," he said.

"You never knew any other kind of life."

"No, I didn't. Never thought about it. Never thought much about what a city girl would make of it. . . . You make sense of what Hannah's driving at?"

"Yes. And dear, it has nothing to do with not loving her family. But I don't think we should send her to school in the east."

"You don't?" he said in a relieved tone.

He felt her head shake on the pillow. "Remember years ago when Harmon wanted to go east and study for the ministry? The twins were twelve, I think."

"Well?"

"Well, that would have been the proper time then, Will, for both of them. Now, it's too late. It's time Hannah was getting married. And it is not as though she is uneducated. She reads and writes well and knows her catechism. She even knows some French, thanks to that immigrant family from Le Havre. She would not fit in with those younger girls, who are at school to learn beautiful manners and penmanship and music and how to paint watercolors."

"Now hold on. Our Hannah is as good as anybody! She is strong and virtuous. A man would be a fool not to see that. And a sight prettier than any girl in town. You tell me—"

Unexpectedly his wife giggled and wrapped her arms around his lean body. "Of course she is! What I'm saying is she's a frontier girl. I am not sure that people back east, young ladies and gentlemen in particular, would admire what we love best about Hannah. In my day, men loved virtuous women more in the absence."

"Faith!"

"Oh, come, Will." Her voice took on a dreamy quality. "Men back then loved coyness and a dainty foot and dancing ability."

"Hannah can learn."

"You are missing the point. I don't think that is what she wants."

"That's what she said she wants."

"It would not fit her to be the wife of a frontier farmer, nor of a shopkeeper. Of course, she wouldn't have to go to school. She could visit my people in Boston. They would love to have her. . . ."

"Hm."

"I worry about Hannah. She thinks the world is such a good place."

"Well, it is, Ma."

"She might marry someone back there and never come home to us."

"I swear, Faith, boys are not half as hard to rear."

"Why don't we let her stay in town with Rosalind? Rosalind will take good care of her. Probably within six months she'll have it out of her system and let young Peter Ruskin court her properly."

"Peter *Ruskin?*"

"Didn't you know? Why he's been in love with her for a year!"

Peter Ruskin! The only image that came to William Roebuck's mind

87

was of a plump, short youth in an ill-fitting black suit. He always managed to be sitting behind them in Sunday-school meeting. Never had an intelligent thing to say, he remembered. William sighed. "We'll do what you think best, Faith."

As he drifted to sleep an image of Faith crossed William's mind, Faith as he had first seen her in the Boston Mariner's Club, eating supper with her father. She was so sweetly appealing, so young and fresh, in a delectable white silk dress with lace insets and a matching taffeta bonnet. And she had married him and come out to this. . . .

12

"Trapping, huh? Well, that's just fine, Harmon. What does your pa think about it?"

"He's not too keen on it, Mr. Fenn. I think he figures I'll get lost and not be home in time to go downriver with the new schooner. I'm just going for a few weeks."

Fenn was a short, merry man who walked with a quick, lopsided stride. He had lost his right arm in the War for Independence, and the resulting loss of balance had produced a compensating gait.

"How soon you leaving?" Fenn grunted as he heaved two blankets on the counter, next to a supply of dried foodstuffs.

"Within a week. Got some chores to finish up for my folks."

"Saw Hannah pass by the door a few minutes ago with your folks. She didn't look none too happy."

"She ain't, Mr. Fenn," Harmon rubbed his slender jaw as he thought about it. Then his brown eyes began to gleam again as he said, "But she's going to be moving into town soon, to stay with Aunt Rosalind."

Fenn nodded. "She'll have swains swarming 'round the place, won't be time to miss the likes o' you."

Harmon laughed, liking Fenn enormously for having said that. Fenn always had a way of saying the right thing, whether true or not. His words relieved Harmon's feelings of guilt at leaving Hannah. "God's truth. But we're going to miss each other, no two ways about it."

"Something about twins does that to 'em. Where you going out of?"

"I was going to just take my horse and mule and head out from here."

Fenn scratched his jaw. "These mountains are so populated they say you got to go west of Saint Louis to get enough good furs to make a living. There's this Spaniard by name of Lisa putting together a party to go up the Mississippi. They say independent trappers can hook up with him."

"That sounds like a fine idea. Mebbe I'll do that next year."

Fenn glanced aside, and a warm grin split his pleasant face. "How do, Miss Roebuck."

"Good afternoon, Mr. Fenn." Hannah looked radiant in a fine cotton dress of raspberry red that set off her dark hair. Black braid edged the

high collar and yoke and the hem. Her skin was the hue and texture of pale maple syrup with berry-splashed cheeks.

"Ah, if I was twenty years younger, Miss Roebuck. You are pretty as a sunset. What you call that color?"

"This?" Hannah looked down and smoothed the skirts of her dress with shy pleasure. "Raspberry." The full-cut bodice was meant to conceal her womanly curves, but with her high color, radiant good health, and sparkling brown eyes, the effect was the opposite.

"Raspberry. It's enough to sink a man."

"Thank you, sir!" She dropped a saucy curtsy, and Harmon's eyes gleamed with affection.

"I guess you ain't going to miss me too much. Where's Ma and Pa?"

"They headed back." Hannah trailed a gloved finger along some bolts of cloth laid on the counter. "Peter Ruskin offered to drop you and me off. He is taking a boatload of lumber down to a new place that's going up beyond our farm." She looked everywhere but at Harmon. Harmon had become a terrific tease lately. Her gloved hand went to her nape, found an errant strand of glossy hair, and tucked it back into the prim, heavy bun at the back of her head, a completely unconscious gesture, as if to reassure herself that she was indeed grown up.

"Hear you are going to be staying with your aunt Rosalind for a spell, Miss Roebuck. Kinda lonesome out on a farm, pretty young gal with a houseful of rowdy brothers."

Hannah wasn't sure how to answer that, so she said merely, "I hope to find a job in town, Mr. Fenn."

"You'll do fine, Miss Roebuck. Always was smarter by half than other kids."

Hannah warmed with pleasure. "Thank you, sir."

"If you run into any trouble, I'll come arunning," Fenn promised. "Don't know as I could do much with only one wing. P'raps I'd better send Mrs. Fenn. She'll be back in a week or two from visiting her sister in Charleston."

The three laughed at the image that presented. Small of stature, but mighty of tongue, Mrs. Fenn had earned a hefty reputation when she once shooed out a crowd of rowdies twice her size.

"You won't need help, Hannah," said Harmon. "The Lord will look after you."

Hannah reached for his hand and squeezed it. "You, too," she said tremulously.

"Come on, let's go down to the dock and see if Ruskin is ready to leave.

Sure was a coincidence, him having to go right by our place like that."
Harmon teased, looking everywhere but at his sister. "So long, Mr.
Fenn."

Fenn called after them, "When you are settled, Miss Roebuck, you
must come by for coffee and cookies."

"Thank you," said Hannah. She glanced at Harmon, and they both
burst out laughing. Persy Fenn was famous for her "teas." She baked ex-
cellent rye and Indian breads, but served coffee that tasted like syrup of
soot and essence of old shoes.

When Harmon and Hannah came out of Fenn's Mercantile, the Miami
Swallowtail was standing unsteadily against the hitching rail. One end of
his flannel shirt was tucked into a pair of jeans, the top button of which
was missing. A triangle of pale pink-russet skin bulged in the gap. From
the size of his belly, it seemed evident that Swallowtail spent more time
eating and drinking than working.

"Hiya."

Harmon nodded a curt greeting.

"Good afternoon, Swallowtail," said Hannah.

"I hear. . . . I hear you going to be living in town, Hannah." His heavy-
lidded eyes focused somewhere near her waist. Mebbe I'll come to see
ya."

"I wouldn't," said Harmon.

Swallowtail shrugged. His body swung back and forth, his legs braced
as if he were on shipboard. "But you ain't gonna be here, hear tell."

"You're drunk, Swallowtail. Better go sleep it off. And she's *Miss Roe-
buck* to you."

"She's *Hannah* to Tecumseh, she's *Hannah* to me." Swallowtail's palm
went in a flat caress to the bone hilt of the knife stuck in his jeans.

Hannah reached instinctively for her brother's arm.

"If I hear you ever bother my sister, I'll come and kill you."

Swallowtail muttered something.

"What?" demanded Harmon.

"You wouldn't say that to Tecumseh. Bet y'din' know Tecumseh's
back in the territory."

Hannah's heart did flip-flops.

"You say." Harmon started on.

Hannah held back. "Is he really, Swallowtail? You're not just teasing?"

"It's a sin to lie, Swallowtail," said Harmon.

"They had a fight."

"Who did?"

"Tecumseh and them that give up the hunting lands. Some of 'em didn't want to stay with the Shawnee. They wanted to be free, like me."

"Where are they?" asked Hannah. Harmon scowled. She felt his tug on her arm.

"Pro'ly back at the old camp."

"The Miami camp upriver of Fort Washington?"

"Yeah." Swallowtail stared hard at Hannah. Behind the little eyes an idea seemed to be formulating. He turned and lumbered away.

"Come on, Hannah."

Something about Swallowtail had always made her uneasy, even though she pitied him, too. All the town Indians. They were despised alike by tribal Indians and townspeople. She and Harmon had discussed it two years ago, after she told him about Swallowtail intercepting her in town that day.

"I think it's because they want to be like white folks, but just aren't," Hannah had said.

"Not it at all," scoffed Harmon. "Town Indians want reg'lar Indians to treat 'em as if they was respected citizens, only they don't want to work as hard as we do, and they want us to treat 'em as if they was proud Indian folk, only they don't want to take the responsibilities of proud Indian folk."

Hannah had looked upon her brother with amazement at how he had figured this out and had never forgotten his explanation.

An hour later Peter Ruskin was handing Hannah proudly aboard a solidly built flatboat with the words *Ruskin & Son* painted in block lettering just under the lip of the deck. Harmon stowed his gear on a wooden pallet in the stern. Most of the deck was taken up with long planks of white and black oak, stacked four feet high and ten feet across.

Ruskin had shot up, distributing his bulk over another twelve inches from the days he used to sit behind the Roebucks in Sunday meetings and furtively tease Hannah by trailing a feather across the back of her neck. Solidly built still, but no longer plump, Peter was ruggedly good-looking and looked at Hannah with helplessly dogged affection. His passion for her was the town's worst-kept secret.

Only Hannah seemed not to notice. "Thank you, Peter," she said as she stepped aboard. The freshly cut lumber gave off a rich, fragrant scent. She looked about for a place to sit, eager to begin the beautiful, peaceful float. This stretch of the Ohio, between town and their farm, with its gentle hilliness and clumps of full-leafed trees was, she suspected, one of the

most beautiful spots on the Lord's earth. No wonder the old French explorers had called their river *La Belle Riviere.* Hannah inhaled deeply and sighed contentedly. She started to sit on a shorter stack of lumber. "Careful!" Peter climbed over to her and seized her elbow. He started to say something, and then his tongue betrayed him again and turned as dry as walnut shells, while the old familiar, painful flush crept over his face. Inwardly cursing, Peter could only point to the wood where she nearly had sat. Sap oozed from a dozen fresh cuts.

Harmon came over and looked, too. "They gonna use unseasoned lumber to build, Peter?"

As long as he looked at Harmon, Peter found he could manage to sound halfway normal. "Pa and I both told 'em they ought to let the wood season a year, or they'd end up with a warped house, but they are a bunch o' greenhorns from Philadelphia. They act like fine clothes gives 'em brains."

"Well, isn't that ridiculous, Peter," said Hannah. "You've been living here all your life. They ought to know enough to take your advice."

"Pa's, anyway," agreed Peter. "Here, this ought to keep the resin off your skirts, Hannah." He threw a piece of canvas over the lumber and helped her sit, not noticing that he was conversing with her as if she were just an ordinary person. "Cast off, Bunty."

Harmon went over to lend a hand with the painter.

Peter Ruskin's poleman, Bunty, was well-known to the community. A young man in his early twenties, with wispy yellow-white hair, he struggled by with only minimal intelligence, but he had carved a niche for himself with his job on the flatboat and was appreciated by all who knew him for his unfailing cheer and dependability.

"How is the mill doing?" Hannah asked, noticing for the first time what a really fine looking young man Peter Ruskin was. His nankeens were clean and fairly new, his shirt pressed and tucked in behind the suspenders. How had she not noticed before how broad his shoulders were and how easily he moved across the deck of this boat as he looped rope and took the other pole?

"We can't keep up with the orders," his voice rose as he called back to her over his shoulder. "That's why the fellers downriver of you took green. Didn't want to wait another season to build."

Hannah nodded. The flatboat creaked as it eased away from the dock. Bunty struck up a conversation with Harmon as he and Peter poled them skillfully out into the current. "If I's goin' trapping like you, I'd get me a

outfit like them Miami wore. All shiny with quills and feathers and all."

Hannah laughed at the image of Bunty barreling through the woods, flashing and clacking. "You'd scare the animals."

"You stick to fishing, Bunty," added Harmon. "You're about as good a fisherman as we got around here."

A grin split Bunty's face as he acknowledged the truth of that.

By river, it took slightly more time to return to the Roebuck farm than by horseback. The current was fast and sluggish by turn, depending on the bends and depths of the river. Skillfully they poled out into the channel, while avoiding the swifter passages of the current.

Suddenly Harmon glanced toward shore. They were in a heavily wooded stretch where the curving channel cut deeply toward the near shore. Bunty was poling not far off shore on the near side of the bow as Peter worked the stern.

"Did you hear something, Harmon?"

"Thought I did. Somebody calling."

Hannah stood with the men and listened. She could see no one.

"Mr. Roebuck!" This time it was unmistakable.

"Yes!" Harmon shouted. "I'm Mr. Roebuck. What is it?"

". . . An accident!"

Hannah gasped.

"What?" yelled Harmon. "Get closer, Bunty."

"This ain't a good place, Harmon. It's too—," Bunty glanced at Peter. "Get closer!"

Peter Ruskin waved for them to go closer. Bunty poled in toward the shore. Brush and debris littered the shoreline. Dense, overhanging branches prevented them from seeing any part of the road.

Hannah felt suddenly afraid. This stretch was particularly isolated. "Harmon, let's go on."

"That's a good idea, Harmon," said Peter. "Bunty—"

"Mr. Roebuck!" came the voice, clearer now. "Your folks had an accident! Can you make shore?"

"Coming!" shouted Harmon. "There, Bunty, pole in there!" Over Peter's protests, Harmon seized a third pole from the deck and shoved it into the mud to help guide the awkward craft in among the eddies. He caught at a branch and pulled them closer.

"I don't think. . . ." Suddenly an arrow whizzed through the air, and Bunty shrieked.

Hannah saw in shocked disbelief that the arrow had pierced his chest. She screamed as eight or nine Indians, in the strangest war paint she had

ever seen, rose simultaneously out of the bushes and began wading and leaping over deadwood toward them.

"Harmon! Peter!" She wrenched Bunty's pole out of his failing grip and tried to help push the boat out into the river. An Indian seized the other end of her pole. She let it go with a shrill cry of terror as though it burned her hands. The Indians caught the edge of the boat and began to haul it into shore.

Harmon screamed. Hannah whirled. To her horror she saw that his body was punctured by arrows. She stumbled over Bunty and threw herself in front of her brother's body, trying to shield him. "Get away," he moaned. "Run! Peter, take Hannah! Run!"

Using his pole as a staff, Peter sprinted atop the stack of lumber and began flailing at the attackers with both ends.

The boat tilted toward the upstream side, and water gushed over the deck. Hannah looked up into a heavy, sweating, painted face just as a heavy tarpaulin dropped over her head. In her panic, all she could think was, it was Swallowtail. *Swallowtail has killed my brother. Swallowtail.*

13

Hannah would have been grateful to lose consciousness. She sat inside the stifling, sour-smelling tarpaulin, with her arms bound at her sides by the cords that fastened the tarpaulin around her waist. She realized that her hands were free below the elbow. Tentatively she felt her skirts and tugged them well down over her drawn-up legs. She felt the rough, splintery surface of the deck. She was sitting on the deck. She dared not explore any more, she did not want to call attention to herself. She listened to the raucous laughter of the exulting Indians. They had evidently commandeered the flatboat. When her panic rose, she fought to control it by listening to their words, trying to make sense of the pidgin English and the silences. They must have liquor, she realized with new horror as their laughter grew increasingly boisterous.

Were Harmon and Bunty and Peter still on board? Had they been left ashore? She pushed down the image of their helpless bodies being rolled overboard. She prayed with ferocious intensity to God for the life of her brother and for Peter and Bunty. Almost in the same breath she vowed that if it took her last breath she would kill Swallowtail.

She believed they were continuing the course downstream. Oh, the audacity! She pictured them careening right past her own home! It ought to be just about now. They had been attacked less than a quarter of the way downriver.

Without thinking, Hannah scrambled to her feet and tried to jump overboard. Someone shouted. Arms seized her. She screamed with all the fury she possessed. A flurry of Miami commands hissed around her. Hands grabbed at her head. She struggled to keep her mouth free. Again and again she screamed. Suddenly she was lifted off her feet and thrown to the deck. Her head was pushed into the river. Hands clamped around her legs. She struggled, but she was being held underwater! She understood. With a great effort she forced herself to stop thrashing. Almost immediately she was hauled back aboard. She lay on the deck, gasping for air.

"That's better," said a voice. "Through hollering?" She nodded, forgetting that they could not see her nod. "Are you?" the voice demanded.

"Yes." She had no doubt at all that it was Swallowtail's voice and that the other Indians were the rest of his no-good friends. The knowledge somehow comforted her. She knew Swallowtail would not kill her. *Oh, no? But he had killed . . . no.* She would not think about that. What were they going to do with her? *Money. Ransom.* But if her brother was dead, he could not let her go . . . *Tecumseh.* Wherever he was, if he knew—when he knew—he would find her. *Tecumseh.* She would think of Tecumseh. How would she get word to him? From that moment she resolved to escape.

Hours must have passed. Hannah huddled, cramped and wet, in her canvas prison. After her attempt to jump overboard, they had bound her wrists and ankles. The early summer air, passing through the wet canvas, chilled her to the bone. Gradually the thick umber light inside her prison congealed to black. Nightfall. The voices grew subdued.

Then the raft bumped the edge of something, and she was being pulled to her feet. The muscles of her limbs were so cramped that she fell. Someone picked her up and tossed her over his shoulder like a sack of grain.

Soon she was set on her feet, not ungently. She felt them untying the canvas. A great rush of fresh air swept over her, and she drew in a deep breath. Her captors were behind her. She caught an image of murky bushes, the flatboat still loaded, the painter leading from it to some point behind her, and a dry patch of earth beneath her feet. Then a blindfold was tied over her eyes. She said, "Swallowtail, wait."

There was a pause. Evidently they had not known that Hannah had recognized him.

"Well?" said a voice.

"Where's my brother? Where're Bunty and Peter Ruskin?" She heard some muttering. No one answered her. "Are they alive?" In spite of her efforts to remain calm, her voice spiraled up in shrill fear.

"No questions."

Sick at heart, having lived through hours of horror, Hannah now found herself having to acknowledge a bodily need before these runagates. It was more humiliating than she would have thought possible. "I need to relieve myself."

She heard momentary shuffling and whispers. Her hands were freed, then retied in front of her. She felt a noose being looped around the high neck of her dress. "I got a length of rope tied to your hands. 'Nother one round your neck. You try to get either one off, I'll kill you. Understand?"

With her head lowered and her cheeks burning, she nodded. "And don't touch the blindfold neither. You can go behind them bushes." Hands turned her shoulders in the proper direction and gave her a shove.

Later, sitting with her back to the bole of a tree, Hannah heard a fire crackling and imagined she could feel its warmth. She realized she was shivering. Someone dropped a blanket across her shoulders, and she felt heartened. They must mean to return her home, if they cared that she not take cold. Her hands had been left tied in front, "Only as long as you don't touch the blindfold," she had been warned. The loop around her neck pulled when she leaned forward. She imagined it fastened to a limb above her.

The smell of singeing hair made her shudder. Sometime later it was replaced by the aroma of roasting meat, reminding her that she had not eaten since she and Harmon and their parents had left the farm after breakfast. Tears spurted into her eyes and were absorbed by the blindfold, and the smell of the meat cooking made her feel nauseous.

"Eat this." Swallowtail took her hands and opened them to receive a broad leaf filled with something hot. She dropped it on the ground and gagged. She knew Swallowtail was still crouched near her. She could see or rather feel his shadow before the firelight and smell the fetidness of his body. She sensed his anger in the silence. He rose and barked a command. Someone else came and placed a gourd in her hand, with the Miami word for *water*. She nodded and drank thirstily.

When the Indians had eaten, she heard them preparing to sleep. Her hands were untied, and she was filled with fear. Her prayers flew to God to protect her. She was ordered to lie down. When she did not move, the command was repeated more sharply. Biting her lip to keep from giving in to her fear, she did as she was told and found that she was crouching on a blanket, not the bare ground. She felt her skirts being pulled down and tucked around her ankles. At another command, someone unlaced and removed her shoes and took them away. After another coarse word, she heard quiet laughter. Then another blanket was thrown over her. Her arms were drawn apart, out from each side. Then her captors seemed to be finished with her. Furtive tugs confirmed that her wrists were tied in that position. By the sudden plunge into blackness she knew the fire had been extinguished or banked, and she was left alone with her thoughts. Like a pool of rainwater settling into the deepest part of a glade, her thoughts assembled around her family. The pain in her chest was too great to bear, and she tried to stop the thoughts. *The Lord is my shepherd,*

she repeated, *I shall not want. He maketh me to lie down in green pastures. . . .* She was asleep.

Hannah awoke just before dawn. A pale gray mist hovered just off the ground. She was lying under a hickory nut tree. Looking up into the still, leafy canopy, she caught a quick flurry of movement as two mockingbirds flitted from branch to branch. A squirrel dashed down the trunk to within four feet of her eyes. They stared at each other a moment, then he vanished around the back side of the trunk. She smiled and tried to move her cold, aching arms. Suddenly she realized where she was. And that she could see. Lifting her head slightly, she noticed the handkerchief that had evidently been her blindfold was crumpled under her hair.

She became aware of a quiet, raspy sound. Her eyes fell on Swallowtail. He was sleeping beside her, flat on his back, with his pudgy, copper-gray hands resting loosely on his ample stomach. His nose jutted up, his mouth was open. Swallowing a gasp of fear, she strained to raise her head far enough to see around her. On her other side, another town Indian, a year or two younger than Swallowtail she guessed, was also sleeping. Cords led from her numb wrists, under the bedrolls of each man. She saw several others sleeping in various poses around the camp. She could see the white ashes of the fire pit. Beyond that, an outer corner of the flatboat bobbing gently with the current. Perhaps her wrists weren't tied to anything. Gently she applied pressure against the cords. There was slack! Hardly daring to breathe, she pulled again, so slowly. Hope sprang in her breast. Once she was free, she had only to follow the river upstream, and she would be home again. Inching the cords out from under the sleeping men, Hannah finally brought her hands together and tore with shaking fingers at the knots binding her wrists. She was free!

Gathering her knees under her, she scrambled to her feet. Suddenly a cord that was around her neck was yanked viciously, bringing her down again. All at once the camp came alive as men tumbled out of their sleeping poses and grabbed their sides with laughter. Swallowtail was beside himself with glee. Dancing up and down, he pointed to her, gesticulated to his friends, and then went off again into gales of laughter.

Howling with pain and rage, Hannah tore at the cord around her throat. She could hardly breathe. It felt as if a potato were lodged against her windpipe. Even with the noose loosened she could manage to breathe only in sharp gasps. Through her tears she shot murderous glances at Swallowtail.

Swallowtail read the look and grinned. He came over to stand above

her as two of the young Indians began to prepare a cold breakfast. "Hungry?"

How could you, Swallowtail? she tried to say. Only a gutteral croak escaped her lips.

He read the reproach in her eyes and scowled angrily. "You promise you no try to escape again."

She shook her head.

"You like blindfold?" he threatened.

She looked aside.

Swallowtail padded away. After a glance to see that he had her attention, he picked up her shoes and flung them out over the river. An ugly smile curled his lips. "You eat. We talk."

As much as Hannah would have liked to refuse food again, she was famished. *It does no good to let myself grow weak,* she consoled herself as she accepted a flat, stale hunk of Indian cake and a cold joint of the small animal they had roasted last night. It was probably raccoon, she decided, tearing at the stringy, half-raw meat and forcing it down her injured throat.

She had to learn what they intended to do with her. They had not retied her. When she had finished eating, they permitted her to see to her needs and to wash her face and arms at the edge of the river. As she did so, she could feel their eyes drilling her back. Hoping she would try to run away again? Like a rabbit trying to dodge the fox? As she splashed water over her face and smoothed down her tangled hair, she was busy thinking. If she could manage to tear off a strip from the bottom on her dress and leave it where someone might find it. . . . Her eyes darted about. The rush crate that had held Harmon's trapping supplies was still on the flatboat, wedged between stacks of lumber. They had apparently rifled the supplies and left it there. A rush basket like Moses'. Hardly heavy enough to support the weight of a woman, even if she could manage to push it overboard and hide inside. She would have to think about it more.

"Come!" shouted Swallowtail impatiently.

Still with no plan in mind, she turned back to the camp.

"You sit here with me," he told her.

He must be made to think she was compliant. She sat where he pointed, tucking her legs under her. Her new dress. The beautiful raspberry cotton was streaked and caked with mud. Swallowtail was still eating, an unpleasant sight. She glanced around at the others. One brave had just cut a green limb from the hickory tree. His knife was a beautiful broad-bladed one with a brass handle. Of course she recognized it. It was

Harmon's, given him on their last birthday, by their father. It didn't mean anything. The man probably stole it while Harmon was unconscious. She scrutinized him more closely. Tall, consumptive looking. He had a gray pallor despite the fact he looked no more than thirty. His face had a mean, pinched look. She had yet to see him smile or even say more than a word or two. She watched while he expertly trimmed the branches and peeled the bark. Then he bent the green wood into a hoop about six inches in diameter and fastened it with the bark.

He took an awl from a pouch at his waist and proceeded to punch holes in a small, brown, furry object in his lap. She watched as he tied the fur inside the hoop, stretching it taut. One side had no fur and looked pink and fatty. Shaking out the long fur, the brave bent over it and carefully began to scrape the inside with his knife. Suddenly Hannah gasped. That was a scalp!

"O God, God!" she croaked. "No!" She covered her face with her hands and bent forward into her lap and sobbed.

Through her horror came Swallowtail's voice. "That not Harmon, Hannah. I good friend. Just need money."

"What are you going to do with me?" she sobbed. *Harmon! Harmon!*

Swallowtail's voice was anxious. "You go to Tecumseh—"

"Tecumseh! Tecumseh will kill you, you stupid man!"

Swallowtail gazed intently at her. She could see a mental block behind the little eyes. "Tecumseh will be very glad I brought you. You will see he is my friend. You be happy. He treat you like honored wife. You see. You be happy, Hannah. Forget this."

I will never forget it. The image of the scalp in two red hands would be with her forever. The fight went out of her. She knew now why she was being treated so carefully. In order for Swallowtail to present her as a wife for Tecumseh, she must be unblemished and virginal. Oh, Harmon! It was as if part of herself stretched on that small, round hoop.

When they were ready to leave, she was pulled to her feet. Her hands were left untied. Instead, a rope collar was fastened to her neck, with ends running to the Indian walking before her and the one following. With dismay she saw Swallowtail untie the painter of Bunty's flatboat and push it out into the current. She could not bear to see it and was relieved when a tug on the rope forced her to march away.

Sharp sticks and knobby roots pushed into her stocking-clad feet. The thin wool stockings protected her feet from only the smallest abrasions, and by the time they made a short rest at midday, Hannah was hobbling.

Swallowtail noticed that she was unable to keep up. She wondered if he

regretted the rash act of throwing away her good leather slippers as much as she did. If it caused him trouble now, she was glad he'd done it. Without comment, he tossed her an extra pair of moccasins from his pack. They were much too big. One of the younger braves took pity on her and showed her how to tie them comfortably around her instep and ankle with extra thongs. She thanked him with a smile that let him see how appreciative she was. He glanced briefly in the direction of Swallowtail before returning it. Good. A possible ally.

Such little tricks helped Hannah stave off the realization of the danger she was in and of the increasing hopelessness of her situation. When she made her next trip into the bushes, Hannah forced apart a seam in the hem of her dress and managed to tear off a small strip of bright raspberry fabric. Hastily she wedged it in a fork of a tree facing away from camp. Then she tore off her moccasin and pressed her weight on her bare foot in the damp earth beneath the bush. With any luck, her captors would not pass by that way.

As each day passed, Hannah tried every way she could think of to persuade Swallowtail to sell her back to her own people. She promised to swear a blood oath—an oath of his choosing—never to reveal who had taken her. She promised him money, not just now, but whenever he came to her, to give him what she could: foodstuffs, store-bought goods, even the illegal whiskey he craved.

Swallowtail steadfastly refused. He knew, as well as she, that he would be hanged if they caught him, whether or not Hannah was ever returned alive.

Hannah knew he meant it. She was certain that it was fear now, not greed, that kept him from taking her back to Cincinnati.

Three days passed, then four, as they marched steadily west. The middle of the fifth day, she heard the men talking about a town. Her heart leaped. Almost as if he could read her thoughts, Swallowtail turned around on the trail and addressed her directly. Usually she was ignored, being told only by gesture and grunt what was expected of her.

"We make stop," he told her. She was allowed to sit comfortably under a tree on a little rise. Her elbows were tied in such a way that her hands were free enough to brush away insects, but she could not reach the knots. The rope was passed around the tree. The young brave who had been kind to her was left to guard her with an ancient musket. The others left. Perhaps they were going into town to arrange her ransom!

She glanced at her guard, who had squatted a dozen paces away and

begun to whittle on a piece of branch. "What are you called?" she asked in Miami dialect.

He glanced at her, startled. "Swallowtail said I was not to talk to you." He turned his back to her.

Her thoughts turned inward. Every day she prayed without ceasing, for her parents and brothers to be comforted in their grief, for the soul of her twin and for Bunty's and Peter's souls. Never, never, had she ever heard of a white person stealing a child or a woman and selling it. Well, almost never. But slavery was different. Only black folk got sold. But her mind was not comfortable with that, and as they tramped she pictured a black girl wrenched from her home and sold to a man who wanted her, taken far away so that she would never be tempted to try to escape and find her way home again. *Lord, I am seeing beyond the mountain, and Lord, you are teaching me a lesson. Is it a sin to want to see beyond the mountain? Have I sinned, Lord, and that's why you let these Indians kill Harmon and take me?* The ever-present panic hovered close to the surface, and she turned to the Miami again.

"It was nice of you to bind my moccasins. My feet do not hurt."

Looking over his shoulder at her, he acknowledged her words with a smile.

A nice smile, she decided. "Tecumseh talks to me," she said.

"You *know* Tecumseh?" He put down his whittling knife and turned around.

"We grew up together. The father of his mother gave my grandfather his land."

The young brave made a face of disbelief. "What does he look like?"

"A very handsome warrior. So tall, taller by a head than his brothers. He seldom wears decoration on his tunic. But I have seen him wear turkey feathers in his hair. We have broken bread together, Tecumseh and my family."

Her words seemed to disturb the Miami. His brow furrowed, and when he got up and came toward her with his knife, Hannah's hopes soared. He was going to cut her bonds, she knew it! "Help me," she begged in low, swift tones. "Come back with me. Or take me to Tecumseh. I will swear it was you who kept me alive. You will not be harmed. My father will not let anyone hurt you. Tecumseh will not either."

Suddenly they both heard the sound of voices raised in raucous song. A long look passed between them. Tears spurted to Hannah's eyes. The brave slid his knife back in its sheath.

By the time Swallowtail and his friends entered the clearing, her new ally had a small cooking fire going. Hannah saw at once that they had been drinking. A long-necked, brown bottle hung from one careless hand as Swallowtail eyed her with unsteady gaze.

A new fear crept in. During the meal and after Hannah did her best to appear invisible. When the bottle was emptied and Swallowtail flung it in the fire, Hannah breathed a sigh of relief. They were not out of control. Perhaps now they would all sleep. To her dismay she saw another brave, the tall one she had nicknamed the Ghoul, uncork a new bottle. Heaven knew how many others they had! The night wore on. The men got drunker, all but her new friend and, strangely, Swallowtail.

At last they allowed the fire to burn to soft embers. The men's voices drifted lower. Through the near blackness, Hannah sensed them throwing glances her way. The voices picked up. An argument seemed to be going on. Swallowtail shot to his feet, speaking rapidly and angrily. She could not follow the conversation, but when she heard her name and saw his hand slice horizontally through the air, she knew the nature of the argument. Something in the pit of her stomach congealed in fear. *God, protect me,* she prayed.

The mood of the camp had changed. Bedrolls were thrown open, the fire obliterated with angry stomps. After the second night, they had no longer spread Hannah's arms, but instead had tied the middle of a long rope securely about her neck and run the ends of it out to the bedrolls of Swallowtail and the Ghoul.

Tonight, as she was being tied, a new argument exploded. Her young guard was taking the other end of the rope away from the Ghoul and placing his own bedroll next to hers. She saw the blade of the Ghoul's knife—Harmon's knife—flash in the moonlight. Then Swallowtail stepped in and ordered him to put it away.

Hannah did not close her eyes at all that night. She lay ready to scream at the slightest move toward her. A new fear was taking root. Swallowtail was not taking her to Tecumseh. The old Miami camp was not even a day's march from Cincinnati. Perhaps she had sealed her own fate when she told him Tecumseh would kill him. Sober, he would know she had spoken the truth. They had marched steadily away from Cincinnati and from the Indian camp.

When morning tinged the sky through the trees with a delicate blend of pearl gray and salmon, Hannah gave thanks for her safety. And she began to pray a new prayer. She had been unable to persuade Swallowtail to take her home. Now she thanked God for him and for the young

brave who had protected her and then prayed for the Holy Spirit to enter and change Swallowtail. As she turned her head she met the watchful eyes of her young friend and smiled. "Thank you," she whispered in Miami.

Swallowtail could not meet Hannah's eyes after that dangerous night. He was sure by her attitude that she had given up hope of rescue. Ever since the second day, when they abandoned the flatboat and struck out through the rolling, forested hills west of Cincinnati, Hannah had obeyed him as if she were in a trance, like the holy men who ate the sacred mushrooms and saw visions. But he had only to look into her unseeing eyes to know what visions haunted her. And he was deeply sorry. Swallowtail had never done anything this bad before. He had wanted her to be afraid of him. He knew that the Roebucks, just like every other family in Cincinnati, thought he was nothing. And then the day when she wore that dress of berry red, it had just seemed like a fine idea to snatch her. It was all her fault. He knew well enough what Tecumseh would do to him if he caught up with them.

Now they were beginning to get into territory that was unfamiliar to Swallowtail. They made less distance each day. What would he do with Hannah? Could he bring himself to sell her? She would bring a good price, of that he was sure. But what if they happened upon a war party of another tribe, one not friendly to the Miami and the Shawnee? They would realize how weak he was, with only three men—the others having succumbed to second thoughts and crept away, one after the other. He could not stand by and let anything happen to Hannah. She was his prize, his—what was the word? He had a duty toward her. Swallowtail was beginning to feel more miserable every day. He wished the medicine woman were here. She would know what was wrong with him.

At evening of the ninth day, Hannah, Swallowtail, the Ghoul, and the young brave she thought of as her friend were eating trout that had been spitted and roasted on a green stick propped over the fire. No one had said a word ever since they stopped to make camp. Another man had deserted during this day, simply melting away from the back of the line.

Suddenly Hannah looked up. "You can never go back either, you know," she said quietly.

Swallowtail stopped chewing. His cheek bulged. "Huh?" he grunted.

"You left the same night we were attacked. You and your friends," she said with emphasis on the last word, not quite a sneer. "Some of them will be back in town by now. What do you think they will tell everyone? They won't take the blame, Swallowtail." Privately Hannah thought any one of

them would be fools to go back. "You might as well kill me now and be done with it."

"No! I have decided to sell you to a Sioux chief instead. A friend. My friend."

"There isn't a Sioux chief anywhere near here, Swallowtail. I've never in my life met a Sioux, and I've lived on the farm since I was born."

Swallowtail seemed to have forgotten the food in his mouth as he stared at Hannah. She sensed he was listening with more attention than he had ever given her. "I wonder if Tecumseh has been to the farm yet," she said dreamily. "He and Harmon were very close, you know. We all were. You were the one who told me he was back."

A sheen rose on Swallowtail's skin. She could see that he was imagining what Tecumseh would do.

Suddenly Swallowtail snorted in contempt, chewed noisily, swallowed, and speared another piece of fish with his knife.

Hannah stared at him, not daring to anger him, but trying to keep him just on the edge of reason. *Lord, Lord, help me!* She rose wearily. "I am ready to walk to the bushes." She waited. No one rose to put the hated rope around her neck. Swallowtail waved the back of his hand at her. "You not go away. Too far."

Her heart leaped. Keeping her posture abject and her head down, she headed for the bushes. *Not now, not yet,* she told herself, automatically ripping another strip from her skirt hem and hurriedly tying it to a branch. *Not in the dark. But soon. If he trusts me now, perhaps he will not tie my neck for the march tomorrow. Lord, keep me of good courage!*

The next morning, Hannah opened her eyes without moving. She had grown used to Swallowtail's cruel pranks. Now she waited until someone else moved before attempting to get up.

As she waited, she sensed a stillness. She felt her neck. There was no rope around it, only raw, scraped skin beneath the frayed neckband of her dress. Cautiously she pushed herself to a sitting position. The camp was empty! Indians, bedrolls, foodstuffs, guns, all gone! No, it must be a trick. Stifling a noise that was something between a sob and a shout, Hannah got to her feet and turned a circle, listening, smelling the air. Praise God, she truly believed they had gone, gone and left her!

Oh, thank you, thank you! she prayed. Her heart was overflowing with gratitude. Then all of her senses awakened, bombarding her with impulses. *Food.* She was ravenous! Then it struck her. Swallowtail might have left her, but he intended her to die. He had taken all the food and all the weapons. Even Harmon's knife. Her death would not be upon him.

She would not die! She knew as much as they did about edible roots and berries. She was only a little over a week from Cincinnati. She could live on hope that long! Due east. She would keep a little off the traveled paths, in case hostile tribes were on the move. Follow the river, follow the Ohio. It would take her home. She picked up her blanket and shook it out, then made a careful inspection of the camp. Nothing. A rueful smile touched her lips. *Lord, I know I'm always asking, but what I need is manna.* She knelt for a long drink at the stream, adjusted her moccasins, tucked her blanket under one arm, and set off.

14

Hannah walked for hours. She was pleased with herself, remembering the first couple days with Swallowtail and the others, how quickly she had tired, how her knees and her calf muscles had ached. She slapped her ear. One thing that had not changed was the constant irritation by mosquitoes and gnats. Great swarms of them passed and entered her mouth or her nostrils or drowned themselves in the moistness of her eyelids.

All I have to do is follow the river. She repeated it to herself like a magic chant. She pictured herself as Christian, the hero of *The Pilgrim's Progress.* Just through the Slough of Despond, just up the Hill of Difficulty. What if they were tracking her? What if it was still a frightful joke? By late afternoon her fears began to overtake her confidence. *What if I am traveling in circles? No. Due east. As long as I follow the Ohio, as long as I keep it in sight at least once a day.* . . . And she might find a settlement, with godly men who would see that she got back home.

The next day she happened upon an abandoned Indian village. She knew that many tribes moved to a permanent camp when winter came and then in spring moved northward, following the grazing patterns of the deer. She had no idea if this was a seasonal camp or which tribe occupied it. In the spent fields she found an ear of dried corn mottled with gray mold. She was so hungry she tried to bite the kernels off the cob, but they were like pebbles. Picking through the field, she found four more ears. She searched over the abandoned grounds, at last finding the hollowed rock she was seeking. Tribes seldom carried their grinding stones from place to place. Nearby she found a smooth, oblong rock that fit nicely in the palm of her hand, as it probably had in many hands before hers.

Hannah plumped herself on the ground. Spreading her skirt out between her legs, she sat to work chipping the kernels off the husk into her skirt. She piled a quarter of the kernels into the center of the grinding stone and eagerly bent to her task of pulverizing the corn.

If only she had a tinderbox! She could wrap moistened cornmeal around a stick and roast it over the fire. She could catch a fish and roast that to go with the corn cake. Or she could stuff the cornmeal inside the

108

fish. At the thought of fish her mouth watered. What could she use for a net or a trap? Ought she waste time trying to catch fish? Shouldn't she keep on her journey?

She finished her arduous task and waded into the stream, rinsing out her skirt as best she could, and drank a few mouthfuls of water. She noticed watercress growing near the bank where she washed. She gathered a bunch, eating as she picked, and slogged back to the grinding stone with her wet skirts clinging to her legs. She wrung a few drops of water over the handful of ground corn nested in the hollow of the stone. Her mouth was watering as she stirred it into a paste with her finger. She scooped it to her mouth.

It was all she could do not to spit it out. Somehow she had envisioned the tasty batter of Indian bread, made with eggs and lard and salt and bicarbonate of soda, not this gritty, dirt-filled mess. On her face came a look of serious concentration. What her mother laughingly called her duty face, which Hannah made when she was performing some task she had not wanted to do. She pictured the sandlike paste filling her stomach and giving her strength.

The sun fell behind the trees. Hannah shivered and realized how stupid she had been to let her skirt get soaked. Before, she had worried about what the Indians might do to her. At least they were human company. The presence of many of them, as well as the fire, had kept animals from molesting them. Now she was alone and cold and wet. Animals would be able to smell that. She scouted the perimeter of the Indian camp. Perhaps the vestigial odor of human would still serve to keep animals at bay. If only she had a fire!

"There's no cave, Lord." Her voice sounded strange to her. Last night she had slept in a cave. She laughed intentionally, wanting to hear human sound again. "Shall it be the ground or a tree?" She looked around her. The ground would be warmer. She could gather a bed of leaves, with more to spread over her blanket. But a tree might be safer. Sycamore, willow, red maple trees. A red maple stood apart from the other trees ringing the clearing. Its branches were low enough that she could climb into them. Near the top of the main trunk, three branches came together. She could use her woolen stockings to tie herself into the tree. She felt certain that mountain lions or wildcats could not jump far enough to reach her from other trees. She would need only to guard against marauders from the ground. It would be well to arm herself with a stout stick, she decided, just in case.

"After dinner, bed," she announced. The bird calls ceased momen-

tarily. Then they started up again. Hannah picked up the hem of her damp skirt in two places and tied it securely across her stomach. With her blanket roll she climbed the tree, her arms turning rosy in the twilight sky. Sharp, black figures streaked across the sky, going to nest, going hunting.

From the mounds of black pellets she had seen along the river's edge, Hannah knew that deer would shortly be coming down to drink and to feed around the clearing. A warm bath. A cup of hot coffee to curl her fingers around. Her eyes watered. "Lord, keep me safe. . . ." Her eyes drifted to a neighboring tree. A beehive. Tecumseh was passionately fond of honey. If Tecumseh found her, she would be the safest person in the world. "And keep my parents from worry." Silly. "Comfort them, Lord. Of course they are worried. Can you tell them I'm all right? That I'm coming home?" And Harmon. And Peter and Bunty. "Oh, Lord, what about them? Lord, merciful God, it's my brother!" Hannah pulled her blanket around her, drew her knees up in her perch, and sobbed silently.

She awoke with a start. Had she really fallen asleep in a tree, without falling? She moved. An involuntary groan escaped her lips. Her leg joints from hip to foot seemed frozen. Grasping one slender ankle, she gently unfolded one leg and swung it experimentally, moving it up and down at the hip at the same time. Then she shifted her sore sitting bones and repeated the exercise with the other leg. *A new day. Thank you, Lord.* She could smell the crisp, fragrant air as she bent her head and murmured thanks for the morning. She looked around.

She was facing east. From her leafy bower she squinted into a globe of sun scintillating through the treetops. Already she imagined its warmth on her face. Gazing east and south, she searched for a glimmer of the river. She must be further inland than she thought. Of course she was only twenty feet or so above ground. Trees and hills would obscure a complete view. Slowly she swung her gaze southwestward. A thin spiral of smoke drifted up. Hannah made a sound of pleasure and struggled to stand upright, only to remember her bonds. Hastily she unknotted the stockings she had secured around her midriff and her hips last night and teetered on her branch. How far? She couldn't even guess. It didn't seem far. But it wasn't in the direction she should be following. And it could be an Indian camp.

No, she doubted this. Indians seldom made fires in the morning unless it was at a permanent camp. If it were that, there would have been more than one fire. Whites, then. A camp? A family settlement? Without realizing it, Hannah made her decision. She tried to mark bearings, then

realized that as long as the fire was going, she had but to climb a tree to keep on track. Hastily she slid and clambered out of the tree.

Hannah emptied a small handful of corn kernels out of the toe of her stocking onto the grinding stone. Then, considering the time it would take to make a palatable paste, she changed her mind, and carefully scooped it back into her stocking and fastened it at her waist. Next she rolled her blanket into a long coil and tied the ends together with her other stocking.

When she had washed in the stream and drank, she gathered more watercress and some tubers of water lily discovered in a shallow pool, to eat as she walked, slipped her bedroll over her head and shoulder, and set off in good spirits.

Two hours later Hannah stood hidden just beyond the edge of a clearing, observing a rude log hut with a low door and no windows, built in the center of the clearing. A few paces in the foreground was a smoking, green-wood fire, over which a double rack of fish was strung through the gills. Nearby she noticed a tin bucket, heartening her belief that a family of settlers inhabited this cabin. She listened. She heard the thrum of insects, chatter of birds. Her own controlled breathing. How she would welcome the shrill cry of a child! Warily she faded from tree to tree until she had circled the clearing. No line of clothes anywhere. No pens or corral. No garden. Not a permanent home then.

"You wanna say watcher doing?"

"Oh!" Hannah whirled around. She hadn't heard a thing! How had anyone gotten so close to her without a sound? Before her loomed a man who was unmistakably a trapper. His fringed buckskins were dark with grease. A buckskin scabbard held a horn-handled knife. His right hand gripped the barrel of a rifle. His black hair was long and pulled back at the nape. His eyes were a fierce black under beetled brows, surrounded by a shag of bristly beard. The jutting angle of his beard and the heavy brows combined to give his face a scrunched-in, mean look.

"Well? You been staking out my place long enough."

"Praise God, a Christian!"

"What?"

"Sir, the Lord led me to you—"

"What?" the man stepped back.

Hannah flung out her fists, threw back her head, and laughed. "Thank you, Lord, that in the midst of the wilderness you have sent me a deliverer."

Astonishment darted across the shagged-over features of her appointed

111

benefactor. "See now—where you from? Where's th'others?" He took in her Indian moccasins, the rolled Indian blanket. Suddenly he seized her wrist and barreled for the cabin. Hannah stumbled. She was forced to run to keep up.

Inside, the cabin was gloomy, and it stank. Light beams slatted the floor from unchinked logs. From the light trapped in the doorway, Hannah detected piles of varmint droppings that no one had bothered to sweep away. Dimly she discerned two bunks against the far wall. A short trestle table and a single bench occupied the center of the packed-earth floor. A lantern teetered close to the near end of the table. The rest of the surface was piled high with skins. A swift glance into the corners revealed what she guessed were different kinds of traps.

The man had closed all but a two-inch crack of the door, through which his rifle poked. She sensed his tension. He threw a brief glare back at her. She started, her eyes going in automatic modesty to the floor. Then she took a deep breath and boldly stared at the back of his head. To shore up her courage, she buried her fists in the folds of her skirts and clenched them.

"Well?" he said without turning his head. "Got your eyes full?"

"I need you to escort me to Cincinnati."

He turned to face her. His mouth stretched into an annoyed grimace. "What?"

"Please, sir, you keep saying 'what.' Are you deaf?"

"I'm deaf, or you're crazy. Don't seem to make no difference."

"Do you have horses? I didn't see—"

"I thought so!" Roughly he reached out and seized her arm and flung her into the corner, as if she were a dying mountain cat caught in his trap by mistake.

She tumbled to a stop against the hard frame of the bunk, bruising the back of her ribs. "What did you think? What is the matter with you?"

"Lookin' for Henry, ain't you!" He slammed the door, and in terror she heard his boots thump across the hard pack toward her. Hannah had a sense of the presence of evil. One part of her mind was drawing the Lord close about her while at the same time she could feel the man towering over her, his black shadow blotting out everything else.

"H-Henry who?" Hannah tried to control her voice, with little success, praying not to cry, as if crying would somehow make her seem weaker than she truly was.

" 'Henry who?' " mimicked the terrible voice in falsetto. Suddenly his hand swiped down and smacked the side of her face.

Hannah screamed. She scooped her skirts together and buried her face. She began to sob, "O Father, O Lord, help me!"

"That's enough of that!" Roughly he seized her by the back of her hair and dragged her to her feet. He marched her across the floor and flung open the door. "She's here! If you want her back, you have to come and get her! Only you don't get her alive unless I get out alive. You hear me? Her life for Jack Wheat's! And blasted quick!"

Hannah's breath came in sharp pants. She stared out into the silent clearing. She held her breath, listening harder. Intense shivering seized her body.

Jack Wheat looked down at her with supreme disgust and shoved her inside again as if she were no more than a scarecrow.

She lay where she was thrown, not daring to move, struggling with every breath not to make any noise at all. Suddenly Jack Wheat went outside. She heard the door rattle, then a scraping noise. Silence. Her own shuddered breathing filled the dusty, fetid air. Gradually her eyes discerned light again. The slits of filtered sunlight filled with slowly drifting dust motes. Dashes of sunlight outlining the door. Light poking through the latchstring hole.

Painfully Hannah climbed to her feet. When she drew a deep breath, her back ached sharply. The back of her head throbbed where he had pulled her by the hair. Her cheek smarted. Gingerly she cupped a palm to it and felt the skin tender and swollen. Leaning on the table for support, she staggered to the door and gently tried to prize it open. It would not budge. She pulled harder. No. Her fingers picked at the latchstring. It was pulled through to the outside. He must have fastened it in some way to keep the door from opening. The door was hung with leather hinges, which felt dry and cracked but solid. He was keeping her here. She was a prisoner. *O Lord!* How could it be? When would the nightmare end? She peered through the cracks. The clearing appeared as it had initially, peaceful and vacated. She looked out all sides, discovering no trace of Jack Wheat.

Sighing deeply, Hannah chose a spot in which the most light seemed to be entering. She swept it with broad, circular motions, using her moccasin, then sat carefully against the log wall and tried to think. Jack Wheat was a trapper. Yes, here were his furs and here his traps. Was he alone, or did he have a partner? She got up and, using hands and eyes together, discovered two bedrolls on the bunks, both apparently slept in. Letters, paper, anything, to help her. A gun or a knife!

Searching now with frantic haste, she went through a jumble of reeking

bedding and clothes. Her hand closed around the blade of a knife. Fear mushroomed in her stomach as she realized she might need it to protect herself. Swiftly she pulled up her skirt and secured the knife in the waist of her underclothing. Next her hands felt a sack hanging from a peg on the wall, and her brain said *food*. As she yanked the sack off its peg the door swung open, and the frame filled with the presence of Jack Wheat.

"So!" he roared. "Going through his things, are you? Well you won't find anything!"

"I'm hungry!" Deliberately she turned her back to him. Her back prickled. Her heart thumped, and her hands grew clammy as she dug into the bag and found a lump of hardtack. She let the bag fall to the floor and gnawed hungrily.

"That stuff's moldy," he said with contempt.

She shook her head and continued to eat. She heard him moving around her, but didn't look up.

"Here."

He thrust a stiff brown strip of jerked beef under her nose. She took it. "Thank you, Mr. Wheat."

"Thank you, Mr. Wheat," he repeated. "Come over here, where I can get a good look at you." He took her shoulder and shoved her, not un-gently, down on the bench, then kicked the door wide. With the same boot—a moccasin and legging affair, no wonder she hadn't heard him coming—he hooked out the other end of the bench and straddled it, fac-ing her. He watched her eat.

Tracking his movements out of the corners of her eyes, Hannah did not look at him directly. She finished every last crumb of the moldy biscuit and the stringy meat. She wiped her mouth with her fingers as delicately as possible, then shook out her skirt and brushed her hair back from her face. She faced him squarely, unafraid.

"Thank you for the food. I was quite hungry."

"Where you from?"

"Cincinnati. Where are you from?"

"Where I—hah! What's your name?"

She told him.

"Roebuck. Roebuck." Jack Wheat rubbed his beard with a hand as bristly with black hairs as the rest of him. "Heard that name. Long time ago. Where did you meet Henry?"

"Henry?"

"Don't start that again!" he roared.

Hannah recoiled. "You needn't yell."

"All right. What you doing out here?"

"Trying to get home again."

"You know where you are?"

"Certainly. Cincinnati is straight up the Ohio River about eight days."

"Oh, ho. And you just happened to be weaseling around in my territory."

"I climbed a tree and saw your smoke. I thought you could help me."

"How you get here?"

Instinctively Hannah did not want to tell him. She knew only too well what happened to the reputations of women captured by Indians. "Lost."

Time seemed to stand on its ear while Jack Wheat used his woodsman's eyes to take her apart from head to toe. An experienced trapper could divine almost magical things from such things as bits of leaf and clots of earth. What he was making of her feet bound in Indian slippers, her stockings used as ties and food storers, her general state of dishabille she could only guess. Then his blunt finger shot out at her. She didn't move. He pulled at the shreds of her once-beautiful braid neckband and grunted. The hand went back to his knee.

"How'd you get that?"

Her fingers went to her neck, found the ring of drying sores from Swallowtail's rope. She shook her head. In spite of her fear, her eyes held his, meeting his challenge.

Jack Wheat coiled both hairy fists on his thighs and reared back on the bench. "Well. So now you want to go to Cincinnati."

She nodded.

"Sorry, little girl, can't help you. I'm going the other way."

"But you can't refuse," she cried in disbelief.

"Oh, ho, and why not?"

"It isn't—neighborly."

Jack Wheat roared. " 'It isn't neighborly!' " Abruptly he got up and flung himself outside. She saw him bend over the smoking fish, testing it. She remained on the bench, watching him. He seemed to be mulling over something. He came back to the doorway and leaned a raised forearm against it. "Mebbe we can both be neighborly. You do what I say, and I'll see that you get back to Cincinnati."

"What—what do I have to do?"

"Be agreeable."

Hannah shook her head.

"Aw, woman, you think if I was of a mind, I couldn't just bed you here and now?"

Hannah gasped. Never in her life had she heard such coarseness. She felt dirtied just listening to him.

Jack Wheat ignored her horrified expression. "I got meself in a bit of a trap—Hannah."

Don't even use my name! she cried out silently.

"You and me going downriver a bit, sell my furs. Then I'll see you get back home safe."

"What—what do I have to do?"

A malignant grin creased the bearded face. "You have to back me up."

She frowned in perplexity.

"Nothing to it. What I say, you say that's gospel truth. One look at you, everybody'll believe."

"Believe what?"

"What I say."

Hannah got up. She thought of walking outside to the fresh, beckoning air, but saw no way to cross the threshold without physically touching the man. Instead she circled the table. "About what?"

He shrugged. "Just anything."

"Maybe I'll just walk to Cincinnati, Mr. Wheat. I'd be beholden if you'd give me some food to take—"

"No."

The menace in his voice was unmistakable. Whatever he had done, she had inadvertently stumbled into the midst of it, and he feared something from her if he were to let her go. "Where must I go with you?"

"Few days downriver," he said vaguely.

"How will we get there?"

"Walk." He saw her glance at the furs. "The furs ride."

Then he did have horses or mules. "I will agree on one condition, Mr. Wheat."

"You will?" He seemed to find this funny.

"Yes. That you swear before God to protect me, to respect my person, and defend my honor."

He burst out laughing. "That, Hannah Roebuck, is my ticket."

Her cheeks colored. "Then, sir, I shall do my part, too."

"And not run away? Or get 'lost'?"

"You have my word."

His *humph* seemed to imply that, with some surprise, he believed her, for he made no further attempt to guard her movements. "We'll leave in

116

the morning," he told her. Expertly he speared off a couple hot fish for their supper. Afterward he disappeared into the cabin. "There's a extra bunk," he called through the door.

"I will sleep by the fire," Hannah said.

Without a word he tossed a pile of bedding out the door. Hannah could smell it even before she bent to examine it for lice. She went inside and without looking at him helped herself to an armful of furs from the table. These she arranged into a soft pile and unrolled her blanket over the top. She lugged a heavy log to the fire and crawled into her bed.

Under her blanket, she clasped her hands together. *Lord, thank you for keeping me safe this day. Keep me from fear, strong in the knowledge that you are with me.* Her mind went automatically to her family, and her lips moved in the ritual begun the first night of her captivity, for the safety of her brother and friends, if any of them lived, for comfort for her parents and family. She pictured the townspeople, who knew and loved her as she loved them. *Lord, be with them all. Help them not to hate all the town Indians for what Swallowtail did.*

Her prayers finished, her eyes wandered to the fire. The quiet crackle, the soft, mesmerizing glow freed her thoughts. What price did Jack Wheat intend to exact for her safe return to Cincinnati? Why was she now necessary to his plans? She was firmly convinced that her presence was intended to help him in some nefarious scheme. Something to do with the unknown Henry? Someone had occupied the other bed. Perhaps that someone had ridden in on the second horse. Someone whom Jack Wheat did not expect to return. Some dreadful knowledge hovered at the edge of her consciousness. She must not think about the man called Henry. Not now.

15

"In my youth," said Tall Tree, "I saw visions. When Black Hoof came to dwell with the Shawnee, I heard her tell the life journeys of the ancestors, and as she spoke their spirits came into my mind and told me what my visions meant."

The horses were moving single file through the dense forest. Tecumseh did not look back or acknowledge Tall Tree's words as he guided the stallion through the profuse mix of weeds and ferns on the silent, spongy earth.

"I *did* see visions.... Do not be angry with me, Tecumseh."

"You were in charge of the furs. You were the most trusted."

After the council Tecumseh had directed the men to count the furs left in the warehouse. In taking stock of the paltry bundles, it was discovered that most of them were worthless. Many had been improperly tanned. Some were as stiff as crusty bark, others had been allowed to stand in water and had mildewed.

"The next time we come, the warehouse will be filled, like a woman with child. You have said, and I have seen that it will be so." Tall Tree's voice was subdued.

Tecumseh did not answer.

"I tell you again, I have thrown away everything of the white man: his rum, his tobacco, his shirts—"

Tecumseh relented at last. "Stop before you throw away his horse."

Both men laughed, recognizing the incongruity presented by Tecumseh's elegant blooded stallion, followed by a tuberous, obedient mare, swaying from side to side.

It had been like taking a sugarloaf from a child. Two days after leaving Little Shawnee Town, they had passed a tiny clearing in the woods, where four or five families had settled. They had discovered a mare, hugely pregnant, hobbled in high, sweet grass, near where a white man labored with a hoe. No trouble at all to inch through the tall grass, slice the hobbles, and prod the mare into a slow drift toward obscurity.

The following days passed in a pleasant deepening of their friendship as Tecumseh and Tall Tree crossed the rich woodlands in a steady course,

roughly seventy miles north of the Ohio River, westward from Little Shawnee Town, on the Scioto, toward the Upper Miami. From talk of boyhood dreams they moved to plans of strategy against the Long Knives, with Tall Tree again protesting his singular devotion to the tribal cause. After many days they reached the old Miami camp of La Demoiselle.

The first words greeting Tecumseh threw his plans into confusion. "A Long Knife came to see you. He waited three days."

Tall Tree snorted.

"What did the Long Knife want?"

"He brought you this." The messenger retrieved a long, red object resembling a pipe. "The son of Spirit-Who-Cries, William Roebuck, sent it with his second son. His first son lies badly wounded."

Tecumseh received it with a sense of shock. It was an ancient Miami calumet, more valuable than a warehouse of furs. "Tell me quickly, everything you know."

"A man of the Miami stole the granddaughter of Spirit-Who-Cries. . . ."

Tecumseh forced himself to remain impassive throughout the recital. *Hannah.* The thought of her in the hands of drunken, irresponsible Miami drove every other thought from mind.

"Your eyes burn, Tecumseh," said Tall Tree anxiously. "Do not go after them. She is only a white woman. The return of La Demoiselle's calumet is a good sign. It has come full circle, from your grandfather to you."

Tall Tree's words were faultless, but Tecumseh knew his clever friend had another reason, and he resented it. What right did Tall Tree have to counsel him? He was ignorant of Tecumseh's love for Hannah.

Scanning the faces of his Miami brothers and sisters, he realized that his answer would help to set the course of his leadership. He must help them to regain courage. He must show them that the word of a Miami is unbreakable. He recalled the words of Little Turtle to them. " 'Not all of our brothers are honorable men, and not all Long Knives are bad.' It is as much to punish Swallowtail as to rescue the granddaughter of Spirit-Who-Cries that we must go." He placed a hand on Tall Tree's shoulder, "The enemy is not faceless, Tall Tree."

Murmers of approval met his words.

"It is true the Long Knife did you a great honor by returning the calumet," Tall Tree conceded, "and so if you must go, I will go."

"It is not necessary. You did not know Spirit-Who-Cries." For reasons unknown to himself, he wanted Tall Tree to live in darkness about Hannah Roebuck.

"I will come," he insisted.

Scarcely an hour later Tecumseh led Tall Tree and six chosen warriors in pursuit of Swallowtail. He forced himself to set aside the outrage he felt, the betrayal of an honorable friendship by one of his brothers. *A brother.* Tecumseh spat. Swallowtail had never been a good man of the Civilized People, but this was the worst thing he could have done. Not only had he shamed his people, he had taken the one person Tecumseh prized most, outside his own family. For this he would not live. Many days had passed since the outrage. He would learn in Cincinnati what Roebuck knew. Then he would find Hannah, if she lived.

"You must not go with him."

Hannah's eyes flew open. It was still dark. The fire was glowing, a nest of embers in a city of ashes. She heard loud snores coming from the open cabin door. Fearfully she looked around the clearing. She was positive she had heard the words. It was her grandmother's voice. Maybe she had been dreaming of her grandmother. *You must not go with him!* The words were firmly entrenched. She would obey. She fingered the comforting presence of the knife in her clothing. Stealthily she crawled out of her bed. She shivered. Wasn't it just a tiny bit light now? She plumped up the bedding into a human-looking bundle and crept past the fire, her heart racketing against her chest wall. She went in the direction she had seen Mr. Wheat come from this afternoon. Yesterday afternoon.

As the day unfolded from sleep, Hannah could see her way well enough to avoid gross pitfalls. She heard soft birdcalls, quick rustles of animals, and a low whinny. Mr. Wheat's horses! She stopped, listening intently. She crept through the undergrowth in the direction of the sound, discerning at last a man-made brush barrier erected across the mouth of a cavelike formation of rock. She tried to see through it. The cave's depths were shrouded, but she heard definite sounds such as horses usually made moving peacefully about in their stalls. She worked her way through the rope-and-brush barrier and discovered that Wheat

or someone had tethered two horses and a mule in the cave, secure from predators.

Hardly daring to believe her good luck, Hannah reached out to one of the horses and hugged its warm, inquiring nose. Straining to see beyond the animals into the depths of the cave, she caught a glimpse of something lighter than the background and crawled toward it. Her fingers found a stump of yielding leather. It became a moccasined foot. Choking back a paralyzed scream, Hannah made herself feel beyond it. The flesh above the foot was icy cold, as cold as a mossy rock.

Speechless with fright, she stumbled backward out of the cave. Now able to see more in the semidark, she spied a saddle propped against a wall. After a second's consideration, she decided to take time to use it. Her hands were shaking so badly she could hardly manage to settle it to the horse's back. As she cinched the girth of the saddle around his belly, thoughts raced over each other in her mind. *Wheat killed the man in the cave. But maybe he didn't. Maybe he took sick and died. Henry it must be. . . . Then why leave him in the cave?* Wheat would not let her go. He would kill her, too. At first she had thought to take only one horse. Now she was afraid to leave him the means of following her. She cut a length of rope from the barrier to halter and string the spare horse and mule to her horse. At last she put heel to flank and rode away from the camp.

Swallowtail was a coward, Tecumseh knew. Thus he would not cross the Ohio. Kentucky swarmed with American settlers and Brass Buttons. He would not go east, where Shawnee and Miami might surprise him. His reputation as a man given to sly, unpredictable behavior had seeped over the land, like bad water. To befriend Swallowtail was as bad as making friends with a coyote.

Leaving the Roebuck ranch, Tecumseh headed west, trying to see through the eyes of a frightened, drunken, anxious man. It was child's play to discover the first camp after Swallowtail had abandoned the boat. As they spread out over the camp one of his men let out a cry of triumph and brought Tecumseh to see a ragged strip of dark-red fabric wedged in a low branch. "And see," added the warrior, pointing at the mud below the branch to a perfect imprint of a foot. It could belong to a woman or a half-grown child. Tecumseh's heart soared with pride. Hannah knew.

His woman had spirit worthy of a man. Tenderly he released the strip of cloth and sniffed it. No sweet scent of her remained, but it was hers. Red dress, yes. Soon he would hold the truth in his hand as he now held Hannah's gift.

Clouds and intermittent rain showers had obscured the sun all day. Angrily Hannah berated herself for giving in to her fright, when with a cooler head she might have had sense enough to take a few smoked fish from Mr. Wheat's camp and to bring her blanket. As it was, she was not only lost, but cold and hungry, too. Until the sun came out, she had no idea whether she faced east or west. All she was certain of was that she was north of the Ohio River. And she believed she had put a safe distance between herself and Jack Wheat, for she had tried to go in a straight path, as much as it was possible in the wooded hills and plunging streams.

Guessing when it was midday, she stopped to give the animals a chance to graze and drink. She blessed God for the pure, sweet water and for the horses and her freedom. "But you counted on my using the wits you gave me, too," she added ruefully. She might not be more than three or four days by horseback from Cincinnati, she told herself, if she had guessed the right direction. Even without food, she could make it, as long as she had water. Thus chastened and heartened, Hannah once more reverted to scavenging watercress, lily, and other water roots and early berries, which she munched on hungrily as she started off once more.

By nightfall, Hannah was doubled over the saddle horn with severe stomach cramps. Wet, cold, and ill, she fought the temptation to give up. She had her knife. She could do what she had heard once of a trapper doing in like circumstances. He had killed his horse, gutted it, crept inside the cavity to keep warm, and the next day cooked some of its flesh. . . . The thought made Hannah so ill she slipped off the horse to empty her stomach in the bushes.

Howls of night beasts, which at one time would have terrified her, caused her only to think that at least it would all be over. . . . The spasms continued to gnaw her insides, but she had nothing left. Weakly she tethered the horses, pulled off the saddle, and huddled in a ball under the scruffy saddle blanket, hardly noticing the sour odor of horse sweat. She tried not to think of Harmon and Joey and her parents. If she just fell asleep and didn't wake up, that would be all right. The Lord would take her home. *Hannah. Hannah.* Gra'mama? She had to live. She had to get

back. They were counting on her. They were watching for her, every day. They were looking for her. She had to tell them what happened. . . .

"Well, Prophet, it happened as you said. The coyote grew frightened of his own shadow and tried to run away from it." The speaker was the youngest of Tecumseh's braves. The men had dubbed Tall Tree Prophet the second day of their search for Hannah, when he had "seen" Swallowtail crashing through the forest and then again "seen" him and two companions drinking rum.

Tall Tree grew more expansive. "I can see because I no longer drink rum or use anything of the white man's," he told them. As the days went on, he added to the list of things that they must no longer use in order to grow strong in body and spirit.

Though seeming to ignore his friend's pronouncements, instinctively placing more faith in his own careful tracking than someone's guesses, Tecumseh nevertheless waited to hear words about Hannah. None came.

Inevitably the day came when they overtook Swallowtail. The hapless man and his friends were insensible beside a cold fire pit. Their hair and clothing were filthy. Several rum bottles were cast nearby. Tecumseh's jubilant companions found it easy to believe Tall Tree's words were prophecy.

Now the tired men relaxed before a small cooking fire, while the young brave tended their supper. Occasionally he cut off cooked strips of venison and tendered them to his elders.

The fire smoked and played tricks on their buckskins and threw tall shadows behind them. Twenty yards away, it reflected eerily on three white faces that seemed to float like disembodied spirits. Swallowtail hung suspended by his wrists from a limb of a giant chestnut tree. His toes barely trailed the ground. His fat flesh bled from several long cuts, where skin had been stripped away. His eyes were open wide and seemed to be staring.

Nearby, the bodies of two other town Indians were still tied to trees. Tecumseh had been merciful to these two. They had known they were dead men as soon as the Miami warriors had roused them from their stupor. He had allowed them to die quickly.

Swallowtail insisted upon his complete ignorance until he watched his terrified friends die. Then he had told Tecumseh everything, insisting over and over that he alone had protected the honor of Tecumseh's

woman. That he had intended her no harm, only to bring her to his friend Tecumseh, but the ungrateful woman had sneakily stolen away from them.

Tecumseh had kicked him viciously, relief spilling out of him as anger, because he believed Swallowtail had told one truth, that Hannah was alive. "Let that remind you that friendship cannot be bought."

Concerning Hannah's present whereabouts, Swallowtail continued to gasp out his innocence until, crazed with pain, he mutely begged to die. At last, Tecumseh grew impatient waiting and allowed his men to send Swallowtail to join Motshee Monitoo in the underworld.

Tall Tree watched approvingly. "Now let us go home."

Tecumseh glanced at him in genuine astonishment.

"Swallowtail is punished."

Tecumseh threw him a look of disgust.

A day later they found the trapper's cabin, enriched with a fur cache but abandoned. Tall Tree urged Tecumseh to let them claim the furs as booty, but he refused.

"They are not white men's goods," muttered Tall Tree, but Tecumseh, absorbed by moccasin tracks found inside and outside the cabin, ignored him. They could have covered the small footprint found at the first campsite. In short order, the Indians discovered the cave, the decomposing body of a man with a large wound in his back, signs that the wearer of the small moccasins had left with three animals and that a heavier person had gone away from the cave on foot in the same direction.

Tecumseh's chest constricted with worry. Easy to read. Hannah had been in mortal danger. She had not killed the man in the cave. He had been dead too long. But she had taken the animals. The man from the cabin knew that she had found the body and was now tracking her.

Tall Tree came to stand beside him. Tecumseh outlined the course of events. Tall Tree agreed. He seemed to be mulling over something.

Tecumseh glanced at him.

"Is she your woman?"

"I will it."

Tall Tree did not look at him. "She is not for you."

"That is for me to say."

"You hold the lives of our people in your hand, Tecumseh. I see it."

Tecumseh scowled with impatience. "That is true. You did not 'see' it. I told you. Tell me, what do you see for her?"

Tall Tree said reluctantly, "She is in her greatest danger, for the man following her is not of the Civilized People, and probably a murderer."

"Yes. And you want me to leave her to him, 'Prophet'? Be my friend, Tall Tree. Every hour counts. She is not more than two days ahead of us." *O Great Spirit,* he prayed, *protect Hannah Roebuck, my woman!*

Hannah awakened before sunup. The sky was clear, praise God. A terrible, gnawing hunger filled her stomach, but the wrenching pain was gone. Her hands shook as she moved the animals to fresh grazing, so they could eat a little more while she prepared to leave. She found a still pool and leaned over it. Her hair hung down like ropes of dark, wet bark. She pushed back the cuffs of her dress, and they slipped down her thin arms again. Her beautiful red dress had lost its shape, she observed with detachment. She drank and decided to eat nothing. As she stood, a wave of dizziness engulfed her.

She plodded back to the animals and saddled her horse. The water, the movement, and the warming rays of the sun all served to lift her spirits. Reckoning east, Hannah turned southeast, confident she would reach Cincinnati in just a day or two.

The second day she ventured to eat again. Not knowing what it was that had made her ill, she ate only berries and cress. By midafternoon Hannah reached a bluff. As she approached the edge, a magnificent panorama unfolded. The broad Ohio stretched to the left and right as far as she could see. She was surrounded by magnificent stands of forest. She felt like singing. Dropping the reins, she lifted her face and hands toward heaven. She turned east. A wind swept upriver, carrying men's voices. Hannah cried out with anguish. The men were speaking Miami!

"Never! Never!" she muttered. Fear lent her new strength and sharpened her wits. She had never known an Indian who did not prize horses. If she set the horses off in one direction and took herself in the opposite, she was certain the men would follow the animals. She slid to the ground and switched the beasts across their rumps. They were still strung together. Her saddle horse reared and pawed the air. She switched him again. He dashed away, pulling the others with him. But fifty yards away, he stopped. They began grazing once again. Tears of frustration filled her eyes. In despair she clenched her fists. "I'll make you leave!" She walked back to them, clawed her way weakly into the saddle, and led them to the edge of the bluff once more. Part of it gentled into a steep incline toward the bank of the river.

She pointed her horse toward the river and switched him with all her

strength, gritting her teeth and digging her heels into his flanks. They began to half slide, half jump down the slope. The tether caused the ones behind to lose footing. Hannah threw herself off as they plunged into the river. She scrabbled back up the bank, panting and trembling from exertion. She watched the horses. The current caught them and pulled them toward the center. Good! If God continued to guide her, the horses would float and swim for miles before they achieved land, or until the Miami caught them. Let her trackers find her now! She went back into the near-freezing river up to her knees. As long as God gave her strength, she would wade upriver. She would be home before anyone found her.

On the bluff not a quarter of a mile from Hannah, a lone warrior watched the struggle.

"What do you see?" called out a voice behind the man on the bluff.

"I see the horses!" said Tall Tree truthfully. "Two horses and a mule. Tell Tecumseh we must go back, downriver, to catch them." With a satisfied smile, he wheeled his mount and rode briskly away from the struggling white woman in the red dress.

16

Micah MacGowan would have been ashamed to admit it, but he was exhausted. He had remained with Lachlan in Baltimore until spring flooded the land with blossoms. Convinced that learning a second trade would aid him more surely in gaining confidence and respect of the mysterious and wild frontiersmen, he passed the winter in apprenticeship to a printer, during the dark, cold days, and tutoring thickheaded young gentlemen at night by the light of hurricane lamps in stuffy, smoky drawing rooms.

With Micah's presence, Lachlan wryly noticed an increase in the numbers of young ladies of his congregation wishing more thorough exposition upon the Scriptures on Sunday afternoons and a steady flow of invitations for both men to take tea in comfortable homes. "Ah, Lord," Lachlan prayed with no twinge of conscience, "would it not be a fine thing for young Micah to find a charge here? Isn't this a needful place for a passionate young missionary like himself right here in Baltimore?"

Armed with warmest, if regretful, farewells from his host of four months, MacGowan took leave of the comfortable life in Baltimore. He continued to obey the admonishment to thrift he had received from Bishop Grundy seven months ago in London and took passage from Baltimore to Charleston on a wagon. Without springs and open to the elements, the wagon was scarcely less uncomfortable than the back of a horse. At Charleston, supporting a miserable head cold, he succumbed to the needs of an aching body and booked passage from Charleston to Pittsburgh by stage. Across from him sat a small, erect woman who looked out at the world with a satisfied air of proprietary pleasure, a woman who appeared eager for the chance to engage her companions in conversation.

MacGowan hid his reddened nose in his handkerchief and hunched in his corner. Occupying the remainder of the scuffed leather seat was a portly man who had arranged himself for sleeping the moment the stage got underway and now filled the air beneath his broad, felt hat with softly sonorous snores. The small, sprightly woman who faced them, after hopeful glances at both men, turned her attentions to the last occupant of the coach, sitting next to her, a woman of middling age swathed in cloak and heavily veiled hat of black.

"Have you lost friends?" she began.

"Yes, I have," answered the woman in black.

"Was they near friends?"

"Yes, they was."

"How near was they?"

"A husband and a brother."

"Where did they die?"

"Mobile."

"What did they die of?"

"Yellow fever."

"How long was they sick?"

"Not very long."

"Was they seafaring men?"

"Yes, they was."

"Did you save their chests?"

"Yes, I did."

"Was they hopefully pious?"

"I hope so."

"Well, if you have saved their chests and they was hopefully pious, you've got much to be thankful for."

"Yes. Thank you, ma'am."

The questioner leaned toward the unfortunate woman once more. "Was they in debt?"

The widow looked uncomfortable.

"Might be useful to know that, if you was to remarry. An' you was willing to wear only your shift and marry at the crossroads in town, you would be absolved of his debts."

The poor woman's eyes filled with tears.

"Not only that—," the small woman seemed intent on reducing the widow to helplessness.

Micah could stand it no longer. He shot the small woman a reproving glance and addressed the widow. "Madam, I am a minister of our Lord, Jesus Christ. My name is MacGowan. May I be of comfort to you?"

She gazed at him from red-rimmed eyes. "Thank you, sir. Shall you be locating in Pittsburgh?"

The small woman glared at him. Micah ignored her. "Alas, no, madam. I go on to Cincinnati."

"Oh!" interjected the small woman, a gleam springing to her eye. "Then you mought be the new preacher. I am Perseverance Fenn. My

husband has the mercantile. You shall be my protector all the way home, and I shall enlighten you about our brave little band of Christians."

"It will be my pleasure, but in a moment, madam." MacGowan returned to the widow. "I am at your service in Pittsburgh, until the boat sails for Cincinnati."

"Oh, thank you, sir!"

Undeterred, Mrs. Fenn pointed her tiny feet primly in his direction and swooped in with glee. "After Parson Haversham, we had none but those horrid Methodist circuit preachers, until poor Parson Randolph."

She waited for him to inquire upon poor Parson Randolph. Instinctively Micah refrained, knowing that whether or not he inquired, the answer would surely be forthcoming.

When the fish failed to rise to the bait, Mrs. Fenn trolled on: "I pray you will call upon us for coffee and cakes."

"I shall be delighted, Mrs. Fenn, once I am established."

"And are you single?"

"I am."

"How shall you be able to minister to women in need?"

"By the grace of our Lord, Mrs. Fenn."

The answer did not appear to ease her worry, MacGowan noted, and was relieved when she changed the subject. "By your accent you are from Scotland."

Micah MacGowan smiled. "More lately from London, from the London Missionary Society."

"Then you mought be a Congregationalist!" At his nod, she continued, "Well that is just fine. Poor Parson Randolph's a Presbyterian, but his wife does poorly, and he be taking her back to Boston, where there are doctors."

"Are there no doctors in Cincinnati?"

"Some, but not for her condition." Mrs. Fenn's smile positively gleamed.

Micah chuckled inwardly at her expression. She looked like a starving wretch ready to tear into m'lord's roast beef and Yorkshire pudding. So rather than satisfying her appetite by inquiring into the nature of the parson's wife's illness, he said, "Tell me about Cincinnati, Mrs. Fenn. Have you lived there long?"

The little mouth curled up in rueful defeat. "Indeed, indeed we have...."

The snorer woke up at the noontime stop. After purposefully and nois-

ily devouring the meal provided at the wayside tavern, he strode outside and glanced up at the sun. "Driver!" he called up to the high seat. "Will you try for better time? Seems to me we lagged a bit this morning."

"These horses won't go any faster than the last relay did, sir." The driver's glance swept the other passengers coming out of the tavern. "And if anyone wants to go faster, may he send to Kentucky and charter a streak of lightning."

Micah heard him and chuckled as he climbed aboard. These coach drivers were as independent as the ones in London. Eagerly he turned his thoughts forward to Cincinnati.

The post road, and with it the coach service, ended in Pittsburgh. From there Micah, accompanied by Perseverance Fenn, who now clung like a burr demanding attention, bought passage on a flatboat, which several days later deposited him upon a new loading dock in Cincinnati, whereupon he received the shock of his life.

No sooner had he introduced himself to a man waiting on the dock than the man exclaimed, "S'trewth, there's another of 'is ilk! He ain't gettin' away, not this 'un!"

Before his astonished traveling companions, Micah was seized by the arms and hustled down a narrow boardwalk, picking up a train of curious citizens in his wake.

"Philip! Philip! We got us another 'un!" shouted his captor.

A big man with heavy black eyebrows stepped out of a doorway a few paces ahead of them. He and Micah exchanged glances.

"If this is your usual welcome for a new parson, I'm not at all surprised that Parson Randolph and his wife are leaving," Micah said mildly. "You may tell your man to unhand me."

"No, sir! Into the calaboose with him, until he tells me where I may find my calf that his mate stole."

Micah turned back to face the irate man. "I took not your calf. But were it a golden calf, you are well rid of it. If it were the fatted calf for the prodigal son, the Lord has already thanked you."

Philip Thicknesse burst out laughing. "A scoundrel you may be, sir, though melikes your tongue. Not at all purse mouthed, like some of our parsons. I'll take responsibility for him, Haney."

Haney scowled and looked away.

Thicknesse said, "All right, let him go."

"You forget, Philip, the last 'un, too, 'peared to be a right-down hearty Christian minister, of savory conversation."

"Aye, he did," agreed Philip. "Be you a thief, sir?" he asked Micah.

130

Journey of No Return

"A thief of sin, that I may replace it with goodness."

"Bah!" said Haney. He shook a fist under Micah's nose. "I want me calf!"

Haney turned on his heel and stalked away in the direction of the tavern. The citizens of Cincinnati gathered around the newcomer, Mrs. Fenn in their midst. "Well I never," she said over and over. "Here I rode all the way with him. Never dreaming. . . ."

"Well you might exclaim, Mrs. Fenn," said Philip Thicknesse. "In your absence Parson Randolph left, and we were visited by a thief impersonating a pious parson. He claimed to be a circuit rider. He was here a week, during which he preached and stole with vigor."

The crowd nodded in assent. "That man had all his wits about him, for he lived upon them. Haney is not the only one to lose property."

"I lost my horse."

"When he came to tea, he robbed my house."

"Well, I never," repeated Mrs. Fenn, with a shade of regret in her voice. Micah grinned. Was it regret that he was probably not a scoundrel? Or just that, being away for weeks, she had missed the most outrageous happening in years?

In this he thought wrong. "Terrible things ha' been happening, Persy," he heard another lady say. "It was a terrible time to be without the parson. That man wouldna' ha' got away with it if times had been normal."

"What happened?" Persy cried.

Micah felt a touch on his arm. Philip Thicknesse was motioning him into his shop. "These are bad times, parson. If you would care to forego the pleasure of finding a rooming house, you could lend comfort to a grieving family."

"Of course. And I'd also like very much to see the church."

Philip Thicknesse and Micah were about the same height, but the apothecary weighed half again as much. His heavy eyebrows lifted. "We have no church, sir."

Micah stopped. "No church? But I understand you have had a succession of ministers."

"Aye. But no church."

Micah decided to reserve judgment. He followed Philip into a model apothecary shop. The walls were lined with well-ordered rows of small shelves containing dozens and dozens of brown bottles, fired clay jars, tins, and linen bags.

"I am an apothecary by trade," Thicknesse explained, noting his inter-

est, "but I am also charged with keeping civil peace. That is why Haney brought you to me. With Fort Washington so near, we have very little trouble. They usually take care of Indian matters, but this time it was a civil matter that outraged the whole town." He launched into the tale of the raid on Ruskins' flatboat.

An hour later, apprised of the sad state of affairs within the Roebuck family, washed, and refreshed by a hearty noontime meal prepared by Philip's wife, Micah rode beside the big man out toward the Roebuck farm. As they traveled, Micah caught glimpses of the Ohio, the strong current dappled by sun-stars between thick, glistening stands of black walnut and white oak trees. Strips and patches of cultivated land that they passed seemed miniscule on the vast landscape. He felt dwarfed and awed by the immensity and beauty of his surroundings.

"God never made better land, parson." Thicknesse seemed to divine what he was feeling. "We're coming on to the Roebuck lands. He has the best farm in the Northwest Territory. Given to his father personally by the Indians."

Glancing at the river, Thicknesse picked up the thread of the disaster that had befallen the Roebucks. "We found the boat, eventually. The Indians must have realized the flatboat would give them away and cut it loose. It went ashore in the United States."

"In the United States!"

"In Kentucky, sir. It's been a state now for four years. Over there." Philip pointed across the river. "Stretches quite a long way on the south side of the Ohio River.

"We looked for the girl for a week. There's parties still out. They are getting ready to start looking downriver on this side. We reasoned perhaps the boat was let go here and drifted that way before it was discovered. Hannah's one of the sweetest, prettiest girls in Cincinnati. Her folks gave her a godly, Christian upbringing. It's purely wicked for the Lord to let anything bad happen to her, parson.

"Here's the turn."

They turned in at an unmarked crossing. Walnuts, maples, and hickory trees dotted the landscape as they wound through the low hillocks, toward the house.

Thicknesse went on: "The men had their muskets, of course, but not time to get them in use. Fortunately one of the lads was only dazed and managed to drag the other two ashore before they drowned. Then he ran back to town. We took boards to carry them up from the riverbank to the

wagon road. I packed the wounds with spiderwebs and bound them before we moved them."

"Spiderwebs!" marveled the parson. "A most efficacious remedy, for which we have our Indian brethren to thank.

"Young Peter Ruskin—t'was he who summoned help for his companions—was able to tell us who the knaves were."

"Thugs from another part of the country?"

Thicknesse shook his head. "A local Indian gone sour and his wretched friends. Once we knew who did it, Mr. Roebuck sent word to the only man he thought had a chance of finding his daughter. But more than a week has passed, and most of us have given up hope of finding her well."

"Well?"

"Er, yes. There's the house, Parson MacGowan."

In the near distance, situated a prudent length from the river, to avoid all but the worst floods, Micah saw a sprawling log house. Climbing roses in gay, bright profusion grew up over the end of the roof.

Micah took a deep, satisfying breath. "Lord, it is beautiful here. I feel a peace about this place."

Philip glanced at him in surprise. "This is Indian holy ground, too. There's Miami and first generation of Roebucks buried hereabouts."

There was nothing of the confident gentleman farmer about the man who opened the door. William Roebuck had slept little since the attack on his children. He was wearing Sunday clothing, but it was badly rumpled. His stern face was aged with sorrow. Introductions were quick. Roebuck murmuring an apology that all of his sons were not here to welcome the new pastor properly, but they were out in the hunt for their sister. Only Joey had been kept home, to help William and Faith with chores.

"I could 'a found her quicker 'n anybody," Joey said.

Joey was a tall, slender youngster, with skin of a lovely olive-tan hue such as Micah had observed in some Frenchmen from the southern parts of that country. "Remaining at the side of your parents is no less important to our Lord, and your prayers for your sister are just as powerful," said Micah.

"Yes, sir," said Joey obediently, but not sounding convinced.

"How is Harmon, Will?" asked Thicknesse.

"Better," Roebuck nodded. "Faith is with him. That potion you mixed up is keeping the infection down."

"Gennie would have done better," Thicknesse murmured.

"Won't have you saying that. My mother would have been proud o' the way you and doc saved both men." At Philip's troubled expression, William added, "Bunty is going to make it, too, isn't he?"

"He took the pneumonia. Bunty only got one arrow, parson, but it went right into his lung. Harmon took a lot o' hits, but none of 'em hit his vitals. Parson MacGowan here got a better chance o' healing Bunty than doc and me."

As the three men started toward the room where the sick man lay, they heard a furious galloping. "Pa! Pa! We found Hannah! They're bringing her home!"

"Thanks be to God!" cried Roebuck. He rushed toward the bedroom. "Faith! Faith! Hannah is alive! Praise God, she's saved!"

17

Joey dashed outside. Thicknesse threw Micah a look of joyful astonishment and followed the youngster. Micah remained rooted in the doorway in the ensuing confusion. A great surge of people, on foot, by horseback, and in farm wagons, escorted a wagon that he assumed carried the missing girl. Several people walked on either side of it, one hand protective—righteously—on its slat sides.

Faith and William brushed past him as it drew up before the porch, and now the entire Roebuck family converged on the wagon: father, mother, three strapping youths strongly resembling the mother, and Joey. William Roebuck lifted down a bundle wrapped in a covering the like of which Micah had never seen before. It looked as if it had been pieced together out of hundreds of different cloths—like Joseph's coat of many colors, yet done in a sure-handed and pleasing design.

Roebuck's face was radiant as he carried Hannah inside. Micah stepped aside. He glimpsed a deeply tanned, emaciated face and a wealth of hair the color of rubbed walnut. A long, slender hand poked through the quilt. "Pa, I can walk," he heard, a determined voice at the brink of exhaustion.

"Bring her in your mother's room," said Faith, leading the way. Micah found himself carried along with the others as William laid her on the bed, still wrapped in the quilt. Friends and neighbors crowded in after them. William Roebuck knelt on one side of the bed and Faith on the other.

Hannah stared at first one and then the other, as if she could not really believe what she was seeing. Her hair was tangled and dirty. Her face bore marks of suffering such as Micah had seen in the faces of children living in the mean streets of London's east end. But as her brothers and the townspeople crowded around and Micah was edged back he realized with a shock that, despite emaciation, it was a face of great beauty. Where had she gotten the strength to survive? He felt an overwhelming desire to talk with her.

"Where did you find her?" William Roebuck was asking one of the young men.

A hush settled on them all as they strained to hear the answer.

"We didn't, Pa, she come wandering into town, not by the road, but out of the hills upriver! We'd just come back ourselves and were parleying in front of Fenn's when we heard this commotion."

Suddenly Hannah began to sob, hoarse cries that sent shivers through Micah. Faith gathered her daughter into her arms.

Hannah's arm curled around her mother's neck, the fist clenched. "It's all right, Hannah! Mother is here! You are safe."

"By the faith, she's skinny," one of the townspeople whispered. "Where you 'spose she's been?"

"Harmon," Hannah sobbed. "Oh, Mother, he's dead. I couldn't do anything. . . . I'm so sorry. . . ."

"No, my precious love! Harmon is here! He's alive! Is that what you're crying about? Harmon is alive, and so are Peter Ruskin and Bunty."

"Praise the Lord," someone uttered softly.

"Amen."

Tears ran like a spring freshet down the hollowed face. Micah felt tears start in his own eyes. He cleared his throat. Suddenly people began looking everywhere but at each other and began to make excuses to take themselves home. The Roebuck family had much to be thankful for and deserved privacy.

"But I want to hear what happened!" A voice Micah recognized piped over the crowd. Goodwife Fenn.

A man gripped her arm through her cloak. *"Later, Persy."*

"But—"

"Later!"

Micah felt of two minds. This family would, he hoped, soon be part of his flock. Should he stay and offer his services, or should he respect the family's right to be alone, rather than in the presence of a newcomer, and take his leave with the others? He turned to go.

"Parson. You are the new parson, aren't you?" Faith Roebuck rose. She awarded him a tear-starred smile. "Perhaps I am superstitious, but I cannot help feeling that you have brought good luck to our house, coming just as our daughter was found. Won't you stay and take supper with us?"

A lopsided smile lit the freckled face. "Mrs. Roebuck, I shall be very pleased to stay. I rejoice in your happiness. Mr. Thicknesse told me what befell your family. My name is Micah MacGowan and—uh—I wish to apologize for my unsavory appearance. I came but an hour or two ago by flatboat from—"

136

Faith waved away his increasingly stilted tale. "Explanations are un-important, Parson MacGowan. *Micah* means 'with Jehovah,' does it not?" She glanced at her daughter, and the harsh lines of her face soft-ened. The thought that living out here could not be an easy life crossed Micah's mind. Faith Roebuck was probably considerably younger than the age etched on her skin. Her face took on a beatific look. "Tell me that that girl is not the most beautiful sight on God's earth."

Hannah glanced at Micah, then back at her mother, and croaked, "Oh, Mama."

Immediately Micah warmed to this lady. Her accent was slightly differ-ent from her husband's, and both differed vastly from Parson Lachlan's in Baltimore. Leaving England, he had not thought that people's speech would be so varied. Yet, in different parts of his own country, the same was true. Why should it not be so here in America? It was like the quilt that enfolded Hannah, a piecing together of many colors and fabrics into a pleasing whole. It struck him that this alone brought home more than anything else he had seen in this country that these were indeed a wholly different people from those he left in England, albeit they spoke dialects of the mother tongue.

William Roebuck was standing now, too, as the room emptied of all but family. He said, "Parson, I'd like my sons to meet you. These are Philippe, Matthew, and Thomas. Joey you met. And this is my sister, Rosalind."

The middle three sons bore an uncanny resemblance to their mother, fair and blue-eyed and as blond as Germans. Joey, he now realized, looked like Hannah and his father, as did the aunt, Rosalind. Micah shook hands around and congratulated them on their efforts to find their sister, rewarded, certainly, by their faith in a good end to their labors.

"And Hannah—," said William.

Micah advanced to the bedside. He picked up her brown hand in his pale, freckled, warm one. It felt dry and stringy, but he imagined he felt its strength. As strong as the girl who had made it home again. "Han-nah."

He felt the pressure of her fingers, gazed at the dark hollows around her eyes and then into the eyes themselves. There he saw not weakness and starvation, but an exulting victory. He nodded. She knew she had won. He smiled. Her lips formed a questioning circle.

"Who am I? Is that what you want to know?"

She nodded almost imperceptibly.

"The Reverend Micah MacGowan, come to serve you on our Lord's behalf—all of you in Cincinnati."

She whispered something. He bent low. She whispered again, "Too young."

Micah straightened and grinned at her.

"William, I think Hannah needs to be—," began her mother.

William nodded, "Out, boys. Parson, would you like to meet her brother Harmon?"

Micah saw Hannah's eyes light up at the mention of her brother's name. "Of course. First let me tell Philip I shan't be returning to town with him." He could not tear his eyes away from the girl in the bed. "May I come see you again?"

She nodded.

Moments later Micah stepped off the low front porch. A dozen men and women lingered near the wagons, talking quietly in the darkening shadows. The apothecary glanced at him with a queer expression, making room for him in the circle. At once voices dwindled. Someone shuffled. Mrs. Fenn, he noticed, had crossed her arms and was gazing in tart defiance from one face to the next.

"Mrs. Roebuck has invited me to take supper, Mr. Thicknesse."

Philip nodded. "Then I'll leave you the mare. They must plan to ask you to stay the night. We don't generally go about after dark if it can be helped. Can you find your way back alone in the morning?"

He nodded.

"So you are staying!" said Persy Fenn, with a triumphant glance around. "You see, she does have something to confess and wants to get it off her chest ere the Lord cast her into the fiery furnace!"

"Now, Perseverance, that is too much."

"Don't you 'too much' me, Mr. Fenn! You can't tell me that—"

Fenn stepped in front of his wife. "Uh, parson—I'm Mr. Fenn. My wife's not always like this."

Micah felt pity for Fenn. He himself had just spent a week with Perseverance Fenn. Did her husband really not perceive that this was indeed exactly what she was like?

Fenn went on, "She had a long journey. That tires one of our age, don't it, Mother? We'll all be thinking more clearly in the morning. And thinking proper," he said with added emphasis.

"Maybe Hannah will be able to tell us where those ruffians went," offered another in tentative voice.

"Say, where's young Peter? Way he carried on after they took her off, I'd 'a' bet a bushel of apples he'd be here before anybody."

"Probably doesn't know. Someone ought to ride out to the mill."

"It'll keep till morning."

"Yes. God rest Hannah well tonight," said Thicknesse. "Good night, parson. We'll give yourself a proper welcome, come Sunday."

With the creak of wagon and clop of horse, the voices, the forms, faded away into the night.

Micah stood in the creeping silence, aware of the sensual richness of the earth, the timbre of insects' music, the stony glitter of stars, and the rich confusion of odors emanating from a cooling earth.

He turned back to the house. Warm light shone from the downstairs windows. The door stood ajar, inviting. With eager stride Micah retraced his steps.

Hannah's eyes opened slowly. Her grandmother's voice faded. Early sunshine flooded her grandmother's bedroom with light and warmth. This time is wasn't a dream. She was really home! Then she saw Harmon at the foot of the bed, looking down at her with unabashed tears streaming down his face. With a whimper of joy she struggled upright and held out her arms. Feeling a flesh-and-blood Harmon in her arms was too much for her, and she gave way to a tide of tears. As they broke away she was crying and laughing at the same time. Harmon brushed at his face like a bear pawing away ants.

"You've got a beard," she said. Her eyes traveled to the bandages, one coming up the side of his neck out of the homespun nightshirt, one hand with no bandage but a sizable scabbed patch that was drying. "You've put on weight."

"More'n I can say for you." Harmon managed a grin.

"Are you okay?"

"Stiff. Seven hits and none vital. Indestructible."

"Praise the Lord."

Harmon nodded. "And you?"

"No hits. Sore feet. Sore neck. Also indestructible."

The twins continued to gaze at each other for several minutes, filling the well of aching emptiness their separation had caused. Harmon shook his head admiringly. "Aren't we lucky. Tell me about it."

She began to talk. Before long, Faith and William came quietly in, then the younger boys. Faith insisted she drink a cup of warm milk. Joey

was still in his nightshirt, and his hair was tousled from sleep. On and on Hannah talked. The expressions on the intent faces before her shifted with her tale: outrage, scorn, anger at the tricks with the rope that burned her neck, pride at how their Hannah had been able to convince Swallowtail to abandon her.

"Then you came home!" cried Joey.

Hannah made room on the bed beside her for Joey, all adolescent elbows and knees. "Not quite, honey. I found a cabin. It was owned by a trapper. He didn't want to bring me back to Cincinnati. He wanted me to go somewhere else with him, so he could sell his furs. But Gra'mama—that is, I decided I shouldn't go with him and I—I left. I took his horses and left. All of his horses."

The blood drained from Faith's face. William put an arm around her.

"You had a horse?" said Thomas. "Where is he?"

"Well, I—," suddenly Hannah felt immensely weary. A buzzing sounded in her ears. She felt Harmon grip her shoulder.

"Later, kids, all right? Best get to your chores anyway."

"Oh, Harmon—Sure, Harmon. . . ." As the boys left the room Hannah slipped down again into the wonderful comfort of sleep. In a soft, faraway voice she heard her mother say, "What did she mean, mentioning your mother? Do you think she's delirious, Will? Someday she must write it all down. In Mama's diary, why not? For surely it was a miracle that our Lord protected the twins."

Hannah stood before the looking glass in Gennie's bedroom, trying to see all herself in the framed oval above her grandmother's dresser. She shook her head. Impossible to see if her hem was even above her kid slippers. She had dressed with scrupulous care today, choosing a calico cotton with a pale daffodil print. She felt a compulsion to avoid strong colors. Perhaps she just was not in the mood to call attention to herself, she thought. The dress was a little faded, which suited her feelings, nearly the color of the straw bonnet Aunt Rosalind had trimmed for her the year before last, which she now set carefully upon her hair. Having pulled her hair into a loose bun at the nape, with her fingers she coaxed a few strands out around her face, to soften the severely plain look she saw in the looking glass.

She pressed her palms against the edges of the dresser top and examined her face minutely. Her brown eyes were as wide and clear as ever, the neat fringe of lashes and well-shaped eyebrows the same as always.

Her cheekbones stood out sharply, but she couldn't even detect circles under her eyes, though her mother affirmed they were still there. She thought her mother was imagining things.

After all, she'd spent three weeks recuperating. She felt well. Really well. Her feet, owing to the soft moccasins, had not blistered, and her neck—gently she grasped the edge of soft cotton that formed a high-standing ridge above the neckline of her dress and examined the healing welts—well, the doctor said he thought that they would not scar.

Even if they did—Hannah smiled. What was it Parson MacGowan had said on his last visit? "Most people wear their scars inside. Yours may serve to remind you of the Lord's grace in keeping you safe."

At first she had thought his awkwardness amusing. So tall and rangy looking, so painfully sincere. *And that red hair! My word.* Her heart felt suddenly lighter.

The night of her return she remembered feeling an overwhelming sense of completeness. Complete safety, as if nothing could ever again harm her. With his own hands the Lord had grasped both ends of the broken circle of her life and forged it whole again. She fell into the feeling as into a bed of down a hundred miles deep. Surrounded by thankfulness and love, she had indulged luxuriously in uncounted golden hours of sleep, had allowed herself to be washed, cosseted, even served her favorite foods in bed.

Her father put his head in the door, interrupting her reverie. It came to her that her father was usually in the fields at this time. She noticed his thick-ribbed wool stockings. Faith had long insisted that muddy shoes be left outside.

"Good morning, Pa."

"You're up. Good. Don't you think it's time you stopped moping about and got on with your life?"

"What do you mean, Pa?" Hannah knew exactly what her father meant.

"A month or so ago, you were all for leaving us for the excitement of town living."

Hannah looked down at her slippers. "Yes, Pa."

"Well? Your aunt Rosalind is expecting you sometime. You haven't even been to town."

"You mean you aren't afraid to let me go?"

His dark eyes challenged her. She looked down. "Daughter, I was against it. But now you must get back on that horse."

141

She was silent. It was true. The first week after she came home she ate very little solid food and slept the sleep of exhaustion. Then for two more weeks she gained appetite little by little and ventured out on brief walks around the farm, dressed in old trousers and a shapeless shirt, never for long, never out of sight of the house, unless Harmon or someone else was with her.

"You're right, Pa," she said in a small voice. "I'll go in and visit with Aunt Rosalind today. Do you think Harmon could come with me?"

William stared at her for a minute. His mouth was set in a small smile. "That's my girl."

She noticed how easily Harmon swung up to the seat of the wagon after helping her up. "You're not stiff at all, Harmon."

"Nope. All better. Gee-ap! You?" The team plunged against the traces and they started off.

"No. . . . Everything seemed so strange when I came home. My life— something happened to my life, and nothing looks the same to me. It's like I'm seeing it second hand. But everything *is* the same. But it shouldn't be. All those terrible days, and people's lives here just going right on."

Harmon had slowed the team to a walk. He was studying her seriously. "This what you been talking to the new preacher about?"

She shook her head. "I don't know how I feel yet, Harmon."

"I'll listen."

The July sun had burned golden highlights into his brown hair. His eyes glowed with warmth and intelligence. He was big and agile, and— She smiled and leaned her head against his shoulder. *How handsome he is,* she thought.

Harmon's voice, which could tease her to distraction, was very gentle as he said, "About that trapper and the horses, Sis. You want to talk about it yet?"

She shook her head and straightened up. She turned away from him, as if she were admiring the rolling, forested hills between the road and the river, and tried not to think of the trapper. The trapper's horses. The—the furs. That was in her past. She had only done what anyone in similar circumstances would have done. "How is Peter?" she said in a carefully casual tone. "Was he hurt badly?"

Harmon seemed to need all his attention on his driving. "Peter Ruskin? No. Knocked on the head. Matter of fact, he was the one got back to town

and brought help for Bunty and me. He went out looking for you as soon as doc said he was okay. He was up home just the day before—"

"The day before I came back?" When Harmon didn't answer, she asked, "Why hasn't he been up to see me?"

"I don't know, Hannah. Shall we ride up to the mill?"

"No."

18

"Well, would you look here? If it isn't the Roebuck twins! You two are a sight for sore eyes." Joshua Kendall stopped in his tracks outside of Fenn's, a hundred-pound bag of feed slung in the crook of neck and shoulder.

Hannah drew a deep breath and smiled down from her seat in the wagon. "Good morning, Mr. Kendall."

"You look a lot better'n the day you come wandering out o' nowhere."

"Thank you."

His gaze lingered a moment. "You feeling okay?"

"Yes, thank you." Impulsively she added, "How's Betsy?"

"Fine. She come in with me today, getting stuff for her ma. Be glad to see you, Hannah. And you, too, Harmon, I daresay," he added with a grin. "She's right glad you mended up, 'case she forgets to say."

"Yessir, thank you," Harmon muttered and avoided his sister's eyes. Kendall went on to his buckboard, smiling.

Harmon glanced over at her, his fine brows wrinkled in a question.

"Shall we go in Fenn's, as long as we're here, or drive directly to Aunt Rosalind's?" asked Hannah.

"Just what I was thinking."

She nodded. "I know." Sometime she would have to walk down the street unafraid, face the prospect of meeting town Indians again, not the same ones—she doubted she'd ever see Swallowtail again—but others. With a deep breath, she said, "Let's walk all over town. It's a beautiful day!"

"Hannah!" squealed the voice of her friend Betsy Kendall. Betsy flew out of Fenn's and to the side of the wagon. "Oh, I'm so glad to see you!" She seized her hand and pulled her off the seat, down to the boardwalk, and hugged her. The pert gaze for once didn't stray toward Harmon. "Gosh, you look good. When I thought of you all alone with that horrible Swallowtail—*disgusting!*"

Harmon jumped down from the seat, came around the wagon and nodded encouragingly at his sister, then ducked into Fenn's.

Betsy's gloved hand clutched her arm and dragged her across the walk, to the weathered siding of the building, cosying toward her as if they were

two children snuggled under a blanket. "Hannah, you've got to tell me all, I'm just dying to hear."

Hannah stepped back. "Hear what, Betsy? Everybody knows that Swallowtail ambushed us."

"Yes, but why? You were the only one he took."

Hannah laughed uncomfortably. Betsy's lively gaze intensified. "He was drunk. He had some idea that he could use me for trade."

"Trade? To *whom?* And why?"

Hannah shrugged.

Betsy shivered. "How perfectly dreadful. Weren't you just horribly frightened?"

"Of course!" she answered with spirit. What had come over Betsy?

"Hannah.... I'm your best friend. You know I'd never repeat anything you told me—I'd swear on it!"

"I know you're my friend, Betsy."

"Well. . . ?"

"Well, what?"

"You know. I mean, what did he do to you?"

"Who?"

"Swallowtail?"

"*Do* to me? Swallowtail? What on earth are you talking about? I just told you!"

Betsy's face reddened. "Well, all right, I'm sorry, Hannah. I didn't know you'd be so touched up. Listen, I've got to go, Pa's waiting. I'll see you Sunday. 'Bye."

Hannah stared after her. She glanced at Fenn's door. Harmon was still inside. She could—no. She'd walk to Aunt Rosalind's. If she met any Indians, well, they were God's children, too. Not all were like Swallowtail. He'd never have nerve to show his face—

"Miss Roebuck! What a pleasure to see you again!" It was the barber. His pink, scrubbed hands twined comfortably across his black waistcoat as he teetered in the doorway of his shop. "Nice morning for a stroll, if the sun doesn't get too hot."

"Indeed it is! Have you done any nice wigs lately?" This had been a private joke between them since the day three years ago when she had watched him struggling to comb and curl the visitor's wig.

"Not lately, thank you." His small, black eyes rested on her with a thoughtful expression. "Business is slow right now. Would you like to come in and take a cup of tea? I have hot water in the shop. Wouldn't take a moment."

His words struck her oddly. "No. Thank you." She turned and hurried away. What was the matter with people? *Oh, silly,* she told herself. *It's just you. You had a dreadful experience, and people are just acting extra kind.* Hannah felt better, lifted her chin, and went on.

Fenn, with his lopsided gait, had hurried around the counter when he spied Harmon. He grasped the young man's hand with his left hand. "God's truth, it's good to see you upright, young man. That was a terrible business."

Fenn shook his head, and Harmon waited patiently for him to ask about Hannah. Fenn always liked to digest human affairs before settling on business, which he said once was his way of tending the Lord's business first.

"Young Peter was in yesterday. Lucky they found the boat. It belongs to his dad, o' course. Well, Peter, junior, too, *Ruskin & Son,* don't you know, so he felt responsible. And they had a sizable order of lumber on board."

"Yes, they did."

"Injuns didn't bother that, neither. . . ." Fenn went behind the counter and found a chicken-feather duster and busied himself with it. "The missus was over to see poor Bunty and says he's doing better. Burns my soul that he was taken advantage of! Poor man. Never done anyone a speck o' harm!" His voice shook with conviction. "Even Swallowtail, drunk as he must 'a' been, surely knew that! That just wasn't right a'tall!—You know we all been praying for him." Fenn peered at Harmon anxiously.

"That's good. Hannah and I may run by his place today."

Fenn dusted in silence a piece. "I didn't realize Hannah was with you. How's she feeling?"

"Fit as a cricket!"

As if to set the question at rest, Hannah swept in. "Good morning, Mr. Fenn!"

Fenn's face creased with delight. "Well, Hannah, don't you look pretty as a picture, yeller bonnet and all! I was just asking your brother about you."

Perseverance Fenn suddenly appeared through the curtain. With a start, Harmon realized she must have been listening all the time. That was odd. Why had she not come out, too?

"Hannah, my dear, dear, child! Well, praise the Lord, here you are back safe and sound! We didn't hear a flicker about you, 'way out home,

you were. We thought maybe something was wrong. Now you will have coffee with me!"

Hannah threw a glance at Harmon, part amusement, part perplexity at Mrs. Fenn's sudden spurt of neighborliness.

"That's nice of you, Mrs. Fenn," said Harmon, wanting Hannah to have a courteous means of escape, "but Aunt Rosalind is waiting for us."

"I was just over there," said Hannah. "She's not home. I thought she might be here, picking up some goods."

"The packet comes Sunday, Hannah. That's tomorrow. Her goods usually come from Boston, so she does her purchasing first thing Monday."

"Then we'd be delighted to have coffee, Mrs. Fenn." Hannah smiled at both Fenns and then at her brother. Even the prospect of Mrs. Fenn's truly awful coffee could not dim her growing sense of confidence. What had she been afraid of? Her town was as it had always been. People were the same—so good! She was the same. The incident had been just that, and it was over, praise God!

The four adjourned to the parlor that separated the storefront from the Fenn's living quarters. Fenn took a captain's chair that creaked when he sat, from which he could keep an eye out for customers. Harmon perched uncomfortably on the edge of a tiny, plush-cushioned chair.

"Well," said Persy brightly, plumping herself down next to Hannah on the settee, after she had served them. "I remember once when I was nearly grown, just about you children's age—"

Children! Harmon winced. "And I was out mushrooming with my parents and my brothers and sisters. It was a foggy morning, not quite light, and suddenly everyone had vanished! It was as if the devil had swallowed them up."

Hannah listened raptly. She loved tales, Harmon knew, and for her sake, he tried not to fidget. He glanced at Fenn and was startled to see an odd expression eroding that good-humored face.

Persy placed a tiny hand confidentially on Hannah's knee, "You would never believe how frightened I was, Hannah. That was back in the Mohawk Valley, of New York, and Iroquois were everywhere. I knew what they would do to a woman—oh, I knew!—but I told myself, no matter what happened, my Lord would keep me. And even if those Iroquois did have their way with me, I would still be the Lord's child and loved just as much! Isn't that just the way you feel?" Perseverance Fenn's face gleamed, her double row of little teeth set on edge.

Hannah half rose, the napkin on her lap sliding to the rug. "No, that is

not the way it was, Mrs. Fenn. That was a perfectly awful story! Why would you think of telling me such a thing? I think you made that story up! I think you are a dreadful woman!"

"What? What? How dare you speak to me like that? Did you hear her, Mr. Fenn? Now, you listen to me, Hannah Roebuck. People in this town are not dumb!"

Harmon was stunned. Events moved so swiftly he had not realized what Mrs. Fenn was up to. His cup clattered as he set it aside. He rose and took Hannah's arm. "It's time we were going. Thank you for the coffee. Mr. Fenn. Mrs.—" Without finishing his sentence he ushered Hannah through the store and out into the flood of clean sunshine.

Fenn trailed after them, his hand out. "I'm awful sorry. . . ."

Harmon looked anxiously at Hannah. Her face was pale and perspiring. Her hand shook as he helped her into the wagon.

Fenn halted on the doorstep, sick at the unfairness of his wife's attack. He stormed back into the parlor. "Mother, why on earth did you do that?" His index finger punched the air in her direction. "You are going to have a lot to answer for someday!"

"That girl spent more than two weeks alone with a bunch of half-naked savages, and you think folks believe that nothing happened? I wasn't born yesterday. And I know my Scripture! If she was righteous, she ought never to have come back, but here she is, big as you please, and expecting to hold her head up in this town!"

Fenn could only stare helplessly.

"We'll be home quicker'n scat," Harmon said as he headed the wagon out of town. He tugged off his kerchief and mopped his face. No air anywhere today.

"I do not want to go home," snapped Hannah. "I want to see Bunty. And then Peter."

"Hannah, don't you think—?"

"Do you realize what that woman was saying to me? Is that what everyone thinks? Is that why Peter hasn't been to see me?" Hannah held herself rigidly upright. Passersby would not have the satisfaction of seeing her cry. "Oh, that evil, evil woman! Here—here, isn't this Bunty's rooming house?"

"Yes, but—"

"*Please,* Harmon."

"Bunty?" said Hannah softly. The housekeeper had shown them to a small, pleasant bedroom off the hall of the first floor of her house. The young man lying in bed was an emaciated version of the man they knew. His head was propped on a bed pillow, the wispy, yellow-white hair like a nest of straw. Bunty's dough-white arms were angled on a turned-over sheet, his thumbs tucked into his coiled fingers. His eyes flew open at her voice.

"Hannah?" His voice was so weak! The welcome in it was unmistakable. Hannah smiled broadly, so she would not cry.

"Hi, Harm," he added. "I'm glad you brought Hannah."

"Told you I would. How are you doing?"

"I guess I'm gonna live," Bunty chuckled in a perfect parody of what the doctor and the apothecary had probably said to him. He had lost a lot of weight, but that, and the fact that he had just come through a near-fatal attack of pneumonia, did not mar the contentment on his face. His eyes gazed trustingly at his friends.

"We were almost goners, weren't we?"

Hannah nodded.

"Well, you know what they say," said Harmon.

Bunty nodded. "What?" he added.

"Friends who go through a bad time like we did are friends for life."

A slow smile spread on Bunty's face. "You and me are friends for life."

"Yes, we are."

"All three of us," added Hannah. "Oh, Bunty, you are such a special person. I'm so glad you are my friend."

Bunty grinned. "Me, too."

When they left a short time later, Hannah's spirits had lifted. "He is such a good person, Harmon. What would the world be like if we could all be as trusting and loving as Bunty?"

"Not bad," said Harmon soberly. They boarded the wagon. He waited. "Still want to see Peter?"

"No. I shall think of Bunty. Peter knows where we live."

"Lord, I am trusting that you put the desire to come to this village in my mind. Therefore someplace in your mind abides the plan through which I shall serve you." Micah MacGowan shifted his knees. The

threadbare carpet upon which he knelt was not much more resilient than the floor itself, a relic of better days in better houses. His elbows were propped on the window seat. From this position, Micah was able to gaze out the second-floor window of his room. He could hear the noises of the street below, wagons and horses clopping by, and occasional voices, and he could see the brown, brick-faced roof of the single-story tavern across the street. These two factors anchored his prayer to earth this day.

Micah had been on his knees for two hours, wrestling with his mission. He had requested this town meeting tonight. No one except him seemed to mind that it was being held in the tavern. He had won a small victory by gaining the consent of the tavern keeper, a slippery sort of chap named Haney, to withhold liquid refreshment during the time of the meeting.

As he finished praying he heard a voice he thought he recognized, a high, clear voice. He could not distinguish words, but the tenor was disheartened. He half rose and leaned over the window sash in time to recognize Hannah Roebuck and her brother Harmon driving away. They must have been visiting Bunty, the wounded and ill boatman whose room lay beneath his own. Perhaps Hannah would be at the meeting. Micah's spirits brightened.

As he shook the wrinkles loose in his best wool suit he considered that perhaps he should use a little of his money for a haircut and shave. It always helped to present a good appearance. Especially when he had a mind to ask the townspeople to alter their ways.

When he returned from the barbershop, a short while later, his ears still ringing from the pithy remarks tossed by other patrons, Micah reconsidered the handsome suit laid carefully over the counterpane. Perhaps the tavern was not the place for even that much formality.

Discovering a smudge of blood on his fingertip, Micah examined his face in the mirror. The barber in the little shop near Fenn's lacked the excellent precision of the chap who barbered at the Congregational Missionary Society, or even the skill of Lachlan's barber back in Baltimore. Hopefully his listeners would be so caught up in his plans for their city they would ignore the nick on his chin and the uneven trim of his sideburns, this evidence of the Lord chastising his vanity.

He replaced his best suit next to the vestments in the trunk and the wig that he had not donned since coming to this land and surveyed his alternatives. Formality aside, when all one's clothing was black, choice was greatly reduced. But a few minutes later, viewing the head and shoulders of himself in his traveling suit and an unblemished white stock in the

clouded dresser mirror and knowing the buckles on his pumps to be gen-
uine silver, Micah fancied he still cut a figure worth listening to. Carefully
he brushed the thatch of neat russet hair back and tied it with a black
grosgrain ribbon. The pale, freckled face reflected in the mirror gave back
a cheery look of hopefulness.

At last the sun dropped behind the hills, leaving an exhausted town still
baking. A breeze had swept away the mugginess, and the evening prom-
ised to be dry and perhaps cool enough to refresh. Micah was pleased to
see the tavern filling to a healthy capacity. Many he now recognized—the
solid, dependable corps who would doubtless make up the nucleus of his
own congregation. They sat casually around the tables in the tavern din-
ing room: gregarious, one-armed Fenn and his shrewd, ungiving wife,
Perseverance; Philip Thicknesse and his generous wife; the Ruskins and
son Peter from the mill (he must ride out and call on them); the barber,
whose name was Coulter, and a few others he had met in the barber's
shop or on the street; Josh Kendall and several other farmers; and Haney
standing behind the grillwork from which ale and stronger spirits were
served, as if to remind Micah that every hour spent on the meeting was an
hour in which he was losing money.

At last the Roebucks came in, Will, Faith, Harmon, and another
brother, Philippe. Micah noted that several eagerly made room for them.
He was disappointed not to see Hannah with them. Perhaps today's out-
ing had been too much for her.

Philip Thicknesse reared to his feet. Micah could understand why he
had been appointed peace officer. He had the gentleness that brooked no
quarrel, often seen in big men. "Parson MacGowan, just want to say be-
fore you open this meeting that we are rightly pleased you felt a call to
serve here in Cincinnati. In my business, I see a lot more of our citizens
than most, and you ought to know that we are all most desirous of your
contentment."

"He means we hope y'all stick around," drawled a farmer. General
laughter erupted, and Micah grinned.

"Preachers don't stay long hereabouts."

Micah acknowledged that with a nod.

"Some of 'em jest weren't man enough to take it. Life ain't no bowl of
was-sail punch out here."

The self-styled satirist got an even rowdier round of laughter.

The men laughing seemed to think of themselves as heroes, but Micah
perceived rudeness and ignorance, as in noisy and disobedient children
who will keep up misbehavior until forcibly stopped. He had noticed it at

the barbershop and on street corners. The Roebucks and a few others, Micah observed, did not laugh.

"One or two thought to stay and make themselves rich. They soon found out what the town thought of men who were not godly enough to trust in the Lord, as they were fond o' preaching."

"What's on your mind, parson?" called someone when the conversation lulled.

These men prized brawn. In any physical encounter Micah would be the man on the bottom. Few of them had an eye for beauty. Passing comments on the glory of their land, its sunsets, its richness met with blank stares. Money they understood. He was learning that they laughed at pain, at crudities, at discomfort. They accepted ugliness and plain food as the larger part of life. Yet at the same time he sensed an exuberant confidence among one and all that they were God's chosen, that God intentionally picked them for this land. And if God chose them, they were good people. They believed that. Micah offered a prayer and took a gamble.

"This is an interesting town. I've been here a month or so. We speak the same language—"

"*We* do, not you, parson."

It was said with good humor, and Micah accepted it as such and used it. "It's not only the language, friends." He scratched his head with a freckled index finger. "Maybe you can help me understand. You have a schoolhouse, but no teacher. And now you have a minister of God, but no church.

"The days are turned around here, too. My packet arrived from Pittsburgh on a Sunday. I expected to find all the good folk worshiping God. Instead they are open for business. And those that are not open for business are waiting on the dock to pound my backside and put me in the 'calaboose'—which I quickly learned was not a church."

A roar of laughter greeted this unexpected pronouncement. Micah saw heads nodding at each other in approval.

"Had us a schoolmarster, parson. He got bit by a bear and went home." This time the guffaws were tinged with guilt, and Micah was sure there was more to it than that.

"Have you looked in the 'calaboose'?" he quipped.

After the laughter had subsided, Will Roebuck stood up. He seemed at a loss for what to do with his big, red-knuckled hands. Finally he unbuttoned the jacket of his stiff-looking suit and thrust his hands in his waist-

band. "Parson MacGowan, we've found the schoolhouse is as good as any for Sunday preaching. Lord might like to see a few more souls there, but as you saw last Sunday, it's got plenty o' elbow room."

Many heads nodded in agreement. Others were listening intently, waiting.

"It is a goodly and sound room, yes," Micah agreed, "but doesn't God deserve a house of his own? Many of you have expressed to me your belief that God chose you to occupy this land. In England the good citizens feel the same way about their home. But you out here, not belonging to any country, you have more of a real conviction. You see it as a stewardship. And you are right. Canaan could not be any more beautiful."

He had their attention. He felt that they were soaking up his words like thirsty soil. He'd been warned they were used to hellfire-and-damnation preaching and would not feel properly churched without it. Perhaps he would get to that in a proper Sunday meeting. He rubbed his hands together, feeling them suddenly moist. "Now then."

"You mean there's more?" someone said in an aside.

Micah ignored this. "If I am to be your parson, what shall I live upon? In England every vicar has his parish house and his stipend, provided by English taxes. Should your parson oversee the spiritual needs of this town by begging in the streets the other six days of the week?"

Haney slipped out from behind his grillwork and propped his knuckles on his lips. "It was our understanding, parson, that the missionary society pays you seven dollars a week." His voice was cutting.

"For one year."

"Well, then. You are a single man. You have no family—"

"And no parish house, nowhere to receive or shelter the troubled and offer counsel."

"Cincinnati is a growing town," admitted Fenn.

"It would look real nice to easterners if they was to see a proper church," added Persy Fenn.

Will Roebuck stood. "I am a man that likes things nailed down, parson. You want a church that sits by itself, a house for yourself, more money, and you ain't happy that our children got no regular teacher."

Micah cleared his throat. "Well, perhaps set forth in those terms it does sound like a lot of wanting. But you must see that these are the tools necessary for God's work, not for me. Though I do like a bed and table of my own, as much as any man."

Finally Thicknesse began to chuckle. "I begin to see why our parsons never stayed. You've been more forthright with us than other men. Perhaps it be that red hair."

"Not very Christian, if you ask me," sniffed a feminine voice.

Micah grinned. "A parson who expects honesty of his people can no' do less."

"Last man called himself a Christian made off with my calf," repeated Haney to no one in particular.

Faith Roebuck rose and addressed the crowd. "I think that the parson is right. God made us a gift of this place to live. No one else will come forth and bring churches and schools and insist that our children grow up learned. We must do it ourselves. We owe it to our Lord in return for his blessings. I—," for the first time she faltered. "I feel above all so thankful. God has given our children back to us."

Betsy Kendall leaned forward and smiled at Harmon. He slid lower on his bench.

As Faith took her seat a general murmur of assent and a few *amens* acknowledged her words.

Philip Thicknesse rose. "You laid out your propositions with considerable boldness, parson. Now we must have time to think upon it."

"S'pose we do this, parson," said a handsome, trim man with black hair streaked with gray. "I am Peter Ruskin, owner of the lumber mill. S'pose we leave things be for a year. Mebbe you yourself won't choose to stay, if what we settle on ain't pleasing to ye after your stipend is cut off. Then if we all agree you should stay, we look at things again."

Micah nodded. "In everything but a church. Our Lord needs a church, whether or not I stay."

Ruskin glanced around. He seemed to have some standing in the community, and the assorted farmers and townspeople nodded agreement to the compromise. "Well, then. You stay, we get to work on a church, and—"

Haney waved his hand for attention. "And if that's everything, parson, I expect people have grown a thirst. Lot of us ain't supped yet."

Micah smiled broadly. That would do. For now. He started to lead them in prayer, but discovered to his dismay he had mistimed it, and they were already pushing back chairs and greeting neighbors. As they broke up, several women came to assure Micah of their support. Suddenly Micah heard angry words and looked up to see everyone's attention drawn to the Roebucks.

"She's fine, no thanks to you, Ruskin," he heard Harmon Roebuck say

to a strapping young man with broad shoulders and dark good looks.
"That ain't fair, Harmon. I was the one went for help when you and
Bunty were bleedin' all over the deck. Indians could 'a' still been around
and kilt me like that!"

"Hannah got the worst of it, and you ain't even been to see her, like
she's poison," Harmon shot out. Philippe scrambled to his brother's side.
A sudden, shocked silence stilled every tongue and foot.

"I tried to find her! I did!"

"Well, she's found!"

"After two weeks with drunken, half-naked creatures gone wild," said
Persy Fenn under her breath, but loudly enough to be heard.

The blood drained from Will Roebuck's face. He stared at Fenn. "If
your wife was a man, I'd kill her for that."

"Surely the girl should be welcomed home with all rejoicing," pro-
tested Micah, hastening toward the Roebucks to put himself between
them and Fenn and the Ruskin lad.

Perseverance Fenn egged them on. "Oh, yes, plenty o' rejoicing, but
none the sort you imagine. Half the men in town are waiting to welcome
her."

To MacGowan's utter surprise, several heads nodded in agreement.
"Persy, git home, woman! I told you—" Fenn stared miserably at Will.
"As God is my witness, Will Roebuck, I apologize for her. It ain't the way
I feel, and it ain't the way rest of us feel."

Fenn grabbed his wife and shoved her toward the door.

Philip Thicknesse seized Micah's sleeve to draw him into it, hoping to
halt an irreparable break. "You see, parson, there are hundreds of thou-
sands of acres to every white family between the Appalachians and the
Mississippi. Every man jack of us went out, even though it was like look-
ing for a will o' the wisp. There's only one reason that girl got safely home
again, and that is God was holding her in his hand, giving her courage
and strength. Some of us have been away from God so long we forget to
rely on him when we're in trouble and forget to thank him for miracles
like Hannah's safe return."

As if anxious to spare the Roebucks further anguish, his words were
met by a loud, shuffling chorus of *amens*.

"I'm sorry, parson, but I don't agree." The elder Ruskin clapped a
hand on his son's shoulder. "She must have done something or said
something for Swallowtail to act like that. He's a no-good, all right, Will,
but he ain't never bothered our womenfolk before. I told Peter, Junior,
the way I see it, it was Hannah's fault we nearly lost our boat and our

lumber and Bunty and Harmon nearly got killed. Not to mention causing you folks grievous worry, and mebbe she got only herself to blame if folks see her now as a stained woman."

With a cry of rage William Roebuck went for Ruskin's throat. At the same time Harmon and Philippe went for Peter. Fists flew, bones cracked, and grunts and curses exploded in the air.

Horrified at the drastic and ugly turn, Micah threw himself into the fray. The last thing he remembered was a hamlike fist blotting out his vision and feeling a sickening crunch in his nose and tasting blood in the back of his throat.

19

"You look like the devil's own," said Philip Thicknesse, when Micah let him into his rooms at the boardinghouse the next morning. "I did not expect to find you dressed."

Philip had taken him back to his shop and stanched the blood from his nose, which was broken. Mrs. Thicknesse had urged him to remain the night, but he had insisted upon going back to his own rooms. This morning, the bruising had spread to his eyes in an owlish pattern of black and stormy red.

"Come in." Micah's voice sounded peculiar in his ears. He could talk without pain as long as he did not move his jaw. He moved stiffly back and pulled a chair around for his visitor before sitting gingerly on the window seat.

"I took the liberty of asking your landlady to send up some coffee, and my wife sent over these." From his pockets Philip produced three dusty-red plums. "No, don't move, I'll just put them on the dresser." He glanced around with unease, noting a bundle of bloodied linens. "Ye are not planning to leave us?"

MacGowan attempted a smile. "No."

They heard the landlady's upward tread sandpapering the uncarpeted steps, and Micah waited until she had placed a tray of coffee, biscuits and preserves on the dresser, and closed the door again. Then he added "Although I do wonder now about the schoolteacher who got bit by the bear."

Thicknesse yelped a laugh. "By all that is holy, MacGowan, though ye'r not husky, I can see that it would take more than a wayward punch to keep ye down!" He poured coffee for them. "The men dearly love their stories. Did they add that the man left in fright because the bear died of the bite? No, eh? True enough. The bear was old and ill-tempered and practically toothless, and the man was convinced he was infected with some scrofulous disease. He left to seek a proper physician and never returned."

"And the children have had no teacher since."

Thicknesse nodded ruefully. "To our shame."

Though his face pained him and he was out of sorts, Micah was in no

hurry for his guest to leave. It was obvious he had more on his mind than bear tales.

"Funny you should mention our lack of schooling," said Thicknesse, one bearlike fist closing around a pewter jug of steaming coffee. The heavy brows knit fretfully. "What happened to you last night, I suppose one could say, might be due to the same lack. People move out to the edge of civilization and settle into a stunted way of life. Physically healthful, yes, if one avoids being killed, but they grow unused to thinking. They feel, and then they act. By and large they become clever and resourceful people, but lost to their own heritage. Being uncultivated, they make a virtue of it. 'Tis a terrible wage of too much freedom. One is not aware of the worst toll until it is visited on the next generation."

"And what is that?"

"Intolerance, my friend, intolerance for any ways save those they own."

Thicknesse left soon after. Over Micah's protests, he stuffed the pastor's bloodied stock and shirt under one arm for his wife to do up.

Micah mulled over his friend's words. Settlers push outward, they settle, they forget. Newcomers like himself and the luckless schoolmaster come with missionary zeal to reintroduce them to their faith and their lost culture and meet with resistance and ridicule. He noticed Thicknesse had not included himself in that estimation, nor the Roebucks. Well, then, at least he was not to be alone in the coming struggle to recivilize Cincinnati.

The Sunday after the fight in Haney's tavern, Micah MacGowan was back holding services in the schoolhouse. His battered face remained a mute reproach to those who came to hear the new man preach, for he never mentioned it during the two-hour-long service. At its conclusion he begged their indulgence for a few moments more. Quick glances were exchanged. Now maybe he'd get on them about fighting.

"Twenty years ago in England," he told the congregation, "a country preacher started teaching Bible classes for the children. The folks of his parish wanted their children to learn well, as well as to be godly, so that when they grew up they would be proper bearers of his Word. American children are no less needful of becoming responsible bearers of the Word. It is not easy for you, out here, with not even a proper schoolteacher."

An uncomfortable silence settled over them as they struggled to digest what Micah MacGowan wanted of them.

"Our youngsters get their book learning at home. Their mothers see to it."

"What if the mothers haven't time or haven't had the education them-selves?" Micah asked. In this land of few servants and not enough women, Micah had seen already the prodigious number of chores women were expected to shoulder. His question met blank stares.

Finally one of them ventured, "You saying our offspring ought to have more Bible learning?"

"Yes. As well as book learning. Proper stewards need to read and write and cipher. And to think."

"Maybe some of the ladies could teach a Bible class on Sunday, before the service," said William Roebuck, presenting a markedly different ap-pearance in his good wool suit and white stock, his dark hair neatly tied at the nape. Micah could almost smell the shaving soap. As before, the daughter, Hannah, was not with them.

"I will help, if you will show me what to do," said Faith Roebuck.

"Splendid!" said Micah. He glanced at the apothecary. Philip Thick-nesse was wearing a huge, proprietary grin.

It took little urging from Faith to persuade Micah to come for Sunday dinner, following the service, and early afternoon found him seated at William's right, before more food than he had seen since leaving London. The table creaked with the bounty of their farm. There were roast smoked pork and baked whitefish, squash, a mixed vegetable tureen of peas, parsnips, and carrots, baked sweet potatoes seasoned with butter and nutmeg, hominy fried in bacon grease, fresh greens from the garden, and the irresistible aroma of freshly simmered applesauce with cinna-mon.

William Roebuck rose from the head of the table. The tow-blond heads belonging to the three middle sons seated next to Micah on the bench stilled; across from Micah turned the dark, burnished heads of Hannah and her twin. The youngest, Joey, seated between them, stared at Micah's face with an awed expression, until Harmon elbowed him. At the other end of the long, oak table, Faith smiled radiantly around at her family and her guest.

Micah felt a stab of recognition of his own loneliness. He tried to imag-ine what it must be like to grow up in the secure bosom of such a healthy and wholesome family—surely an education equal to that of a chap raised as a poor relation until old enough to be sent off to school. He prayed that God would one day grant him to know. Hannah raised a shy glance and smiled at him. What an extraordinary girl she was, he mar-veled, to be so serene after being subjected to such unwarranted attack in Haney's tavern. Unless no one had told her about it. . . .

Her dark hair was wound in a loose coil at the nape of her neck. She was wearing a pale blue linen dress, ruffled at the shoulder, with a round neck and fitted bodice. Around her throat a wide strip of lace was pinned with a hand-painted brooch. He wondered if beneath the lace she still carried the scars of rope burns.

Hannah's velvet brown eyes glowed softly as Micah returned her smile. Then he bowed his head to listen as William prayed. "O Lord, we thank you for putting on our table the goodness of your earth. Bless my wife and all our children, that we go about our daily chores with a hearty spirit and without sin in word or thought. Thanks be to you for bringing us this Micah MacGowan, a mighty fine preacher of your word, Lord. . . ."

The children ate in decorous silence. Dinner was nearly finished when Joey screwed up his adolescent face and blurted, "You sure look awful, parson."

"Joey!" said his mother sharply.

Micah laughed and then groaned. The Roebucks watched him anxiously.

"Does it hurt bad?"

"Shush, Joey," said Hannah.

"I think my chastened spirit is more painful than my face, Joey," Micah said. His voice had a peculiar nasal quality, owing to the swelling. "It was hardly how I had planned to appear before a new congregation." Micah grinned as he said this, and relieved laughter rippled around the table.

"Wish I'd seen the fight," Joey persisted. "You were a hero."

"Yeah," added Matthew, "you stood up to the Ruskins and got punched instead of Pa."

"You stood up for Hannah."

"Hey! Be quiet!" ordered Harmon.

"Stood up for me?" said Hannah. Suddenly the table fell silent. "Parson MacGowan, how did you receive your bruises? I was told it was a fall."

"Now, Hannah—," said Faith.

"I'm gonna string you birds out to dry!" Harmon told his brothers.

"I've a right to know!" Hannah turned a troubled gaze on her father. William cleared his throat. "Daughter, it's best forgotten."

"No! What happened? Tell me!"

Harmon leaned behind Joey to give Hannah's neck a rough caress. "It was just something old man Ruskin said, trying to make folks think it was

your fault Swallowtail went after his boat. Not that anyone believed him! But me and Pa and Philippe had to make sure they understood."

"Mrs. Fenn started it," added Philippe. "Nobody meant for the parson to get hit."

Hannah would have shrunk into the bench if it had been humanly possible.

Harmon said quickly, "Hey, Pa, can we show Parson MacGowan the calumet that belonged to old Chief La Demoiselle?"

Philippe threw a startled glance at his father.

"What is a calumet?" asked Micah, anxious to do his part to relieve Hannah's misery.

"Like a long pipe," said Joey offhandedly.

Roebuck paused with a forkful of meat en route to his mouth. He took the bite and then chewed slowly and returned the fork to his plate. "It isn't here," he said reluctantly.

"Yes it is, Pa," said Harmon. "I saw it in the bottom of Gram's chest."

"No, I gave it to someone."

"Who?"

"Tecumseh."

"Tecumseh!" Hannah looked up. "When?"

"To help find you, Hannah."

"I'm the one who took it to his camp," volunteered Philippe. "They went crazy over it, like I'd brought 'em magic. Only Tecumseh wasn't there."

"He came here a few days later."

"Wish I'd seen him," said Harmon in tones of regret.

"He saw you. You were out of your head, Son." To Micah, William said, "He had six or seven of the meanest looking braves with him I'd ever seen. I knew if anyone could find Hannah, he was that man."

"I've heard of him, if it is the same man," exclaimed Micah. "Even back in Baltimore, they talk about him. The paper printed an engraving of him. He is a real Indian chief, isn't that so?"

"Chief of the Shawnee nation. His grandfather was a famous chief of the Miami, before the Miami got so weak they united with the Shawnee," said William.

"Him and us been friends all our lives," said Joey.

Micah glanced at Hannah.

Faith watched her with evident concern. "What is it, Hannah? Did you see him?"

"No, Mother."

The words were said so plaintively that her parents exchanged looks of alarm.

"People respect Tecumseh." Hannah stared out the window opposite. "If he had brought me back, everyone would have known I was—was just the way I'd always been." The words came out painfully. "I tried so hard to get home. I just kept thinking how everyone here was praying for me and imagining I could feel everyone's strength helping me to go on. But it wasn't—wasn't so." Slowly her head lowered. No one seemed to know what to say.

Finally Harmon jumped up and threw down his fork. "I'm going to kill that Fenn woman! It's all her fault. She's the one."

Faith grasped her son's wrist and pulled him down. "No, Son. You cannot change things by returning evil for evil. People like that know the truth and will not be content with it."

"Hannah." Roebuck's voice was more gentle than anyone had ever heard him speak.

She did not look up at him.

"You could not be more cherished in this house if you were an angel of the Lord. You are not to blame for the wicked tongues of others."

"But, Pa, it ain't fair!"

"Harmon is right, it is unfair," Micah said suddenly. "Forgive me, but I cannot understand people who choose malice as better than rejoicing. Perhaps a sermon on—"

"'Scuse me, parson. Not meaning to tell you what you should do or shouldn't do, but the less said about Hannah from here on, the better. Folks been lacking a guide on the uplifting path, to be sure, but seems to me if you was to pull their minds along the higher way, instead of dwellin' where they're used to thinkin' about things, it'd be more—more. . . ."

"*Efficacious*, as our friend the apothecary might put it?" supplied Micah.

"That's the word, all right," William said.

"You have not seen much of goodness since you came," admitted Faith. "But there is, parson. A lot of good people."

"They just don't bray like donkeys when they got something to say," added William.

Micah nodded. He folded his napkin and lined it up neatly with the edge of the table. "Miss Roebuck, would you care to walk?"

Faith said quickly. "Do, Hannah. You haven't been outside for days."

"It pleases me to see how well you are progressing, Miss Roebuck," said Micah as they strolled in the leafy shade of the peach orchard.

"Mother feeds me like the Christmas goose," she said quietly.

He chuckled. "What an odd analogy! . . . Christmas. Everything here in the wilderness is so different. I wonder how it can possibly seem like Christmas when it is Christmas. No streetlights, no carriages—well, not what we'd call carriages. In Baltimore I stayed with a preacher, Andrew Lachlan, for several months. At Christmas, more than any other time, it reminded me of ho—of London."

She glanced up quickly. "I warrant you miss it."

"Aye." He gazed down at her. "I miss the gardens. I would like to see you in an English garden. That is," he stammered, "I should like to show you our lovely gardens." Suddenly he added, "I was hoping that you would be up to attending service this morning."

She stopped and faced him, letting her eyes dwell deliberately on his bruises. "I am more a coward than you, Parson MacGowan."

"Please, could not you call me Micah? We are so near in age, and I'm quite the same as other men."

"I thought I was quite the same as other women." She started walking again. "Please accept my apologies. I—I am outraged at the way they have treated you."

"It was quite by accident."

She plunged on, disregarding his words. "That they can allow their hatreds to possess their sensibilities and—and *destroy* people. It is one thing when a person has done evil and God sees that he is punished. But it is quite another to be so *unfair,* and all with a deaf ear for the truth that lies all around them! A deaf ear and a blind eye and sitting in judgment!"

"Ah," he said softly, understanding that Hannah was no longer talking about him but about herself. He stopped and turned her to face him.

"I don't know how to fight it, Micah," she whispered. She looked at the valleys and peaks of his face, altered by the bruises he had taken on her behalf. Even the freckles were gone.

"The Lord will—," the words came automatically to his lips, then he stopped with a laugh of self-deprecation. "I thought I was prepared to meet every contingency, but no one has asked me the things I have answers to." He reached for her hand, pressed it softly, then let it go and placed his hand on her shoulder. Gently the ball of his thumb touched the lace around her throat. "You are so very beautiful, Hannah Roebuck. So beautiful. . . . Sometimes I think Satan abides within us, goading us to destroy the beauty and goodness in our midst."

The touch of his hand thrilled her and threw her into confusion. What did he mean when he said he was just like other men? Did he wish to

court her? She loved the way his clear blue eyes looked at her, as if he could truly see her. She backed off a step, and he sprang away, as if he had presumed too much.

"There is peach pie, Parson MacGowan, if a sweet is to your taste. Micah."

His eyes held hers for a moment longer. "If you prepared it, I shall find it exquisite."

A tentative smile crept into the corners of her lips. "I shan't tell you until you've had a bite."

Faith looked up when they entered. "Oh, it is so good to see you smile, Hannah." She flashed a grateful glance at Micah, a look that embarrassed Hannah. She busied herself fetching her mother's prized blue delft plates down from the plate rail.

Soon she and Micah were sitting on the porch steps and her parents on a bench against the wall, devouring generous slices of crusty peach pie in glistening syrup.

"Where is everyone else?" she asked.

"At their chores," said William. He cleared his throat and gazed out across the yard. "Hannah, your mother and I have been thinking mebbe you should take that trip to her people in Boston."

"Boston!" She glanced quickly at Micah and surprised a look of dismay before he had time to muffle it. "Would they still like to have me?"

"They have wanted you to visit for a long while," said Faith. "You could stay as long as you like. You could even take music lessons if you wished. They have a piano."

"Excuse me, sir, may I have your permission to offer a comment?"

" 'Right ahead, parson," said William.

"Thank you. If this trip is intended to help your lovely daughter recover from her bitter experiences, it is all wrong. As hard as it is for Hannah right now, surely it would be better for her to stay here and fight this cruel misunderstanding before it proceeds any further. I will help all I can. She is—," he turned to Hannah. "You are a—a—an exemplary young lady, a young lady any man would be honored to—to claim as a friend."

Micah swallowed and gazed stoutly at the Roebucks. William and Faith seemed stunned. Micah could guess at their thoughts. He had known the girl only a few weeks, and he was already declaring himself. And himself without two coins to rub together.

"Hannah?"

Before Hannah could answer her father, Harmon rounded the corner

164

of the porch, wheeling a barrow of manure for the garden. Gone were the Sunday clothes, replaced by the familiar brown nankeens. He parked the barrow and hiked a leg up a couple porch steps. His handsome, tanned face brimmed with anticipation as he said, "I just got a whopping good idea. Hannah ought to come with me to New Orleans."

Faith and William stared at him as if he'd lost his senses.

"How do you mean, Son?" asked William.

"Well, the ship the *James Ross* is due any day. Hannah's the one good with figures. I'm going to be busy arranging the sales of our wheat when we get to New Orleans. She could come and keep accounts." Harmon added awkwardly, "You know I'd take good care of her."

The look of utter love that passed between the twins was not lost on Micah. His heart sank. His efforts to keep Hannah in town appeared doomed.

Hannah rose to her feet, clutching the forgotten pie plate. "Oh, Harmon, it sounds divine! May I go? May I?"

"On a *boat*, downriver? Oh, William!" said Faith.

"Well. . . . Harmon would be with her. I think it would be a mighty fine thing for her."

"No!"

"Now, Mother, you weren't much older than Hannah when you come west with me. We had to come a far piece through Indian territory. When the schooner reaches the Mississippi, they will be in Spanish territory, and the Spaniards are at peace with all the tribes."

"But William, Harmon might be gone for months!"

"More'n likely," he agreed.

"But she's just a girl. It is different with girls."

"Faith, I have met the gentlemen from Marietta who built the schooner," William said. "Two of them will be along to oversee the sale of the *James Ross*. They are fine men. Our Hannah will not lack for responsible care."

"I can take care of myself." Hannah glanced at Micah. The stricken expression on her mother's face was repeated on his. "I *want* to go."

Part III

Hannah

20

The next week was the first period of happiness Hannah had known since early summer. As she grew absorbed in preparation for the journey memory of the hurts caused by the town's callousness began to fade. Many agreed privately it was a good thing that Hannah was going, whether because their own consciences were uneasy or that they were glad to see her spunk reassert itself.

Gradually, as word spread that William Roebuck had enough confidence in the enterprise to send his own son to factor the goods from Cincinnati, more and more people spoke to him about adding their surplus to the cargo.

The night before they were to leave, Hannah slipped up to the hayloft. She was barefoot, wearing her old nankeen jumper and a loose, cream-colored shirt. She pushed back the hayloft doors and settled comfortably to absorb the twilight hills gentling in a suffusion of red. The view never failed to give her pleasure. The Ohio ran like a ribbon of dark memory through the shadows. Strangely, rather than feeling anticipation, Hannah felt a sense of loss and wondered at it. It was as if she were leaving her girlhood behind. Was this how her little grandmother felt when she bundled up her baby and fled into a chilly night? No. Grandmother was fleeing for her life. She was frightened. She was. . . .

Hannah looked down at the soft brown leather of the slim diary, clasped like a prayer between her hands. And *she* was frightened. Isn't that why *she* was leaving? Micah wanted her to stay. Was she trying desperately to prolong her girlhood? To avoid moving into the ranks of sedate women with the little hands of children clutching their faded skirts that she saw in town every market day? Women whose eyes were permanently slitted from years of facing the strong sun and drying winds, eyes faded with exhaustion like their menfolks'? What else was there for women?

Or was it also that—suddenly her eye captured a movement outside the loft doors. Tecumseh was down below at the edge of the road, on horseback, out of view of the house. She knew instantly it was he. She couldn't be sure, but she thought he was watching the barn. She scrambled to her

feet and leaned out the loft doors to wave to him. As soon as she saw him head toward the barn, she turned and clambered down the ladder.

They met outside in the peach orchard, where just a few days before she had strolled with Micah. The glossy green leaves, changed by the swiftly darkening night, concealed them from casual view.

"Badger."

"Little Squirrel."

Swiftly, unexpectedly, she was in his arms. His lips came down to meet hers in a kiss filled with longing. Hannah gave herself up to the joy of his embrace. Her body tingled with new sensations. She strained to be so close to him that his strength would surround her and blot out the rest of the world.

At last they separated. Her hands crept up the soft buckskin of his tunic to his face, feeling the hard planes, the muscled ridges in his cheeks that told her he was smiling. She could make out his eyes, glowing softly at her. Again he took her in his arms, holding her close, gently, then releasing her.

"You are all I have thought of, my Little Squirrel."

"Badger. . . . Badger. I prayed that you would find me."

"You were cunning like a fox, a worthy and brave woman."

Hannah stood a little straighter at the praise. "I was so frightened, Tecumseh." She could feel his heat, smell the sweat-salt essence of his body. She moved apart from him. His presence was so strong, so commanding, that she could not think clearly so close to him.

"When your father sent the calumet, I set out. I found this." His hand placed an indistinguishable scrap of fabric in her hand.

She glanced up questioningly.

"The dress. Your marker."

"Then you did track me!"

"Yes."

"Did you—did you meet a trapper?" She felt the sense of fear roll over her again, overwhelming fear.

"He followed you after you left his cabin. A good tracker. And a clever one. When he found us on his track, he disappeared, Hannah."

"Then he is still—," she pulled in a deep breath, trying to conquer her trembling, "out there."

"Far away. I would know his track. Do not fear, Little Squirrel." He reached for her again, but she resisted. *And what of Swallowtail?* The question choked in her throat.

Tecumseh's deep, quiet voice faltered as he felt her resistance. Then he too backed a step and stood beside her. "My men and I tracked you as far as the bluffs. Tall Tree discovered the horses thrashing in the swift current. I feared you had drowned, but Tall Tree told me you had not."

"I heard your voices! I thought it was—" She laughed, a shrill edge cutting the sound. "And your friend did not see me? The bluff was where I let the horses go, Tecumseh, and waded upstream. If he was on the bluff, he must have seen me."

Tecumseh remained silent. She felt him reaching for her hand and she gave it. Gently he pulled her close again. "Hannah Roebuck, I need you to be my woman. I bring no gifts, but whatever your father desires shall be his if it is mine to give."

"Be a Shawnee wife?" Hannah blurted. With horror she realized that her own instantaneous reaction to being an "Indian wife" came from years of living on the edge of uneasy truces shattered by swift, savage fights. A "dirty squaw," the white women would call her. "Do you love me, Tecumseh?"

He chuckled softly, a deep, throaty sound that sent pleasurable chills through her. "You say love. I say I have desired you since you rode behind me on my horse as a child. You fill my thoughts. I want my sons and daughters to come from your body, to carry on the line of Tecumseh. I will care for you and protect you as long as I live."

Hannah shivered, overwhelmed by the urgency of his words. She wanted to tell him she loved him, too, had dreamed of him since childhood, but the words would not come. At last she stuttered, "But where would we live, Tecumseh? Would you settle on the land and be a farmer?"

"Tilling the land is women's work," he said with scorn. "But neither would I pass the day in gossip or in the smoke lodge. It is for me to keep the land free for all. You shall come with me. A woman, after all, receives the seed, as the land does."

"Can't someone else lead the Shawnee?" she said timidly. "You have done nothing else for years. Just a few days ago I heard a tale about you and your warriors in a battle in Virginia, days and days from here! But someone else said it couldn't be, that you'd been fighting soldiers up north!"

Tecumseh chuckled, and his warm hand cupped her shoulder in a brief caress. "Even I cannot be in two places at once."

"I would be so frightened, wondering if you'd been killed or captured.

You have no home anymore. It can't go on, Tecumseh. Everybody knows
that eventually we'll all—"

"Hannah!"

"But, don't you see that for me to live as you do is also impossible? We
could be so happy—"

"No!"

Hannah's fingers, womanly, assured, went to his shoulder, his neck, in-
vading the warmth under the coarse, straight hair braided over his left
ear. "Does the thought of being just a farmer frighten you, my Tecum-
seh?" He did not answer. Hannah's mind was tumbling about now, seek-
ing solutions. She had never really thought about—what did she fear? It
was true, she could bear seeds of greatness as Tecumseh's wife and
mother of his children. She never doubted his greatness. He did her great
honor to choose her for his wife. A new thought occurred to her. Perhaps
this was the Lord's will for her life. An unreasoning mushroom of fear
swelled in her stomach, and she knew that she hoped it was not so. She
was not strong enough. . . . Not even if through her peace could come
about? Humbly, she wrapped her arms about his hard middle and lifted
her face to be kissed.

Desire flowed through their bodies as they embraced with all the
sweetness and tender exploration of love first discovered. Gently Tecum-
seh pulled her arms away from him. "I must speak to your father."

Hannah shook her head.

He waited.

"You must give me time," she whispered. "I am—I am leaving Cincin-
nati tomorrow with Harmon. We will be away several months." She felt
him grow still. She knew instinctively that she was thwarting a dream to
which he had expected no opposition.

"Is your father sending you away?"

"It is my decision."

"You are deciding a thing like this for yourself?"

She smiled in the fragrant darkness. "Yes."

"And what of your Badger?"

She hugged him. "I must have time to think, dear Badger."

"I should have spoken to William Roebuck first."

She heard the hurt anger in his voice. "It would have been the same.
He would have asked me, and I would have said I must have time to
think."

"You would always be first wife."

171

"I would expect to be only wife," she replied tartly.

"I will not wait forever."

"Hannah!" a male voice called.

Tecumseh and Hannah froze like rabbits scenting the fox.

"Who?" Tecumseh hissed.

"Harmon. Coming! . . . It is not safe for you here, Tecumseh. If the soldiers catch you—"

"New Madrid," he ordered, naming a fur trading post where the Ohio met the Mississippi in territory beyond American control. "First new moon of next summer."

"How will I find you?" she whispered.

"I will find you."

"If I am not there—" But Tecumseh had disappeared, slipping away in the shadows of the orchard. She thought she heard his horse, but then it became Harmon's boots thumping on the hard soil. She ran out to meet him.

"What the devil are you doing out in the peach orchard? I've been looking for the ledgers. We've still got cargo to enter—"

"Tecumseh was just here."

Harmon stopped a few feet from her and glanced around. "Here? Why didn't he come up to the house?"

Hannah caught up with him, and they walked slowly toward the flickering lamplight coming from the house windows. She could see her mother and brothers moving around inside.

"Well? What's the matter with you?" he said with sudden suspicion. "What did he want?"

"He came to see me. He is in love with me."

Harmon's answer was a disbelieving howl.

Hannah's dream state crashed to earth, shattered by anger. "He wants to marry me."

"And be a farmer? Settle down? Raise little half-breeds?"

"Harmon!"

"Listen to me, Sis. Somebody's been into the cider, and it ain't me. It would never work. Even if you loved him, it would never work."

"He won't be a farmer. It's not his mission."

"He's got that right. He's got all he can do to stay alive."

Tecumseh captured by American soldiers. Tortured. Imprisoned. Caged and helpless, ridiculed, the way she had been. "Harmon, I can't go with you!"

"You can't change your mind now! Our family would be a laughing-stock."

"Is that all you care about?"

"Well, what do *you* care about? You aren't telling me the whole truth, Hannah Roebuck. Come on, out with it!"

She had never seen her brother so angry. "I thought I could go with you and everything would be all right again. But I—I'm so afraid I can hardly breathe. That's the truth, Harmon. I can't get rid of that feeling, that deep *knowing* that Swallowtail and his men could have done as they pleased. I have nightmares about it. They could have buried me, and no one—"

"Hannah...." Awkwardly he threw an arm about her shoulders.

"They still could! No one has ever found them. There are dozens of tribes between us and New Madrid; there are renegade Indians who hate Americans and Americans who shoot Indians on sight—you know some of them are that way.... Seeing Tecumseh made me realize I don't want to be where it could happen again. I could go to Boston after all. I could stay with Mama's people. They still want me. And then maybe later—"

"You don't love him."

"I—I think I do. But I'm not sure."

"If you were really in love, you'd go with him," Harmon said.

"What makes you so sure? Have you ever been in love? I know that Tecumseh is not like other Indians. He is a man of such honor—he is like the colonel at Fort Washington, brave and fearless and looked up to."

"Even if you do love him," Harmon said softly, "even if you do, if you go running off to Boston now, you'll never be sure, will you? You'll be running away again. That could get to be a habit, you know. Parson MacGowan would say the same thing. You know he would."

Hannah bit her lip and felt the pain. Even Harmon thought she was running away. They stopped at the base of the porch steps.

"Well, Hannah, let me know when you've made up your mind. Meantime there's still those ledgers." Harmon took the steps in one leap and vanished inside.

Tall Tree watched the young man leap to the porch and go in. Hannah was alone. His hand lifted the bow with the cocked arrow. An arrow now and the question of Hannah Roebuck would be forever solved. It was up

to him, Prophet, spirit man of the Shawnee, to guide Tecumseh away from harm. If his brother took a white woman, his strength and power would trickle from his body like the skin shed from a snake. He would leave the nation weakened. He would become like Swallowtail, despised, like all renegade men of the civilized tribes.

As he watched Hannah trudged up the steps and into her lodge. His arm arced slowly downward. Not here. Tecumseh must not guess how the blow came. There would be other times, other ways. Meanwhile he would see that Tecumseh purified himself in the smoke lodge while Prophet prayed to the god of the underworld. One way or another, Prophet knew he would destroy the bad medicine, the white woman ensnaring his brother.

Hannah decided to skip her prayers that night. In her flannel bedgown she huddled under the quilts in Gra'mama's old bed, hers since Gennie's death, feeling confused and miserable. Suddenly she remembered she had left the diary in the loft. She must remember to put it back in the trunk before they left tomorrow. Before they left. Then was she going after all?

How had Gra'mama known it was right with the Lord for her to leave? They all lived in hope of salvation. What if God's plan for her life was that she should go with Tecumseh? Perhaps she was meant to help, in some small way, to bridge the trouble between Tecumseh's people and her own. The nameless fear came back, hovering somewhere in her midsection. She slipped out of bed and clasped her hands and began to pray.

The last day of July, 1797, dawned in a blaze of heat. By midmorning the dew would dry from all the hidden corners of earth and blade. By noon animals would be slinking for shade and humans for naps.

The small dock at a shallow scoop of inlet on the Ohio was dwarfed by the anomalistic presence of a 250-ton, ocean-bound schooner moored 40 yards offshore. The red oak hull of the *James Ross* gleamed like a mug of Haney's beer. The white pine mainmast sheered up like a flagpole empty of flag, awaiting the canvas sheets that would be fitted in New Orleans, 2,000 miles away, crowning the end of her maiden and only voyage as a river vessel.

The citizens of Cincinnati, large and small, farmers and townspeople, gathered on the dock for a picnic to launch their fantastic venture, to send their portion of a bounty unheard of from the wilderness of the Ohio. It would be a signal of their enterprise to men and women of other nations in faraway New Orleans. At the last moment, the women of Cincinnati got into the spirit of the communal undertaking and added small wooden drums filled with preserved and pickled foods of all descriptions, carefully sealed and crated.

"You be sure to fetch a good price for my pickled corn chowder," Betsy Kendall's mother admonished Hannah, one hand protectively on a crate to be loaded, which represented a summer's labor in garden and kitchen. "And my beets and beans and the preserves."

"I'll do my best," promised Hannah as they stood together with Faith Roebuck on the dock. "I'll check all the storekeepers in New Orleans. Folks probably have never tasted food like we are bringing."

"Too bad there be no way to carry your peach pies," Mrs. Kendall added graciously.

"The ladies can make their own," Hannah laughed. "Four of the farms are sending bushels of dried peaches and apples." She glanced casually at Faith. Her mother had said very little this morning. Several times she had caught her looking at her with moist eyes.

"Mama, aren't you going to kiss me?" Hannah opened her arms.

The two women embraced. She heard her mother sniffle against her shoulder. "I thought it was so fine and brave of you to set out with Harmon. A little part of me has always wanted to go on. I guess it gets in one's blood. When I was your age, I was setting out, too, with never a thought nor fear that I remember." She held her daughter quietly, and Hannah felt an inexplicable shift in their roles. She hugged her mother reassuringly.

"I am still in the Lord's keep, Mama. After this year, probably everyone will want to be the one to take new boats down the Ohio. It'll be a regular event."

A ruckus caused by two mule teams trying to occupy the same space simultaneously brought the conversation to an end. The lumber from Ruskin's mill had been loaded yesterday, and all morning men had poled back and forth on flatboats bearing the last of Cincinnati's cargo. The women's foodstuffs topped out the leftover space. All told, the schooner carried from both cities 721 barrels of flour, 500 barrels of whiskey, 4,000 deerskins, 2,000 bearskins, hemp, flax, firearms, ammunition, plus provi-

sions for a crew of eight and for five passengers, representatives of the owners and farmers.

Hannah had had several glimpses of Peter Ruskin among the men hauling lumber. Neither had spoken. It heartened her resolve to leave.

"I'm going to miss you, Hannah."

She jumped.

"Sorry," said Micah. He smiled down at her. His bruises were faded to yellow, and the freckles again reappearing, like stars coming out at night. He was dressed as always in black wool, the sobriety lifted somewhat by the sun's glint on his impossibly red hair, water slicked to a dark russet.

"Sure you won't change your mind?" The blue eyes searched her face.

"I was tempted." She smiled. The Lord had not said *not* to go. Micah was worried about her, she knew, and she forced herself to appear gay and confident.

"Promise me you'll not forsake us for any French fellow."

"Please, Micah! My French grandmother would not have liked to hear that!" She relented. "I shall write to you and save the letters until there is a means to post them. You must write, too."

Solemnly Micah took her hand and kissed it.

"Hannah!" called a familiar voice.

"Bunty! Bunty, are you well enough to be about?"

"Yep." The towheaded man, thin and pale but wearing a cocky grin, looked over the schooner with a boatman's eye. "This here's the biggest boat I ever seen. You really going on her, Hannah?"

"I really am. I wish you were, too."

"Harmon says next time I can. He promised. I'll be as good as new by then." A last smile for Hannah included Micah, then off went Bunty to greet other friends.

She turned back to Micah. "I *will* be back, Micah."

"I hope you find what you're looking for."

His remark startled her, but by then she saw her father coming toward them through the noisy crowd.

"Parson MacGowan, will you say a blessing on our ship and its people and the cargo?"

"I shall be proud to." The crowd grew hushed as Micah sprang up to the bed of a buckboard and raised his hands for silence. Heads bowed and Micah blessed the enterprise, those going and those remaining. As his voice uttered the amen Hannah heard her father's deep voice begin to sing a new hymn from London that Micah had taught them: *"All hail the power of Jesus' name! . . ."*

Quickly the rest of them took it up. While they sang, the captain and crew lined up on the edge of the deck, listening. *"Let angels prostrate fall. . . ."* Then the representatives from Marietta and Harmon and Hannah climbed aboard the flatboat. As soon as they had boarded the schooner Captain Swinburne took the helm, the crew cast off and seized poles and oars. Unwieldy at first, the *James Ross* inched inexorably away and out into the current.

"Good-bye! Good-bye!"
"Bring forth the royal diadem.
"And crown Him Lo-o-rd of all!"

177

21

The current was running about eight or nine miles an hour, Captain Swinburne estimated as he ordered the big schooner freed of its moorings. With hardly a creak it gathered speed and fishtailed into the current, requiring two men on the large steering oar to keep the rudder responding.

As they floated peacefully downstream, day by day, passing forests of sycamore, locust, birch, acacia, and red maple, Hannah found herself growing more relaxed and less afraid. She no longer stared each day at the thick stands of showy red maples and wondered if somewhere in their depths lurked a man named Jack Wheat. She laughed at wild turkeys, with deep red feet, who raced clumsily along the banks, their huge wings unfurling as if about to launch; she listened to their gobbles and screams and no longer imagined in them the secret shouts of angry Miami.

Twelve days after leaving Cincinnati, crew and passengers merged on deck, listening, the captain with chart in hand. It had started as an indistinct rush—wind in the treetops or a flyover of ducks. The sound grew into a noisy roar.

"It is the falls!" shouted the captain, with the relief of one who wasn't all that sure of his territory. "Louisville to port soon. . . . Sure enough, here's the fort coming up, you can see it!"

Falls! thought Hannah. *That is what it was.* For an instant her breath caught in her throat.

Harmon said, "Not frightened, are you, Sis? Lookin' a mite peculiar."

"I just realized where I heard the sound of the falls before."

"We've never been here."

"I have. Swallowtail camped near here one night. From then on we went north. I did not realize there was a settlement across the river, but he must have known."

"Now don't be alarmed, folks," said Captain Swinburne. "We don't propose to go over the falls. We go around them." A wizened, capable man, Swinburne had run a packet line for nineteen years between the cities of Pittsburgh and Marietta.

As the big ship began easing out of the current, toward the inadequate dock, a flag of thirteen stars and stripes whipping smartly from her rear

mast, inhabitants of the city of Louisville began to collect on the levee. Other folks, white and black, children and grown-ups, were running along the top of the levee, waving their arms and shouting.

Harmon chuckled. "They don't know what to make of us."

The Kentuckians pointed and gaped in amazement at the huge, sleek schooner headed their way.

Captain Swinburne cupped his hands. "Ahoy!" he shouted with boldness. "Permission to anchor. The schooner *James Ross* out of Marietta, Ohio, bound for the Atlantic Ocean!"

A spontaneous shout of welcome rose from the shore. Louisville had been laid out in 1773, on a floodplain behind the levee of the Ohio. Its site was chosen not only because of the rich lands, but because it offered portage for river cargo. Over a promontory guarding the river, where it made a sharp bend south, rose the fort they had seen. It has been built by the explorer George Rogers Clark, who led the first party of settlers to Louisville in 1778.

The ship anchored above the head of the falls, and the eager passengers were rowed ashore near the dock. "My word, this is a beautiful place," exclaimed a merchant from Marietta, who at the last moment had decided to include himself in the grand adventure.

"It's so *settled*," said Hannah in amazement. It felt strange to be walking on land again, and she clasped her brother's arm. Once over the high levee, they could see how utterly different it was from Cincinnati. The streets were broad and crossed by other streets in orderly fashion. Already trees had been planted at regular intervals, so that Louisville looked in places like the backgrounds of *boulevards* in Aunt Rosalind's fashion books.

"And the fields. Just look, Harmon, corn as far as you can see, and that blue-green field could be tobacco."

"No wonder Tecumseh couldn't keep Americans out of Kentucky."

"No wonder he's still trying," she said tartly. "This was part of their own hunting lands."

"Too bad, it's a state now."

Hannah tore her attention away from the small, graceful carriages passing on the street below the levee and the freshly planted saplings that separated the street from the pedestrian boardwalks. "You sound angry. What is the matter? Don't you like Tecumseh anymore?"

Harmon glanced briefly at her. "Since you ask, I'm beginning to think I don't."

"Harmon!"

"It wasn't fitting for him to ask for your hand. And he wasn't even man enough to come up to the house."

"You are twisting it all around. He could be shot on sight."

"Even so. . . . He's an Indian, Hannah. Don't that make no difference to you?"

Hannah could not answer. She did not know herself.

Captain Swinburne caught up with them. "Ill news, my children. The water is too low to portage the ship around the falls. We will have to remain in Louisville for a time."

"For how long?" asked Harmon.

Swinburne shrugged. "Two weeks, two months, they tell me, until the tides raise the river level again. And," Swinburne paused dramatically, "if it don't happen before a good freeze sets in, we could set here till spring."

The twins looked at each other. Hannah could almost see Harmon's brain whirring and clicking.

"Good," he announced. "I have a use for the time." Then he looked at Hannah and apparently realized that he would be leaving her unchaperoned. "Captain, do you think there is an upright family in town where my sister could stay in safety and comfort until we leave again?"

Swinburne laughed. "You got me, laddie. This is my first trip, too."

The Grayson house, they learned from those on the docks, was the logical place to start. It was the pride of Louisville, a three-story home that had just been completed. Its wealthy owners were famous for their charity and hospitality.

True to their reputation, the Grayson family graciously extended a welcome to both Hannah and Harmon. Entering into the spirit of the plight of their unexpected guests, other settlers came forward with offers of hospitality, until everyone was assured a home. Swinburne appointed a watch to keep an eye on the tides, so that they might continue their journey at first opportunity.

Harmon lost no time organizing a party of four and renting horses in exchange for goods. They had traveled only ninety miles, but he was determined to explore parts of Kentucky that lay to the south. Everywhere the blue grass and the hundreds and hundreds of acres under cultivation astounded him. He had a mind to survey the crops being grown within fifty miles of the river and, if possible, win consignment of goods for future trips.

Hedges, one of the owner-farmers from Marietta, was bubbling with different enthusiasms. "I've talked with lots of folks here today, and I tell

you there are fortunes to be made without going another step. Why, do you know what they are willing to pay for milled wheat flour? It never entered my head that a place so near wouldn't be growing the same crops as we! With your permission, captain, I will gladly pay the crew to haul my goods off right here. I might as well start selling. Who knows what could happen to the ship before we reach New Orleans? Or New Madrid, for that matter?"

Harmon and Hannah exchanged glances. He was referring to the fact that the waters between Louisville and New Madrid ran through danger-ous Indian country. If they should be so unlucky as to get hung up on a sandbar or in a shallow channel at low tide, they would be like a foun-dered duck in a mud pond, ripe prey for predatory Indians.

The afternoon before Harmon was to leave, he came seeking Hannah. "You know you could come, too, if you really wanted to. 'Course it'll be a hard trip, not really fittin'. . . ." He trailed off and caught her eye. They exchanged grins of perfect understanding.

"Go, go, for heaven's sake!" she said. "This may be my only chance for civilized living, until we reach New Orleans." Harmon had demonstrated growing enthusiasm for the free life, unconstrained by the hard realities of farm living, the inescapable chores, the endless cycles of plowing and harvesting, feeding, milking, and butchering.

"You sure you won't mind, Sis?" Then off he had gone with all the in-souciance of a lad ducking school for a fine afternoon's fishing.

After he left, Hannah tried to insist upon earning her keep by helping out. She soon found this embarrassed her hostess.

"We have our people for all this work," Mrs. Grayson said, in a soft, pleasing accent unlike any Hannah had heard. Mrs. Grayson came barely to her shoulder, a dark woman with obviously French blood. Hannah soon learned "our people" meant black slaves. She remembered once, when two gentlemen and ladies had passed through Cincinnati, there had been two dark-skinned people, a man and a woman, who attended them. It had never occurred to her that they might have been slaves. They prob-ably were. And now she was discovering that this nice Mrs. Grayson and her husband owned almost as many slaves as there were settlers in Cin-cinnati.

". . . House negroes. Most of them, of course, work the fields," said Mrs. Grayson, leading Hannah out on a tour through the flower gardens.

Hannah nodded, not wanting to offend her hostess. "I am sorry, Mrs. Grayson, if I sound ignorant. I suppose I am. We don't have slaves in Cincinnati. The ordinance, you know." The Northwest Ordinance,

passed a dozen years earlier, had forbidden slavery in the Northwest Territories.

"That always struck me as very odd." Rose beds, laid out with formal precision between manicured box hedges, flanked the short walk from the carriageway to the verandah. "The British are still disputing the American right to all that land, and those people up in Philadelphia go right ahead making silly laws."

Mrs. Grayson glanced up at her with a deprecatory smile. "I shall give you an example you can appreciate, since I know you all still have your little problems with the Indians. You've heard of that famous chief Tecumseh? Well, in Philadelphia they know perfectly well this is an American state, and those savages have *no right,* absolutely *no business* abiding here at all. That Indian is still on the loose, stirrin' up trouble. And all they do, up in Philadelphia, is make more silly little laws, which no one pays the slightest bit of attention to, when they cannot even enforce the ones they have already made."

"Mrs. Grayson, I do not know anything about Philadelphia, but I know Tecumseh. He—"

"Surely not!" Mrs. Grayson brought a perfumed lace handkerchief to her nose.

Hannah felt like shaking her. "I grew up with him. He is the sort of man one—one looks up to."

"Man?" Mrs. Grayson laughed, *"Man?"* Her little hand went out in a broad gesture, encompassing the slaves working in the rose garden and beyond that in the tobacco field.

That hospitable, piquant, well-kept little face. Hannah stared into it, suddenly appalled by the differences between them. How had she grown up speaking the same language, worshiping the same God, owing allegiance to the same Constitution, the same laws as this creature? They were no more alike than Tecumseh and Swallowtail! Suddenly she could hardly wait to resume their journey. She made herself smile at her hostess. "Shall we stroll back to the house?"

One blustery afternoon Hannah was seized with restlessness. Harmon had been gone over a month. She had washed and mended all their clothing, sewn extra undergarments for them both, spent long afternoons in the Grayson's library—more books than she had ever seen—reading English works and struggling through a French work by La Rochefoucauld. Now she dressed in her warmest clothes, heavy knitted stockings, several petticoats, ankle-length wool skirt, linsey-woolsey bodice laced

over a fine wool blouse, and her wool cloak, new last year (she had wanted to buy red wool for the cloak, but even after she had convinced her mother that red would keep her just as warm as brown, there was none to be had in Cincinnati). She tied a bright forest green scarf over her dark hair.

"Shall I come with you, Miss Hannah?" asked a gentle-faced Negro girl who had watched while she dressed. Mrs. Grayson had lent the girl as a personal servant during Hannah's stay. The girl appeared to be ten or twelve. If she had parents, they were never mentioned. The girl worked as long and steadily as any housemistress, was forbidden to retire until after Hannah was in bed, and was always up before Hannah herself, to see to a fire in the fireplace in her bedroom.

Hannah picked up a slim volume of poems by William Blake, which she had been reading. She offered it to the girl. "Here. This man writes small verses about tigers and lambs. Stay up here and read by the fire while I am gone."

"No, Miss Hannah."

"Don't you like to read?"

"It hain't allowed, Miss Hannah."

"Because you are working, you mean?"

"No, Miss Hannah. Books is bad luck. My mistress, she say so."

Hannah started to say more, but could see that the girl was growing uncomfortable. She smiled. "Well, at any rate, I wish to go alone. I'll not be gone long."

"Yes, Miss Hannah."

Hannah walked briskly through Louisville. When she reached the dock, she paused to consider the *James Ross,* rocking at its moorings, looking forlorn, it seemed to her. Suddenly Hannah grew aware that she was not alone. From a distance of several lengths, a tall Indian was staring at her. He was dressed inconspicuously, like a half-breed or trapper, yet something about his posture disturbed her. She felt instinctively that he was her enemy.

He called out. "Granddaughter of Spirit-Who-Cries!"

Hannah gasped. She glanced uneasily about and suddenly realized they were alone on the dock. As if by magic she had stepped into a dimension in which only she and this—whatever he was—existed. "Who are you?"

The Indian stepped closer. His eyes seemed to burn. His face was in the gaunt. He began to speak rapidly, in a dialect that combined syllables of the Miami and Shawnee tongues. She was able to follow with difficulty.

"Chief La Demoiselle gave the land to Roebuck that he might dwell among the Civilized People. Spirit-Who-Cries nourished the Civilized People. She was a healer, a link between this life and the unseen world of the Great Spirit."

"How do you know about my grandmother?" The man's intensity frightened her more than his person, a sense that he might do something quick and irrational. What if he was a relative of Swallowtail's? Her heart began to pound as she forced herself to scrutinize his face for resembling features. She saw nothing that reminded her of the dull, slovenly town Indian.

The man fixed her with a stare. "You are also a link. A link between this life and the unseen world of Motshee Monitoo. You have come to destroy our chief. You bear the mark of the underworld." The Indian seemed to stretch even taller before her eyes. "I, Prophet, know this."

She backed a step toward the end of the dock. "Prophet? Who is Prophet?"

"One whose destiny it is to guide our great leader and to vanquish his enemies."

"Who is your leader?"

"Mighty Tecumseh, war chief of the Shawnee."

Hannah shook her head with the beginning of relief. "Then you know Tecumseh is my friend. Our friend, of all the Roebucks."

Prophet's lips drew back in a mirthless grin, revealing broken, decaying teeth. "And Swallowtail, too?"

Hannah choked back a cry of horror.

Prophet seemed pleased by her reaction. "Have you ever seen a man beg to die?"

"Stop this! Does Tecumseh know you are here?"

Prophet seemed to grow weary of the game. Angrily he said, "I, Prophet, know Tecumseh's desires and needs best. You release him, O daughter of Motshee Monitoo!"

Suddenly Hannah remembered how the Lord had protected her when she had been Swallowtail's captive. Staring at the man who called himself Prophet, she willed a wall between himself and herself, willing herself into God's protective custody. She felt her fear vanish as if it had been a physical oppression.

"I will not listen to any more!"

"Tecumseh and I tracked you after you bewitched Swallowtail. We found the places you lay with Swallowtail."

Hannah bit back a retort. Anything she might say now would only

goad him further. The Shawnee was raving on as if he had forgotten she was even there. She began casting about for a means of getting away from him. Surely, someone would appear soon, and she could call for help!

"We found a cabin and a dead Long Knife. We found Swallowtail and his friends rotted with rum got from the Long Knives. We tracked you to the river. It was I who let you go."

"Tecumseh did not see me."

For the first time, Prophet looked away. "It was not necessary to tell Tecumseh. You would interfere with his destiny." He looked back at her, a swift glance filled with deadly intensity. "I believed the night spirits would take you then, but they did not. Your power was too great, O night side of Spirit-Who-Cries."

Hannah heard voices and saw several men on horseback at a distance, recognizing by their low-crowned, wide-brimmed hats some of the local planters. Relief flooded through her. She turned back to the Indian. He once more seemed merely human. "I shall always be Tecumseh's friend. Nothing you can do will change that."

Prophet's eyes flicked from the approaching riders back to her. All was not finished between them, he seemed to say. Then he turned his back deliberately and sauntered away.

Hannah stared after him. The cold was numbing her feet. Her fingers felt icy. Slowly she began to walk back toward the protection and warmth of the Grayson house.

Tecumseh leaned against a tree. He was dressed in furs against the cold. In his hand he held a gourd bowl filled with a hot stew of rabbit and dried green corn boiled with beans and dried pumpkin, which he was scooping up with a horn spoon. Traveling by horse, with only a young brave as companion and servant, Tecumseh had covered 300 miles in the last moon. The industry of summer had brought a bounty of goods for trade among the tribes. He had seen lodge after lodge filled with beeswax, honey, bear oil, tanned skins, and furs. It was well. With the return of industrious ways they would soon grow strong and be able to resist the lure of false goods. He scraped the last bit of food from the bottom of the gourd and then brought it to his lips to drain the savory juices.

He wondered what Hannah was doing at this moment. He knew that the great house-on-the-water carrying her down the river was landlocked at the fort of the Long Knives at Louisville. The memory of her filled him with warmth and longing, and he smiled. Only nine more moons until the first new moon of summer, and she would be in his arms.

Then Tecumseh thought of Prophet, and he scowled. Prophet swore he saw Hannah in visions in the company of Motshee Monitoo. He swore her own gods would not let her go. Had not Swallowtail admitted he had heard her praying to the strange white God, demanded Prophet, and after that gone off his head? Gunh! What did Prophet know?

Suddenly Tecumseh was seized with a longing for Hannah so strong that he no longer saw any reason to wait until the first new moon of summer. He tossed his food bowl aside. Perhaps the schooner would have gone from Louisville before he returned north. If so, he would follow it, all the way to New Orleans if he must.

Three months after the schooner docked at Louisville, all hands and a few slaves, volunteered by owners who had now become good friends with the wanderers, manned towropes and hauled the behemoth through the portage channels around the falls, and they were on their way again.

Mr. Hedges had sold all thirty-four barrels of his own flour, plus some iron tools on consignment from ironmongers in Pittsburgh, in exchange for a pledge of tobacco to be paid out of the next harvest. He had fallen in love with Louisville and decided to open a store there. Lacking additional money or goods for exchange, he regretfully informed the Cincinnati contingent that he could not offer to retain any of their goods for barter.

"Well that is mighty generous of you to want to," Harmon declared. "But for my part, Mr. Hedges, I reckon we'll get a deal more taking it all the way to New Orleans." The others agreed, and by the time they left, Hedges was standing rather disconsolately on the dock, among his new friends, waving good-bye. Catching Hannah's glance, he dove into his shirt and produced a letter, the latest one Hannah had written home, which he promised to see delivered along with the rest.

A few snow flurries presaged winter, but then melted, and Harmon and Hannah found the passing landscape endlessly fascinating as Captain Swinburne's crew grew ever more dexterous at maneuvering their ship downriver. Gradually the terrain changed. Intervals of grassy floodplains and smaller trees began to appear among the deep forests and coves of rocky outcrops.

Harmon rested a foot on the deck rail and leaned his forearms over his knee. "Well, Sis, we might have ourselves a real business. Do you know how many folks grow more than they need right now? Why, if they was to have a guaranteed way to get it downriver in a boat as big as the *James Ross*—you know, one they wasn't feared would be ambushed by In-

dians—they'd produce even more. I figure we could commission a ship each year. Just imagine—" He glanced at her. "You ain't even listening! What's the matter, Hannah? You been awful quiet the past few days."

"Hm. I've been thinking about Swallowtail."

Harmon glanced around. They had entered a winding, densely forested passage where the river was swift and narrow. Towering sycamores overhung the banks. "Good place for an ambush."

Hannah started. "Don't joke like that. It's not funny!" She had not told Harmon about the confrontation with the Shawnee man who called himself Prophet. "Can we talk?"

"What about, Sis?"

"Well. . . . I can tell you've already put that bad time behind you, and I really want to forget it, too."

Harmon smiled, his brown eyes affectionate. "Okay. Ready to get it off your chest?"

She nodded, her throat clogging with tears. "First I want to tell you about a man called Prophet. . . ."

"Why in blazes didn't you tell me this before?" he said when she had finished.

Her eyes filled. Safe now, she could let her weakness show. "Because I was afraid that if Prophet was in Louisville, Tecumseh could be nearby, and—and I don't want anything to happen to him."

Harmon turned away from her. She could see the line of his jaw tighten and felt that something had come between them that joshing and love couldn't cure. "Is that all?" he said in a harsh voice.

She shook her head.

"Well?" he turned to look at her. His eyes had become hostile, distant.

Suddenly Hannah regretted her confession, but she was determined to tell him everything. "No, there is something else. I want to tell you about a man named Jack Wheat. He is a trapper. A terribly ugly, frightful-looking man. I think he is a murderer. I think I am the only person who knows this. And I think—I think that he hates me enough to kill me. See, I left him out in the wilderness, all alone."

Harmon stared at her. His jaw dropped. "My gosh, Hannah! What in blazes is all this? Is this the man with the horses? Is this about you getting away from Swallowtail?"

She nodded, tears streaming down her face. "And I'm so afraid. Harmon, I'm so afraid!"

He held his arms out, and she went into them, weeping as if her heart would break, struggling for the words to tell him about Jack Wheat.

Harmon stroked her hair. "Now, now. You got to forget it, Sis, you got to forget it."

"I can't!" she sobbed.

"Yes, you can. You told me how you prayed and you could feel the Lord there when you were so bad off." She nodded against his chest. "Well, now all you got to do is thank him and hand over everything you can't do anything about and tell yourself how lucky we are to be alive! Just think about, well, gee, is there anywhere on this beautiful earth you'd rather be?"

He pushed her away gently and smoothed her hair, embarrassed by his own motherly behavior.

She smiled through her tears, warm feelings of release welling up at last and infecting her with Harmon's optimism. She allowed herself to experience the crisp wind on her earlobes, to see the brash and brilliant explosion of color in the woods, to sense the exotic adventure waiting for them in New Orleans, haven of pirates and Spaniards, of mysterious breeds called Cajuns and Creoles. She raised her arms heavenward and laughed for joy.

Captain Swinburne wandered up beside them.

Hannah hastily lowered her arms. How unladylike he must think her.

"I reckon we ought to lay to pretty soon."

"Here?" Harmon was startled. "Must we, captain?"

"We ain't but a few miles from New Madrid, and I want to fill the water casks. Hear tell the water of the Mississippi ain't good."

"Not here, captain. This is prime ambush country."

Swinburne looked first at Hannah, then back at Harmon. "I guess you'd know," he muttered. "We'll go on."

As they approached New Madrid, the land suddenly flattened out as if a giant hand had pounded it into mud cakes. Reflecting the clouded sky overhead, the waters of the Ohio shot out like a ladle of stream water poured into a bucket of dirty soapsuds, straight into the biggest stretch of water any of them had ever seen.

22

A lone figure braced in the center of a canoe maneuvered across waters of the Mississippi that were as treacherous as rapids. A squall as heavy as an ocean storm whistled past his ears, threatening to capsize him and the baled furs loaded fore and aft. The man's head was covered with a beaver pelt, his body with a buffalo-hide poncho. With difficulty he beached the craft and pulled it up the levee, strength of will allowing him to accomplish it without help.

His black beard jutted higher as he stopped to catch his breath. He looked up at the log fort ahead, its outlines blurred by a snow flurry. Grimacing and grunting, he shouldered a huge pack of furs, one-quarter of the canoe's load. Fifty yards away he encountered a man he knew, who would guard the canoe while the trapper lurched on to the fort and the trading post within.

Forty minutes later the entire load, wet and rank smelling, rested on the trader's table in exchange for chits; the canoe was secured; and Jack Wheat was thawing his bones at the tavern. Though not his temper.

Trader'd wanted to know where Jasper Henry was. Huh. Stand there and jaw when he was half froze, no. Wheat thatched his stiff fingers around a mug of coffee and hunched close to the fire, ignoring a dozen or more men while he awaited his supper. Jasper Henry was Manuel Lisa's son-in-law. That was the sticky part. But no one steals Jack Wheat's animals and gets away with it.

A woman, no. He had rehearsed the story for days, weeks. But not a woman. No one would believe a woman murdered Henry and stole his animals, unless she was trying to get away from him. Devil take the woman! It was set to work just fine.... Henry killed when the two of them went to the rescue of this here poor girl.... And the girl herself, as pure and beautiful as a madonna, hangin' on his every word, noddin'. Just lookin' at them moccasins and the blanket a body'd know she'd been stole by the Miami. Blast her. Blast her! If by some miracle she was still alive, he would find her one day. *Hannah Roebuck. Hannah Roebuck.* He'd fix her good.

By the time the trader, Honore du Plen, appeared and Jack Wheat had a hot meal in his belly, he was fairly convincing.

He had occasion to repeat his tale half a dozen times before Manuel Lisa arrived from New Orleans to pick up the consignment and hear the terrible news about his son-in-law. Jack Wheat mustered tears of sorrow and a voice that shook with outrage as he described the despicable Indians who had rushed the cabin at night, shot an arrow in poor Henry's back, and made off with their horses and pack mule. It was only because God hid him from the heathen that Jack Wheat's life was spared.

His audience was fascinated. Encouraged, Wheat went on to tell them in satisfying, grisly detail about the three Miami bodies he had found bound to trees and tortured to death when he went looking for his animals.

Manuel Lisa, head of the Missouri Fur Trading Company, and du Plen, the factor who ran the post at New Madrid, listened for a final time to Wheat's tale, closeted in the office of the trading post. A bale of Wheat's furs was heaped on the worktable. Lisa, a handsome, smooth-skinned man of about forty, had worked hard to build his trading company into a vigorous, fair-dealing enterprise. Du Plen, by Lisa's order, had not yet paid Jack for any of the furs.

Wheat managed to look offended. "Look, you can find his body, still up at the cabin. I give 'im a nice, Christian burial." Huh. Someone should do as much for Jack Wheat someday! But first he had taken the precaution of digging out the ball and gouging the wound completely through the chest, so that it would look like an arrow'd done it. Case there was anything left to see, if they was to dig him up.

"I couldn't haul Henry back and the furs. Had to lift a canoe as it was. I'd a' got back sooner, but I follered the Indians for days, trying to figger a way to get our horses back," he said truthfully. He had followed Hannah and then managed to conceal himself when he discovered six or eight Shawnee following her also. He was maliciously pleased to leave her to her well-deserved fate, knowing the horses were lost. In his efforts to put distance between himself and the trackers, he had stumbled upon the bodies of the three Miami. He knew from the manner of their deaths that they had suffered horribly and probably at the hands of their own tribesmen. Wheat had realized he was caught in the midst of something bigger than he or his horses and made tracks away as fast as he could.

Lisa fingered a prime beaver pelt. Wheat watched his hands. Automatically the hands were gauging the worth of the pelts. As Lisa was judging the worth of his story?

"Under general agreement," Lisa said in cultured Spanish tones, "you now receive the monies for all the furs. You know I have never cheated

any man who works for me. I had great faith in you, Wheat. And now my daughter's husband is dead, God rest his soul. I thought that I could send him out with you and that with you of all men he would be safe. You have always been resourceful. But he is dead, the horses are gone, and you and the furs are safe."

Wheat said nothing for a moment. His black eyes measured Lisa's mood, the bared gaze of a man who will find the truth. Wheat felt himself beginning to sweat. "You give Jasper's share to 'is widder, Mr. Lisa. That'd be the proper thing to do."

"How is it that the Indians did not steal the furs?" Lisa went on as if he had not heard.

Wheat's dished-in face looked completely blank. How is it that the Indians did not steal the furs? "Didn't find 'em," he mumbled.

"I thought this was a sneak attack at night," Lisa said sharply.

"Yeah."

"And so, without feeling that you were in the slightest bit of danger, you cached the furs away from the cabin, but left the horses out?"

Jack Wheat shrugged.

Lisa tossed the top pelt at du Plen. "Pay him. For all of them." Wheat brightened. "This man does no more work for me. He does no more trading at this post." Lisa crossed the office in two steps, unlocked the door, and flung it open. They could hear his steps creak across the wood floor of the deserted trading post and disappear outside.

Wheat heaved himself to his feet. "Huh! That ain't fair! I know this territory. He ain't got no right to say I can't trade here."

The trader folded his arms and glared distastefully at Wheat. "Go on out and wait while I get your money."

Wheat started for the door. "And don't gimme none o' that Britannia metal. I want Spanish *reals.*"

"We don't deal with Brit currency, you know that. But I'll tell you this, Wheat, if I *did* have any counterfeit, I'd pass it to you without a thought."

"That'd be your last mistake," Wheat snarled.

Hundreds of miles northeast of New Madrid, an errand boy rode out to the Roebuck farm to deliver personally Hannah's first letter. As it was midafternoon, with chores still to be finished, William tucked it in his shirt to keep until suppertime.

The long, polished oak table seemed larger and quieter since the twins had left. It was early December, cold, but so far a dry year. Philippe had moved up on the bench to occupy Harmon's place beside his mother.

with Matthew beside him next to their father. The two youngest occupied the bench opposite.

"What does it say, Pa?" said Philippe, who had been eyeing the letter with growing impatience all through supper.

William tore open the wax seal on the envelope and scanned the contents. The silence was palpable. Finally he said, "Humph," and began to read aloud. When he had finished, a sigh of disappointment hovered in the air.

"Louisville! I know lots o' folks been that far," scoffed Philippe. "A body could have walked to New Orleans by this time."

"That Mr. Hedges thought it was far enough. Hannah says he was going to stay there," put in Thomas.

"At least they are all well," said Faith as William passed the letter down the table to her. "I'm going to tuck all of Hannah's letters in your mother's journal until she comes home."

"For good luck, right, Ma?" said Matthew.

"Right."

Joey cupped his cheeks in his fists and propped his arms on the table and stared down at his empty plate.

"What is the matter, Joey?" asked Faith.

"I just thought o' something."

"What, Son?" said William.

"They ain't going to be back for Christmas."

The brothers stared at each other in dismay. Not home for Christmas! How could it be Christmas unless the whole family was together?

Hannah was not certain what she had expected when they finally sighted New Madrid from the plunging and rearing deck of the ship. The ship's size was suddenly a liability. The strength of the Ohio current swept them far out into the Mississippi. Clouds were boiling up out of the northwest, and thunderstorms grumbled like tormented bulls. It took three men handling the steering oar to keep the heavy schooner nosed upriver to reach port without being swept past.

"This is like an ocean!" shouted Captain Swinburne. As soon as the schooner was sighted by men on the far shore, small boats put out to help her in. Shepherded like Gulliver by the Lilliputians, the *James Ross* finally reached a sheltered cove and was made fast.

When rowboats brought them ashore and they climbed the levee for the first time, Hannah realized that New Madrid was as different from Louisville as Louisville from Cincinnati. The settlement was smaller than

she had envisioned. It was no more than a log-walled fort, some cabins and log outbuildings, and one real city-type house, painted pink with green shutters. Harmon had told her that Spain kept the post manned just for the fur trade.

Spanish explorers had pushed up the Mississippi a generation earlier. They had extended trade into the upper Missouri basin, to challenge British competition from the north, and organized their own fur-trading company. They had put a Frenchman in charge at each trading post, since the French had the most experience and success dealing with Indians of various tribes and keeping the fur trade healthy.

When a few years later the American colonies began the struggle to free themselves from British dominion, Spain and France were quick to see that their best interests lay opposite Great Britain's. They threw their military weight and public wealth behind the colonies. France fought the British at sea and east of the Mississippi. Spain harassed her old enemy more directly, actually declaring war on Britain three years into the American revolt. In addition to fighting her on the seas off the coast of Europe, Spain sent a constant supply of powder and other military supplies up the Mississippi by small boats from New Orleans to help George Rogers Clark and other Americans break Britain's stranglehold on the Northwest Territories.

The new republic was grateful for Spain's help. After the war it returned to Spain East and West Florida, which Britain had held for twenty years. Spain in turn recognized America's claim to lands north of the Florida territories, as far west as the Mississippi.

The Spanish throne also claimed a vast territory west of the Mississippi, south of the Great Lakes, but here the British continued to operate with impunity. It would take more than a territorial claim by a government too overstretched to enforce it for the British to give up the furs they had traded for generations. So Spain clung to New Madrid and to her dwindling illusions of empire.

Music tinkled into a night made glittering by hoarfrost. Real glass windows shone with the reflection of dozens of lighted candles in carved walnut sconces. In the pink-and-green house beside the fort, Colonel Esteban Delgado was hosting a ball in celebration of Christmas.

Waiting to greet Delgado, who had not yet put in an appearance, Manuel Lisa kept time with a small, well-shod, patrician foot to the sprightly music of two violins, a guitar, and an accordion, being played on a dais at one end of the room. He wore a black suit of fine worsted,

with ruffled white stock, and a white club wig. A ruby ring set in heavy gold flashed on his right forefinger as he lifted his wine glass. Only his tanned and scarred hands, though immaculately manicured, suggested he was not entirely a leisured gentleman of the aristocracy.

Over the rim of his glass Lisa watched the officers garrisoned at New Madrid strutting around the floor. In waist-length red jackets with gold epaulettes, skintight white breeches, and highly polished, black Castilian boots, they presented a handsome picture. And were no doubt wishing, thought Lisa, that among their French, Canadian, and American guests were a few more ladies. Women as always were in short supply. He had heard that a beautiful girl from the Territories was among the guests who would be arriving from the schooner anchored in the cove. In the meantime Cherokee Katy, an Indian girl got up in Spanish finery, was whirling around the floor, perennial belle of the ball. She had lost none of her dancing partners over the nine years Lisa had known her.

His glance moved to a young woman shrouded in black. She sat very erect in an inconspicuous corner. On her lap lay a closed black lace fan. Her gaze was shadowed by the forward fall of an exquisite black *mantilla,* Lisa's Christmas gift to his daughter. His eyes softened in pity for her. Jasper Henry had not been a man of much native ability, but his daughter had loved him. Widowed a month ago. Custom dictated that she should sequester herself in mourning for one year. He would have none of it. He had decided to send her back to New Orleans. His wife would welcome her with arms of love. Isabella's life had once been filled with light and music and laughter. He wanted it to be that way again.

At last Lisa spied Colonel Delgado, resplendent in formal black and a brilliant blue shoulder sash glittering with medals, coming out of an adjoining room with an aide. He started across the room to greet Delgado just as half a dozen newcomers arrived.

"By the Blessed Virgin, who could that be?" he heard someone say. He glanced over to see a young woman entering the ballroom on the arm of a young man. Their dark good looks were so strikingly similar he knew at once they were brother and sister.

Hannah's hair was pulled back in a chignon at the nape, with a single long curl twining down one side of her neck, copied from a style she had seen on a fashion-plate model. She wore a creamy white silk ankle-length dress, trimmed with satin, and slippers with pink silk rosettes sewn across the instep. Powder-puff sleeves and a low neckline enhanced the tawny beauty of her skin down to the swell of her soft bosom. The high-waisted skirt was softly draped, revealing her natural grace as she walked—a new

fashion look that, Aunt Rosalind had declared, instantly branded any woman still in hoop skirts as out-of-date. A matching band of cream-colored satin at her throat was held by a shell pink cameo brooch.

She saw the slim, handsome man across the room staring at her with unabashed pleasure. She smiled demurely, then looked away, her brown eyes dancing with excitement as she swept the room with her gaze.

"Everyone is staring at you," murmured Harmon.

"Only because there aren't very many ladies." Nonetheless, Hannah blushed with pleasure. Aunt Rosalind had been right, she thought. She had argued with Hannah's parents until they had given in and paid for Hannah and Harmon each to have made two sets of fine clothes of good cut, one for afternoon and one for evening wear, assuring them that elegant clothes did as much to confirm one's worthiness as a dozen illustrious ancestors.

"I wish Mama and Aunt Rosalind could be here. How they would love it."

"An hour ago you were moaning about being away from the family at Christmastime."

She shrugged. "I know, and I meant it. But I am still going to have a good time."

Harmon rotated his jaw, feeling ill at ease in a maroon tailcoat with nipped waist and padded shoulders. His white stock was plain, a relief from ruffles (also passé, according to Aunt Rosalind). His black trousers were held taut by a strap of fabric that passed under the instep of his polished shoes, fitting like a second skin to enhance calf and thigh. Harmon had the figure for elegant attire, Hannah observed, although it had not been easy to persuade him to submit to the fittings. She was glad he had. How handsome he was!

Despite her laughing protestations that she had never danced, Hannah was soon besieged by admirers. Manuel Lisa introduced himself with courtly grace and won the honor of presenting the adventurers to their host.

On his arm, Hannah good-naturedly attempted to learn to waltz, at last begging his indulgence for her awkwardness and asking to be taken where she could not mash his toes anymore.

Lisa inclined his head and his eyes crinkled in a smile. "May I get you some punch? Then I shall introduce you to my daughter. She is lately widowed. You are near her age. Perhaps you can cheer her up. Her English is quite good. Her husband was American."

Across the room, Harmon was pleased to see Hannah enjoying herself.

For himself, he rather considered balls a waste of time and was more than pleased that Manuel Lisa had left him in congenial masculine company. Possibly he could get some solid information about what to expect downriver. Putting the question to his companions, he received a host of different answers.

"You'll have some weather," one remarked. "But it shouldn't bother a ship that size. The one came through a couple years ago had no trouble, I hear."

"What about ambushes?"

"Spain has never had the trouble with tribes we Americans have," said a man who was both farmer and trapper. "That is why Lisa is a good man to work for. He understands the Indians. Treats 'em like whites. He don't change the price o' goods at the change in the color of skin."

"That's good," said Harmon. "Now, if the Indians would only start acting like whites. They are a problem to safe development of this country."

"Whose country?"

"Why America, of course."

"Hm. Spain and France may not agree with you there. You think big for a young man."

Harmon grinned. "Big country." The men were standing in the draft of a door at the rear of the house. The succulent aroma of roasting meat drifted in, and Harmon felt suddenly ravenous. He remembered seeing, as the open coach rounded the corner to the house, haunches of buffalo turning slowly on spits over huge fire pits. He looked for his host or hostess, hoping a signal for supper would soon be given. Hannah, he noticed, was still in the company of Manuel Lisa and looked as if she had forgotten all about food.

"I grew up neighbors with the Shawnee and the Miami," he said idly. "Can't say everyone in Cincinnati treated them fairly, but most tried to."

His three companions exchanged glances. "Shawnee are on the warpath, I hear."

"What have you heard?" Harmon was suddenly attentive again.

"A trapper was in a few weeks ago. A bunch of them killed his partner and stole his horses."

"Tell him the rest of it," said the second man.

"Hard to know how much to believe. You know Jack Wheat. He always was a strange one."

Harmon concealed his alarm. "That the trapper you're talking about?"

"Yeah. Had some tale about tracking the Shawnee and finding three Indians tortured to death. Their skin had been stripped off—"

"As long as they just kill each other, why, I don't mind a'tall." The three men laughed.

Harmon tried to look civilly entertained. *Swallowtail and two others! Hannah had said only three were left that last day. If Tecumseh tracked her—my God!—Tecumseh was half Miami. He killed his own men!*

"You look rather green, Roebuck. You feeling all right?" one of the men inquired. "Some of you folks from back east don't know our Injuns out here. They aren't rightly civilized yet."

Carrying two polished silver punch cups, Manuel Lisa led Hannah to an alcove where a young Castilian woman sat in company with a white-haired lady snoring softly against the scrolled back of her chair.

The young woman smiled mechanically as Lisa approached. "The hour grew late for *la vieja.*"

"So I see." Lisa smiled, offering his daughter a frosted cup and Hannah a second one. "Isabella, this is Senorita Hannah Roebuck. She and her brother are from the schooner, bound for New Orleans. You weren't here when the other ship was floated downriver. Senorita Roebuck, my daughter, Senora Jasper Henry."

The cup slipped from Hannah's gloved fingers, flinging a wine-colored stain down the front of her gown.

Isabella rose to her feet and clutched her fan in both hands. "Oh, your lovely gown! Oh, dear!"

The old lady awakened and stared around with a blank air.

Harmon hurried up to them. "What the devil, Hannah! How did you manage that?" He knelt to retrieve the cup and glanced up at her face. His expression changed. "You are as white as a sheet, Sis."

Lisa stared at her, frowning. Suddenly he seemed to snap to and asked Isabella if she had another gown Senorita Roebuck might change into.

Hannah turned swiftly to Lisa as Isabella took her arm. "Do you know a man named Jack Wheat?" she said in an urgent whisper.

Lisa's fine lips formed into a grim line. He nodded. His eyes swept the room, and he inclined his head toward the anteroom lately occupied by Colonel Delgado and his aide. "Will you meet me in there when you are comfortable again?"

"We both will," said Harmon, shooting her an encouraging glance as she allowed herself to be escorted away by Isabella and her chaperone.

Manuel Lisa maintained an apartment in an upper wing of the colonel's home. After his daughter had married Jasper Henry, he had allowed the young couple to use it so that Isabella would not be so far from her husband while he was learning about the supply side of the fur trade. It was Henry's idea that he should spend a season with a trapper, and Lisa had agreed reluctantly, admiring the young man's willingness to apprentice in all facets of the trade.

An hour after they had left the ballroom, Hannah, Harmon, and Manuel Lisa were staring in silence at the cheerily crackling fire in the stone fireplace in the library. Isabella had begged to be included, but Lisa had gently insisted she must not. Hannah's face was a portrait of sadness. She had not let go of Harmon's hand throughout the difficult recital.

"So the blackguard murdered an innocent young man, a man with no more guile in his breast than a lamb."

Hannah lifted her shoulders wearily. "I do not know of a certainty, Senor Lisa. I have told you all I can remember."

"Where is Wheat now?" Harmon asked.

Lisa drained his wineglass. "I ordered him off the post. I would advise you to get your sister away from New Madrid with all dispatch. Wheat is a ruthless man. If he learns that she has been here before my men find him. . . ."

"I will take care of my sister," said Harmon.

"Yes. But you and I are like animals who kill for food. Wheat is an animal who kills for pleasure."

"Please, let us stop this talk of killing," begged Hannah. "We'll probably never see Jack Wheat again. Listen!" She stopped and tilted her head. A smile parted her lips as strains of Christmas carols sung by predominantly male voices filtered sweetly through the paneled walnut doors. The melodies were rich with longings for home and the holy season.

Harmon listened. But as he watched Hannah's face his thoughts were on another man who killed without mercy. A man his sister thought she loved. He hoped to God they never saw Tecumseh again, either.

"Shall we join the others?"

Lisa smiled, encompassing them with widespread arms.

By agreement the next morning Hannah met with Lisa and Colonel Delgado to give a sworn deposition. The *James Ross* was preparing to leave New Madrid at midday. Harmon secured Lisa's word his sister would not be left unguarded. Then, itching with impatience to be away,

he nosed about the small post, absorbing with his quick mind its flavor and possibilities.

Most Spanish settlements grew up around a Catholic mission and a public square. By contrast New Madrid was built around a military fort. Within the walls of the fort, an area as large as a public square was lined, not with trees, but by functional shops serving military needs for clothing repair, ironwork, candles, and leather. Butting the inside of the entire north wall of the fort was the trading post, which dominated life at the fort.

As he headed for the trader's two Indians brushed past him. From their peculiar gait he was almost certain they were drunk. They were of a nation unfamiliar to him, their faces broader than Shawnee faces. Their bodies, too, were bulkier than those of the men of the woodland nations.

"*La tafia!*" one of the Indians called as they stumbled up the board-walk and into the post.

In no time they were being hustled unceremoniously outside again. Harmon scrambled out of the way. "No *tafia*. No more. Need more furs!" said the trader. He glanced at Harmon, and smiled. "*Bonjour,* Monsieur Roebuck. We met very briefly last night. Honore du Plen at your service."

Harmon exchanged courtesies, then asked curiously, "What is *la tafia?*"

"Molasses rum. It is not fit for a civilized belly," du Plen warned. "We try to keep it away from the Indians, but some will not give up their furs for anything else. We have lost some of our best trappers that way. They go cuckoo in the head."

Suddenly a tall man in a black suit and clerical collar put his head in. "Revival meeting tonight! Afternoon, folks!" Armed with a rock and a handful of playbills, the man unconcernedly pounded a nail in the wall of the trading post and stuck a playbill over it. "For them as can read," he said with a wave. "Storm coming," he added cheerfully as he vanished.

Harmon sauntered over to read the bill. In hand-lettered English, French, and Spanish, it announced a camp meeting that afternoon at Parsons Meadow.

"Circuit rider," Honore du Plen called over to him, meanwhile keeping up running conversations with a stream of men entering and leaving the trading post. "Methodist and Baptist, most of them. That gentleman is as fine a person as you would want to meet. His circuit is hundreds of miles. He tries to get around to people at least once a year, catching up on the

marrying and burying and the baptisms. *Eh bien,* they hold grand meetings and then are on their way."

"What if it storms?"

The trader laughed. "Have no fear. Those Protestant ministers are like crows. They go abroad in all weather. . . . Here is your credit for the furs," he said to a trapper who had just come in. "What is it that you need?"

"Salt."

"The last boat from New Orleans didn't have any aboard."

The trapper expelled a quick breath of exasperation.

"I 'ave been caught here for a week! 'No salt. No salt.' I can't even buy the local salt with dirt in it."

"I am sorry, my friend. Everyone else is in the same boat. From what I have heard, the yellow fever hit Tortuga Island a few months ago. The ships they will not stop there. More than half the miners have died, *le bon Dieu* rest their souls." The trader crossed himself, and the trapper did likewise.

The trapper muttered a few imprecations that reached only the trader's ears. Du Plen lifted his shoulders in a Gallic shrug and said after the trapper left, "Salt is more valuable than gold. Settlers that run across a salt spring can get four dollars in gold for a bushel."

"In Kentucky they ship it in over the mountains from Virginia. Make it on the seacoast and sell it mighty dear," said Harmon.

"How much?" asked the trader.

"Twenty dollars a bushel."

"Mon Dieu! They pay that, the ones in Kentucky?"

"They do," said Harmon. "It's good salt."

"Not as good as the salt-lake bed on the island of Tortuga."

Harmon had been letting his beard grow since leaving home. It was long enough to be itchy but not yet full enough that he considered it attractive. Absently he scratched his bearded cheek now, thinking. "How much you pay for Tortuga salt?"

"Thirty in gold *reals.*"

"A lake bed, you say?" The trader nodded. *That would be a sight easier to harvest than sea salt,* Harmon thought. It ought to cost a lot less at the source than sea salt, which had to be harvested from shallow beds of sea water run in and allowed to evaporate. Still, Tortuga was out in the Caribbean, over a thousand miles away.

Hannah came in the post, accompanied by a soldier, her face calm, Harmon was pleased to observe, and carrying a package wrapped in cloth. She thanked the man, who saluted and left, then smiled at her

brother. "Mrs. Henry was kind enough to have my dress sponged and pressed."

"No pretty dress, no more balls," said Harmon lightly. "How'd it go?"

She nodded, and he knew she wanted to put everything concerning Jack Wheat behind her.

She took his arm, and they said good-bye to Honore du Plen and stepped out in the cold air. "Senor Lisa is asking Captain Swinburne if Isabella may travel with us to her mother in New Orleans. I hope he agrees. She's suffered a tragic loss for one so young."

"You'd be good for her, Hannah. We can both try to cheer up Mrs. Henry."

23

Jack Wheat stared into the fire. His eyes kept drifting out of focus. He tilted the bottle to his lips again. Discovering it empty, he threw it angrily at a tree, smashing it.

"Hey, Wheat!"

Jack Wheat struggled to his feet, fumbling his knife out of its sheath. "Who's there?" He squinted, weaving slightly, straining to see into the darkness beyond the small fire.

"Friend."

"Huh!"

Another trapper appeared as if out of nowhere, his rifle couched in the crook of his arm. "Thought I'd find you here."

Wheat nodded and sat again.

The stranger waited. "Got any coffee?"

"Make some."

"Don't bother." He hunkered across the fire from Wheat. "You did me a good turn once, lot o' years ago. I never forgot . . . so even though you ain't much of a man now, I'm gonna return it. They know you lied, Wheat."

Wheat's eyes were on his, quick as a mountain cat. The gaze shifted to the shadows around the stranger and returned.

"Gal came through the post and met Lisa's daughter and found out she was Jasper Henry's widow. She must 'a' got the name from you, Wheat. Anyways, the story she give Lisa ain't at all what you said."

Jack Wheat went cold with fury.

"You hear what I said?"

"She still there?"

"No. She was traveling on the biggest ship I ever seen. They were bound for N'Oluns."

Wheat grabbed a thick handful of greasy hair and pulled it this way and that, as if the action might clear his head.

The stranger rose. "Anyway—I wouldn't go to New Madrid. Not Saint Louis, neither. Lisa's got men up there lookin' for you." He waited. Wheat made no move to stop him. He left.

That Roebuck woman, thought Wheat. *It's all her fault. I can't trap no*

more hereabouts because of her, and now because of her they's trying to kill me. She deserved to die, even more than that mewling mouthed Jasper Henry. He got to his feet, and his eyes cleared momentarily. He could track her to New Orleans. Get rid of her, like she deserved. Or wait till she got back to Cincinnati. That storekeeper said they was all going back to Cincinnati after they sold the boat. Yes. Or he could forget it and go up the northwest. Heard tell furs was better there anyways. He might do both. He just might.

"Good morrow, Peter Ruskin. How are your family?"

"Fine, parson." Peter hung his thumbs in his trousers and watched as Micah maneuvered the team around to back up the wagon to the printer's door. He was becoming more adept at managing a team and buckboard, and Peter told him so.

"Thank you. I am never quite certain whether I am driving the team or they are driving me. Since I have begun working for the printer, I am finding myself capable of many things I never quite imagined doing. There was no one else about to meet the packet from Pittsburgh." He grinned at Peter. "And therefore Inkk delegated me." Printer Inkk. The name delighted him. He would have to ask him someday if the name steered him into his choice of profession.

"You want help with that?"

"These chaps have already offered." Micah beckoned to three waiting Miami dressed in furred jeans and ragged flannel shirts. Peter backed up, a look of surprise on his face. Together the men hoisted the heavy bundles wrapped in burlap off the end of the buckboard and carried them into the printshop. Micah paid them, they left, and when he reemerged to return the team to the livery stable, Peter was still dawdling on the boardwalk.

Micah blotted his neck with a kerchief. His freckles were a burnished copper, his face a healthy pink. His hair had paled to strawberry, as straight as ever. As he rolled down his full sleeves and struggled into his black wool coat, he noticed that the fit had become very snug under the arms and through the shoulders. He supposed he was filling out a bit. Not as muscular as Peter, but then he was taller and a bit leaner by nature.

He noticed Peter staring after the three Indians. "I try to give them work when I can."

"Why?"

"Honest labor is a blessing, Peter. You know, if you and your father

added a press to mill paper, we wouldn't have to have it shipped from the States." He climbed back to the spring seat over the wheel and slowly *click-click*ed the team toward the stable. Peter fell into step beside the iron-rimmed wheel.

"He's been thinking about it."

"Then perhaps you could hire some of the Miami around here. Plenty of them need work, and they are strong enough."

Peter looked up at him with a strange expression. "If you say so, sir. Might we talk about another matter?"

"Certainly." Moments like this, Micah chafed at the entrenched ways of the town. He had been their preacher for months, had hinted gently and in parable that they ought to get started on the church. Troubled souls needed the solace of a church. In vain. "Shall we go to my rooms or take a stroll?"

"Uh, walk'll do."

After Micah returned the wagon, the two young men walked in silence through town and up a path that led to a good fishing hole.

The glade was unoccupied. Micah realized he could not have wished for a more peaceful confessional. He leaned against the bole of a gnarled pine, his hands clasped loosely, and listened to the music of the wind. He wondered what youthful transgression was on Peter's conscience. Young Ruskin was a compact, muscular man of dark good looks, smooth shaven, and always tanned. His shoulder-length hair waved in a most becoming fashion. Little wonder young ladies always managed to appear when he went about in town. Micah imagined the confession might be connected with this fact.

Peter crouched at the edge of the pool and began tossing pebbles. The water was so clear it reflected the velvet brown of the moss-covered rocks in the bottom. *The gold-flecked, velvet brown of Hannah Roebuck's eyes,* Micah thought. Where was the *James Ross* now?

"Have you heard from the twins?"

Peter's question startled him. "No. Have you?"

Peter shook his head, staring at the concentric rings pulsing out from the pebbles. "I treated her awful, parson. You being an outsider, mebbe it's different where you come from. But we men have to protect the womenfolk; we're taught that at our father's knee, 'cause if we didn't, life would be fearsome."

Micah was glad Peter could not see him, heartily wishing for any excuse to avoid hearing what Peter had to confess that involved Hannah. "How did you treat her awful?" he forced himself to say.

"When she come back. I just couldn't bear to look upon her, parson! Girls are—are like a bird. You have to hold 'em gentle, or their wings bust. Hannah come back, and after she was up and about, folks said she had this look in her eye."

"What sort of look?"

"Well, like she knew something nobody else did."

"Going through an experience like that is bound to change a person."

Suddenly Peter turned and fixed Micah with a stare. "You think she's still a—a pure girl, parson?"

"Why is that important to you, Peter?" he hedged, relieved on one count.

"Well, a man has a right. . . ."

Micah sighed and turned away. Lord, he was trying not to judge, but he couldn't help feeling disappointed in Peter.

"Do you and Hannah have an understanding, are you betrothed?"

"Well, no, but I was thinking on it before. . . ." Suddenly Peter blurted, "God help me, parson, I get the feeling she thinks I let her down, and I don't like the feeling one bit. I didn't *want* to let her down, I just couldn't help it. If she was here, I'd tell her."

Micah nodded.

"But she ain't. So I been thinking something else. If we was to build outposts along the river, out in both directions beyond the last farms, that would stop any more ambushes close to town, wouldn't it?"

"It would certainly help," agreed Micah.

"Then when Hannah comes back, she'd know right away how bad I felt about her getting kidnapped, wouldn't she?"

"I would think so."

Peter sprang to his feet. A happy grin brightened his face. He clasped Micah's hand. "I sure do thank you for this little powwow, parson."

A few minutes later, the younger man veered off toward his father's lumber mill, and Micah continued into town alone, reflecting upon the ways lives are shaped by what men do that they ought not to do, and ought to do but do not. It would be worth exploring Sunday.

Usually, hitting upon an appropriate subject to sermonize generated a sense of excitement. Today, his pleasure was dulled by the morose discovery of a rival for Hannah's affections. He hoped that the Lord would notice this and come to his aid when Hannah made a choice. Peter had not gotten far off the main road before Micah saw Betsy Randall come out of nowhere to join him. It was good to have friends. The thought depressed him. He knew what was the matter. He was missing Hannah.

Philip Thicknesse was idling on the boardwalk outside the apothecary shop as he passed. " 'Afternoon, parson. Doling a bit of advice to young Peter?"

Micah said peevishly, "Does nothing escape notice in this town?"

"Not much," Thicknesse said imperturbably.

"Then I do wish the folks would notice we still have no church."

Thicknesse laughed. "Don't look at me that way, man. I vote for it every month."

Suddenly Micah felt in the need of some advice himself. "Have you a moment, Thicknesse?"

"Step into my office, dear chap," said the big man.

The familiar scents of acidic and aromatic chemicals mingled in Micah's nostrils. As the shop had no customers, they found stools and sat down. "Early today I hired some Miami to help me unload a shipment of paper at the printshop. I suggested that perhaps Peter's father could hire some of them at the mill. Young Ruskin felt this was foolish. To put it bluntly, he looked at me as if I had just eaten an insect."

Philip laughed. "Did you pay them in coin?"

"I did."

"And Peter warned you they would only use it to buy spirits."

"He did not say that. He might have thought it."

Philip nodded. "I swear, parson, your education must have had a lot in common with mine. Our teachers left out a good many things needful to work in the wilderness. Perhaps when you see the effect liquor has on Indians, you will reconsider. From a medical standpoint, it is fascinating. Spirits seem to have a universally pernicious effect upon their poor brains."

Then, to Micah's surprise, Thicknesse sided with Peter. "What Peter was trying to tell you is that the men will never work for long. It is against their religion. The squaws do all the day-to-day labor, haven't you noticed? I suppose you would not know that unless you had visited one of their camps. The men will hunt meat, and fish if they choose. Everything else is the province of their women."

"I am an outsider, and perhaps for that reason I find it difficult to understand what you are pursuing."

"You ought to know, better than anybody."

"Know what?"

"That God brought us here. He chose us to bring his Word into the wilderness. We may even now be treading on the new Jerusalem. We live here knowing our days are but preparation for our true lives in heaven."

Micah smiled, delighted at his friend's clear perception of his faith.

"Few of the natives know the first thing about God. Working for coin that will buy things for their comfort next year is a concept that is quite beyond them."

"They only have to be *taught,* Philip," Micah said confidently. "The Holy Spirit will take over from there. After all, God put them here, too. And first."

Philip stared at him from beneath his bushy eyebrows for a long moment. "That's rubbish, parson, and you ought to know it. Mark me, 'tis rubbish!"

"Roebuck? Not surprised you heard the name, stranger," one-armed Fenn said to the mountain man who had just come in. He motioned him to a seat next to the stove. "Getting chilly."

"Early winter comin'."

"You reckon?" Fenn pulled up a stool for himself and loosened his apron. "Roebucks are prominent folks hereabouts. You a friend of the family?" He doubted it; the stranger looked as if he hadn't seen the inside of a house for years and stank to all getout.

"Depends if it's the right Roebucks," Jack Wheat said. "Seed a few Miami and Shawnee on the way in. Much trouble with 'em hereabouts?"

"Not gen'ally. Had some trouble last spring, some of the town bunch took it into their heads to raise a little whoopee."

"Do say! Anybody kilt?"

"No. They carried off a young lady."

Wheat grunted. "Ever see her agin?"

"Yep! She could see through a millstone, that gal. Give 'em the slip and got home again."

Jack Wheat grew as still as a tracking weasel.

"It was one of the Roebucks got took, how's that for coincidence? *Hannah* is her name. Come to think of it, one of the Roebucks *was* a trapper. Old fella, 'fore my time, an uncle or something. Frenchman. *Etienne,* that was his name. Mebbe he's the one you knew. I remember some of the stories they usta tell about him. . . ."

"The Roebucks live in town?"

"No, they're farmers." Fenn chuckled with quiet pride. "But lately in the shipping business. All the folks got together and ordered a schooner built and sent it downriver. Mebbe it passed you—the *James Ross.* No, heh? Gonna sell ship and cargo. Matter of fact, young Hannah and her twin brother went with it to see to our goods."

"Downriver." Wheat's black eyes beaded watchfully on Fenn. "Down the Ohio?"

"You see any other river hereabouts? Going all the way to New Orleans."

Fenn gazed kindly at the stranger. "If you want a place to wash up before you pay your visit, the barber has a bathhouse in back. There's a washerwoman could do your clothes up in a couple hours. It's right down the street." Fenn jerked a thumb in the proper direction.

The stranger didn't act like he heard. Fenn was relieved when he left.

24

"I should not have listened to you, my brother," said Tecumseh. They sat bundled in buffalo robes, on horseback, just below the crest of a low, sloping knoll several miles south of New Madrid. The winter wind whistled across the plains, bending the split grasses to earth, whipping the horses' manes like streamers. In the distance, the incongruous sight of a huge ship shaped like an inverted leaf floated down the yellow-gray Mississippi.

"What have I said that is not true?" asked Prophet.

"Nothing. But I must see my woman. There is no trouble for the moment."

"Then I should come—"

"Peace. I will go alone, I will be safe. You will stay with our people in the Old Territory. Listen to my mother, Prophet. Black Hoof will tell you how it is. She understands."

Anger darkened Prophet's eyes. "After all I have told you."

Tecumseh did not answer. After a moment, he gave a tug on the halter of a second horse, laden with supplies, and wheeled away to the south.

Prophet remained, a solitary, rigid figure watching Tecumseh ride away. Reluctantly he turned his mount north. Then, as if goaded, Prophet picked up the pace and hurried forward.

Dear Father and Mother,

I am sitting in the kitchen—the galley, that is—writing this. The Mississippi is much less turbulent than the Ohio, but not beautiful and clear like our river. The water is a dirty yellow. Believe me, it took courage to take my first swallow of such unappealing stuff, but it is only a little brackish and not unhealthful, we are told.

Harmon and I are well.

We took on another passenger in New Madrid. She is a pretty Castilian girl with lovely manners. Catholic, as you might imagine, reared in a convent in New Orleans. Isabella is younger than I, and already a widow. . . .

"Harmon, what shall I tell Mama and Papa about that dreadful Mr. Wheat?"

"Are you crazy? Nothing!"

> When they had been married only six months, her husband was killed out in the woods. She is the daughter of the head of the fur-trading post at New Madrid, who is a very rich and influential man, Harmon says. He—Harmon—is thinking of a way to involve him in our shipping company. . . .

"Don't write that! There ain't any shipping company yet."

"There will be."

"Hannah—"

"I must say something! All right, I'll start this sheet over."

> It is cold, but not so cold as Cincinnati, I warrant. . . .

Hannah paused and stroked the feathered quill under her chin. "I wish. . . ."

"What?" said Harmon.

"Nothing." *I wish I could write to Tecumseh,* she had almost said. She wanted to tell him that he was always in her mind, a warm presence. Could he write? she wondered. Had he ever learned to read English words? She pictured herself teaching him. In her mind the scene was a reimage of herself and Joey and Matthew and Philippe around the kitchen table by lamplight, only now it was herself and Tecumseh. Somehow he was dressed like Harmon. She would make him beautiful linen shirts to wear to church on Sundays. . . .

> Dear Father and Mother,
>
> It is now over a week since I started this letter, and we will soon be in New Orleans. The leisurely trip has been good for Isabella. She talks to us—well, Harmon mostly, but I listen, too—just like family. Isabella has lived in New Orleans all her life. Before she was born, the Louisiana Territory was partitioned between Britain and Spain. New Orleans became the capital of Spanish Louisiana.
>
> She remembers her father saying that Spain wanted more Catholics to come and live in the city. There were never enough. The Creoles—white descendants of early French and Spanish settlers—were, for the most part, Catholic. The Spanish king finally

decided to allow Protestants to settle in the territory, so over the years 5,000 migrated from Acadia, in French Canada, and settled in south central Louisiana. And guess what, Pa, they were *Huguenots,* like Gra'mama! Do you suppose we have kinfolk here?

"But we call them Cajuns, do not ask why," said Isabella Henry, watching Hannah write. She laughed. "Even I have difficulty understanding them. They speak a French patois quite different from Creole French."

"You speak French, too, then, as well as Spanish and English."

"Everyone in New Orleans does. And usually a little German. Thousands of Germans came, too, as indentured servants. Many of them are farmers."

The days passed into one another, as dull and leaden as the sky and as even as the landscape. The towering walnuts and sycamores that overhung the Ohio had been replaced by smaller, more slender trees that dwindled for long stretches into bare plains. The remembered mountains and gorges of home, rearing up to spew their waters out to join the mad rush toward the Ohio, gave way to deltas within deltas, where broad rivers flowed amicably into the Mississippi, creating bars and spits and tiny unoccupied islands and a deep, steady current.

"Not as pretty as the Ohio, is it?" said Hannah, leaning over the rail one day. She and Harmon were out of hearing of Isabella, whose anticipation at nearing home mounted daily.

Harmon shook his head. "Different."

She threw him a teasing smile. "You must be sorry our journey is almost over. I've never seen you talk so much as you have with Isabella."

"She needed cheering up," said Harmon—rather defensively, Hannah judged.

Just a few years earlier, in 1795, Spain and the United States concluded a treaty opening New Orleans to free American trade. Spanish law had already forbidden further slavery in Louisiana Territory, but that year growers succeeded in refining sugar by boiling cane juice until it granulated. Before this time, only a brownish milky liquid suitable for making rum had been produced. Suddenly aware of the vast potential for profit from sugar, Spain was persuaded to modify her antislavery law to allow Americans to resume purchase and ownership of slaves. By the time the Roebucks brought the *James Ross* down the Mississippi, sixty plantations were exporting 4 million pounds of sugar, and Negro slaves and freemen comprised half the population.

Traffic on the river grew heavier as they approached the city.

"Few turns 'round the bend and you'll be there!" a mate called across the water in response to Harmon's query the last day out.

Isabella came on deck, wearing a beautiful plum-colored velvet coat that reached to her knees, over a matching, floor-length dress, with a tiny hat perched on her upswept curls. Hannah had never seen a costume so lovely and told her so.

"Thank you." Isabella fingered the creamy bow at her throat, looking as if she might cry.

"Are you all right?"

Isabella nodded. "I wore this on our last day in New Orleans. Jasper and I were joking about going into the wilderness and wondering if there were any ladies, except savages . . . out there. . . ."

Quickly Harmon reached for her hand. "Dear Mrs. Henry. Will you allow us to call on you now that you are home?"

"Oh, please, I was hoping that you would stay with me—that is, at my parents' home—while you are here. You do have business to conclude, do you not? You have both been so kind to me," she said, tipping her soft chin up to look into Harmon's eyes.

Hannah pretended to ignore them. She had never seen her brother so smitten with a young lady. She hoped that Isabella's vulnerability in her grief did not lead Harmon to believe the young widow cared for him more than he thought.

An unfamiliar thrumming filled the air as the *James Ross* neared anchorage. Dozens of ships, both large and small, rode at anchor around them. Hannah craned to see what was causing the noise. She could see only a few buildings jutting above the levees and tried to mask her disappointment. Isabella had filled their ears with tales of New Orleans's past, from the time the French had colonized it with convicts to protect the southern opening to her empire in the New World, until it fell into the hands of Spain.

Captain Swinburne and his crew formed a jubilant line on deck. Their progress had been watched from shore, and soon eight sailors, in smart white uniforms, and a Spanish official scrambled into a rowboat and came out to meet her, the official, in brilliant white-and-gold uniform, standing with one foot on the prow as they approached.

"Good day, sir!" called their captain, relief and pride ringing in his voice. "Captain Charles Swinburne aboard the schooner *James Ross,* out of Marietta, Ohio, requesting permission to come ashore!"

"I am very sorry, but I must deny your request, captain."

"What is that you say, sir?"

"Permission denied!"

"Now see here, sir, not five years ago your country and ours exchanged free-trade agreements."

The official turned toward shore, twenty-five yards away, and barked an order. Twenty rifles were leveled at the *James Ross*. Harmon threw his arms around Hannah and Isabella.

Captain Swinburne drew himself to the peak of his small, wiry frame. "We have come all the way from the Northwest Territories. We carry no contraband goods, sir. We have wheat flour, lumber, corn—"

An adjutant spoke up. "There's yellow fever aboard a ship from the Caribbean. Two seamen were infected. Therefore the governor has forbidden all ocean vessels to dock or deposit goods."

"But we have not been on the ocean!" expostulated Swinburne. "We floated down the Mississippi River, man! From New Madrid, Louisville, Cincinnati! See for yourselves, we are not even sea rigged!"

The commandant was unmoved.

Suddenly Isabella pressed Harmon aside and called out to the official, *"Senor! Soy Senora Isabella Maria Lisa y Henry."* She spoke to him for several minutes. Her words were soft, yet firm. The commandant's face was a mixture of indecision. Certainly he had his orders, but apparently Isabella Lisa y Henry was a lady of importance.

He bowed to her, as formally as possible in the gently rocking boat, answered her, and gestured to be taken ashore.

"He begs us to wait while he personally asks the governor to make an exception," Isabella translated.

The captain blew out his cheeks. "I thought he was angling for a bribe."

Isabella smiled. "That is not improbable, Captain Swinburne. *Con todo,* we will have no more trouble."

As Isabella predicted, they had no more trouble. Soon they were being towed to a cargo mooring and allowed to disembark. Only as they followed the wooden steps and paths to the top of the levee did Hannah realize that the high levees protected a city built below sea level. They were fifty miles inland from the Gulf of Mexico and surrounded by marshland, Isabella told them. The city itself was built on wooden foundations, because brick foundations had a tendency to sink in the mud.

Leaving Captain Swinburne with the ship, Harmon engaged a carriage to take Isabella and her trunks home. It was agreed that Hannah would stay with her while Harmon came back into the city to arrange for their

cargo to be transported to warehouses and sold. As they settled breathlessly in the carriage, Isabella's face shone with joy at being back in her native city.

The mixture of shacks, tents, churches, and open-air markets had Hannah shaking her head at the naiveté of herself and the women of Cincinnati, believing they were supplying the ladies of New Orleans with delicacies their unfortunate families had never tasted. How she wished her neighbors could see these marketplaces!

And everywhere people and animals: people of every hue, hustling, strolling, visiting; birds of spectacular plumage, their raucous cackles and screeches filling the air with lively song. She watched goats and pigs herded along beside liveried footmen riding behind carriages that clattered over cobblestones; she gaped openly at dashing horsemen on blooded stallions.

"Oh, Harmon! It's magnificent! I never dreamed there were places like this! I never dreamed!" Louisville with its tiny clique of planters and miniature society paled beside the sprawling, rollicking bonhomie of New Orleans.

Tecumseh had followed the ship during its entire course. When it was only a day from New Orleans, he rode ahead to prepare his welcome.

Tethering Hannah's horse in a hidden glade near his camp, Tecumseh considered how to get word to her without exposing his identity. In the end he exchanged a small bundle of marten pelts for an outfit approximating a Long Knife trapper, including boots and a Kentucky rifle.

His knife sheathed comfortingly inside his belt, Tecumseh rode into town. He stood out among the Creoles and Cajuns and the Castilian officials swarming over the city. Only the easily recognizable Long Knives from Kentucky and the men of blackest skin matched his size.

Tecumseh was on the levee when the *James Ross* docked. He was no more than fifty yards away when Hannah and Harmon and a second lady entered a carriage drawn by four bay horses. His love was dressed in blue the color of a bird's wing. Her dark, burnished hair was partly covered by a headdress of the same blue. Tecumseh did not know how to control the heart that hammered so painfully in his chest. He fought an urge to ride up to her in the street. Instead he followed the carriage as it proceeded out of the main part of the city to a great house of brick, set among orange trees.

Tecumseh had a gift for enjoying himself immensely. So much of his life was lived close to danger that the times in which he felt truly at peace

were immediately recognized and enjoyed with no thought for tomorrow. So he found a secluded oak tree, tethered his horse in grass to graze, and mounted into a comfortable crotch from which to watch the gated drive and beyond it the entrance of the house. Tecumseh knew his Hannah well. She could not remain cooped up within walls for too long.

The air was heady with the sweet scent of thousands of small, white orange blossoms. Hannah, Isabella, and Harmon stood on the portico after a sumptuous feast of unfamiliar-tasting dishes. They had eaten thick, peppery stews made with shellfish, tomatoes, and strange-looking vegetables; bright yellow curried rice and plump game hens; dishes of sugared nutmeats and candied orange blossoms; then aromatic coffee and a mountainous rum-flavored cake that left them groaning with delight.

"Would you like to see the grounds?" asked Isabella.

"Isn't it too dark?"

"Yes, of course."

Hannah and Harmon had spoken simultaneously. Hannah laughed. "I'll wait here for you." Harmon gave Isabella his arm, and they stepped off the portico into the moonlit night.

Hannah drew in a deep breath. *Thank you, Lord, for this perfect beauty.* Still under the throbbing spell of the city, Hannah knew she should finish her letters to the family and to Micah, letting them know of their safe arrival. Isabella had promised to see that the letters were dispatched in the morning post by ship to the United States. Already she was despairing that they would have no more than a week or two in New Orleans, only as long as it took to sell their cargo and rig the ship for ocean voyaging.

Inhaling the wonderful pungence of the orange blossoms, Hannah resisted taking herself inside. The very air had a presence, a sense of something calling to her. She felt a mad urge to take a walk herself. She could call for one of the black servants to accompany her. She peered into the scented night. The glossy leaves of the blossom-studded trees gleamed in a wash of moonlight. No. Tonight the letters. Tomorrow town with Harmon. Smiling for no good reason, Hannah went inside.

When Prophet left Tecumseh on the windy hillside below New Madrid, he had pressed northeast until reaching their main camp, several days later.

Among the Shawnee were several men who were trappers. He asked them who the trapper might have been whose path had crossed Hannah

Roebuck's after she escaped from Swallowtail. None remembered seeing any trapper who worked with a partner in that area, but they all agreed that the man probably used the post at New Madrid to dispose of his furs. With the patience and forethought of a man determined to succeed, Prophet borrowed a cache of furs and took himself to New Madrid.

He need not have worried how to discover the information he needed. On the post, no one spoke of anything else. The renegade's name was Jack Wheat. It was rumored that this renegade Wheat had sworn to kill an American woman. She alone, it was said, knew that he and not the Shawnee had killed his partner. Well satisfied, Prophet returned to camp, knowing that when the time was full, he would use this knowledge to cure his chieftain of his passion.

"There's a ropewalk a league south," Captain Swinburne said. "I suggest we take 'er there and get 'er rigged for the sea before we advertise she's for sale." The five of them, Swinburne, the Roebucks, and the pair from Marietta, sat in the captain's cabin aboard the schooner. Lightened of her cargo, she pranced high in the water, like a spring lamb.

Harmon leaned forward. He was dressed in the "afternoon suit" prescribed by their Aunt Rosalind. The coat was brown worsted with fawn-colored breeches, a vest of butter yellow, and knee-length Hessian boots. "Captain Swinburne, last night I had the good fortune to make the acquaintance of a very knowledgeable merchant banker, the brother of Manuel Lisa. He told me if we sell the *James Ross* here, the governor's going to assess port duties. He thinks we ought to go elsewhere."

"But that is blackmail! Spain has its trade agreements!"

"We have already taken commitments on part of our cargo," added one of the gentlemen from Marietta.

Harmon nodded. "Well, so be it. Lisa says we ought to take the rest to Havana, where we can get even better prices, duty free. I think we ought to take his advice. Then I propose to buy something else, even more precious, for the Atlantic Coast and sail our ship up to Baltimore. I guarantee you we'll all profit and pay no duties."

"Sir, I am at best a riverboat captain. This has been quite enough adventure for me for a lifetime."

"What cargo?" the others wanted to know.

"White gold."

"Gold?"

"Salt." There were no known salt deposits in North America, Harmon

told them, and the prices it brought inland were dizzying to think about. The sparkle of his eyes lent savor to his arguments.

Imbued with the same sense of reckless excitement Harmon and Hannah had felt upon arriving in New Orleans, the men from Marietta listened to his scheme with growing conviction. With little persuasion the two investors agreed.

"Splendid! I was hoping you would!" Harmon sprang to his feet. "Senor Lisa has asked us to meet him at his bank on Rampart Street if we came to an agreement. Shall we?"

Hannah watched her brother with pride. He seemed in his element here, as if he had lived all his life in fine clothes, confident enough to persuade older, more cautious men to see things his way.

As they waited on the dock for the carriage Senor Lisa had put at their disposal, Hannah said, "I promised Aunt Rosalind that I would look into fashions here. Also, I want to find sellers to buy my ladies' goods."

"Wait till tomorrow," said Harmon. "I'll come with you."

Hannah smiled. "While I spend hours fingering laces and velvets?"

"Wel-l-l. . . ." The carriage arrived. The footman was a young black lad dressed in fuchsia satin livery. Harmon called up to the driver, asking if the footman might accompany his sister through the marketplace while he and the other gentlemen were at the bank. Soon it was arranged, and the carriage dropped Hannah and her brilliantly plumed attendant in the center of the French Quarter marketplace, promising to return for them in an hour. Hannah planned to explore goods and designs for Rosalind's shop today, and tomorrow Harmon would accompany her to sell the ladies' exports.

Hannah soon found herself surrounded by a swirling array of jewel-toned fabrics: tone-on-tone peacock damasks, rich silks, and cottons so fine they seemed like silk. Her eye roved over furs for trim, dyed kid for slippers and gloves, felts and velvets and satins, laces and silk hosiery from Spain. How could she ever select goods for Aunt Rosalind from such bounty? She tried to imagine Perseverance Fenn dressed in peacock silk and gushes of lace. The image made her giggle. Or her mother—her lovely, workworn mother—wearing silk hosiery and paper-thin kid slippers as she tried to sidestep mud puddles on Cincinnati streets.

The thought saddened Hannah. Some people were born where everyone toiled in dark colors, constantly fighting hard weather, sudden droughts, fevers, and distances too difficult to raise medical help. While others—

A brown hand enfolded her gloved one as it rested on a length of red China silk. At first swift glance, a trapper, a tricorn hat, a—"Tecumseh! Oh!" Hannah threw her arms wide, almost embracing him before she realized the impropriety of it. She seized his hand and brought it to her breast. "My dear one! Look at you!"

Tecumseh, in a sandy brown wool pullover shirt, laced at the throat, with wide leather belt and dark brown twill trousers and jackboots. On his black hair a tricorn hat squarely set. In place of braids his hair was as Harmon wore his, tied at the back of his neck. As fine looking a Christian man as ever existed.

The wide lips in the red-brown face wavered between pleasure and a stronger emotion held in check. "How are you, Little Squirrel, after that fine journey?" His voice washed over her like balm.

She laughed with sheer exhilaration. "Oh, it was wonderful. I wish . . . I thought of you," she said, suddenly serious.

His pewter gray eyes kindled. "I came to take you home. I have brought you a fine horse. . . ."

Suddenly Hannah remembered and glanced around. "Tecumseh, is it safe? Is it safe for you here?"

A flicker of irritation crossed his face, as if he were being pestered by a gnat. "I am unknown here."

The old question, flooded back to her. Had he changed? Was he willing to adopt American ways? What a fine man he was, her Tecumseh! Why, he could be a trader, a merchant, or a senator, even.

"We will be married," he said.

"In a Christian ceremony."

"Yes, if it will please you. And there will be no second wife."

"Oh, Tecumseh, when you know my Lord, you will see that he can give us such peace, such happiness! Come, we must wait for Harmon."

Leaving the young footman to direct Harmon to them, they crossed to a little café that sold hot chocolate. She paid for the drinks with a small Spanish coin. Across from her, Tecumseh squatted carefully on the tiny, wrought-iron chair on the brick patio. Gravely he observed others lifting the delicate cups and sipping the liquid. His eyes met Hannah's. Together they lifted their cups, their eyes locking in promise as they drank. The chocolate, which she had had for the first time this morning at breakfast, was utterly delicious. She smiled at Tecumseh, enjoying his discovery, thinking how many more things they would experience together for the first time.

Suddenly Hannah thought of Swallowtail, and at last the thought did not frighten her. Oh, how foolish of her not to have seen that Prophet's tale was no more than a hot wind. Her marvelous Tecumseh could never—

"Here you are!" called Harmon, weaving through the ladies and gentlemen to his sister's table. He was in the act of removing his hat when he took a second look and recognized Tecumseh.

Tecumseh remained as he was, his feet planted solidly on the floor, one wrist poised on the edge of the table, the fist loosely coiled. He watched Harmon, neither smiling nor frowning.

Harmon glanced uneasily around. "Tecumseh," he said in a low voice. "Is it safe for you here?"

"This is not American territory."

"I know, but there's a bounty—"

"Harmon, please, sit down."

Harmon did as he asked, his face closing. "Why are you here?"

"For Hannah."

"We are going to be married."

Harmon's eyes narrowed. "Like the very blazes you are! You're not marrying my sister."

"He is! We are going to have a Christian wedding. Tecumseh agrees."

"Hannah! Ah, dear God!" Harmon's voice grated with anguish.

"But Harmon, what is it? You knew—"

The twins glanced around and lowered their voices. Harmon leaned in. "Tell her about Swallowtail, Tecumseh. Tell her what you did to him! Tell her how you tied him and the others to trees and stripped away their skin while they were still alive. Tell her—"

"Stop it, Harmon! It isn't true, it isn't true!"

"Tell her!"

Tecumseh looked at Hannah. The gray eyes transmuted to granite. The warrior chief now, not the lover. "She did not need to know."

Hannah groaned, a deep, wrenching sound from the bottom of her stomach. "Oh, why?"

"Ask your brother how they would have treated him."

"He would have hung."

Tecumseh nodded.

"Killed, but not tortured, Tecumseh! Not in agony, not begging to die."

Hannah felt herself growing dizzy. The two men glared at each other, ignoring her.

"Don't you see, Hannah, it isn't the same, none of our lives!" said Harmon.

Tecumseh reached for her hand, and she gave it, tears belling in her eyes. "Little Squirrel," his voice was so gentle, "did your father ever tell you what happened to La Demoiselle?"

She nodded, childlike, and began to recite. "He gave land to Thomas Roebuck, my grandfather—"

"After that. After the French soldiers stole his furs and killed all his people." She shook her head, not wanting to know. His eyes commanded her to share, to understand. "The Frenchmen killed my grandfather, and cooked him, and ate him."

A knot tightened in her throat. "But that's not you, Tecumseh. Things change. We will be married, and it will all be different. You can be a farmer. . . ."

Harmon propped an elbow on the table and gripped his temples with a gloved hand. "He can't be a farmer, Sis. Tell her the truth, Tecumseh, tell her the truth!"

"My love is yours, Hannah. Little Squirrel. We will have your Christian wedding."

"You see, Harmon?"

"And live in town, Tecumseh? And be a town Indian?"

Tecumseh rose and leaned on the table, nose to nose with Harmon. "I would let no other man talk to me this way, grandson of Thomas Roebuck." He straightened and looked at Hannah. "It is true, Little Squirrel. I would not be a town Indian. I am Tecumseh, and that is who I must be. It is you who must become Shawnee. I will go to New Madrid as we have promised, until you come to me."

"Then I will never come to you. I am not a Shawnee, I am Hannah Roebuck, an American." Hannah's cheeks were steamy with tears, and her eyes flashed. "Never, Tecumseh, never!"

Tecumseh gazed down at her, absorbing her until she thought she would faint. He nodded. "You will."

Hannah filled the following days with frantic activity on behalf of Aunt Rosalind and the ladies of Cincinnati. Thoughts of Tecumseh filled her nights with sleepless agony. Day and night she found herself praying endlessly to know the right thing to do. She could not stand to look at Harmon, and he kept out of her path. Harmon had ruined her life! How had he learned what Tecumseh had done? How could a man as fine as

Tecumseh treat another human being as he had? Not their agile and teasing mate of childhood. Her mind blocked out the vision of a scene in a clearing, Swallowtail screaming to die.... Finally she knew that she could not bear the thought of returning to Cincinnati. Not yet. She would go anywhere to keep from her need to go to him.

25

Dear Philippe, Matthew, Thomas, and Joey,

I can just hear you saying that you have never gotten a real letter, so Harmon and I thought we should address this one to you. Consider it your history lesson.

We are in Spanish territory now, in a beautiful city called New Orleans. It used to belong to France. Americans are not too popular here. The Bishop of Louisiana says Americans are "a gang of adventurers, who have no religion and acknowledge no God, and that they have made much worse the morals of our people."

"No morals!" said Philippe indignantly. He lowered the letter and glanced around the porch, where the whole family had assembled, along with Micah, to hear their sister's letter. As the eldest after Harmon, Philippe had the privilege of the first reading. Then everyone else could have a turn reading it aloud again.

Micah grinned. "The bishop must think there are no good Protestants."

"Read some more," urged Joey.

The King of Spain does not want the governor to give the Americans any more land grants, especially Protestants. . . .

"Aha!" said Thomas.

But Harmon says that it is too late. Spain can't stop us now. For a while she (Spain) did invite Americans living in the territories west of the United States to settle in Louisiana, because they needed more people on the land. They hoped to convert them to Spanish subjects. After a few years, everyone could see that the experiment was a failure. Americans seem to stay American, no matter where they live.

"Americans have a way of ignoring boundaries," said Micah, thinking of the never-ending stream of settlers passing through town, who evaded regulations and official proclamations to enter and settle Indian lands.

Micah had been on the frontier over a year and was still dismayed by the callous treatment his fellow Ohioans accorded Indian brethren. Men and women who were otherwise righteous and caring seemed unconcerned by their plight. Believing firmly that they were God's chosen, they blithely drove the Indians out of their homelands, warred on the ones who resisted, and disparaged the ones who tried to adapt to their ways. Of course, he had not known them before Swallowtail's attack on Hannah and Harmon. Perhaps the attack had hardened their thinking.

The young parson turned his attention back to the family's letter, wishing there was a way he might borrow it and savor it alone for a few hours.

> Many people here are very rich. They live on plantations and harvest cotton, sugar, rice, and a blue dye called indigo. Spain has laws saying the people can't ship their goods anywhere but to Spain without paying extra taxes on it. That law isn't very popular, so everyone tries to think up ways to get around it, like shipping out their cargo without telling the officials. Americans, too. I am not sure I approve of this, but Harmon says everybody does it.

"They's smugglers, ain't they, Pa?" said Matthew.

"Harmon and Hannah is smugglers?" said Joey.

"Pro'ly not, but 'most everybody else," opined Philippe, sticking a finger on the paper to keep his place.

Faith stopped rocking and leaned forward. "Does she say when they will be home?"

"That's next, Ma."

> We hope to be in Baltimore by early summer. We, too, are having trouble with port duties. Harmon is convinced we should sail to Havana to sell the cargo, then engage another cargo that will sell well to the Atlantic states. If this sounds as if we have suddenly become merchants instead of farmers, why, I guess we have! Mama, please tell our friends that their preserved and pickled foods were very popular. Harmon says I drove a good bargain. (These were not taxed.) Also, please tell Aunt Rosalind that I have found some unbelievable yard goods and fashion plates for her shop.

Faith leaned back and began rocking again, a pleased glow suffusing her face. "William, I am so thankful that you persuaded me to let Hannah go with her brother. She sounds quite her old self again!"

Micah listened as Hannah closed with loving regards to each of her family and prim regards to himself. He smiled, feeling a warm glow of pleasure. He heaved himself off the porch steps.

"Well, friends, I've a mind to take a trip."

"Where might that be, parson?" said William.

"I believe I shall pay a call on my friend, Pastor Andrew Lachlan, in Baltimore. He has been after me to visit, and it has been nigh two years."

"Oh, oh, I know where you're going. . . ," sang Joey. "You're going to meet Hannah and Harmon's ship when they come back!"

"Joey, that is not respectful," said Faith. "Apologize to Parson Mac-Gowan."

Joey did, but with a slyness that belied his contrition.

In the long months after the *James Ross* had settled into the current and floated out of sight of Cincinnati, Micah had waited patiently for his new congregation to organize work on a church. At first it was harvesting that claimed their time. Then it was winter and too frigid. Since the spring thaw, nothing. Now, as he walked home to his bare lodgings at the rooming house, he began turning over the problem in his mind. He did not want Hannah to come back and find Cincinnati with no church. And, yes, himself with no house. No house to offer a woman you love when you ask her to marry.

He stopped on the rutted wagon road, still patched with puddles from last week's rainstorm, seeing none of it. *Where your treasure is, there will your heart be also.* He finished the distance more slowly, planning Sunday's sermon.

That Sunday, for the first time, Micah donned his Genevan black wool robe. He craned for a decent view of himself in the tiny square mirror over his washstand. The robe was too short, barely covering his calf. Looking down at himself, his legs seemed too thin, made more so by the black silk hose. Everyone admired a well-turned calf, but with his thin shanks, why had it been *his* robe that the tailor had mismeasured? And why had *he* been so naive that he hadn't tried it on before he sailed? Carefully he fitted his white wig over his gleaming red hair. Let his parishioners have their fun, as he knew they would.

"Well, parson. . . . Well," said Mr. Fenn as he crossed the street, robe billowing out around him.

"May I borrow a crate, Mr. Fenn? A large one."

"Why, that you may, parson. Can I take it somewheres for you?"

"No, thank you."

Fenn, in Sunday dress, led the way back to his store and found Mac-Gowan a large, sturdy crate, lately used for shipping crockery. Micah remained outside.

"Mrs. Fenn not coming to church this morning?"

"No, she's minding the store." Fenn did not meet his eyes. Haney's tavern, the farrier, and the printshop, the barber, and the tailor shop, and the feedstore were also open and doing brisk business.

A few minutes later, Micah strode through the parked buggies and tethered horses and complacent citizenry—so they seemed—up the schoolhouse steps and down in front of the blackboard. He set his crate atop the table that served as a teacher's desk and draped it with a white altar cloth. His blue eyes sparked, daring anyone to comment on the anomaly of crude altar and formal attire or on the wig, which on a man they had grown used to seeing topped with straight, red hair, probably seemed ludicrous.

They sang a song of gathering. His opening prayer was brief and crisp. He observed them stealing sidelong glances at one another. He waited for their complete attention.

"If you honor the Lord, you must honor me. You have lived so long in the wilderness you have come to act like beasts of the forest. I see more of an eye for an eye than turning the other cheek. You talk of being served by a parson, yet you are unwilling to give him the means to serve you well. How can you grow in grace and charity when those of you with the most to share are so busy making money on Sunday that you do not spare the time for the Lord's Word?"

Micah felt by this time that he had already sealed his fate—he could tell it by the sudden silent chill invading the sunny schoolroom—so that he might as well plunge ahead.

"You pay much lip service to your precious freedoms. 'Oh, for the government to tax the people to support the church would lead to the state tellin' the church what to do.' If we taxed it for the Baptists, would we also have to give a share to the Methodists? And the Jews? And the Episcopalians?

"Then who shall support the Lord's work, if you be not willing to tax everyone and you be not willing to close your shops on Sunday? You say the Lord gave you this land. Divine Providence. Then where is his thanks? Even the Shawnee burn a portion of their meat in thanks to their spirit folk and bury a portion of their corn. Go home, see the faces of your dear children, see your lands, your forests, and then answer me: Where is the Lord's tithe? In my righteous life, you say. And whose life is

righteous, if he or she be not willing to credit the Lord? And to see to it that all those coming to this shore and all those precious children born on this free soil are not also taught how to live in a manner pleasing to our Lord?

"Forgiveness and growing are two sides of the same thing, like the back and front of hands clasped in prayer. Forgiving wrong attitudes in ourselves opens the door to growing toward God.

"I am leaving you, my friends." He saw faces sprout genuine alarm. He relented and allowed a bare smile. "For a visit to Baltimore. I confess it will be a profound pleasure to attend church where the altar is more than a food crate and the edifice consecrated to our Lord.

"I tell you these things because they are the things on my heart. Being away from you for a month will give me time to consider how I am failing to serve the Lord . . . why my words have so little effect. . . ."

By this time, no one was looking at him. His voice broke with the passion of his feeling. He asked them to stand and bow their heads for a closing prayer, then picked up the food crate, the altar cloth, and his Bible and strode between the school benches and out the door.

26

Hannah stood at the tall French windows, gazing out over the front portico of the Lisas' home in New Orleans. Seated in the large, gracious room behind her, Harmon, Isabella, and Isabella's mother were laughing over some bit of gossip that had circulated at a party they had all attended the previous night. Since Tecumseh's departure, Hannah had withdrawn into herself, courteous to her hostesses, but not speaking to her brother. As she stared moodily out at the foggy morning, a huge, unmarked carriage lumbered out of the mist, up the straight drive, through the veiled mounds of orange trees, to the circle at the entrance of the Lisa mansion. The footman sprang down and smartly pulled out the steps below the carriage door. One man, small, dressed in black, with a high beaver hat, alighted. Moments later the butler came into the morning room, bearing a silver salver with a card upon it.

Senora Lisa took the card.

"He wishes to see the owners of the ship, Senora Constanza."

Her face bright with amused surprise, Constanza Lisa rose at once in a swish of taffeta. "I hope neither of you committed some dreadful indiscretion last night, like giving away your ship. Come, Isabella. You may show the gentleman in here, Jobe."

Hannah caught the special look that passed between her brother and Isabella as the girl followed her mother out of the room and felt like crying for her own aching loss.

"Senor Henri Rouchfort."

The butler disappeared, leaving the small gentleman in black, who bowed briskly. "Monsieur and Mademoiselle Roebuck, it is a great honor to meet you."

Hannah came forward. "Mr. Rouchfort, please sit. May I send for coffee or perhaps chocolate?"

"Chocolate would be nice, thank you." His eyes lingered appreciatively on her, on the embroidered ruching at the shallow neck of her yellow morning dress, the cameo fastened at her throat by a slim band of yellow velvet, the loose, coffee-colored curls that fell from a yellow bow tied at the crown.

As Hannah summoned Jobe and requested refreshment, Harmon waved their guest to a seat. "I don't believe we know—"

Rouchfort nodded easily, pulling his gaze at last from Hannah's graceful movements. "How much alike you appear! I represent a most honorable gentleman. Before saying more, may I assume, nay, have your word, that I have your complete discretion?"

Sister and brother looked at each other and nodded. Jobe brought a tray and disappeared.

"Thank you." Rouchfort accepted the chocolate from Hannah and set it down untouched. "The party of whom I spoke must depart for France within the next two weeks. He is being closely watched, as his leaving will signal certain enterprises have reached—ah—fruition, shall we say. You and your partners can help us by selling us your schooner. We are prepared to top the best offer you have received and to make further recompense for services, under certain conditions."

"Well!" Harmon said with relish. "You've got me curious. What are the conditions?"

"That no news of the sale is made public. . . ."

Harmon glanced at Hannah. She answered with a slight shrug. "We cannot speak for our partners, you understand, sir."

"Quite."

"What is the next condition?"

"That your crew takes the ship to France, as if you had planned to do so all along, as a merchant venture."

Harmon barked a laugh of surprise. "That is highly unlikely."

Hannah caught her breath. *France.*

Rouchfort rolled on as if he had not heard. "I understand your captain is not versed in ocean crossings. We will provide an experienced captain and mate. I would hope the rest of the crew would sign on."

"Why the *James Ross?*" said Harmon.

For the first time, Rouchfort paused to think before he answered. "For one reason, there is fever in the Caribbean. Any ship already in service in these waters is likely to fall prey to it. If that happened, the ship would be at its mercy, with no port willing to have her until the sickness was past. I assure you, our mission is urgent!"

"Is it also legal?" Hannah asked.

"It is." Giving a slight smile, Rouchfort tipped his head. "And as a consideration, it is also patriotic."

"To whom, sir?" said Harmon. "France and Britain have only just got-

ten over a war. I know little of it, save that the *Gazette* says President Adams had the devil's own time keeping the Congress from raising a provisional army and going to war against France."

This time the man's smile was a little broader. "You are correct. Praise be to our Father Almighty that he was able to stop them. I assure you, President Adams is quite in accord with the aims I desire now to further with your help.

Also, you may be interested to know that since moving the capital from Philadelphia to Washington, the president has begun the process of building a navy. If you had a navy, I would not now be at the mercy of your good offices."

"You said *you*," said Hannah. "Does that mean that you do not include yourself when you speak of America?"

"That is correct. But a friend. Definitely a friend, as is my employer."

For some reason, his words brought one person's name to Hannah's mind, that of the idealistic, dashing Frenchman, the Marquis de Lafayette, who as a young man had earned the gratitude of all American patriots by joining General Washington when he led the fight for independence. Lafayette was saved from the guillotine when the king of France and most of the nobility met death during the French Revolution a dozen years later because he was languishing in an Austrian prison, and the French commoners did not consider him an enemy.

The French Revolution had helped crystallize American politics into two parties. In Cincinnati most citizens who gave any thought at all to affairs outside their own territory favored Thomas Jefferson's party, which had supported the French Revolution from afar. They shared Jefferson's distrust of cities, high finance, and industrialization, as well as his belief that, with education, commoners were as capable of governing as well as aristocrats.

"Can you tell us any more?" asked Hannah eagerly.

"Not at this point, regretfully, Mademoiselle Hannah. However—"

"Yes?"

"Soon. As soon as we are away from New Orleans."

"Are you so sure we will accept your offer?"

"It *is* in your best interest."

"So you must get out of New Orleans—Spanish Louisiana—without the fox knowing the nest is empty," guessed Harmon. He glanced at Hannah, and she returned an encouraging smile. "If our other business partners are willing, I propose that we accept your offer, but that we also go about our business normally. We had planned, when the rigging

is finished, to sail to Havana, where we can sell our remaining cargo duty free. Then we are going on to Tortuga Island to pick up our next cargo."

"What might that cargo be?"

"Salt."

"What had you planned after that?"

"Why, sell the salt and the ship in Baltimore and head for home."

"Home being?"

"The Ohio Territory, sir."

"Marvelous," he murmured. He slapped his knees with gloved hands and rose. "If you sell the ship to me now, I shall agree to carry on as you have proposed, with one small difference: All business to be concluded at Norfolk, Virginia. I will pay for your passages home on board another ship after I have gone, and I must have the word of each of your partners as honorable men not to speak of our agreement."

"Not ever?" asked Hannah.

"You will know when the time is propitious to reveal your part in this little adventure."

The next day Harmon met the mysterious M. Rouchfort again, as arranged, in his carriage in the vigorous, noisy heart of the shipping district. "Sir, it is done. All partners are agreed."

"Splendid! Then you will have three passengers, including myself. *A propos,* Roebuck. . . ."

"Yes, sir?"

"You strike me as a bright young man. You are not by chance a part of the crew, too, are you?"

"No, sir."

"Care to be?"

Harmon thought. "Go to France, you mean?"

"Yes. You are well-spoken. The fact that you are a commoner will appeal to—er—our interests."

Quickly Harmon realized what an opportunity it represented, falling like a golden peach in his lap, to discuss an exchange of trade with French merchants. Just as quickly, he thought of Hannah. His conscience had bedeviled him since he had destroyed her plans to marry Tecumseh. What course might she take without him? "Could my sister come along?" he said suddenly.

"But of course. I understand how it is with twins."

Jubilantly Harmon shook hands with his new employer. It would be the perfect diversion to take her thoughts in new directions. As for his

own thoughts, only briefly had they returned to Isabella since meeting the enigmatic M. Rouchfort.

"As I live and breathe, Micah MacGowan!" The cleric stood on the doorsill of his snug brick home in Baltimore and beamed delightedly up at the red-haired man blocking his doorway. "Ye've filled out in the wilderness. And now your tour is over, and ye are on your way home! Come in, come in!"

Micah entered, laughing. Andrew Lachlan, with his outrageous way of assuming the obvious, called to Lettie to provide tea—and perhaps just a wee bit of wine—to celebrate Micah's return to civilization.

"A moment, Parson Lachlan. I don't suppose we might walk a bit? I've done a tremendous amount of sitting the past week."

"*Walk?* Why, yes, a capital idea." Again he yelled for Lettie, this time to bring him his coat and belay the order for tea until their return. "Now, lad, we'll stroll toward the bay, and y' can point out the ship that'll be carryin' ye home."

As they strode off, Micah quickly set Lachlan straight.

Lachlan stopped where he was, in the middle of a busy street, heavy wagons and light carriages lumbering and bustling past, rat-tatting their music on the cobblestones. "You are *not* sailing for home?"

"Cincinnati is home."

"Then you came all this way just to visit a poor old man!" cried Lachlan.

"Whoa! I never saw one to take such giant leaps of imagination. A man as fast as you has no need of horses." Before Lachlan's flights could carry them even farther from the truth, Micah told him why he had come.

"Oh, lad, lad. Comin' four hundred miles to squire your ladylove home! Oh 'tis grand. And the name of the ship?"

"The *James Ross.*"

"And built out in the wilderness. Fancy that! Like Noah's Ark! Well then, come." Without waiting, Lachlan plunged ahead.

"Where are we going?"

"To the port-authority office, to peruse the list of arrivals. When is she due?"

"To the best of my calculations, within a week."

"A week. Oh, grand. I shall be delighted to meet her, and in the meantime, I intend to make use of every moment of your company." Lachlan stopped in his tracks as three husky seamen lurched out of a tavern across their path. "Isn't that a sight to shame the Lord! D'ye know, Micah, that

last month this city refused to hire a police force? Drunkenness, beat-ings, cutpurses on every side.... 'Oh, 'twould be a threat to individual liberty,' they say, 'a drain on town funds!' Ach! I've a mind to go away mysel'."

"Come to Cincinnati. Take my pulpit for a while. I've been needing more time to reach the unchurched, Indian and white."

"In the *wilderness?* Hmm. Ah, no, what am I thinking of, a man of my age?"

The *James Ross* was not listed among the arrivals or among ships due.

After a week with no new intelligence, Lachlan suggested they ask the port authority to check with other seaboard ports to discover if she had put in elsewhere. Micah agreed quickly, grateful for a course of action that allowed him to push aside his fears for Hannah's safety.

In the meantime, he allowed Lachlan to draw him out about his min-istry in Cincinnati. Aye, Lachlan would nod as Micah admitted what he had found to be true, too close to the cynical predictions of his teachers at the London Missionary Society. "Two years, and they've yet to build a church. Perhaps I should take an ordinary job where a man might pros-per and have a good living to offer a wife."

"Ye'd never do that!"

"Not yet," Micah admitted. "It will look more hopeful with a wife at my side. But it is not only the church, Andrew. Have you any dealings with Indians in your parish? No, eh? Ever seen hunting dogs running around a trapped porcupine? That is how it was when I first arrived in Cincinnati. The Roebuck family and a few others have worked to im-prove things, but by and large we've a long way to go to become Chris-tians in deed and faith.

"It is not all one-sided, of course, never is. I have discovered a remark-able Indian chap who calls himself Prophet. Some call him a dangerous fanatic. Perhaps he is, but not all of what he says is false. He's related in some way to Tecumseh—"

"The Shawnee chief! I say, I have heard of him. Have you met him?"

"No, but he comes to Prophet's town sometimes, so perhaps I shall. I have tried to get Prophet to understand Christianity. Some days he is willing to sit and listen and other days not. I would say he is typical of the Indians' unwillingness to cast off their Great Spirit for the one true God."

The men were sitting in Lachlan's tiny garden, behind his house. Micah leaned back and closed his eyes. He heard a pair of orioles chat-tering overhead. "They are all good folk in Cincinnati, Andrew, but oh, there is a perversity that sits among them. They expect me to do my part

in easing Indian relations and to trust in the Lord for my subsistence; then they stubbornly sit back and wait to see how the Lord might accomplish this without their help!"

"Have you not told them that Christ is within them? That he can only work through them?"

Micah ran his long, freckled fingers through the straight red hair. "Oh, yes, I have told them. I have tried to show them by example. And they like me, I believe they do, but it is a game to them. In which they will prove that if I stay on despite their lack of help, I did not need it after all; or if I go, then clearly I was not possessed of the Spirit in the first place."

"And your betrothed? What does she think of this?"

Micah grinned shyly. "Ah, now I have to confess to great leaps of the imagination. She has not accepted me yet. But she will."

Something about this struck Lachlan funny, and he roared with laughter. "So leave the town and you lose the girl. Stay and preach and be too poor to marry her!"

"Something like that."

"Now that, my lad, is just the sort of problem our Lord loves. Be of good cheer, Micah. I have a feeling it will all work out just grand!"

Early one morning, several days later, Micah stood with hunched shoulders at the farthest edge of a dock, brooding across the choppy waters of Chesapeake Bay. Whitecaps broke the gray reflection of the clouds above his bared head. His eyes were chafed and watery as he stared through the chill wind at the peaceful, wooded inlets on the far shore. A line from Jeremiah sobbed on the wind: "The roads to Zion mourn, for none come to the appointed feasts."

He had never felt quite so close to despair. God had brought him to this magnificent land and given him a charge. He had tried his best to work for its fulfillment and yet on all sides met defeat.

The first time he had seen Hannah Roebuck, she had been lying on a bed, her hair a tangled, mud brown mass staining a pure white pillow slip. He had looked at her and she at him. He thought now that he knew even then that Hannah was the girl God intended for him. "I brought her before thee the first time I saw her and truly felt thy blessing," he said aloud.

The wind whipped through his red hair. His head sank to his breast. When he was a little boy he used to run to his mother's knee and cry when he was hurt. With all his soul he knew that if she were here today, nothing could keep him from crying.

233

"Gone to France, you say! Truly, gone to France?" Lachlan was sitting in his tiny study, wearing his favorite wool vest and comfortable felt slippers, when Micah returned.

The air felt overheated and stale to Micah. "Yes. The schooner docked at Norfolk, Virginia. It was purchased by a French shipping company. The port authorities had for me a partial list of passengers and crew. . . ."

"And your Hannah Roebuck's name was on that list. Isn't that incredible! What now, my lad?"

"I am leaving."

Lachlan struggled out of his chair. "Not giving up, are you? Micah, dear friend, please reconsider. . . ."

"For G___ sake, Andrew, listen for once in your life!"

The older man blanched.

Micah took two steps forward and grasped Lachlan's shoulders. "Ah, Lord, forgive me. I seem to have lost all, and now I would lose you, too."

Lachlan reached up and patted his hand. "No, Micah, you have not lost me, and God hasn't forgotten you. Come, my lad. Shall we pray?" The two men knelt side by side at a threadbare settee. Lettie, passing the door a few minutes later, saw the heaving shoulders of their big, red-haired guest and heard the comforting words of her doughty little employer. Softly, she closed the door.

Neither the captain nor the Marietta partners were aware that the Roebucks were remaining on board, until they met for the final time in Norfolk, two months after leaving New Orleans. Their first venture had succeeded beyond their wildest imaginings. Sale of the ship, the salt, and other minor cargo purchased in Havana had brought the adventurers a profit of ten times their investment. They talked of forming a permanent shipping company, Harmon to pursue contacts on the European continent and the Marietta partners to build upon it from the United States.

While the schooner was being refitted and resupplied for her maiden ocean crossing, Hannah was too busy to think about personal problems. Harmon had deposited the Cincinnati funds in the Bank of Virginia and prepared a detailed proposal of their next venture in a long letter to their father. Hannah drew up a final accounting for each person in Cincinnati who had sent goods, to be sent along with the receipt of deposit and Harmon's letter.

There were letters of her own to write, new clothing and personal items to be obtained before the voyage, and arrangements for shipment of the ladies' fashion goods purchased in New Orleans for her aunt's shop

(with assurances that they were new and had never been worn by plague carriers or anyone else). Cincinnati, the farm, and her family and friends all seemed very far away now, as if they existed in a separate life. Tecumseh she could not bear to summon up and kept all thought of him boxed securely in a hidden corner of her heart.

On May 2, 1800, the *James Ross* sailed for France. Hannah and Harmon had had not a glimpse of the two passengers who accompanied M. Rouchfort aboard in New Orleans. Not until they were out of Norfolk did the mysterious passengers finally appear on deck. Hannah was dazzled by their prominence: one a nephew of Lafayette, the other a courier of Napoleon Bonaparte.

"You see," Rouchfort told Hannah one afternoon as they strolled the deck, "unbeknown to the Spanish governor in New Orleans, Spain has just ceded Louisiana back to France." The dapper man peered up at her anxiously, as if afraid such worldly talk would overtax her feminine capacity to understand.

Hannah nodded. "This is the secret business your friends just concluded."

"Yes. And the next few years are critical. As your brother discovered, the governor of New Orleans teeters back and forth, one day closing ports to all foreign ships, the next admitting ships to unload only after paying massive duties, and the following day declaring certain goods illegal. France will not interfere. We have agreed to maintain the fiction that Spain still owns the Louisiana Territory."

"Why is that, M. Rouchfort?"

"Why, it is very simple, my dear. A Spanish Louisiana is no threat to England's imperialism in North America. A French Louisiana is quite another matter."

"What imperialism?"

M. Rouchfort stopped. "Mademoiselle, do not delude yourself into thinking that the British have given up on North America. Your Revolutionary War was to them a battle, not the war."

27

1804, Paris. "You see," said Henri Rouchfort to the assembled guests, "the Mississippi was the key. The cries of outrage from American farmers in Kentucky and Tennessee were heard all the way to Washington. The labor of farmers for an entire year, gentlemen, rotting away in the holds of ships while port authorities in New Orleans held them up for blackmail. "My young friend here—," Rouchfort leaned down the formal table, past two sconces of glittering candelabra, to nod at Harmon, "can tell you. He put up with Spain's avariciousness for four long years!"

Hannah and Harmon sat side by side, hardly believing that they were in company with James Monroe, special emissary of President Thomas Jefferson, and twenty men and women of the noblest blood of France. The dinner party was being given in the chateau of the American ambassador, in honor of Monroe's triumphal return to France.

Commercial upheaval in New Orleans, stepchild of political maneuvering between France and Spain, had produced a crosshatch of bizarre schemes, escalation of smuggling, pirating, and bogus pirating. The payment and receipt of bribes had become an expected business expense for every merchant using the Mississippi to reach the seas.

All Paris was buzzing with the best-kept secret of the new century, which between them, Henri Rouchfort and James Monroe were now revealing to twenty entranced French citizens and two ordinary Americans. Three years ago, when Thomas Jefferson succeeded Adams as president, he sent Monroe to France, with authority to sound out Emperor Napoleon Bonaparte about selling New Orleans and West Florida to the United States.

"He could see no other way, short of war, of guaranteeing an open port for our new states beyond the Appalachians," explained Monroe. "Therefore he authorized me to bargain up to the price of ten million dollars. Your emperor, as you know better than I, was up to his ears in war and badly in need of cash. Even so, when he offered to sell the whole of the Louisiana Territory for fifteen million, I was stunned." Monroe looked down both sides of the laden table.

Few of the guests had any conception of the vastness of the lands Monroe was talking about. Eight hundred thousand acres, all the lands

between the Mississippi River and the Rocky Mountains, which France had claimed, to the regions of the far north claimed by Britain.

"But this was an offer that you were not authorized to accept," an elderly man in an elegantly curled silver wig pointed out.

"Aye, you're right," laughed Monroe. "And some were ready to secede from the union rather than authorize funds spent so recklessly and without permission."

"Why did you do it?"

This time James Monroe was slower to answer. "Emperor Bonaparte did not want to wait for his answer while I sailed to America and back again. He wanted it and his money immediately. In America, we seem to believe that every man has common sense, given a chance to use it. I knew President Jefferson would realize the greatness of the emperor's offer. . . . As you can see, I still have my head."

General laughter swept the table. "We are glad to have you back again, M. Monroe. And I suspect our two young citizens from the Territories are equally so."

Monroe looked diagonally down the table. "What part of the Territories are you and your sister from, Mr. Roebuck?" he asked.

"The Ohio, sir."

Monroe's smile broadened. He reached for his champagne glass. "Then may I have the honor to tell you that your territory is now the seventeenth state of our holy Union. It was so voted just months before I left Washington." Monroe rose. "To Ohio!"

Bewigged and liveried servants leaped forward and filled the glasses.

Tears sprang into Hannah's eyes, shooting the crystal goblet into diamonds and bathing the candlelight in a radiant blur.

"To Ohio!" "To Ohio!"

"I was reading the other day about a famous Indian chief in America, and I believe he lives also in the Ohio Territory," said Rouchfort, when they had all resumed seats. "His name was Tecumseh."

Harmon glanced at Hannah. Her gaze remained upon Rouchfort.

"Oh, yes," said Monroe acidly. "Tecumseh. He is the leader of the Shawnee, M. Rouchfort, a very nasty, warlike tribe. The British are quite delighted with him. Tecumseh is a brilliant tactician. The Americans have been trying to put him away for years."

"Indeed!"

Hannah clenched her teeth.

"I confess he outwits us," said Monroe. "He's got some sort of shaman

in tow, a fanatic if there ever was one, who strikes holy terror in the hearts of other people, even Indians."

"Why? What does he do?" asked the old gentleman in the silver wig, his eyes gleaming, ready to be entertained.

"As I understand it, he tells them they will all die and go to live in the underworld forever unless they return to their Indian ways. Which includes destroying the white man, wherever they meet him. He believes that he and Tecumseh are invincible."

"What a delicious tale!" trilled one of the women. She leaned across the table and asked Hannah, "Have you ever heard of them?"

"Who hasn't?" Harmon interjected lightly. He smiled at his sister, his eyes pleading with her to keep silent.

"I'm ready to go home." The bells of Notre Dame Cathedral had just rung out the hour of two in the morning when Harmon appeared in the doorway of his sister's bedroom. His stock was wrinkled with perspiration and hung loosely around his shoulders, and his evening coat was rumpled. Harmon seldom wore wigs. His dark hair was thick and slightly curled. His eyebrows were fine, straight wings on the broad forehead.

"Home?" Hannah could not resist teasing him. "From the way you and Mademoiselle Petitechou were nibbling on each other's ears at dinner, I hardly expected you home at all."

Harmon made a face at her. "The mademoiselle is the daughter of a business associate. Hardly more than an acquaintance. You're the one I'm surprised to see so early. You have more *beaux hommes* traipsing after you than geese after a goosegirl."

Hannah shrugged. "Business acquaintances. The French like older women."

The two of them eyed each other. The masks dropped. Hannah looked away first and made an affair out of primping up the lace of the sleeve of her dressing gown, an exquisite creation of azure silk and Alençon lace. Her chestnut hair was unbound. Brushed out around her shoulders, it gleamed in the candlelight.

"It is time to go home," Harmon persisted. "Isabella wanted a two-year mourning period, I have not seen her in four. I have been all over this country establishing trading ties. We have a reliable French firm to handle our exports, and now that New Orleans is ours, it is time to build up our trade lines westward from the Mississippi."

She didn't answer her brother.

"What is it, Hannah? Every time I talk about going home, you think up something else that we have to do. First it was my business, then it was yours for Aunt Rosalind. Then it was that journey up to Le Havre, last fall, to find the farm where Gra'mama lived as a young girl. You like this life, don't you?"

That made her laugh, a rich, appreciative laugh, but not a gay one. "I like wearing gowns like this one. Can you imagine wearing this in Cincinnati?"

"We haven't been there in nearly five years. It might surprise you. Is it that Louis what's-his-name, Lafayette's nephew?"

Harmon hooked his thumbs in his waistcoat and wandered about the room. He crossed to her writing table. "All these bills for dresses—yours?"

She shook her head. "Rosalind's accounts. Our accounts, Rosalind and I are partners now. I told you."

"I forgot." Harmon's voice was cutting, as if ladies' fashions were beneath interest. "You see Micah's last letter?"

"Yes."

The lilt in her voice made him look up.

"He must spend a fortune in posting."

"We tuck letters in every shipment of goods and all the packets to the family."

"Look at me, Hannah."

She looked at him with amusement. "Every time you get that tone in your voice, I think, *I was born first!*"

"Well, all right. Please, then."

"I don't mind, Harmon. I know you love me, and I love you."

"Then what is it, Sis?" Harmon flopped on a satin chaise and crossed his long, booted legs at the ankle. "Why don't you want to talk about going home?"

Again she did not answer.

"Look, this time I'm going. Whether or not you go. I want to get married, have children. And if you wait much longer, you'll be too old to marry."

The eyes, the set expression of the features, so perfectly matched, faced each other. Tecumseh. His image, unspoken, lay between them.

"*Bon voyage,* Harmon."

"Harmon is coming home!" yelled Matthew, waving the letter as he galloped at breakneck speed into the yard and pounded up the steps into the house.

"Harmon and not Hannah?" said William, raising himself on one elbow, grimacing with pain from the bout of rheumatism that had laid him up for a spell.

"Guess not. He don't say Hannah." At twenty-four, Matthew filled the doorframe, a husky man with sun-bleached blond hair, as tall now as Harmon had been when he left Cincinnati, married, with two children. He held the letter at arm's length and read it through his new gold-rimmed glasses. "Yep, does too say. Hannah's stayin' in Paris 'cause of her and Aunt Rosalind's business. Humph!" he added. "Girls like her ought not to be in business."

Faith laid aside the rag rug she was crocheting and gazed out the window at her thriving flower garden. "Poor Micah," she said softly, burying her own disappointment philosophically. "Read us the letter, Matthew, dear."

28

"**M**rs. Fenn? Mrs. Fenn!" Fenn stared at the crock of butter on the counter before him. "If it ain't those dimmed British with their counterfeit paper, it'll be me own wife doin' me in! *Mrs. Fenn!*"

The two soldiers from Fort Washington exchanged uneasy glances. Apparently when they had brought back the crock of rancid butter, they had not expected this reaction. Fenn was a patient and fair man, only rarely given to temper, who had for years supplied goods and foodstuffs to the fort when the quartermaster ran short.

"What is it?" Perseverance Fenn appeared from the storeroom. Her little mouth was pulled in a line as tight as a needle.

Fenn shoved the heavy butter crock down the counter at her. "Explain this, madam!"

She craned a look at the greasy, transparent yellow surface and sniffed. "It appears to be rancid."

" 'It appears to be rancid.' And how did fresh butter turn rancid overnight?"

The look she shot at the hard-bitten soldiers was full of malice. "Most soldiers don't know rancid butter from fresh!" she muttered. "Who d'they think they are, bringing my butter back?"

"You never threw out the batch that turned putrid, did ye? Ye dolloped it in the crocks and smeared it over wit' a layer of fresh churned. Ah, woman! What am I to do with you? Go and get these men a crock of fresh butter. And when I go to the springhouse, I better not see a bit of this stuff left!"

Fenn lifted his shoulder and hand in apology when she left. "She gets a mite testy some days."

"Yessir. Some days it ain't bad bein' a bachelor."

"Bert!" his companion nudged him. "He di'n' mean no disrespect, sir."

"I understand," Fenn nodded.

"Good morning, Mr. Fenn and gentlemen!" called a merry voice.

"Well, good morrow to yourself, Parson MacGowan."

Micah's glance took in the frayed, dusty uniforms of the horse soldiers. "So, how is life out at the fort these days, now that Ohio is a full-fledged state?"

241

"It is mighty fine with us! You look up and see that flag with them seventeen stars, an' y'know one of 'em's ourn. Now mebbe we can get rid of the savages, once for all."

"I hadn't heard of any trouble," said Fenn.

"Ain't none, Mr. Fenn. It's just that them Shawnee camps oughtn't to be allowed now. Ohio ought to be for Americans."

Perseverance Fenn struggled through the rear door, with her arms wrapped around a heavy crock. The soldier Bert sprang forward. "Allow me, ma'am." He took it from her and started out.

Micah took a step toward the soldiers. "Did you notice something new in town when you rode in?"

The soldiers looked at each other. "Couple new stores. . . ."

"A new church! Cincinnati has a beautiful new church! Come on down and see it!"

"Be glad to see your church some other time, preacher."

"Tell your companions. Remind them," Micah said earnestly, "that our church has a choir, with a sweetness of voice unmatched by the chapel at your fort."

The soldier stopped. "You mean you got ladies that sing in your choir? I ain't heard ladies singing hymns since I was a little un in New Hampshire. I'll surely tell 'em, preacher. A little sweetness would go right nice."

"Thank you."

As he went out the soldier nearly collided with a jet-haired lady wearing an enormous hat shaped like a beehive. " 'Scuse me, ma'am."

"Quite all right, young man," said the lady with a fetching twinkle of her black eyes. She rustled inside in a mist of perfume. "Good morrow, parson. You are up and about early."

Micah tipped his black tricorn. " 'Morning, Miss Rosalind."

"My niece mentioned you in her last letter. She asked me to give you her kind regards."

"Very kind of her," Micah said coolly.

Mrs. Fenn had disappeared again when Micah turned back to Fenn, who waited behind the counter. "Your delivery boy said you had a box for me."

"And for me!" added Rosalind. She laughed and said to Micah, "I hope it is from Hannah. She sends the most marvelous things, laces and whalebone buttons and embroidered linens. Our ladies are becoming as well dressed as any in Baltimore or Philadelphia. . . . Perhaps you have noticed, Parson MacGowan?"

"No, Miss Rosalind."

"Oh, my," she said regretfully, "I overheard some of our young ladies in town express the opinion that they hoped you would notice their new frocks on Sunday mornings!"

Micah chuckled. "Perhaps men of God are immune."

"Why, parson! What a naughty thing to say! I shall not tell my clients you said that, else they might stop coming to me."

"Here you are, parson." Fenn had a small, stout crate under his arm, balanced on his hip. "Heavy enough. Bibles?"

"Spellers."

"Spellers?"

"Indeed. A Mr. Webster has hit upon a wonderful scheme to improve our learning. A book giving a uniform spelling for words. We will be spelling words large and small—," the blue eyes under the bleached red brows danced roguishly at Rosalind, "just like they do in Baltimore or Philadelphia."

Rosalind smiled back, a willing party to flirtation with the handsome young parson.

Fenn wiped his brow. "Interesting. Your crate's considerable larger, Miss Rosalind."

"Harmon said he would meet me here and take it over in the wagon."

Fenn nodded. "Seeing as he ain't here, I'll tell him he can pick it up in back."

"Oh, thank you, Mr. Fenn, then I've other errands to run."

Rosalind's smile was as enchanting as a young girl's, Micah observed. *She looks a lot like*—He crushed the thought.

"Good day, parson." She slipped a tiny, gloved hand in his and gave his fingers gentle pressure. Her spirited gaze held his for a moment, and he thought she would speak more, but with a little smile, she left.

Package under one arm, Micah dawdled in the fresh morning sunshine outside Fenn's. He mulled over the soldier's words about getting rid of the Indians "to make Ohio safe for Ohioans." This opinion was getting aired about with regularity. The possibility of more clashes made him a little sick. In the years since his return, without Hannah, from Baltimore, he prided himself that with the Lord's help he had made genuine inroads into peace between the races.

He visited Prophet's village regularly. He had discovered to his surprise that the feared "fanatic" Prophet and he had much in common. Both clearly saw their duty as spiritual leaders of their people. Little by little, Prophet had lost his antagonism toward Micah. Micah remembered his last visit, a week ago. Prophet's village was a scene of such peace it would

have seemed laughable to compare it with the military view of "the enemy, whose camps are hotbeds of destructiveness," had not the implications been so serious.

Pleasant laughter had greeted his ears. Several girls of about ten were rolling hoops made of saplings twisted into a circle. He saw three new babies propped in the shade, laced in cradleboards, while their mothers tended vegetable gardens. Liquor had been outlawed by Tecumseh, and Prophet enforced it with swift punishment of perpetrators.

Suddenly a man had whipped back the door hanging of a lodge and strode toward the council house. He was tall and well muscled, wearing buckskin trousers and a vest. He moved like a man of great authority.

Micah stared. "That is Tecumseh, isn't it?" For some inexplicable reason Micah felt a surge of hostility. He was appalled at himself. Of course Hannah's family had known him for years. It was not possible that he was *jealous* of a family friendship! Was it?

Prophet's friendly stance altered subtly. A secretive expression stole over his face.

Micah turned back to Prophet. "I'd like to meet him."

Prophet met his eyes. He wavered. "Wait, then."

Micah watched as Prophet crossed the compound. *Lord, you are making possible this meeting. . . ,* he prayed, hoping for the best. Then Prophet turned and beckoned to him. Tecumseh watched Micah approach. His hands rested lightly on his hips, his weight settled on the back foot.

As he neared Tecumseh, Micah recalled the relish with which Cincinnatians denigrated town Indians for holding to their Indian ways on the one hand, and for "trying to emulate Cincinnatians" on the other.

Micah extended his hand as Prophet introduced him. "It is an honor to meet you, Tecumseh." Tecumseh was taller than Micah, with greater breadth.

"Prophet tells me that you are the spirit man of Cincinnati." His flinty eyes were cool, probing. They examined the red hair on his head. "Are the men with flaming hair the chosen?"

"I've been called other things, but never that." Tecumseh's voice enthralled him with its unexpected command of a foreign tongue. No one could ever mistake this man for an "ignorant savage." "I am called Micah, or Parson MacGowan usually," he said.

Tecumseh motioned that the three men would sit. "You know the Roebuck clan?"

"Yes, I—," color flooded his cheeks.

Comprehension dawned in Prophet's eyes. *So.*

"I met them several years ago, the day the girl, Hannah, came back after her family had thought she was lost to them." Micah smiled with engaging sincerity. "That was also the day I first heard of you, Tecumseh. I think our Lord has willed this meeting."

Tecumseh waved his hand, as if brushing aside those words. "Your lord is a fierce god, wanting blood. We grow weary, spirit man. Our Great Spirit grows weary."

Micah shook his head vehemently. "Please. Hear me. The Americans fight you because they fear your Great Spirit. Our Lord wants all to live in peace, the lion and the lamb—"

"You lie." The words were said with such venomous conviction that they shook Micah. "The lion lives in peace, his belly filled with the lamb."

Micah glanced at Prophet.

"Micah is a good man, Tecumseh. We listen to him and learn how the white mind works."

Tecumseh nodded and leaned back on one elbow, as if ready to be amused.

Micah was so convinced that Christianity was the only way to God's heavenly kingdom that he saw anything else as lack of education, certain that if Tecumseh and Prophet heard the word with open minds, they, too, would know the truth.

The afternoon wore on as Micah talked. Prophet's wife brought a rush basket of fruit and smoked trout and gourds of fermented ale.

". . . And then, just as their Master had done, missionaries came to this land and preached and died. Marquette, Joliet, Jogues. . . . All died at the hands of Indian nations."

Tecumseh shrugged indifferently. "My grandfather, La Demoiselle, was killed and eaten by French soldiers who overran his fort. Would you say then that he died for his god or for the French god?" He leaned forward. "To die is not good, spirit man. A god that commands a warrior to die is a bloodthirsty god, a fierce god, wanting blood, as I have said.

"A man cannot be one of you unless he also accepts your god, you say. I say the Great Spirit made us all in all the earth and the sky and the underworld. What more does your god claim to do?"

Micah recalled as a callow student in London how blithely he thought he would convert the savages. But the reality of their lives confounded him. "Jesus came for them," he thought he believed. To do what? Judge them though they cannot see him? Comfort them without embraces or songs? Feed them, clothe them, stop the snow? Heal a sick child or a

wounded warrior? Hasten the final journey through their underworld? Forbid enemies who called themselves Christians from dealing falsely?

And Micah realized that teaching these natives to love the Christian God would be the work of a lifetime. In that moment he knew that his flip words to his superior in London about his call to the wilderness had not been mere braggadocio. Christ had known. He had not.

Suddenly Tecumseh sprang to his feet. "I must go, and so should you. Good-bye, spirit man."

Prophet walked him to his horse, the two men casting lean shadows. Elated by his meeting with Tecumseh, Micah ignored Prophet. The grasp, the cool intelligence of the man overwhelmed him. No wonder people followed Tecumseh! He had heard that the American generals were trying everything to woo him into supporting them and concentrating his horrifying raids on the British, whom the Americans still considered outlaws in their territory.

"You have no children."

Prophet's words pulled him back. "No. I envy you." Prophet's words had surprised him.

"A prophet needs a wife and children."

"I am not a prophet." Suddenly Micah added, "I loved a woman once. But she believed she loved another."

"And did he take her to his blanket?"

Micah shook his head.

Prophet grunted, as if something had been confirmed. "My wife loved me after I took her to my blanket."

Micah smiled. "Our Lord says we must wait for his time. And always have hope. I have hope. I believe she loves me. It only waits for her to see it clearly."

The two men exchanged a glance. Prophet seemed satisfied. "And will this happen?"

"Yes. . . . Yes, I believe it will."

"Micah!"

Hearing his name called snapped Micah out of his reverie as Harmon Roebuck jumped lightly down from the spring seat of his wagon, in front of Fenn's. Harmon had changed considerably since returning from Europe last year. Gone was the beard. He had forsaken the tricorn for the wide-brimmed, shallow-crowned slouch hat and the full white shirt and well-fitting trousers of the Kentucky planter. His feet were shod in supple, high-topped boots of buffalo hide. But it was more than that he was

an energetic, successful citizen of twenty-seven. He had changed in subtle ways, too.

The restless young man Micah had met for the first time when he was recuperating from wounds after the Indian attack several years ago had disappeared, and in his place stood a shrewd man who viewed the world with deliberateness and cynicism, and saw the Indians as a Problem to Be Dealt With. The shipping business was off to a promising start. Each year since 1800, a new schooner had floated down the Ohio to the Mississippi and out to the Gulf of Mexico, stopping at established trade points along the way. Last year they reached a New Orleans that for the first time was an American port, which had given an immediate boost to their enterprise.

"How long will you be gone this time?" asked Micah.

Harmon smiled with a hint of his old boyishness. "Can you keep a secret?"

Micah grinned. "If not me, then who?"

"Too true. I am going to be married, parson."

"I say, Harmon! That is splendid news. Who is she?"

"A lady I met five years ago in New Madrid, the daughter of Manuel Lisa of the Missouri Fur Trading Company. Her father trades out of Saint Louis now. I'm building Isabella a house there. You should be married, parson," he added suddenly. "You are older than I am."

"Aye. Not much," Micah added rather defensively.

"Well?"

"What?"

"Why haven't you?" Micah looked away suddenly, but not before Harmon caught a glimpse of a sadness and distance in his friend's eye. "By thunder. It is Hannah, isn't it?" Harmon grabbed his friend's coat sleeve and walked him away from Fenn's, out of earshot.

"Go and bring her back, Micah."

"Bring her back? She has never said she wanted to come back. She has her own life in France. It was my understanding that your Aunt Rosalind and Hannah are—"

"Yes, yes, but that is not the reason Hannah stays away. Look, Micah—" Harmon breathed an impatient sigh, then suddenly his concern for his friend overtook his aura of preoccupation with business. "Let's walk out to the fishpond."

The fishpond was the glade that was jokingly referred to as Micah's confessional. Although Micah's church now provided sanctuary for those in need of solace, a habit had developed among his parishioners, and they

continued to find excuses to seek his counsel there rather than in church.

Harmon hoisted a boot to the log that served alternately as bench and prayer rest. He took off his hat and pulled the smooth, felt brim through his fingers.

Micah leaned a shoulder against a willow tree, arms folded, his body tense. "Well?" he said lightly, but it came out strained.

"Hannah left the United States because she was in love with Tecumseh."

"Tecumseh! Tecumseh!" Micah felt disbelieving horror. The noble, misguided adversary, yes, but the—the *lover*. . . ? "All these years. . . ." *O my God! God, why didn't you let me love someone else?*

"Look, parson. . . . Micah. I know how you feel about her. For what it's worth, I am on your side."

Micah bent his arms over his stomach and turned away from Harmon. The trout pool was shadowed and black today. You couldn't see the bottom today. He meant to say nothing. He meant to endure in silence. He heard himself say in a strangled voice, "And why do you think I should go after her?"

"Because she needs you."

Micah shook his head. "No, Harmon. I need her, that's the truth. When she left Cincinnati, I asked her when she was going to stop running away."

"It was Tecumseh even then, Micah. We go way back. His ancestors were friends of the Roebucks. Tecumseh visited Hannah the week before the *James Ross* ever left. He showed up again in New Orleans. He wanted her to go with him then. If I had not been there to stop it, I think she would have. I believe with all my heart that she is still in France because she has never allowed herself to make the decision that would either break her heart or break Tecumseh's."

"A woman could not break Tecumseh's heart. I never met a more single-minded devil."

"You've met him?"

"At Prophet's camp. I honored his request not to mention it at the time." Micah laughed bitterly. "This explains much, Harmon. Thank you." Micah started to leave the glade.

"Wait! What does it explain?"

"Prophet has known this all along. I think he has been as much against it as you. I would not put it past him to try to destroy Hannah if he ever felt she was a threat to Tecumseh's sense of purpose. Our Lord might have had a hand, after all, in keeping Hannah away."

"What are you going to do?"

Micah was a long time answering. Finally he said bleakly, "I have no choice. It may come to nought, but I shall do the same as you have done, my friend. I am going a-courting."

"I will give you the money for passage."

Micah shook his head. "I cannot leave my church for a year to go to France. She will have to come to me. But I will write to her." Then the chin lifted. "If she will not have me, it is better to know. Thank you, Harmon. May I hope to have the privilege of marrying you and your lady?"

Harmon looked uncomfortable. "We'll have to talk about that some other time, parson. She is Catholic."

Micah simply nodded. "Our Lord will work it out. My prayers are with you on your trip, Harmon."

"And mine with you, Micah." Their eyes met, the blue pair bleak with despair. They embraced roughly, then headed back to town.

29

Illinois, Sauk, and Fox. These and other Indians of the Upper Mississippi and the Missouri gathered at their annual spring rendezvous, called by the British traders of Hudson's Bay Company at Fort Detroit. It was rumored that Tecumseh was coming. The traders awaited as eagerly as the British military the appearance of the famed Shawnee war chief. So great was his power, it was said, that neither arrow nor ball could pierce his hide. He never thirsted or grew hungry. Those who traveled with him said he had once gone four days without food and fought as well as newcomers on full bellies. He wanted nothing for himself but the impossible: an empire of Indian nations such as the American tribes had forged.

A rendezvous promised sanctuary. No tribes would war within the time and bounds of a rendezvous. Yet Tecumseh had agreed to come only after he had been promised safe conduct by the Brass Buttons at Fort Detroit, whose emissaries declaimed they wanted the same things for the Indian nations as did the Civilized Nations themselves.

Tecumseh traveled steadily north, following the Upper Miami. Above the rapids he and his warriors followed one of several streams that came together to form the river. On this branch a series of placid ponds signaled a stretch that was long a favorite of Tecumseh's, housing scores of beaver dams spread across narrow shallows. Here he intended to make camp.

Tecumseh strained to hear the telltale slap of beaver tails hitting the water, signaling to one another the approach of enemies. Watching beavers at play was endlessly entertaining. Beavers mated for life and displayed affection to all within a colony. But the beavers were silent, and as the Shawnee emerged from the bushy growth along the shore he could see not one.

Bats hurtled across the red twilight, and mourning doves called to each other, charging the dusky forest with sound. Upstream a hundred paces a family of deer came down to drink. Tecumseh uttered an exclamation of surprise and slid lightly from his horse. The beaver lodge was gone. A

platform of mud and stones created a forlorn-looking island a dozen lengths off shore. The beaver dam was broken through completely. He left his horse and trod upriver. Another lodge gone. Destroyed. Smashed through.

No longer contained by the small dams, the river moved in a swift current. "Tecumseh." A brave beckoned him to the opposite side of the stream. Several of them waded across, where a jumble of small animal bones littered a clearing.

"Must have been a hundred beaver."

"No skins," commented Tecumseh.

"Whiskey trappers," said the brave with disgust.

The next morning Tecumseh said they would keep to the river as they traveled. Everywhere the story was the same. Lodges destroyed, whole colonies slaughtered, dams broken through.

A week later, Tecumseh and his twenty warriors neared Fort Detroit. In every clearing he found tribes eager to barter their winter catch with Hudson's traders. The camps he passed through were nothing like his own well-ordered home camps. He saw no children or dogs, no women serving their men. The Indians seemed not to care that their grounds were littered, their bodies unkempt.

One of his braves rode up and touched his arm. He pointed toward a smaller enclave in which French, American, Spanish, and British trappers camped in wary tolerance, white-skinned loners. Many of them were getting to their feet, watching the progress of the Shawnee. "Jack Wheat." Seeing his chief did not comprehend, the brave said, "Prophet sent me to find him many winters ago. He is a coyote, Tecumseh. He killed his friend and stole his furs. He—"

Tecumseh nodded. As they passed, he stared at the hairy man with the jutting beard, the dished-in face, and the half-crazed expression. He had seen the look on others, even Shawnee, who chose the lonely life of a trapper.

Word flew ahead of Tecumseh. By the time he and his men skirted the river, many had gathered in homage, appearing out of nowhere to raise a clenched rifle or to invite him to rest at their campfire. Their ranks grew thicker as he passed through the rendezvous and between the huge log gates of the fort itself. Inside, British soldiers stopped their tasks to watch his passage. He heard his name carried before him.

Such was the fierce pride of his men that none betrayed fear at passing into a lodge controlled by the British army. Though the British had a rep-

utation of never having gone back on their word, there was always a first time. A man could become rich on the price on Tecumseh's head.

Inside the fort milled Indians of a dozen nations. Bales of fur as numerous and high as lodges in a village were stacked and sorted, huge numbers of dense, coarse buffalo furs, a surprising number of dressed raccoon pelts, only a few bales of beaver.

A hatted soldier stepped off a porch and strode smartly to Tecumseh's side. He saluted. "Chief Tecumseh? I am Leftenaunt Marley. We have been waiting for you, sir." Marley signaled, and a soldier sprang forward to hold his horse. Immediately a Shawnee sprang down and waved the soldier away. Tecumseh alighted with two wary, alert aides.

"Thank you for honoring us, Chief Tecumseh." The room into which they were ushered was overheated and overdry. The man at the stone fire pit built into the wall was small in stature, gray and balding. He stood with a slight stoop, a heavy knitted shawl around the shoulders of his uniform.

"Chief Tecumseh," said Marley. "May I present Colonel Bodwith-Pickens and Captain Wickingham."

"Gentlemen." Tecumseh shook hands. He noted the barely raised eyebrows, the quick exchange of glances.

"I am relieved to see that we will not need a translator, Chief Tecumseh," said Wickingham as Marley excused himself.

"I speak passable American, thank you. I also read. It was necessary to understand the contracts my people signed with the Americans."

"Yes," said Bodwith-Pickens, the small, gray man with the woman's shawl. "I see your point. Will you sit?" He indicated a pair of comfortable-looking armchairs facing each other before the fireplace and took one himself. Tecumseh's aides moved against the wall and remained standing. Wickingham moved to a decanter. Bodwith-Pickens questioned Tecumseh with a look, and he shook his head.

"No, eh? I had heard you did not drink. To business, then. Tecumseh, I'll be frank with you. We have as much trouble with the Americans as you do. A little more than a quarter of a century ago, they revolted against the king—our chief—and being occupied with other interests at the time, we let them go. One of the conditions was that they not interfere with our territories here in the north. Our people, traders, not warriors, you understand, have spent more than a century—one hundred winters—developing the fur trade. Our job, as British soldiers, is to protect them."

The colonel leaned back expansively, reminding Tecumseh of a turkey cock preening its feathers. "Men have come to the English, from all nations, and we have taught them how to trap and dress pelts to produce the highest grade furs. We have paid them fair prices and set up a string of posts extending hundreds of miles east and west, north and south, for them to exchange their furs for goods they desire."

"What will you do for beaver next year?"

"I beg your pardon, sir?"

"Next year. Soon your trappers will bring you no more beaver."

"Oh? Why is that?"

"Because this year they did not trap the beaver, they destroyed them. The lodges, the kits, whole colonies."

Bodwith-Pickens's face lost its self-congratulatory air. He glanced at Wickersham.

"I say, Tecumseh, that's news to us. I can't say it was Hudson's trappers who ruined those beaver dams. But I can't say it wasn't, either. Hudson's has never preached that, sir. Never," said Wickersham. "A man would have to be crazy to destroy the lodges."

"Yes. Whiskey crazy. A trapper who earns for his family does not destroy his source. Only a trapper who has lost himself does this."

"Chief Tecumseh, our position is not quite the same as yours. You order your men not to drink and have the power to banish those who do. Hudson's has the power to purchase or not to purchase a man's furs. He has the power to sell or not to sell. Do you know what trappers desire most?" Colonel Bodwith-Pickens leaned toward him and held up a thumb. "Whiskey. A buffalo robe buys a pint. Tobacco, horses, guns, and women," he enumerated on his fingers.

Tecumseh got up and prowled around the room, the closeness threatening to overcome him. "If you had no whiskey for sale, they could not buy it."

"Aha, but the British are not the only traders, Chief Tecumseh. Don't you think the Americans and French are doing it, too? If we did not offer whiskey for those who demanded it, the trappers would take their furs to those who did."

Tecumseh knew he spoke truly. He knew how difficult it was to bring different tribes together to agree on a course of action. Nevertheless. He fixed his eyes on his host. "What would happen, colonel, if all traders and all your armies agreed not to buy the Civilized Nations with whiskey?"

Bodwith-Pickens smothered a laugh. "Never, sir, that would never

happen. The Americans have made themselves our enemies. And the French—well, those chaps would like nothing better than to have us lose our shirts. Er, fail. Leave the field to them."

Tecumseh smiled thinly. "Since you already have an abundance of enemies of your own skin, what is it you want of me?"

"I want you on my side," Bodwith-Pickens declared. "You and the Shawnee nation. You are the most powerful chieftain in the Northwest Territories. The Miami follow you. Reports are the Cherokees, too. Tecumseh, mark my words: Another war is coming with the Americans—and before too many winters. The Americans want us off this continent. That will never happen.

"America's enemies will breathe a sigh of relief when this upstart is brought to her knees. It is only a pity our colleagues in Versailles did not realize this. Napoleon had only to ask: We would have given him three times the amount the Americans paid for the purchase of the Louisiana Territory."

Tecumseh cared little for the political ramifications of the squabbles that seemed to fascinate the Englishmen. He endured their animated recital until at last Bodwith-Pickens riveted his attention with matters within Tecumseh's province.

"We are prepared to offer you a position on our staff, if you will bring your people in to defend both our interests. Your people are not the only ones who have been subjected to treaties that the Americans no sooner signed than ignored."

"How can our interests be the same, colonel? My interest has ever been to keep white men from settling in our hunting lands. One hundred years ago, when you were making fur trapping a way of life, our people had a way of life thus: these lands for summer and winter homes, these lands for hunting. These lands for the Shawnee and Miami, these lands for the Iroquois. No one came to the Shawnee for help in destroying another tribe. The Shawnee gave help when a weaker nation was being taken advantage of. Then we went back, each to our tribal ways. We allowed the white hunters to hunt in our lands. Then they wanted to make our hunting lands into their summer and winter homes. We could not allow this. Their government made treaties thus: Trade this land for that land. But soon the white men came to our new hunting lands, and again it began."

Tecumseh leaned toward the colonel, placing his hands over the back of his vacated leather chair. "Now you are asking Tecumseh to join you in the slaughter of other white men. I have fought and struggled to bring the Indian nations together under one leadership. I do not know if

I will succeed or fail. To join you would mean I have failed. You are always inviting the tribes to conferences. The Americans do likewise. Why do not you and the Americans sit down together and make your own treaties and share the lands you have now? And both nations get rid of the whiskey."

Bodwith-Pickens waited impatiently for him to finish speaking. "Will you just consider it, Tecumseh?"

Tecumseh straightened and stared down his long, fine nose at the colonel. "I will join you when the Mississippi River changes its course."

Tecumseh and his aides left, escorted by Wickersham, leaving Bodwith-Pickens staring in exasperation at the closed door. Leftenaunt Marley stuck his head in the door. "Well, sir, did he go for it?"

"When the Mississippi River changes course."

"Beg pardon, sir?"

"Nothing, Marley. Tell Jenkins to send in dinner. I'll mess alone tonight."

30

"*My dear Miss Roebuck*," the letter began.

"Will you need me for a while, Mademoiselle Hannah? I was just leaving to market. Shall I help you with your hat and coat first?"

Hannah looked up. "No, go ahead, Emilie," she told the petite, olive-skinned girl. Emilie tucked an empty drawstring bag into her basket and slipped the handle over her arm. She closed the ornate door of the apartment behind her, shutting out the noises and heat of the street two stories below. She had served the twins since they first came to France, nearly seven years ago, had come to Paris from a farm in Brittany. For the last two years the women had lived alone. Hannah had just come in from viewing a new line of fashion plates and fabrics and found letters from her family and Rosalind and the one she now held, from Micah, awaiting her.

She stared at the closed door, her mind unfocused. What was the matter with her this morning? Her mind kept wandering away from her business. She couldn't concentrate, couldn't make up her mind which plates would appeal to their customers in Cincinnati and in the other cities where they had developed a large mail-order clientele, had draped and felt the hand of dozens of fabrics without reaching any decisions, had examined countless pairs of tailor's shears, trying to decide which pairs would meet Rosalind's meticulous needs, and had come back to the apartment feeling she had accomplished nothing.

Hannah removed her hat and coat and cut herself a piece of milky, ripe cheese, put it on a plate with a fresh peach and a biscuit, took a linen napkin and her letters and carried them through the French doors to the shaded balcony. The air was still and humid, gathering itself for an early summer heat wave. Noises were subsiding as most Parisians retired for the midday.

Holding Micah's letter unread, Hannah leaned back on the settee and gazed out at the venerable, deep green chestnut trees, at the towers and spires of Paris rising among them. Birds swooped from tree to tree, filling the air with their sweet chatter, darting hither and yon with bits of twigs and grass as they put the finishing touches on nests. Hannah sighed and thought about Micah.

A year or two ago he had reported that her old school friends Peter Ruskin and Betsy Kendall had married. She wondered if he were writing now to tell her that he had married, too. The thought brought with it an uncomfortable sense of loss. How much she had discovered about Micah through his dependable letters! How much she had grown to look forward to them. Yet he never mentioned anything about his personal life, other than the humorously described tussle with the faithful over funding a church building for the city. His concerns had always been directed outward. Letters about his projects with the town Indians, meetings with the Shawnee called Prophet (how had he ever met him?), and his hopes that his work was helping to shape a permanent peace.

Hannah cut the peach and bit into a juicy, red-fringed slice. A few days after Harmon had sailed for home, Hannah had come upon a miniature of Isabella, which Harmon had misplaced. She had sent it to him, thinking then of Micah. She had written once requesting that he send a likeness of himself. He never had, and she realized that the image of the straight, red hair and guileless blue eyes in the ruddy, freckled face was as clear in her mind as if he were smiling at her in person. He had been the only person outside of her mother and brothers with whom she always felt completely at ease.

Hannah sighed and lowered her eyes to the letter.

> My dear Miss Roebuck . . . Hannah. This may seem an odd request, but I beg you to come home. I wish I knew the words to say this gracefully, and if it were a sermon I no doubt could, but it is too painful to expose my feelings to you in any other words but the rough nuggets that now weigh upon me. Harmon revealed to me today something of the lifelong friendship between you and Tecumseh, the Shawnee. I have met him. Tecumseh is more powerful now than he has ever been. Feared, hated, and yes, admired by some. Whatever my personal feelings about the man, I find it impossible to believe that you could find happiness with him.
>
> As you probably realize, my dear [a capital *M* was crossed out with an angry slash] Hannah, this is a marriage proposal. I have waited all these years, with each letter dreading that I might find within your declaration of love for some lucky—and unworthy!—French gentleman. That you have not gives me hope that Harmon is right, that you have stayed away from your natural home as a way of removing yourself from painful choices. I was wrong when I said once to you that one cannot run away from one's life, one's

choices. Many people do and so dwell in aimless lives until death ends them.

The Apostle Paul advised young Timothy to have faith and be of good conscience. I do not doubt your faith, dear Hannah, for you are a good Christian woman, but are you living your life in good conscience, making use of all the talents our Lord has given you? See there, I have got into a sermon after all. It is the lack of one woman's touch. I sound too much the old bachelor and too little the man in love. Come home and change that.

Micah

At first she was stunned. Then angry. Why had Harmon confided her personal life to *him?* Then she grew angry with Micah. How dare he suggest that she was not living a life of good conscience? How dare he! *He's in love with me. How could he be, with nothing but letters between us all these years? He probably thinks he knows me as well as I know him.* She struggled to recall the things she wrote to him. They were nothing . . . inconsequential things, about her life, about the vegetables they ate for dinner, and the places they strolled on Sunday afternoons after church.

Tecumseh. Her Tecumseh. Her almost brother. Micah said he was powerful and hated and feared and admired. Yes, she did not doubt it. If his beliefs were less strong, he would not be the man—the leader—that he was. She doubted whether anyone, including Micah, could dent Tecumseh's beliefs. Sooner ask a bear to become a coyote.

Did he still go to New Madrid every year, the first new moon of summer? Surely not. Romantic, childish nonsense! . . . Did he? She would ask him. No. She would not need to ask. She would know when she saw him. Did she even need to see him? Was her love for Micah more than affection, enough to make her forget Tecumseh? What did her conscience tell her? But what if her Lord truly needed her to help heal the breach between Tecumseh's Shawnee and the Ohioans? Was she prepared to do that?

Hannah left the balcony and wandered restlessly inside. She looked around the quiet, elegant salon and suddenly knew that she was ready to go home. Micah was right, about one thing at least—one should not live out life avoiding decisions.

The apartment door opened, and Emilie breezed in, her eyes shiny and cheeks flushed from her errands and the climb up two flights of steps. Her basket was laden with leafy greens and carrots almost the color of copper spikes. "Oh, mademoiselle, you should hear the latest—"

"Emilie! How would you like to come to America with me?"

"America!" Her eyes widened in shock. "But it is full of wild animals and savages, no?"

"Of course not," Hannah laughed. "But it isn't Paris!" A great weight flew from her shoulders. Images of her mother and father, of Philippe and Matthew and Thomas and Joey, crowded into her mind. "All grown up" Micah had reported. She could not imagine it. How had she stayed away so long?

"Miss Roebuck?"

Hannah shied away from the salt spray that whooshed up the port side of the vessel as the ship tacked into the wind. Emilie was leaning so far over the gunwale she was in danger of going topsy-turvy. The girl was beside herself with joy. They had been aboard two days, and she did not think Emilie had slept a minute. It had been an inspiration to invite her, not just as a maid and a traveling companion, but because Hannah believed that Emilie could find a better life in Ohio. In Paris she would always be a member of the serving class. In America, as she had assured the brother who came from Brittany to discuss it one day, Emilie could marry well and perhaps in time even have servants of her own.

"Miss Roebuck?"

"Good morning, captain!"

A gentleman stood beside him, a man of about forty, with side whiskers covering ample jowls and wearing a beautifully cut dark blue suit that did not completely conceal a generous girth.

Mr. Farnsworth was from New York, the captain explained, returning from business in France, and he desired an introduction to Miss Roebuck and her beautiful ward.

"I understand how difficult it is when young ladies must travel the high seas without a proper escort, Miss Roebuck," said Mr. Farnsworth. "So I would be very pleased to offer you my protection while we are aboard ship. Is your ward being met when we reach Baltimore?"

Suppressing a smile, Hannah thanked him for his gallantry and assured him that her "ward" was indeed being met. "I have lived in Paris for several years, Mr. Farnsworth. In what business are you engaged?"

"Oh, very ordinary business, Miss Roebuck. Nothing of interest to your pretty head."

Tipping his beaver, Mr. Farnsworth strode in brisk and fatherly fash-

ion toward Emilie, leaving a bemused Hannah to consider that she must indeed look like a spinster, old enough to be a fit chaperone for young ladies and certainly far too doddering to entertain serious thoughts—much less thoughts of love—herself! Ah, 'twas not so in France!

"I'll tell you, Major Cabot, the key to this whole problem's Tecumseh." Restlessly Captain Slade caressed the barrel of his duelling pistol. He leaned forward and dropped his boots from Cabot's scarred desk to the floor with a thud. "Let me go after him. Nobody'll be the wiser."

"No."

"Look, I swear to heaven, it's true. The guy goes on some mystical mission to New Madrid every year, early in summer. Then he comes back to the Ohio and makes life hell for us."

It was late summer in 1808. The men were sitting in Cabot's cramped office in a second story tower at Fort Washington. In spite of observation windows on two sides of the room, the air was stifling. Slade's heavy blue wool jacket was unbuttoned part way down his chest. A rash of fine red pimples infused the skin around the collar area, which caused him to be exceedingly irritated. That and the fact that his career seemed to be going nowhere.

He tried once more. "Look, major. Everybody knows that war with His Majesty's troops is only a matter of time."

"We defeated the British before. We'll do it again," Cabot said. "I only wish they would stop flooding the states with counterfeit currency. They are so good at it, it is impossible to tell from the real thing. When it comes to undermining an economy, we could learn a thing or two from them."

"Well, they've been pulling that for years. But wouldn't it be nice to get the Indian question settled before war comes? The Brits can make things hot for us up there between the Great Lakes and the Upper Mississippi. They are not dolts, you know."

Major Cabot picked up two dispatches. One from Washington aired complaints from commercial interests about Britain's grip on the northern fur trade. Their trappers ranged at will through the upper American territories, killing American animals, and the British profited.

The other dispatch was a decoded message from General William Henry Harrison. It disturbed Cabot far more than any complaints about unfair business tactics. "Have you ever met Tecumseh?" Major Cabot asked.

"No," said Slade. "But that's even better, don't you see. No one would suspect—"

"He's an extraordinary man, Slade. I've met him several times. Each time he impresses me more. He has the gift—great intelligence, foresight, drive—to always be learning. It sets him apart from other men."

"Other Indians, you mean."

Cabot shook his head. "In every race a few men are linked to each other more than to their race or their tribe. A fraternity of greatness. Tecumseh has more in common with President Jefferson than you and I do. We could not rise to his vision."

"Come *on.*"

"I'd rather have him on my side than all the other Indian nations together." Slade was staring at him now, head thrust forward, trying to fathom the direction of his commandant's thoughts. Cabot touched the dispatch with his fingertips, moving it slightly. "Last spring he pow-wowed with the British at Fort Detroit."

Slade's prospects seemed suddenly brighter. He grinned knowingly.

"We can't just go out and assassinate him. If we could find him. We'd have the whole Shawnee nation down our throats. . . . His half-brother, or blood brother or whatever, has kept a rein on the Shawnee for him for years. Our relations aren't too bad with this man. He's got a new treaty camp out on Tippecanoe Creek, near the Wabash River. Ever been out there? Pretty. Maybe we could try one more time to persuade him to talk to Tecumseh. Or at least arrange another meeting. I'll get in touch with Washington. See what we can offer the man."

"What did the British offer?"

"His own command. Money and uniforms for two thousand troops."

Slade's eyebrows shot up. "If he turned that down, what can we offer?"

"We'll find out what he wants. Besides his own kingdom."

"And if that doesn't work?"

"Maybe then we'll try it your way, Captain Slade."

31

Hannah's mouse gray glove was grimy with dust as she gripped the wooden window ledge of the coach. Her eyes felt gritty. Since leaving Baltimore they had traveled endless days on the rocking stagecoach and spent nights in coach taverns that seldom offered more than lice-ridden pallets and execrable food. The smart, fitted traveling suit and veil-swathed gray hat with its melange of silk roses crowning the straw brim were coated with fine dust, as were the high-heeled kidskin shoes she had had made especially for the last leg of the journey home. No amount of fragrance could disguise the fact that her clothing, from undergarments out, had lost all freshness. She longed to bathe and don sweet-smelling garments once again.

Yet she could not have been happier. Hannah and Emilie might have taken the river packet from Baltimore, but when Hannah learned that the post road went all the way to Cincinnati, she chose to go by stage. Once there, it was even possible to cross the Ohio by ferry and take a stage to Louisville, they said.

Seated next to her in the tightly packed coach, Mr. Barberry touched her arm and pointed. They were entering a broad, sweeping bend where the road lay very near the river. Peering up where he pointed, she saw a log tower. A man inside waved down at the passing stage.

"I do not remember that being there," said Hannah.

Barberry was a recent resident of Cincinnati, a young schoolteacher with an inexhaustible supply of historical lore and boundless enthusiasm for his new town and state. "Put up about five years ago, Miss Hannah. There's an interesting tale goes along." At Hannah's and Emilie's inquiring expressions, Mr. Barberry expanded. "It seems a fair young maiden was stolen by the Indians as she was going home on the river. Her swain was grief stricken and built a string of these outposts all along the river, on both sides of Cincinnati, so that the savages couldn't ever again ambush innocent travelers."

Tears sprang to Hannah's eyes. When she could speak, she said, "What a lovely thing for him to do, Mr. Barberry!"

"We're nearly there," he murmured to cover his embarrassed pleasure at her response.

Emilie leaned across the seat to whisper in French to Hannah, "What was the tale?" Emilie managed well enough with English, having acquired a practical vocabulary in Hannah's employ; but since reaching America, she confessed the native tongue sounded strange indeed, not in the least like Englishmen spoke.

"I'll tell you the story sometime," Hannah promised. For the last hour they had been passing new farms, newly cleared land, the wood gone into houses and barns and fences, the land turned over in undulating furrows following the curve of the hills. It was so beautiful! Suddenly they were drawing up before a pink brick building, and the driver was springing down to assist the passengers out.

"We're home!" she cried to Emilie.

"Hannah."

Hannah whirled. "Micah!"

He was striding toward her, his hand bringing his hat off, exposing that lovely red hair to the crisp wind. He loomed so big in the black suit and handsomer than she remembered. In her joy she threw her arms wide. Micah copied her gesture, and in a moment they were in each other's arms. He felt so good, so natural in her embrace and yet as unfamiliar as a stranger. He smelled like a stranger, the wool on the shoulder next to her nose not the same odor as French wool, his soap unlike delicately scented French soap.

"Let me look at you!" The blue eyes had tears in them. His hands encased hers at arms' length. "Hannah, Hannah. . . . I had forgotten how fair you are!"

"Oh, I'm an old woman now," she laughed. "It is so good to see you. You've lost your accent! You sound like an American!" His face looked longer. Two vertical furrows beginning near the center of each clean-shaven cheek coursed past his wide, smiling mouth. A pinch of lines sprouted upward between his russet brows.

"Now, not true. But you! You sound like a Parisian. And your. . . ." Embarrassed, Micah's glance swept her attire. "You are so elegant, Hannah!"

She laughed giddily and pirouetted before him. "After all, it is my business, no? Or do Americans consider it shameful for women to be in business?"

"Nothing you do could ever be shameful. Oh, Hannah, I—" Suddenly Micah's glance took in a young woman, with large, dark eyes, standing behind Hannah, her shoulders hunched in rather fearfully.

Hannah drew her forward, and included Mr. Barberry in her smile.

"This is Emilie, Micah. She has been my servant since Harmon and I reached Paris. I did not want to leave her behind, and she and her family were willing for her to come."

Micah heartily welcomed her and a smiling Barberry.

"Hallo there, parson!" Barberry and Micah shook hands. "Nice to be home again. I did not recollect that you greeted travelers. Ever the shepherd!"

Micah laughed, a deep joyous sound that exploded happily in Hannah's ears. "Since I received Miss Roebuck's letter, I have met every single stage!"

"Oh, Micah, you didn't!"

His eyes dwelled on her face, so brimming with love and happiness that she ached. She had an overwhelming desire to be taken in his arms and kissed.

Micah cleared his throat and prodded his stock with his fingers. "Are your trunks aboard? . . . Coming on the packet? Good." He picked up the two small valises the driver had deposited beside the women. "Come. I've a small trap. Your family is waiting. . . . Barberry," Micah nodded goodbye, then guided Hannah and Emilie toward the livery stable.

"If I do not spirit you away quickly, everyone in town will come a-running. We have all kept up with your adventures. I want to hear about M. Lafayette and Mr. Monroe. Did you actually meet the emperor? Harmon had us enthralled with his stories." Micah kept up a nonstop conversation all the way out to the house. Hannah begged to be driven by his new church, but he demurred, promising "later" with a mysterious pucker of his eyebrows.

"Isn't our town something? . . . new businesses, and another church, too, now . . . Mr. Barberry, a real schoolteacher at last, paid for by the— You are an aunt three times over, a nephew and two nieces . . . farm prosperous. . . . Oh, yes, the shipping company! The Cincinnati Trading Company, but it is actually a Roebuck concern since Harmon bought out the Marietta partners. . . . And Bunty, remember Bunty? He works for them! . . . Yes, praise the Lord.

"Thomas has put his brain to fine use. He is the trading company's solicitor, but also has an office in town. Aunt Rosalind? Well, now, that is something I know little about! But our ladies look mighty handsome, and Miss Rosalind gave generously to the church building fund. . . . Fanciest-looking shop in Cincinnati! Go by there? Later, Hannah, later. . . . Joey wants to be a poet . . . yes, I thought he might write you about it. . . . Not shown us any of it yet. . . . Matthew and Philippe are big, strapping men.

They actually run the farm. . . . He's fine, just a touch of rheumatism, but your mother takes wonderful care of him. She's just the same, Hannah. You two are alike. Faith Roebuck is my favorite lady in town (but do not tell the others!), next to you . . . to you . . . to you. . . .

Pandemonium broke out at the Roebuck farmstead when Micah appeared with Hannah and Emilie. She embraced and talked and laughed and cried until her arms grew leaden and her throat was raw. With the whole family trooping and clamoring along, including Matthew and Philippe's wives and children and the servants and field hands, Hannah was led proudly on an inspection tour of the farm. The farm burgeoned with life and good health. Only Harmon was missing to make the celebration complete. Micah had forgotten to mention that Harmon and Isabella were living temporarily in Saint Louis, an American city since the acquisition of the Louisiana Territory.

At sundown, Hannah and her pale, shrewd brother Thomas walked Micah to his trap. "This has been an almost perfect day!" she declared, linking arms with the two men.

"Even without Tecumseh?" said Thomas slyly. "I noticed whenever anybody mentioned his name today, you changed the subject."

"I didn't!"

"I'm right, aren't I, Micah?"

Micah looked away and said nothing.

"Admit it, Hannah."

"He's fighting for his home! What do you expect him to do?"

"Move with the times. The days when a few Indians on the warpath could stop or slow down the lawful travel by Americans through their lands must end! They have to begin to abide by the law of the land." Thomas Roebuck, solicitor, had adopted Harmon's reasoning, if not his style.

"American law, you mean."

"Of course that is what I mean." Thomas glanced at Micah. "Tell her, Micah. It's not only against the Americans but against God. The laws of God," he repeated, liking the sound of it.

"Which ones?"

"Worship of idols," he responded promptly. "Remember all that Shawnee talk of Motshee Monitoo?"

"It is just their understanding of Satan," said Hannah.

"They don't worship God."

"They understand that the Creator made the earth. Micah—"

"I agree with Hannah, Thomas. I have seen something of the Divine Right of the Americans—"

"I like that!" approved Thomas.

". . . Which politicians and armies fall back on when all else fails. They might teach Europeans respect for the common man. . . ."

"I *do* like that!"

"But, Thomas, we are all guilty of excluding the copper race when we think of common man. Our Lord would not have it that way. You and Harmon are merchants now. You look at the rivers as the means to increase your business. You look at the land and picture it filled with potential customers."

"Of course. People just waiting to settle, as soon as they know there will be no more trouble with natives."

Micah smiled warmly at Hannah, covering her face with a caressing glance. "Hannah looks and sees what is already there."

"And you, Micah?" she said. "What do you see?"

"I see that there is room for all. Even in our own congregation, not everyone gets along. But we do not kill each other. We strive to grow in harmony, which means growing toward God.

"Perhaps the Indians will not give up their Great Spirit. But he is not a comforter, he is only the provider of life. Prophet has taught me that. That is why they need our Savior. I have tried to force them to change, and I have failed. I believe God means us to open their hearts in his own way and time."

Thomas's voice was tinged with sarcasm as he said, "And in the meantime, parson?"

"In the meantime I shall go on befriending those who seek me out and help those I can." His smile was boyish. "Much as your grandmother Gennie did."

"Oh, Micah, that's just *beautiful.*"

"Isn't it. Goodnight, Micah." With a handshake, Thomas left them in the drive and headed back to the house.

Micah took her hand. "Do you still want to see my church tomorrow?"

"You know I do."

Micah called for Hannah shortly after breakfast. To her surprise, his sober black attire had been exchanged for a well-tailored coat of forest green wool, with velvet lapels, and moleskin brown trousers and vest with bone buttons. His boots had been made by a bootmaker who

knew what he was doing. Although his broad-brimmed hat sat at a very proper angle, Micah seemed embarrassed by his finery, finally allowing as how Rosalind had insisted upon making him "a decent suit of clothes, for even a man of God ought to appear joyous at least some of the time."

Hannah carried a picnic basket covered with a starched, lace-edged napkin. She apologized that she had nothing new to wear for the occasion. Her trunks would not arrive for at least a week, probably because of the great number: one each for her and Emilie and a dozen other trunks and crates containing gifts for the family and goods for the shop. The gown she wore now was low necked with a form-fitted bodice that laced down the back and flared into a billowy, gauzy skirt. Not until Hannah had pulled it over her head this morning and examined the fit in the mirror had she realized that the scars that once branded her neck had disappeared completely. She wondered if Micah would notice. Her hair was brushed into a heavy, loose bun. Carefully she had perched a beribboned straw belonging to her mother atop the bun.

As they faced each other now next to the big iron-rimmed wheel of the trap, each apologizing for their clothes, the ridiculousness of the conversation suddenly dawned upon them, and they burst into simultaneous laughter.

"Here, give me that," said Micah. He scarcely took his eyes from her as he accepted the basket and handed her up to the spring seat. "I have always loved that yellow gown on you. Do you not need a wrap? 'Tis nearly summer, but you know how quickly it can cloud over. Or do you remember?"

They fell silent as Micah drove leisurely toward town, turning at length into a shaded lane that wound up at a small knoll. As the road left the shade of the overhanging trees, a beautiful little white church came into view. "It has the shape of praying hands!" she exclaimed delightedly. "Micah, it's lovely, a jewel!" She jumped lightly over the wheel and walked up a neat, graveled path, bordered by tiny bedding plants of coral petunias. Together they went up the three steps and paused before thick, walnut doors.

Hannah removed a glove to run her fingertips over the figures carved in the doors. "These are wonderful! Who carved them?"

"Peter Ruskin. Peter built those log outposts, too. You must have passed some on the way into town."

"Then it was Peter."

Micah smiled down tenderly at her. "As atonement. It took him years to get over the feeling that he had run away and left you when you needed him."

"Oh, Micah. I shall call on him and thank him for the towers and for making you such marvelous doors! I will do it before I leave."

"Before you leave!" Micah cried, his hands on the door latch.

She could feel cool air slipping out of the partly opened door. She laid a hand on his sleeve. "I want to visit Harmon and Isabella." She laughed a little self-consciously. "I know I saw Harmon two years ago and had not seen the rest of you for far longer, but Micah, I dreamed about him last night. I feel that I must see him, see that everything is all right."

"They are coming back!" Micah exploded. "Harmon is just working things out with his father-in-law, something about linking his business with Lisa's fur-trading company."

"When will he be back?"

"A year—two at the most. What is it with you, Hannah? Stay here, now, and marry me!"

Hannah stared up at him, unable to put her feelings into words.

Micah stared back. His eyes, so tender a moment ago, were shot with disbelief. He turned his back to her on the narrow porch of the church. Suddenly he smashed a fist into his palm, reeled around, and grabbed her shoulders. "It isn't Harmon you are worried about, it is Tecumseh, isn't it?" He brought her face right under his nose. "Isn't it!" he roared.

"Micah!"

"Don't you know it yet, Hannah? Give him up! Your life'll be a horror if you marry him."

"It is *my* life," she said coldly.

Micah let her go, his face stony.

She tried to explain. "I will never know how I feel unless I see him again."

"Then you intend to see him again?"

"The Americans can't always be at war with the Nations."

Micah's face twisted with pain.

Hannah said pleadingly, "If I do not, I will always wonder if I avoided him because I am afraid. And—and it's more. Years ago I thought that perhaps our Lord had a mission for me. I know it is presumptuous, but our friendship goes back generations. Maybe it is through *our* generation—Tecumseh and me—that the breach between our nations can begin to heal."

She took his hand and drew him down on the church steps beside her.

"You wrote to me and asked me when I was going to face my problems. It is because of you that I decided not to be one of those people who lives life hiding from the hard decisions. Now I must trust in God. I must face Tecumseh. I must make myself look at him and know my love for what it is. Or—or isn't."

Micah stared ahead. Wearily he took off his new hat and laid it on the step and ran his hands through his straight hair. His voice was gravelly as he said quietly, "Of all the wrongheaded thinkers among the Indians, Tecumseh's the worst. I should not be angry with you. You have not been here to know how dangerous he is, how at any time he could set off a spark that would literally destroy a white settlement. Hannah, I've worked with prejudices for years. I've been able to achieve some success in improving the lot of town Indians and the attitudes of whites, and I have even interceded in their behalf at times with the military. Thomas is right in one thing: It is probably useless for them to resist. The sooner they embrace the life offered by the new American states—but as equal sharers of God's bounty, without restriction—the better off they will be."

"I cannot believe that!" she said passionately. "The same God made us all! Why is it so impossible for two races to live their lives differently and yet within the same territory? Why must they become like us?"

"I do not know why!" Micah said. "Do you know the man the Shawnee call Prophet?"

Hannah shivered. "Yes. *He* is the fanatic, not Tecumseh."

"Is he? Prophet and I have had long discussions about God. Did you know that he is willing to accept Christ as a manifestation of our God? Although he is not yet ready to give up the existence of something called Motshee Monitoo as god of the underworld, plus assorted spirit gods. Years ago, he would not even have listened to the gospel of Jesus Christ. I am hopeful for him and his people. Prophet's changed, Hannah. He has never dealt falsely with me. He abides with many of the Shawnee now in a permanent homeland about three days west of here. His own rules, too. No liquor. Retention of Indian ways. I believe that gradually he will lead his people to change even more, to make our differences less as years go by."

"How is Tecumseh different?" she demanded.

Micah barked a harsh laugh. "Only in that he would like to torch every living white. With the possible exception of you."

Hannah rose, shaking with anger. "I don't believe it!"

Micah leaned back on two elbows, staring up at her, drawling in a deliberately scathing tone, "When you see him ask him."

The rest of the day was a nightmare to Hannah. She never intended things to reach this impasse. Somehow she had fallen into thinking that everything would be just as it had been when she was eighteen, that Tecumseh, friendly, unknown save as the son of an honorable family, lived only a short ride away, showing up in unlikely places, and fear had been no part of her life.

In a cool, remote tone, Micah declined to show her through his church. They drove through Cincinnati, visiting Peter and Betsy Ruskin and their baby, Bunty, a host of others at Fenn's, and picnicked in near silence on a table in the deserted schoolyard.

When they had finished eating, Micah leaned on Faith's tablecloth and picked at the embroidered, multicolored daisies. Hannah sat opposite, back straight, hands in her lap, memorizing his downcast face. Suddenly she remembered the night he had been punched in the face defending her at the town meeting. How he had joked about it the next day at Sunday dinner at the farmstead. The letters, year in and year out, remaining the faithful friend, desiring to be more but never pushing her. Until now. A delicate, new feeling of tenderness welled inside her. It was unlike the pulsing, demanding feeling that Tecumseh brought out in her. Was it love? Micah would be a good husband, a good father. He—suddenly he glanced up.

"Are you ready?"

Her breath caught in her throat. Her lips parted.

In a moment Micah was around the table and brought her to her feet. His lips met hers in a crushing kiss, filled with desire.

"Oh Micah, I won't—"

"I am going with you, Hannah. We'll find Tecumseh. You will need me there."

"You'll go with me?" she said in a daze.

"Yes. Then you will know." He kissed her again. "Come. I'll find out where he is. I'll not live with his shadow upon us."

"I know where he is."

"That's impossible!"

"I *know*."

32

Prophet paced alone in the common area before the medicine lodge. What would he tell Tecumseh? He would see for himself what was happening. Many were ill—and many women. Some of the warriors were disgruntled because they had not been able to find enough meat to supply their needs. Some fields had gone unplanted because men forced into inactivity refused to do women's labor. He was certain some of the men were smuggling liquor in, though none would admit to it. Stores of furs were mysteriously being depleted.

Another seventy refugees from western Kentucky had drifted in a few days ago, hungry, without animals or tools or household goods, Creeks and Chocktaws sent by Tecumseh when an ambush meant to recapture hunting lands before the deer migration had backfired, and the Kentuckians had taken revenge on their villages.

Prophet looked up at the sound of a horse. It was not Tecumseh. It was a town Indian, one who came regularly to report to Prophet on their people living in Cincinnati. Prophet greeted him somberly. They squatted together before the lodge. Prophet offered him his own tobacco.

As the messenger tamped his pipe, he told the news: good things about their brother Micah and a few others; bad things about a few whites who were known troublemakers for the Shawnee.

The Miami sucked meditatively on his pipe, then added, "There is news too about the Roebuck woman who was under Tecumseh's special protection."

Prophet's ear pricked up.

"She is back. She has returned to Cincinnati, and our brother Micah is her near companion."

Prophet's gaunt face darkened like sour wine. Another portent of evil. For some time the monsters beneath the earth who kept the fires of Motshee Monitoo had rumbled and shifted in discontent. "Thank you," he said.

Suddenly Prophet realized there was a stirring in the camp. He got to his feet. Tecumseh had arrived. Prophet had not seen his chief for nearly a year. He was dressed head to foot in buckskins, with a fur collar of marten and a fringe of ermine tails, like epaulettes, at the shoulder.

Tecumseh's bodyguard sprang off their horses. They were men lean and hardened from years of strike fighting and privation. They began without wasted effort to feed and water the horses and prepare a camp, ignoring the wider sanctuary of Tecumseh's home camp. Behind Tecumseh's Shawnee streamed new recruits, subchiefs and warriors from the Creeks and Chocktaws, from Cherokees and Delawares, Kickapoo and Potawatomi. Tecumseh's trip south had obviously been successful.

Prophet watched as he stopped to accept greetings from men of various tribes already crowding the camp. His fine, gray eyes were alight with pleasure as he strode across the common.

"My brother." His handclasp was firm and dry. His face appeared as smooth and hard as weathered pine resin.

"I hope they have brought food," said Prophet.

Tecumseh laughed. "Do not look so sour, Prophet. These men will not stay here. Our confederacy will soon be so strong even you will not need to stay here if you do not wish."

"Was that Broken Foot with the Potawatomi?"

"Yes. Convinced at last that the land is not his alone. He has agreed not to sell any more territory without permission from the warrior council. He sees now the strength that comes with unity."

There was no feast or general celebration in honor of his visit. By his own order, his comings and goings were to offer no sign to spies that anything out of the ordinary was happening at any camp he visited.

The two men ate alone, out of earshot of the overlapping drone of voices at campfires all around them. In unvarnished words, Prophet affirmed the deteriorating conditions of their camp. Now he could see the deepening course of wrinkles outward from Tecumseh's eyes, eyes that seemed less receptive to pain, eyes that took in and kept all he knew.

"It will not be for much longer," Tecumseh promised.

"At least we can offer them protection and enough food. That, at least, is good, and I thank the Great Spirit."

"Are you content here, then? I know you, Tall Tree."

Prophet smiled. "I have not heard that name in many years. I am not happy, but yes, I am content. Our problems look bad, but they are not without solution. And the Shawnee have some friends among the white tribes."

Tecumseh leaned forward. "Do not count on that. It pleases them that you remain behind the treaty line they drew around you. It is never good to exist only at the pleasure of another."

"The Americans guaranteed protection of this camp and these lands."

"Then you still trust them?"

"I waited for the tricks and the deceit by which they are known. But it has not happened, Tecumseh."

The chief nodded. "It is pleasing to come here, Prophet. You are a good leader. Elsewhere I see our former allies deserting the confederation and joining the Americans. The Cherokee have gone over."

"I know. The Brass Buttons told me this. But it is still your allegiance they want most. They want to powwow. This time, they say, their father will give the Indian nations power in Washington. They have offered to make our Great Western Confederation part of the council of white chiefs. It is what you—all of us—have been fighting for for twelve winters."

Tecumseh looked askance at his friend. "How did you learn this?"

"Two Brass Buttons came with gifts the day of the last full moon. They wanted me to provide guides to lead them to you." Prophet grimaced at the foolishness of their request. "I promised nothing. . . . Still, everything is not the same, Tecumseh." Prophet glanced around the overcrowded camp. "I do not challenge your leadership—"

"Many do."

"Yes." Prophet leaned forward and said urgently, "Will the Great Spirit grant us victory? And when? Look. Two thousand Shawnee here. We need more safe camps, larger ones. We need our hunting lands returned to us. If we do not win the Nations to us, what then? We have no power. We have no more than what you have brought with you."

Tecumseh gazed out over the huge camp. A stillness had settled over it. His eyes rested on a certain lodge, set off in a place of honor by a border of white stones, and his expression softened. "You meet with your Brass Buttons. When I see our lands returned to us, I will believe that they have also changed, and not just you, my friend."

His words stung Prophet. "You talk as if I am an old woman!"

Tecumseh smiled. "You want peace, my brother. Sometimes smoke from a peace pipe hides the truth. Tell your Brass Buttons they may present their proposals to you. Tell them Tecumseh waits to be shown."

Prophet had followed the direction of his gaze to the small, neat lodge. "You are free to make Leaf-of-Gold first wife."

Tecumseh looked at him with amusement. "Thank you."

"Do you remember spirit man, the one from Cincinnati who came to this place three summers ago? He will take the Roebuck woman to his blanket."

Tecumseh grew still, his head cocked slightly toward Prophet.

"Many summers and winters ago, Tecumseh, I prayed to the Great Spirit to show me how to protect you as leader of our people, how to keep you from the wiles of the white woman. I swore myself then that I would never join the Americans. That is why, the day we pursued her to the cliffs, I never told you that I saw her." Prophet chuckled, remembering.

"In my immaturity, I believed that by wishing her dead, she would die in the beautiful river. I saw her red dress settling like sunset in the water. . . . But she did not die, and still the Great Spirit has preserved our nation and you, O Tecumseh. See how the strength of Tecumseh, coupled with my spirit link, has won us respect and a permanent home, which might not have come to pass if you had married the Roebuck woman!" Prophet brought his gaze back to Tecumseh and was surprised by the intensity of his expression.

"Soon I will go to New Madrid."

"What? Why do you go now?" Prophet demanded angrily.

Tecumseh's expression softened. "She is back. She will come."

"That is not a good place for you to be!" Prophet said sharply. "It is overrun with Americans."

"As long as my spirit touches the Great Spirit, my magic cannot be pierced. You are the one who told me that, Prophet." Their gazes locked.

Prophet looked away. He heard Tecumseh get up. He watched as Tecumseh headed away from the small white-stone lodge where Leaf-of-Gold waited. Prophet gnashed his teeth. The wild feather of the mighty eagle! Motshee Monitoo had reason to grumble.

The next morning Prophet summoned a runner. "Remember the white trapper called Jack Wheat? Go and find him, if he still dwells on the land. Tell him that the Roebuck woman is coming to New Madrid to destroy him." Now let the Great Spirit move in his desired course!

Ten days after Tecumseh and his men had left, Micah MacGowan rode northwest toward the Shawnee camp. The snows had melted. The spongy ground under his horse's hooves was decked with ferns and early summer wild flowers. Usually the opportunity for a trek through the forests on such a day gladdened his soul and caused him to break into song, praising Almighty God. Today he did not see the beauty. His mind was troubled. When he had left Cincinnati two days ago, the air was filled with talk of war. Micah pitied all the tribes. Neither the British nor the Americans would allow them to remain neutral. Each was jockeying to force the Nations to declare themselves.

And Micah also pitied the pioneers. Always on the crest of westward

expansion, they would ever bear the brunt of territorial war. Every day a few new settlers traveled downriver, past Cincinnati, with their families and all they owned. And many of them added to their ranks western Ohioans themselves, who felt stifled by the increasingly citified ways of Cincinnati. Men like Harmon. Women, restless women, like Hannah. . . .

"Lord, you alone know why Hannah is so determined on this course. Perhaps you will also use me. With your help, I shall try to persuade Tecumseh to give up his crusade and live peaceably like his brother, Prophet."

As Micah rode into Prophet's camp he was appalled by the hordes of people and the unnatural stillness. The Shawnee town looked like a city recovering from plague. No houses empty, no heaps of furniture and clothing burned in pyres in the square, no bodies in dead carts; yet the crowded, verminous-looking lodges, the squalor evident in the common areas, the sick and whining children reeked of disaster. His eyes searched for Prophet.

Prophet was waiting as he did customarily beside his lodge. His shoulders were slumped.

After they had greeted each other, Micah asked him what had happened in the six months since his last visit. Prophet told him.

"What can I do?" Micah asked.

"We and our allies are no longer hunters, but the hunted, driven from place to place, never to rest. Our people tire of fighting, Micah. I have told this to Tecumseh, and he does not hear. Two thousand Shawnee, three hundred Miami, Creeks, and Choctaws dwell here. Each year hundreds more come."

"The government has offered to help you."

"The men you sent at the end of the summer."

"What did they speak of?"

"That our people will be safe as long as they occupy this land."

"What is the matter, then?"

"They will not give us more land. And they want Tecumseh to live among us."

"Will he do this?"

"What do you think?"

"Something is afoot, Prophet. I do not know if there is any substance to it, but I have heard it in many places. There is a certain body of soldiers that is extremely dangerous. These men are single-minded in their hatred of Indian nations."

Prophet's face masked over. He did not want to be reminded. Micah

sighed. It would not matter to Prophet that he had traveled over one hundred miles to warn him of this. He changed tack. He brought out a beaten silver cross on a silken cord. "Here, I have brought you the gift I promised."

Prophet exclaimed with pleasure at its beauty. Then he grew thoughtful and weighed the cross in the palm of his hand. "The symbol of your God."

"Of our Jesus Christ, yes."

"And if I wear it, his Spirit will protect me."

"If you believe. Yes."

"Thank you. I accept your gift." Prophet lifted the silk cord and dropped it around his neck.

"But Prophet, be wary. Do not give the soldiers any excuse to move against you."

Prophet snorted. "The Great Spirit turns our enemies into women. Only two days ago two more Brass Buttons visited, with my permission. They sat where you sit now and played with my children."

"What did they want?"

"To learn if Tecumseh would come to their powwow. I told them he is no longer at Tippecanoe."

"I see. And is this so?" he made himself ask.

"Yes."

"Where is he, Prophet? Where is Tecumseh?"

Prophet watched a bird take wing. "I hear that the Roebuck woman has returned."

"Yes."

The eyes hooded and darted to Micah's face. "And you take her to your blanket."

"Not yet," said Micah reluctantly.

Prophet nodded. He studied Micah for several long seconds.

Prophet knew the cause as well as he, Micah thought. He could feel his face growing warm. He would tell him nothing. His anger at Tecumseh was growing more monstrous by the moment. Jealousy, yes, a deadly sin, before this time no more than words in a book. Micah sprang to his feet.

"Wait!"

"What is it, Prophet?"

"You must not let the Roebuck woman go to New Madrid."

"Why would she go there?"

"She is going to New Madrid for the first new moon of summer. Te-

cumseh will be there." Prophet watched him closely with an expression of contemptuous affection. "A man waits to kill her in New Madrid."

"Who?"

"A trapper. A bad white man called Jack Wheat. Many summers ago he killed his partner. The Roebuck woman knows."

33

"What is it?" Micah reached for Hannah's arm, then pulled back. He had not touched her since that day at his church a month ago.

New Madrid now had a small, floating dock connected to the levee by a rope-rail gangway. They had stepped off the packet in silence.

Hannah shook her head. "I feel awful."

"Hannah. . . ."

"Not sick, Micah. Something awful has happened. Or is going to! I wish we were in Saint Louis! Harmon. . . ."

Micah looked around uneasily. He took Hannah's elbow and together they ascended the levee and started walking across the beaten path to the fort. They stopped simultaneously and looked at each other.

"Did you feel that?"

"Yes, did you? A little earthquake, wasn't it?"

"Yes." The air suddenly seemed still. Moments before, it had been thick with birdcalls. Hannah turned back to look out over the Mississippi. A broad gray sheet of simmering currents. The Ohio churning into it, clear water shooting a deep, steady stream into the muddy surface. So unlike the night, years before, when they had landed during a storm.

Hannah cleared her throat. "When I was younger—," her voice came out in a squeak. She laughed and started again. "When I was younger, Gra'mama used to tell me I had second sight. Is that true, Micah? Can people have second sight?"

"I don't know. What do you see?"

She shrank against him. "Not good."

If she does have second sight, he thought, *may heaven protect her. Jack Wheat could be here, it must be that.* He put his arm around her. "Come, Hannah. Let's see if there is a place travelers can put up."

Hannah's nervousness increased as they passed through the fort gates. She gestured toward the trading post along the north wall. As they approached the broad porch fronting the post, Hannah caught a glimpse of a familiar figure. She stopped.

"What is it?"

278

"Nothing. Go on."

"Not without you."

Suddenly Tecumseh was there, only yards away. Hannah felt such a well of gladness rising in her that she forgot everything else. His pewter-colored eyes rested on hers. His beloved face filled her sight. Gray streaked his temples. How careworn he looked! His garb was indistinguishable from that of the trappers moving about the post, a wonderful disguise that he wore with magnificent ease. A fur hat covered most of his black hair. He walked toward her. Their hands came forth simultaneously to touch and clasp.

He looked down at her, his eyes light with joy. "I knew you would come."

"Badger. . . ."

"Little Squirrel."

He would have taken her in his arms. She reached out and grasped his forearms, feeling their strength. "This is Micah. Micah MacGowan. He is Prophet's friend."

Tecumseh kept his grasp loosely on her arms. A veil of hostility dropped over his face. "We have met."

"Miss Roebuck is with me. You must not see her again, Tecumseh."

Hannah's eyes filled with tears. How could she tell him? She loved him in a way she could never explain, as she could never explain loving Harmon more than her other brothers. A dizzy sensation engulfed her. She thought it was her own feelings, until she saw both men glance around at mules bucking in their traces, heard their neighing, and again realized the stark silence of birds. The feeling, whatever it was, passed.

A company of soldiers rode into the fort. Her senses seemed heightened. Colors were brighter, sounds more distinct. Instinctively she moved back, facing the approaching soldiers. Tecumseh backed to her side, Micah to the other.

The cavalry halted in front of the flagpole. As the leader dismounted and disappeared into the commandant's office, some of the soldiers of the fort ambled over to pass time with the mounted troops. Gradually Hannah realized that something out of the ordinary was happening. A buzz of excitement, speeding from man to man. She glanced uneasily at Tecumseh. She felt his tension. Did they know he was here? She glanced at the gates. No one was moving to close them. Micah's hand slid around her waist.

Suddenly two of the fort soldiers exploded in laughter and began

gesticulating and pounding each other on the back. Then they started shaking the hands of the mounted soldiers. "What is it? What's going on?" Hannah whispered.

The commandant of the fort strode out to the porch. "For those of you who haven't heard the news," he shouted, "that Shawnee trouble-maker—"

A roaring developed in Hannah's ears.

"Tecumseh!" shouted a soldier.

"The very same. General Harrison went in with nine hundred Kentuckians and regulars and leveled his town!" Cries of jubilation rang out. Guns went off in the air. The commandant planted his fists on his hips. "These fine lads have just informed me that there isn't a soul left in that iniquitous place. Not a hut, not a headdress, neither chick nor child. . . ."

Hannah strangled a cry. Micah gripped her arm. Tecumseh started at a run across the compound toward the gates. "Badger! Where are you going?"

"That nest of renegades'll stage no more raids!" yelled a voice somewhere behind her.

"That was a protected camp!" Micah shouted. "Those were families! Why?"

Tecumseh ran swiftly out the gates and scrambled up some limestone cliffs overlooking New Madrid. Cries and shrieks tore from his chest as he ran. He wrenched off the fur hat, the buffalo coat, his shirt, the thong binding his hair. He stood on the cliff with his legs braced and raked his fingernails across his chest again and again, screaming his rage as tears of blood trickled down his body.

The earth began to rumble. Tecumseh stared at the river, his fists clenched. Unearthly things were happening. "Prophet! Prophet! Thy might is proclaimed! Thou art at the right hand of Motshee Monitoo. Kill them! Kill the spirit man! Destroy them all!" He shook his bloody fists at the sky.

Suddenly the Mississippi erupted like a boiling pot. Towering waves crashed against each other. A stand of trees across the river slid in slow motion toward the water. For several unbelievable minutes he watched the course of the river shift and flow upstream. The ground rose and fell in huge swells across the land. Tecumseh laughed.

The towers of the fort began to fall, as if some gigantic foot had kicked out the braces. Men and animals streaked and plunged out the gates. A section of the wall swayed and toppled. Over the crash of timbers, sounds

like groans and rocks grating together emanated from the earth beneath his feet. A huge crack raced along the top of the cliff, with ominous popping sounds. Tecumseh raced before it, down the bank, and across the field toward the fort.

Hannah stood alone in the square. The twin towers at the corners of the fort weren't there. The ground was bucking and heaving as if someone were shaking a giant blanket. She gazed around in confusion. Her knuckles brushed her long hair back from her face, and she discovered blood on them. Something must have hit her. She had been standing with Micah under an overhang. She stared down. Impossible. A deep rift in the square, a chasm! A knocking sound jolted her, and then she found herself on the ground. She heard water rushing. Crawling to an edge that wasn't there moments before, she saw water spewing out of the ground. The split widened. She looked around helplessly for Micah. She struggled to her feet and rubbed her face with both hands. The walls were gone. She could see the river. Trees and parts of boats and sacks and timbers roared past. She turned in a faltering circle. Nothing was the same.

She heard crying and someone screaming again and again, a monotonous, high-pitched cry. Calls. Excited shouts. Whinnies and squeals of animals. The sky a deep steel gray. A few minutes ago, it had been midday.

She looked down. Oh, Rosalind would be so disgusted. Her beautiful blue traveling suit and her gloves, ripped. She pulled together the gaping tear of the sleeve at the shoulder. And a shoe was missing! She would have to have a pair made now. Unless they could make one to match. She heaved a sigh and heard a sob.

A riderless bay horse dashed across the square, missing her by inches in his panic. There had been a man leading him. . . . She saw a pair of legs in buckskin breeches and fallen logs across the chest of the man. In a daze she stumbled toward the figure. Black hair and beard. The downed man's head turned as she stepped over the logs pinioning his chest. They stared at each other. She had seen the face in a hundred nightmares, the malignant mix of fear and craft that she now saw on Jack Wheat's face. Hannah stared at the logs. His chest was caved in so badly. He did not seem to know it. Blood and spittle frothed out of his mouth. Hannah wandered away.

She saw a bare-chested man with blood on him. His hair was long and black. He was running toward her.

Hannah lifted her arms and was seized in his embrace. She closed her

eyes and laid her cheek on the warm flesh of his chest. A part of her wished she could die like this, never awakening to anything else.

She was no better than the early Christians, who were too fearful to shed familiar ways to seek the new way to God through Christ. Her own fear had been the mighty barrier. Even Prophet had sensed it. With terrible clarity, she saw that the Lord gave her the experience with Swallowtail not to frighten her but to teach her that even in danger he was with her.

She opened her eyes and looked up into Tecumseh's face. The gray eyes were like a dead man's. His face was so filled with sorrow that tears began to course down her cheeks.

"Tecumseh, I am so sorry. I didn't know. Micah didn't know. He and Prophet were friends."

Tecumseh's hands slid down her arms and grasped her wrists. He pulled them up between them.

She looked into his terrible eyes. "Kill me, Tecumseh, if it will help. I will go with you, I will do anything, dear Tecumseh, only do not hate me. I love you! Together maybe we can do something. I was afraid, Tecumseh! I am not afraid any longer. If you want me, I will go." The tears would not stop, for Tecumseh, for Prophet, for herself and the past that could never come again.

"Let her go!" Micah charged across the square, scrambling over fallen logs and dead animals. He reached the opposite side of the chasm. The gully had broken into a gorge wider than a man and filled with raging waters. A jagged piece of pink, painted wood with a green shutter still attached shot past them. Dozens of cabbages and bright oranges tumbled along the rushing surface. "It's finished, Tecumseh!"

Tecumseh looked at Micah. "It is never finished!" He raised Hannah's arms toward heaven. Hannah looked in terror at the water. Then he flung her aside and sprang back. The bay horse was near, dashing back and forth in short gallops, his eyes rolling with fear. Tecumseh caught him and flung himself on his back. The horse plunged toward the buildings at the rear of the fort.

Hannah scrambled to her feet. "Tecumseh! Take me with you!"

"No!" screamed Micah, running back and forth on the opposite side of the gorge.

"Tecumseh!" she cried. "Badger!"

Micah dashed down the side of the gully, seeking a way to cross.

The horse reared at the edge of the buildings. Tecumseh pulled him

around in tight circles to bring him under control. Hannah ran toward him, her arms raised. "Tecumseh!"

The horse ran straight at her, toward the open field that lay beyond the ruined wall.

"Tecumseh!"

Tecumseh reined back and leaned down for her. She grabbed his arm and scrambled up behind.

"No!" Micah screamed. "Hannah! Hannah. . . !"

Epilogue

Hannah and Tecumseh were married by a British chaplain at Fort Detroit. Tecumseh lived to celebrate the birth of his son. And as for Hannah, well . . . that is another story.

Historical Note

Tecumseh's dream of a Great Western Indian Confederacy was shattered in 1811 when General William Henry Harrison and his men destroyed Prophet's Town near the mouth of Tippecanoe Creek and the Wabash River, in present-day Indiana.

Later in that year, over a two-month period, struck the three greatest earthquakes ever recorded. Centered in New Madrid, where the Ohio and Mississippi Rivers meet, all three had the intensity of twelve on the Richter scale. Whole forests slid into the churning seas of the Mississippi; islands disappeared, and new ones were born, the largest forty miles long and a half mile wide. The shocks were felt from Canada to New Orleans and from the headwaters of the Missouri to Boston. About 2 million square miles were shaken. In the most seriously affected area, between 30,000 and 50,000 square miles, huge blows of gas, sand, and mud pocked the land with moonlike craters. Domelike mounds ten miles across grew into existence. Fissures opened in the earth and permanently changed the course of the Mississippi River. Because of the sparse settlement of the region and the adaptability of the log cabin to earthquakes, only one life was lost.

Tecumseh rebuilt Prophet's Town but he never forgave the United States' treachery. In the War of 1812, he went over to the British. His Northwest alliance of tribes remained staunch British allies. Tecumseh rose to the rank of general, leading his troops in bloody, determined, fearless, and effective border raids until he was killed in battle on October 5, 1813, near the Thames River in Canada.

CHRISTIAN HERALD ASSOCIATION AND ITS MINISTRIES

CHRISTIAN HERALD ASSOCIATION, founded in 1878, publishes The Christian Herald Magazine, one of the leading interdenominational religious monthlies in America. Through its wide circulation, it brings inspiring articles and the latest news of religious developments to many families. From the magazine's pages came the initiative for CHRISTIAN HERALD CHILDREN and THE BOWERY MISSION, two individually supported not-for-profit corporations.

CHRISTIAN HERALD CHILDREN, established in 1894, is the name for a unique and dynamic ministry to disadvantaged children, offering hope and opportunities which would not otherwise be available for reasons of poverty and neglect. The goal is to develop each child's potential and to demonstrate Christian compassion and understanding to children in need.

Mont Lawn is a permanent camp located in Bushkill, Pennsylvania. It is the focal point of a ministry which provides a healthful "vacation with a purpose" to children who without it would be confined to the streets of the city. Up to 1000 children between the age of 7 and 11 come to Mont Lawn each year.

Christian Herald Children maintains year-round contact with children by means of a *City Youth Ministry*. Central to its philosophy is the belief that only through sustained relationships and demonstrated concern can individual lives be truly enriched. Special emphasis is on individual guidance, spiritual and family counseling and tutoring. This follow-up ministry to inner-city children culminates for many in financial assistance toward higher education and career counseling.

THE BOWERY MISSION, located at 227 Bowery, New York City, has since 1879 been reaching out to the lost men on the Bowery, offering them what could be their last chance to rebuild their lives. Every man is fed, clothed and ministered to. Countless numbers have entered the 90-day residential rehabilitation program at the Bowery Mission. A concentrated ministry of counseling, medical care, nutrition therapy, Bible study and Gospel services awakens a man to spiritual renewal within himself.

These ministries are supported solely by the voluntary contributions of individuals and by legacies and bequests. Contributions are tax deductible. Checks should be made out either to CHRISTIAN HERALD CHILDREN or to THE BOWERY MISSION.

Administrative Office: 40 Overlook Drive, Chappaqua, New York 10514
Telephone: (914) 769-9000